50
TRADE SECRETS OF
GREAT DESIGN
PACKAGING

ROCKPORT

50

STAFFORD CLIFF

TRADE SECRETS OF GREAT DESIGN

PACKAGING

ROCKPORT PUBLISHERS

GLOUCESTER MASSACHUSETTS

A QUINTET BOOK

First published in the United States of America by:
Rockport Publishers, Inc.
33 Commercial Street
Gloucester, Massachusetts 01930
Telephone (978) 282-9590
Fax: (978) 283-2742
Website: www.rockpub.com

ISBN 1-56496-872-3

10 9 8 7 6 5 4

Copyright ©1999 Quintet Publishing Limited

Reprinted 2001
First Rockport Publishers paperback printed in 2002

This book was designed and produced by
Quintet Publishing Limited
6 Blundell Street, London N7 9BH

Designers: Stuart Smith, Stafford Cliff, Keith Bambury
Project Editors: Anna Southgate, Victoria Leitch,
Doreen Palamartschuk, Diana Steedman
Creative Director: Richard Dewing
Publisher: Oliver Salzmann

Manufactured in Malaysia by C.H. Colourscan Sdn Bhd
Printed in China by Leefung-Asco Printers Ltd

COVER PHOTOGRAPHS: see pages, 10, 30, 46, 212
RIGHT Part of a series of over 160 different food packs
designed for the Conran Collection by Morag Myerscough
and seen here at the Blue Bird store in London's Kings
Road. (see page 132).

Among the material suppied by the designers are roughs
and presentation boards used to illustrate an approach or
focus on a market position. These images are taken from
available sources. By reproducing them it is not our
intention to infringe copyright. Every effort has been made
to acknowledge these sources fully. In the event of
omissions, we apologise and would be pleased to include
acknowledgment in future editions.

ACKNOWLEDGMENTS

Kulbir Thandi Priscilla Carluccio
Amanda Dixon Kevin Gould
Susan Scrymgour Dominic Blackmore
Virginia Pepper Jean Cazals
John Scott Lydia Darbyshire

and the dozens of designers, marketing managers, and
company executives, who gave up their time, and without
whose knowledge, patience, and cooperation, this book
would not have been possible.

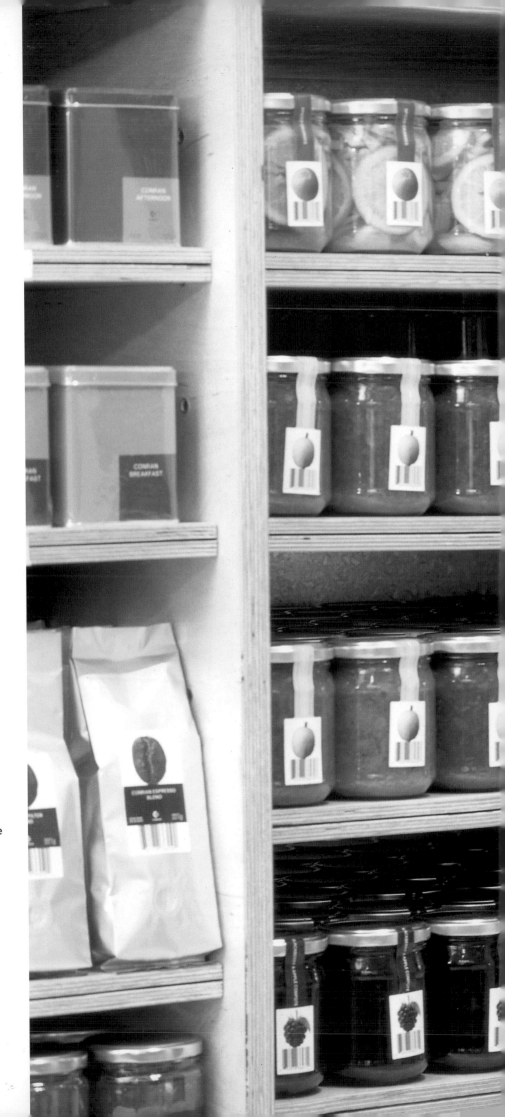

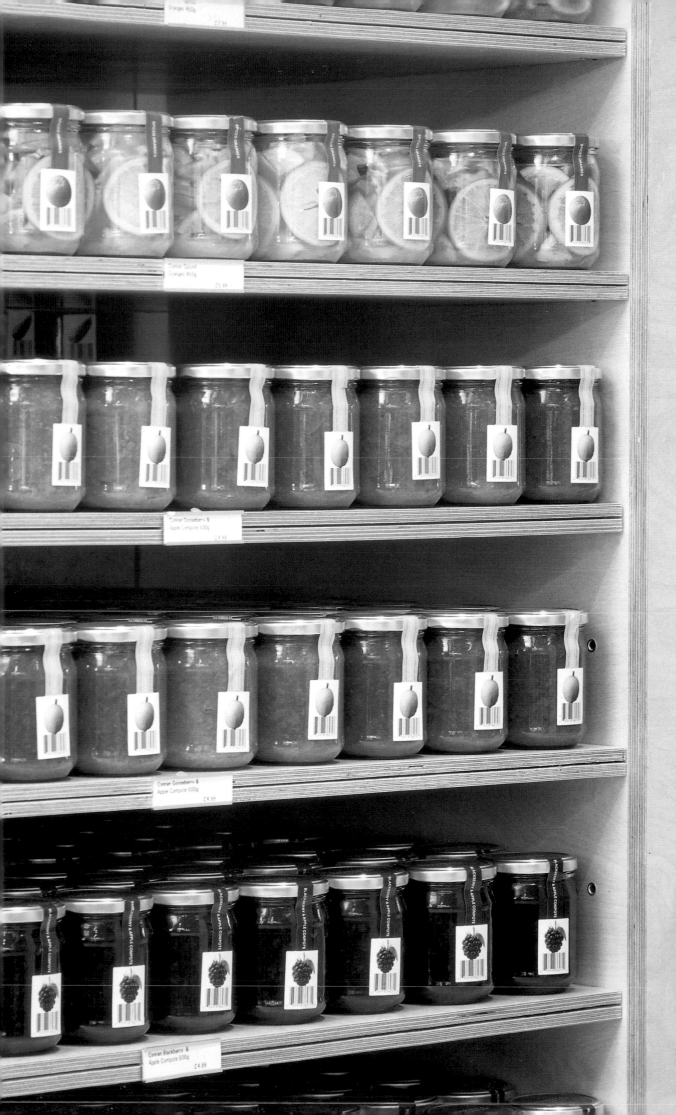

CONTENTS

INTRODUCTION

Of all areas of design, packaging is, say those who specialize in it, the most emotional. "It's totally physical," says one. "That's why I never show the client flat roughs on paper."All the designers I spoke to agreed that part of the joy of packaging is touching it, seeing how it catches the light, how its three-dimensional character and its one-to-one, "in-your-hand" qualities trigger responses. The physical properties, and therefore the possibilities open to designers working in plastics or ceramics are very different from those involved in paper or card, where textures, finishes, and methods of construction can be made to reflect both the product's qualities as well as recycling concerns. When special moldings are involved, the remarkable capabilities of computer-generated visuals have given designers and modelmakers advantages they once did not have, as well as saving vast amounts on machine prototyping. And, in the case of glass, the transparency and the weight can be used to achieve uniquely varied effects. At every turn, the designer must know what is possible and what is not.

From that point of view, the work I have selected for this book can only be a pale reminder or a tempting preview of the real thing. The stories that follow are a unique document of an important process, for many of the designers I interviewed, who showed me their original roughs, said: "Even our client never saw these."

I asked them all: How do you begin work on a design project? What sort of briefs do you get? What design process do you use? How do you know when it is the right solution? The replies I received were remarkably frank and varied. While one company might show only one final solution, another will give the client dozens of choices. While one company will spend months working on its initial ideas, another does its best work the day before the first presentation.

Designers need to keep up to date with changing technology, as well as new materials and existing designs, and many who specialize in one product area will keep an ongoing library of competitors' samples and manufacturing possibilities to which clients can refer. Sometimes the client's brief will include the type of container to be used and the manufacture, but in other examples, designers have a free hand to suggest packaging methods and materials, and even in some cases, a responsibility to hit target production costs.

This book covers a wide range of products and design methods. Most of the designers spoke of the importance of the initial brief and stressed the need to understand the client's business, the brand positioning and the customers' expectations. Clients often put together design rosters of up to a dozen different consultants, with whom they develop long-term relationships Clients often put together design rosters of up to a dozen different consultants, with whom they develop long-term relationships, and if, as is sometimes the case, clients find it difficult to understand how designers work, this book sould leave them in no doubt.

Stafford Cliff

Vosene

Direct contact between the client and the designer is an important element for the designers at Tin Horse, a small packaging design studio in Wiltshire, "design can be done anywhere, our clients are used to seeing us with cellulose paint on our fingers," remarks partner John Lamb. "When we start work on a new job, **we tend to plunge in rather than play safe"**

When Wella GB came to Tin Horse in 1994, the company had already carried out research into people's perceptions of Vosene, a tried and tested medicated shampoo, and this suggested that a radical rethink was indicated for a product that had been a household name since the 1940s. Having worked on haircare products before, Tin Horse understood the market and the need to have a Vosene bottle that was both individual and new while still echoing the traditions of a medicated shampoo. But this combination of aim—holding onto existing and loyal customers while making a fresh appeal to a new and increasing target market—is a tricky path to tread. As the marketing brief put it, the objectives were:

- To create a proposition, supported by packaging, production, and communication, that is relevant to today's and future customers.
- To grow the brand in terms of turnover and market share.
- To attract new and lapsed users/purchasers to the brand, while retaining current loyalists.
- To increase frequency of use.
- To increase the Vosene range.

In addition, the report summarized the design requirements as follows:

- Both existing and non-users of the brand desperately want a redesign, and the change can be radical (some users are too embarrassed to leave it out on the bathroom shelf).
- Current users want Vosene Original to stay green. Among non-users, however, green is not such a key feature, Vosene Fresh (relaunched as Vosene Frequent) and Vosene Junior launched in October 1995, could be in different colors.

WITH THE TEARDROP AS A STARTING POINT, SOME OF THE FIRST "SCRIBBLES" SHOW HOW TYPE AND PACK COULD BE CLOSELY RELATED.

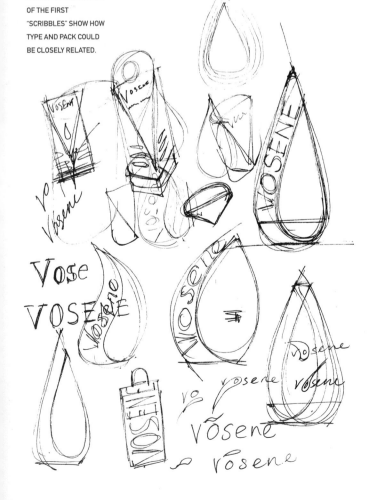

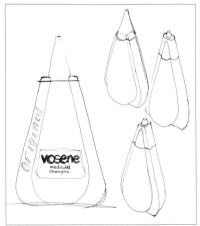

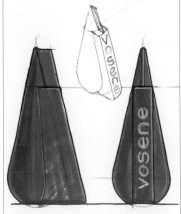

USING THE CAP AS PART OF THE OVERALL SHAPE, THESE EARLY SKETCHES DEMONSTRATE HOW TOTALLY THREE-DIMENSIONAL THE FORM COULD BE, EVEN TO THE EXTENT OF MOLDING IN AN AREA FOR THE NAME.

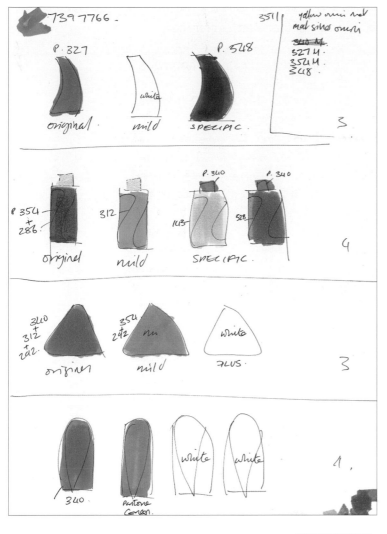

- The teardrop device is important and could serve as a useful link to the existing design.
- Vosene is fundamentally non-frilly/non-cosmetic and unfussy, and the design needs to reflect this in a broadly unisex fashion.
- Above all, Vosene needs to have its confidence restored.

The mention of green in the research is curious, a carry-over, perhaps, from the traditional Vosene Original green bottle that has made customers' perception of the liquid to be green too, although it is, in fact, brown.

In the response document, Tin Horse allied the color to our feelings about Santa Claus: "The color green is seen as a sacred cow that must be perpetuated. It's a little like Father Christmas. We all know he isn't real, but the thought of him is warm and reassuring. People who know the brand, know the product isn't really green, but the association lives on, and this is another instance where it isn't worth shattering the myth."

Stage one took three weeks and resulted in hundreds of sketches and a table full of rough foam models, as well as competitors' samples, moodboards, color swatches, and graphic approaches.

Although it looks simple, making a foam model is an art in itself, but one that every product designer is expected to master. Blocks of pale blue expanded polystyrene styrofoam are carved to the contours of a rough paper sketch using the methods of a sculptor rather than a potter, and with a band saw rather than a chisel.

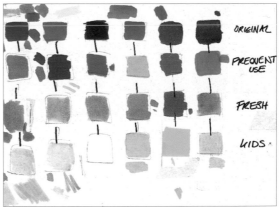

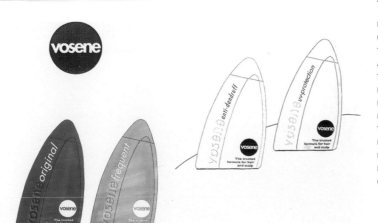

REFERRING BACK TO ONE OF THE FIRST SKETCHES, THIS GROUP EMPLOYED AREAS OF MATTE AND TEXTURE, AS WELL AS AN INVERTED TEARDROP RENDERED IN AN ALMOST PHOTOGRAPHIC TECHNIQUE, WHICH EVOKES A TRAPPED BUBBLE OF AIR, RISING INSIDE THE LIQUID CONTENTS.

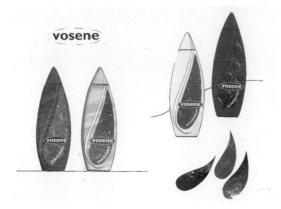

ONE OF THE MOST UNUSUAL ROUTES EMPLOYED A SYMMETRICAL BOTTLE AND AN ASYMMETRICAL LABEL, WHICH WAS GIVEN AN ALMOST THREE-DIMENSIONAL QUALITY BY ADDING A PATTERN OF WATER REFLECTIONS. THE DESIGNERS HAD TO REMEMBER THAT "THE FEEL OF THE VOSENE PACK IN HAND AND IN USE HAS TO BE A KEY CONSIDERATION."

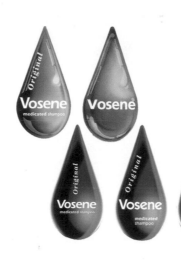

PRESENTATION - 11-AUG - "TEARDROP."

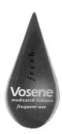

LOOKING AT THE IMAGE OF A "REAL" TEARDROP OR A DROP OF SHAMPOO, ADGE GITTINGS AND KEITH PICTON USED PHOTOSHOP ON A MACINTOSH TO PRODUCE ALTERNATIVE SOLUTIONS ONCE A FINAL PACK SHAPE AND LABEL AREA HAD BEEN AGREED. LABEL MACHINERY HAD TO BE MODIFIED IN ORDER TO POSITION EACH LABEL ACCURATELY IN ITS IDENTIFIED PROFILE POSITION.

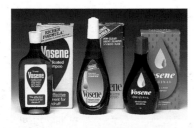

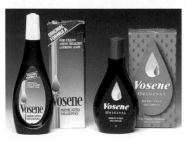

PACKS FROM THE ARCHIVE, DATING FROM THE 1970S AND 1980S, SHOW WHY "MANY CUSTOMERS HIDE THE BOTTLE AWAY IN THE BATHROOM CABINET, DEEMING IT TOO UNATTRACTIVE TO LEAVE ON SHOW."

Sifting through all the options Wella GB chose eight routes for development and the application of graphics. The graphic designers worked on the rendering of what became known as the teardrop motif, a visualization of the contents that has been with the brand for many years. From this group, six were selected for further research, the outcome of which changed the whole direction of the project and even overturned the brief itself. Contrary to expectations, customers reacted strongly against any radical developments. They felt it was no longer the Vosene they knew and trusted, and they demanded a rethink.

Finally, the designers got the right brief. It had to be symmetrical. The teardrop shape was liked. And it had to be green. From three shapes that conformed to these criteria, one was chosen for further development and research before it was approved technically in Germany.

During this time John Lamb produced engineering drawings and worked closely with the bottle manufacturer, the cap manufacturer, and the label application machinery manufacturer.

After an unusually extended program—the whole process took one-and-a-half years—what emerged was a modern-ization of the brand, rather than a radical redesign, but one that could compete with what is happening in the shampoo market and that placed its emphasis firmly on product function. For the designers it was also a job that brought together structural packaging and graphic design in a unique and wholly appropriate way.

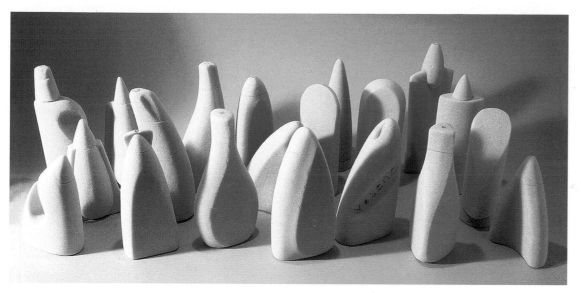

ROUGH FOAM MODELS OF
THE VARIOUS ROUTES
FROM WHICH EIGHT
WERE SELECTED FOR
DEVELOPMENT AT THE
END OF STAGE ONE.

REFLECTING THE DESIGN OBJECTIVES LAID OUT IN THE ORIGINAL CLIENT BRIEF, THE VOSENE PACKS "SUPPORT THE FUTURE POSITIONING OF THE BRAND, [AND] WILL HAVE THE FOLLOWING VALUES: HEALTHY, FRESH, AND ENERGETIC; REASSURING, EFFICIENT, AND PERSONAL; CONFIDENT, STRAIGHTFORWARD, AND SYMPATHETIC." AT THE SAME TIME, THE COMBINATION OF GRAPHICS AND MOLDED SURFACE, AND THE WAY IN WHICH THE LIGHT FALLS ON THEM, GIVES THE PACK A THREE-DIMENSIONAL SENSUALITY THAT MAKES YOU WANT TO REACH OUT AND USE IT.

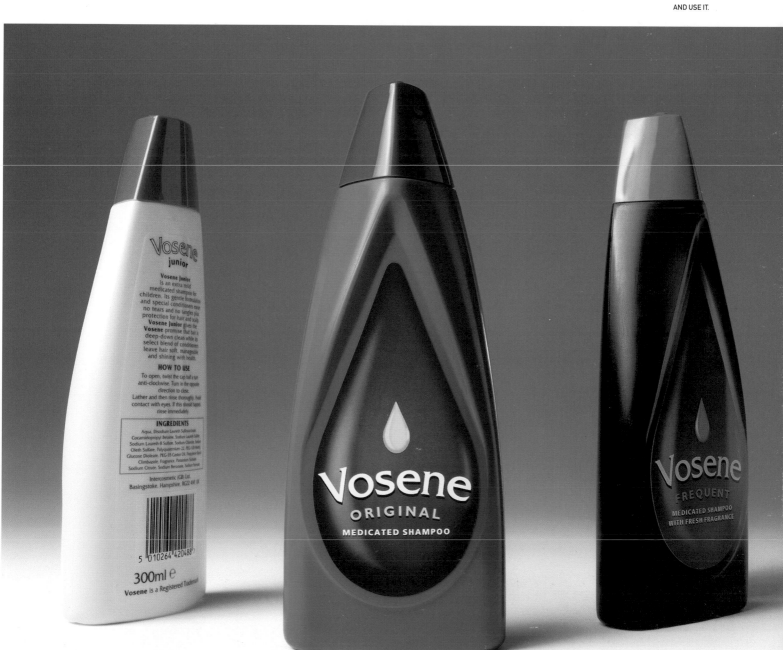

Maggie Beer

Ask anyone in South Australia's Barossa Valley and they will probably know who you are talking about—the woman who established a pheasant farm two hours' drive north of Adelaide and then turned the idyllic country farmhouse on the edge of a trout-filled lake into a restaurant. Gradually, by word of mouth, **it became well known**, as much for its exuberant chef-cum-owner as **for its delicious pheasant pâté**

As time went by and to satisfy the demand of her customers, Maggie Beer started to offer slices of pâté to sell to her enthusiastic patrons, until, with the help of her husband Colin, she decided to sell the restaurant and devote all her time to making and packaging gourmet food products. With some trepidation, she approached the Adelaide designer Ian Kidd, himself something of a food enthusiast. "She had used some kind of designer before," recalls Kidd, and she seemed to know enough about the process to realize that Kidd's outfit and expertise might be expensive, so he took "a soft line when it came to quoting a fee." But the two got on well. "She has a very fertile mind and waves her arms around a lot," recalls Kidd, and everyone in the studio "ate the pâté until they were almost sick."

Maggie Beer's existing packs had a literal drawing of a pheasant, but it was an awkward shape and wasn't at all suitable for brand development or for "her company's boutique personality, quality, and price orientation." In the way that he works, Kidd and his team produced just one idea. Senior designer Dinah Edwards—"a very good illustrator," says Kidd—did a woodcut of a pheasant that was "a figment of her imagination." However, it was a tight image that was suitable for a lot of different applications—aprons, banners, and plates as well as packaging—and it seemed to have a "lovely European restaurant feel," Kidd recalls. "The Barossa Valley has a strong European heritage and Beer's cooking is basic fare," so that the French Provençal-inspired style seemed right. In addition, the packs were covered with substantial amounts of typeset information about the product and recipes, dotted about with quirky little drawings. In addition to boxes and pots of pâté, the primarily monochrome identity, which proved to be extremely flexible, was applied to bottles.

At the presentation, Maggie Beer asked for only one change. The reference to her "legendary status" was replaced with copy about the equally famous Barossa Valley.

Working at home with her kitchen staff, Maggie Beer undertook all the product development herself. There were six products, which were exported as far afield as Japan and Southeast Asia. To the gourmet pheasant, she has added emu and venison pâtés, has written three very personal cookbooks, which are as much about her life as about her recipes, and has been in constant demand as a speaker and cooking demonstrator.

DINAH EDWARDS WORKED ON CREATING AN IMAGINARY EVOCATION OF A PHEASANT, DRAWN LIKE A RUBBER STAMP, WHICH COULD HAVE THE NAME AND SLOGAN COMBINED IN THE SAME BLOCK. THE DESIGNERS KNEW THAT IT WOULD HAVE TO HAVE GREAT FLEXIBILITY, WHETHER IT WAS PRINTED IN ONE COLOR OR WAS BURNED INTO WOOD AND WHETHER IT WAS REPRODUCED LARGE ON APRONS OR SMALL ON BOTTLES. THE SECOND VERSION (*RIGHT*) USED THE SAME TYPOGRAPHY, BUT THE BIRD LOOKED MORE LIKE A WOODCUT ILLUSTRATION. IN THE FINAL LOGO (*RIGHT*) THE BIRD WAS ADAPTED SLIGHTLY AND THE TYPE WAS CHANGED TO BETTER MATCH THE ILLUSTRATION

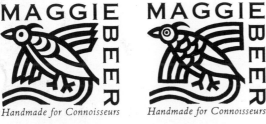

MAGGIE BEER
Handmade for Connoisseurs

MAGGIE BEER
Handmade for Connoisseurs

MAGGIE BEER
Handmade for Connoisseurs

MAGGIE BEER
Handmade for Connoisseurs

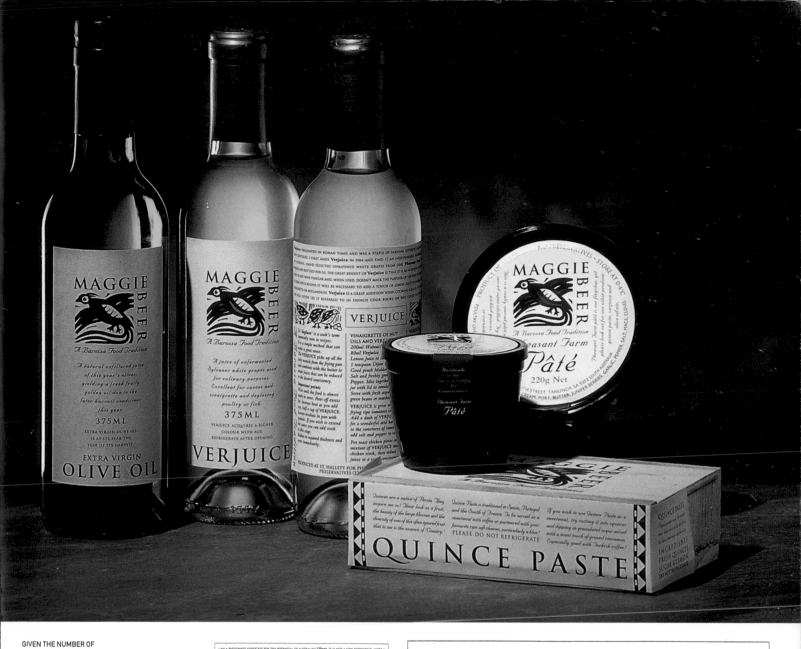

GIVEN THE NUMBER OF BOTTLES AND POTS, IAN KIDD'S STUDIO ORGANIZED ALL THE ARTWORK AND ARRANGED THE PRINTING. AT THE LAST COUNT, THERE WERE SIX PRODUCTS ON SALE, WITH MORE BEING DEVELOPED.

TWO VERSIONS OF THE LABELS ON THE BACK OF THE BOTTLES. THE ILLUSTRATIONS WERE IN THE SAME STYLE AS THE PHEASANT LOGO, AND THE COPY—FULL OF FASCINATING INFORMATION—WAS WRITTEN BY IAN KIDD, WHILE THE RECIPES WERE ADDED BY THE CLIENT HERSELF.

I AM A PASSIONATE ADVOCATE FOR THE POTENTIAL OF AUSTRALIAN Olives. IT IS NOT A NEW ENDEAVOUR, MORE A RENAISSANCE. IN SOUTH AUSTRALIA THERE WERE SERIOUS Olive GROVES IN THE MID 1800'S. G. W. FRANCIS, WHO LATER BECAME THE DIRECTOR OF THE ADELAIDE BOTANIC GARDENS SENT HIS OWN Olive OIL TO THE GREAT EXHIBITION OF LONDON IN 1851 AND RECEIVED AN HONOURABLE MENTION. THE MAKING OF EXTRA VIRGIN Olive OIL THOUGH TRADITIONALLY A VERY SIMPLE PROCESS, REQUIRES ATTENTION TO DETAIL AT EVERY STAGE. FOR THE NEXT 3 TO 10 YEARS IN AUSTRALIA THIS INDUSTRY WILL BE LIMITED BY A SHORTAGE OF Olives AND TREES OF THE RIGHT VARIETIES FOR THE RIGHT AREAS. AT THE MOMENT THE Olives WE ARE PICKING GIVE US A WONDERFUL FLAVOUR, BUT LESS THAN HALF THE YIELD WE CAN EXPECT WHEN THE TREES WE HAVE PLANTED COME INTO BEARING. EXTRA VIRGIN Olive OIL USES ONLY THE FIRST PRESS OF THE JUICE OF THE Olives AND SO IS INCREDIBLY EXPENSIVE TO PRODUCE.

EXTRA VIRGIN OLIVE OIL

A Barossa Food Tradition

There is a huge flavour difference between Extra Virgin OLIVE oil and bulk OLIVE oil. Extra Virgin OLIVE oil is to use for the finishing touches of a meal. As little as a drizzle can transform the ordinary into the sublime. Add at the last moment to soups, vegetables, grilled fish or poultry, or salad greens.

Toss good quality pasta, cooked al dente, with this oil and shave Parmigiano Reggiano over it liberally, season and serve with freshly chopped flat leaf parsley.

To preserve the wonderful flavours of extra virgin OLIVE oil, once the bottle is open, use within a reasonable time, rather than saving for special occasions! We have chosen a dark glass as it helps to preserve the oil. Oils are reactive and in the presence of heat, light and oxygen, they can break down to form undesirable products which will affect the odour and taste of the oil, resulting in rancidity.

Only oil with less than 1% acid expressed as free oleic acid and free of flavour defects can be classified as Extra Virgin.

OLIVE oil not only contains healthy monounsaturated fat but is an excellent source of a wide variety of natural antioxidants. Extra virgin OLIVE oil has the highest content of these substances, many of which also contributes to its superb flavour.

DUCK EGG PASTA WITH GOATS CHEESE
250gm Duck Egg Pasta
Extra Virgin OLIVE Oil
300gm Woodside Cheesenymphs
goats cheese – grated or sliced very finely
8 cloves garlic – peeled
1/2 cup of chopped flat leaf parsley,
salt and freshly ground black pepper

In a large pan, generously cover the bottom with oil, add garlic cloves and sauté over a gentle heat till garlic cloves are golden and soft. Cook pasta in salted boiling water till al dente, drain and whilst hot, add the warm caramelised garlic, goats cheese, parsley and a drizzle more oil. Season with lots of freshly ground black pepper. OR

Make a paste of garlic, anchovies and OLIVE oil and then toss freshly cooked pasta, the paste and a generous amount of flat leaf parsley, a little more oil, season and serve.

BOTTLED AT PHEASANT FARM, PHEASANT FARM ROAD, NURIOOTPA 5355. PRODUCE OF SOUTH AUSTRALIA

Verjuice ORIGINATED IN ROMAN TIMES AND WAS A STAPLE OF PARISIAN KITCHENS DURING THE 14TH AND 15TH CENTURIES. I FIRST MADE **Verjuice** IN 1984 AND FIND IT AN INDISPENSABLE INGREDIENT TO MY STYLE OF COOKING. HAND SELECTED UNRIPENED WHITE GRAPES FROM OUR **Pheasant Farm** VINEYARDS ARE PRESSED AND BOTTLED FOR US. THE GREAT BENEFIT OF **Verjuice** IS THAT IT IS AN ACIDULANT, MILDER THAN LEMON JUICE OR RED WINE VINEGAR AND, WHEN USED, DOESN'T MASK THE FLAVOUR OF THE FOOD TO WHICH IT IS ADDED. IN SOME APPLICATIONS IT WILL BE NECESSARY TO ADD A TOUCH OF LEMON JUICE TO INCREASE SHARPNESS. EG. VINAIGRETTE OR HOLLANDAISE. **Verjuice** IS A GREAT ADDITION WHEN COOKING SCALLOPS, TROUT, VEAL OR QUAIL. YOU WILL OFTEN SEE IT REFERRED TO IN FRENCH COOK BOOKS OR YOU COULD USE SOME OF MY IDEAS.

A Barossa Food Tradition

To 'deglaze' is a cook's term you will often see in recipes. It is a simple method that can make a great sauce. The VERJUICE picks up all the tasty morsels from the frying pan and combines with the butter to create juices that can be reduced to the desired consistency.

Important points
Wait until the food is almost ready to serve. Pour off excess fat. Increase heat as you add say, half a cup of VERJUICE. Loosen residues in pan with spatula. If you wish to extend the sauce you can add stock at this stage. Reduce to required thickness and serve immediately.

VINAIGRETTE OF NUT OILS AND VERJUICE
200ml Walnut or Almond Oil
80ml Verjuice
20ml Lemon Juice
1 teaspoon Dijon Mustard
Good pinch Maldon Sea Salt
and freshly ground Black Pepper.
Mix together in glass jar with lid to emulsify. Serve VERJUICE and walnut oil vinaigrette or hollandaise with fresh asparagus, green beans and mushrooms.

VERJUICE can be reduced to a syrup in the making of a Hollandaise or Beurre Blanc to give a classic sauce another dimension, particularly when serving with seafood. It's a natural marriage of flavours.

Use in winter to poach Beurre Bosc Pears and in summer to poach soft fruits, particularly nectarines and peaches or to reconstitute dried fruits.

Pot roast chicken pieces in a mixture of VERJUICE and chicken stock, then reduce juices to a sauce consistency.

Pan fry chicken or duck livers in nut brown butter and at the last moment throw currants or sultanas soaked in VERJUICE, in the pan, and deglaze the pan with the remaining soaking juices.

VERJUICE is great when pan frying ripe tomatoes in butter. Add a dash of VERJUICE for a wonderful acid balance to the sweetness of tomatoes, add salt and pepper to taste.

PRODUCED AT ST. HALLETT FOR PHEASANT FARM, SAMUEL ROAD, NURIOOTPA S.A. 5355
PRESERVATIVES (220) (202) ANTIOXIDANT (300) ADDED

Halfords

When you are launching an own-brand product into a market that is already saturated by commercially successful, proprietary brands, where do you start? **The answer is with the customer** and with good packaging

Halfords has been in the bicycle business since 1907. By the 1930s the company had 200 outlets across Britain, and in 1989 it was purchased by the Boots Company. Halfords now sells almost a third of all bikes sold in Britain and more than 40 percent of all cycle accessories. As part of its sales and marketing initiative, it has followed the lead of the parent company and set up a unique design roster, with John McConnell, senior partner at Pentagram, as coordinator. In 1993 three design consultants—Lewis Moberly, Newell & Sorrell, and Lippa Pearce—were briefed to tackle their first projects for Halfords. All three visions were perfectly in tune, recalls Harry Pearce, partner at Lippa Pearce. "You couldn't get a razor blade between them." So the extraordinary quartet blossomed, and each month the design management party (DMP) discusses new briefs, allocates design work, and reviews creative presentations. "It's a very open process of discussion, with time for reflection," explains Pearce.

This particular brief called for the design of packaging for a range of cycle computers, a product whose sales were expected to grow as the popularity of cycling increased. The market was divided into three proprietary brand segments: well-known and commercially dominant brands; low-volume, premium brands for customers "in the know;" and secondary brands, which were not technically advanced but which were aimed at the fashion market and were comparatively

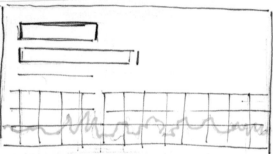

(LEFT) ONE OF THE FIRST SKETCHES OF LARGE NUMERALS TO DENOTE THE VARIOUS FUNCTIONS OF EACH MODEL. ALTHOUGH DRAWN WITHOUT ANY DETAIL, THIS IDEA WAS STRONG ENOUGH TO MAKE IT THROUGH TO THE END.

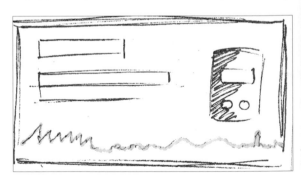

(ABOVE) SOME OF THE EARLY THUMBNAIL SKETCHES ONLY A FEW INCHES WIDE, INCLUDED ONE USING CONTOUR LINES ON A GRID. THAT MATCHED ONE WITH A GRAPH MARRIED TO THE OUTLINE OF THE LANDSCAPE. ON ANOTHER, THE PROFILE OF THE LANDSCAPE, BECAME A GRAPH.

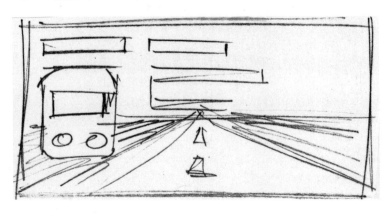

ANOTHER IDEA WAS TO USE DIFFERENT VIEWS OF THE ROAD AHEAD. ONE WITH A CALIBRATED DIAL AND ONE WITH BOLD COLOR, AS A WAY TO DIFFERENTIATE BETWEEN FUNCTIONS.

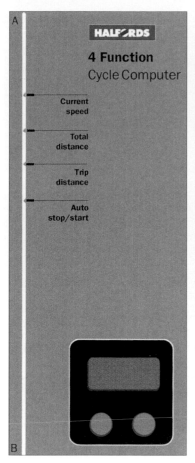

HALF RDS

4 Function
Cycle Computer

A

Current
speed

Total
distance

Trip
distance

Auto
stop/start

B

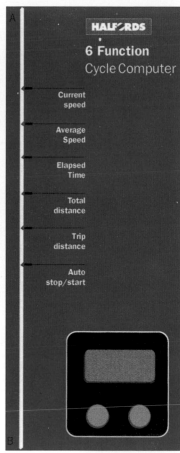

HALF RDS

6 Function
Cycle Computer

A

Current
speed

Average
Speed

Elapsed
Time

Total
distance

Trip
distance

Auto
stop/start

B

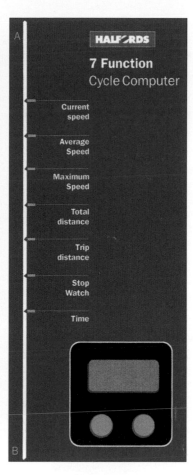

HALF RDS

7 Function
Cycle Computer

A

Current
speed

Average
Speed

Maximum
Speed

Total
distance

Trip
distance

Stop
Watch

Time

B

WHEN IT WAS ON THE
COMPUTER. THE
DESIGNERS TOOK THE
BASIC BOX SHAPE AND
APPLIED VARIOUS
LAYOUTS. EVEN
CONSIDERING A
SOLUTION THAT SHOWED
THE BOX AS AN UPRIGHT
LAYOUT WITH THE
FUNCTIONS DISTRIBUTED
BETWEEN TRAVEL
POINTS A AND B.

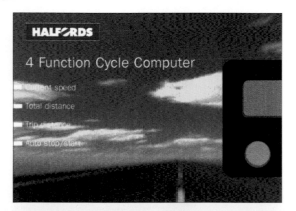

ALTHOUGH NOT
FOLLOWED UP, THIS WAS
THE IDEA USING A
PHOTOGRAPH TO CONVEY
THE JOY OF THE OPEN
ROAD. BUT THE CLIENT
THOUGHT IT "EMOTIONAL
AND NOT
INFORMATIONAL."

inexpensive. Before the creation of its own-brand range, Halfords sold products from all three brand sectors.

Echoing the fashion clothing market, each of the proprietary brands featured its identity aggressively on the packaging to the exclusion of product information. Even when product leaflets were included inside the box, these were often confusingly translated by the manufacturers in the Far East or were dauntingly technical. This lack of technical information for the customer gave Halfords its first major commercial problem—and opportunity—in the computer market. Customers were buying computers at an accelerating rate, but then returning them in large quantities because they could not understand how to make them work. Customers suffered from "technofear" and misunderstood the different computer functions. The strategic importance of giving customers enough product information and the long-term need to upgrade customer perception of Halfords' own-brand cycle accessories became the core elements of the brief.

Over the past four years, Lippa Pearce has been responsible for the design of 400 to 500 individual packs for Halfords, so it already knew a lot about the market, and Harry Pearce, who lives near his office in Richmond, even cycles to work each morning. Nevertheless, the first stage is always a period of assimilation—perhaps a week—to review the competition (supplied, in this instance, by the client), collect magazines and generally get acquainted with the market, more in order to avoid what others are doing than to emulate them. "In this case," remembers Pearce, "everything

seemed confused—titles people didn't really understand and things sold as fashion items rather than products that provide information." Information seemed to be the key. In all its work for Halfords, Lippa Pearce has tried to demystify everything—get rid of the anxiety—with clear graphics and a picture of the product in situ," continues Pearce. "The aim is to tell very simple tales."

Following its philosophy of idea-led design solutions based on strategic analyses, Harry Pearce ran the project, working with Paul Tunnicliffe, who has also designed many other packs for Halfords. "It was largely there in my head," recalls Pearce, but the two spent a half day together to discuss the potential of routes and then another two days working alone before they met again to share their work.

Although they normally show the client only two or three design routes, in this case the two designers produced about 10 possibilities before pruning the selection down "to see if our early notions had got legs. We could have attacked it from several directions, but probably only one was right," remarks Pearce. In their pre-edit, they selected three routes to work up to presentation standard.

In their desire to convey simple product information about the computer itself and about its features and benefits, they had to take care not to lose the fashion image or make it look too expensive. As the brief put it, the aim was "to make people really want the own-brand more than the proprietary brands."

Unusually, all the first roughs look remarkably similar, with simple type, and a small window through which the product could be viewed. The main differences concern the ways in which the "function story" and choice of five, seven, or eight functions were to be explained, although one solution went for a rather more imaginative proposal, and

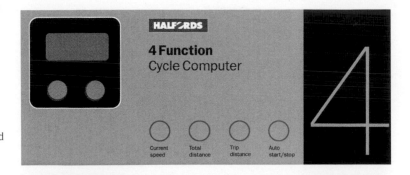

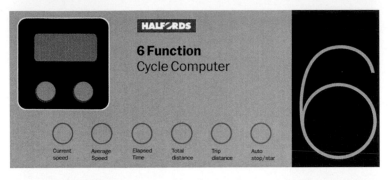

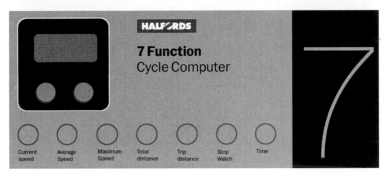

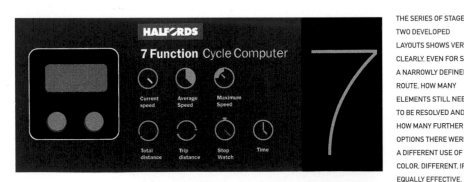

THE SERIES OF STAGE TWO DEVELOPED LAYOUTS SHOWS VERY CLEARLY, EVEN FOR SUCH A NARROWLY DEFINED ROUTE, HOW MANY ELEMENTS STILL NEEDED TO BE RESOLVED AND HOW MANY FURTHER OPTIONS THERE WERE. A DIFFERENT USE OF COLOR, DIFFERENT, IF EQUALLY EFFECTIVE, WAYS OF SHOWING FUNCTIONS, AND A DIFFERENT USE OF LARGE NUMERALS ALL CHANGE THE LOOK OF THE PACK.

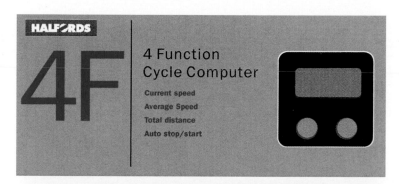

HALFORDS

4F
4 Function Cycle Computer

Current speed
Average Speed
Total distance
Auto stop/start

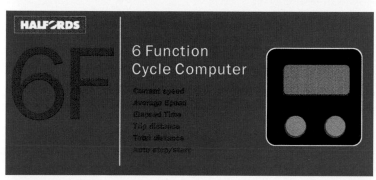

HALFORDS

6F
6 Function Cycle Computer

Current speed
Average Speed
Elapsed Time
Trip distance
Total distance
Auto stop/start

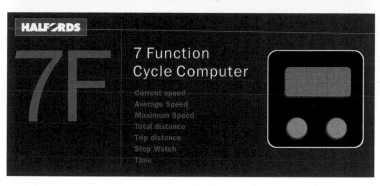

HALFORDS

7F
7 Function Cycle Computer

Current speed
Average Speed
Maximum Speed
Total distance
Trip distance
Stop Watch
Time

AN IMPORTANT PART OF THE BRIEF WAS TO REDESIGN THE INSTRUCTIONS LEAFLET INSIDE EACH BOX AND TO EXPLAIN, WITH CLEAR DRAWINGS AND SIMPLE, STEP-BY-STEP INSTRUCTION, HOW TO INSTAL AND USE THE PRODUCT.

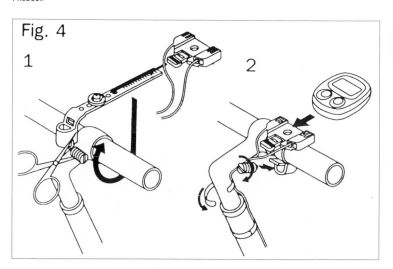

Fig. 4
1 2

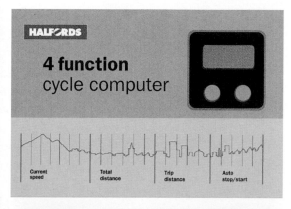

HALFORDS

4 function cycle computer

Current speed	Total distance	Trip distance	Auto stop/start

ONE OF THE TWO FAVORED ROUTES USED FASHION COLORS AND A GRAPH THAT PLOTTED THE COMPUTER FUNCTIONS AS WELL AS A JOURNEY FROM MOUNTAIN TO CITY AND BACK AGAIN.

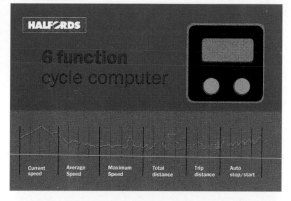

HALFORDS

6 function cycle computer

Current speed	Average Speed	Maximum Speed	Total distance	Trip distance	Auto stop/start

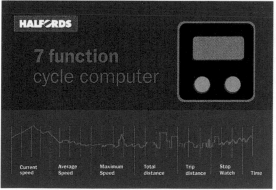

HALFORDS

7 function cycle computer

Current speed	Average Speed	Maximum Speed	Total distance	Trip distance	Stop Watch	Time

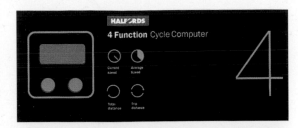

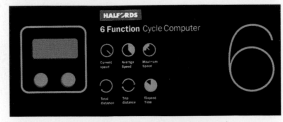

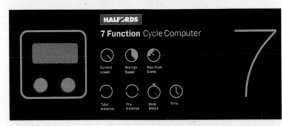

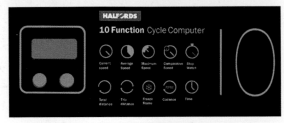

FINALLY RESOLVING ALL
THE ELEMENTS, EVEN
IMAGINING THAT THERE
MIGHT ONE DAY BE 10
FUNCTIONS, THIS GROUP
OF FOUR LAYOUTS GOES
FROM THE SIMPLEST TO
THE MOST COMPLEX. THE
SAME COLORS WERE
USED FOR ALL VARIANTS,
AND THE WEIGHT AND
THICKNESS OF THE
LARGE SPECIALLY DRAWN
NUMERALS PERFECTLY
MATCHED THE LINE
AROUND THE WINDOW
THROUGH WHICH THE
PRODUCT WAS SEEN.

showed sky and the open road. In trying to decide which symbols to use to convey the functions, they had considered using computer icons but decided against them because it was "just a style thing that got in the way of the message."

The first presentation, three weeks later, was to the Halfords buyer and her assistant. They discarded the sky route but requested development of the other two, preferring even at this early stage the route with "large numbers." In the meantime, Pearce, who liked the icons route, was having problems with their clarity and thought they needed more refining. They had chosen three background colors that related to fashion to make each computer "feel" different, but in the end he decided to rely on numbers to differentiate each model.

Throughout this process the designers were thinking of the clearest, simplest way to explain to customers what the products did. "Any other messages were the wrong messages," they reasoned, and they spent more time on the fine tuning than on the initial ideas. They sent the developments to Halfords—"We never got to second presentation stage"—and the company was, Pearce says, "thrilled to bits."

The presentation to the DMP committee went equally well, although Pearce took all three routes, just in case. "It doesn't always go through as well," but as it turned out, he showed only the one he believed in. All they had to do then was resolve the problem with the icons and go straight to artwork. Although Pearce sees minor things that he would like to change, the results speak for themselves:

- Four weeks from launch, the own-brand accounted for 56 percent of Halfords' cycle computer sales; this share is now 80 percent.
- One year from launch, the own-brand had a 37 percent share of the U.K. cycle computer market.
- Halfords' share of the U.K. market has risen by 7 percent.
- Sales of individual own-brand products are between 57 and 135 percent higher than proprietary brand equivalents.
- The design fee for all this was paid back through increased profits in just 12 weeks from the launch.

FROM THE BEGINNING,
THE DESIGNERS AT LIPPA
PEARCE WANTED TO PUT
THE TINY COMPUTERS IN
A BOX. RESEARCH HAD
SHOWN THAT MOST
PROPRIETARY BRAND
COMPUTERS WERE
PACKED IN ACRYLIC
BOXES, WHICH NOT ONLY
SCRATCHED AND
CRACKED BUT REVEALED
THE WIRES AND THE
FITTINGS AND, WITH
THEIR GARISHLY
COLORED GRAPHICS,
DETRACTED FROM THE
PRODUCT ITSELF. THE
HALFORDS BOX, WHICH
WAS PRINTED IN THE FAR
EAST, HAD LAMINATED
CARD WITH EMBOSSED
ICONS AND AN ACRYLIC
WINDOW INSERT.

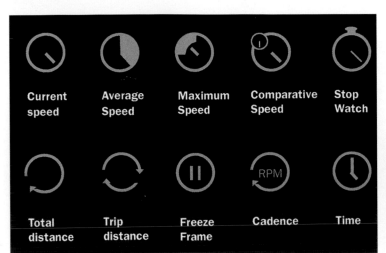

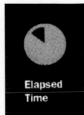

OF ALL THE ICONS THE
DESIGNERS HAD TO
CREATE, THE ONE THAT
GAVE THEM MOST
PROBLEMS WAS
"ELAPSED TIME," *(BELOW)*
WHICH WAS NOT USED
ON THE FIRST SERIES
OF PACKS *(RIGHT)*.

HALFORDS

5 Function Cycle Computer

Auto scan Auto on/off Total distance

Trip distance Current speed

5

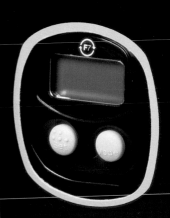

HALFORDS

7 Function Cycle Computer

Auto scan Auto on/off Total distance Trip distance

Current speed Average speed Riding time

7

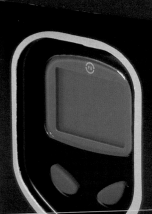

HALFORDS

8 Function Cycle Computer

Auto on/off Total distance Trip distance Current speed

Maximum speed Average speed Clock Riding time

Calvert's Cocktail Mix

Anyone admiring idiosyncratic packaging design in the United States over the last 10 years will almost certainly have noticed—and probably bought—products by the El Paso Chile Company. It has **no unifying identity, no consistent elements, and no corporate look.** In fact, it is the individuality and the use of high quality, colorful, quirky illustration that links the company's work, and although they might be found in boutique-style specialty food emporia, its **products are just as likely to be seen in chain stores and supermarkets**

Based in the Texas border town from which it takes its name, the family-run business produces quality products and has been responsible for commissioning an enormous variety of design and illustration to package products such as Margarita Mix and salsa. The naming of their various products is as distinctive as

IN AN EXTRAORDINARY RECORD OF THEIR CONVERSATIONS AND THE CREATIVE PROCESS, FAXED SHEETS OF SKETCHES BY DAN YACCARINO GAVE LOUISE FILI A SERIES OF CHARACTERS AND ARCHITECTURAL ELEMENTS TO CHOOSE FROM. ASPECTS OF THE FINAL LABEL CAN BE TRACED BACK TO THESE FIRST PAGES.

FROM THE SECOND ROUND OF ROUGHS. PEOPLE START TO DOMINATE THE LABEL-SHAPED LAYOUTS. ALTHOUGH THE CLIENT LIKES TO GET INVOLVED IN BRIEFING THE ILLUSTRATOR (SOMETIMES EVEN SUGGESTING SOMEONE) AND ENJOYS PHONING UP TO DISCUSS THE IDEAS— THEREBY CREATING WHAT CAN BE A CONFUSING THREE-WAY TRIANGLE— IN THIS INSTANCE THE DIALOGUE WAS JUST BETWEEN DESIGNER AND ILLUSTRATOR.

the design: names such as Pow Wow Trail Mix, Desert Pepper, Salsa Divino, Mango Tango. The policy of managing director Park Kerr is to use a variety of small design companies, switching between them apparently at random, and providing briefs that break every conceivable rule.

A couple of years back the entrepreneurial Kerr bought the Calvert's Company in North Carolina. He asked Louise Fili to redesign its line of 15 or so packs. The company was best known for its range of mustards and salad dressings, all with "terrible labels," recalls Fili, and although Kerr wanted to keep the Calvert name, for its goodwill and reputation, he wanted to apply his El Paso Chile approach to the designs.

Kerr is well known for his energetic, flamboyant personality, and his hands-on approach, so Fili, who had worked for him for over four years, asked him for a brief. "Sometimes he'll describe a mood, sometimes he'll say 'I don't know—you tell me'." After waiting about nine months for the go-ahead, one of the first lines to be launched—in conjunction with Williams-Sonoma, whose large chain of kitchen and food stores also supports a successful mail-order business in the US—was a set of three varieties of cocktail mix (nibbles to eat with drinks). Contained in chunky 5-inch

high cans, the three varieties were Orient Express, Roman Holiday, and Happy Trail (which had a southwestern flavor).

The products lent themselves to colorful illustration, and Fili, with her background in publishing design, wanted a solution more akin to book jackets that integrated type and drawing and gave them "more of a meaning." Having just worked with the illustrator Dan Yaccarino on Red Dragon Marinade for the same client, she started to discuss the new range with him.

Most of their "meetings" were conducted by fax. Fili wanted to use people on each label and was looking for "some kind of unifying element." There was "a lot of back and forth," recalls Fili, but uniquely the whole creative process can be traced through these faxes from Yaccarino. They quickly hit on the right theme. Once they got the first one, Roman Holiday, "the other two were quite easy." Eventually the drawing took the shape of labels on which Fili was able to apply type and then produce a highly finished mockup wrapped around a can, which she sent to El Paso by courier. Kerr "loved them," admits Fili, who cannot recall if there were any further changes.

To fit into Williams-Sonoma's Asian promotion, the launch of the Orient Express flavor was in the spring of 1997.

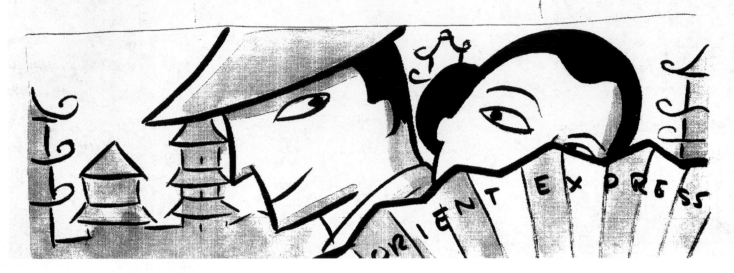

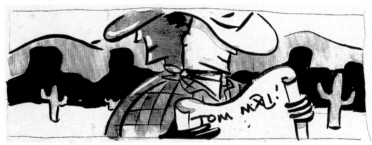

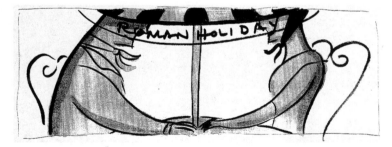

IN A UNIQUELY RELAXED RELATIONSHIP. FILI SIMPLY FAXED THESE FOUR LAYOUTS AS HER PRESENTATION OF CONCEPTS FOR THE COCKTAIL MIX COLLECTION. HER CLIENT'S RESPONSE: "OK. LET'S DO IT." BUT THERE WAS MORE DEVELOPMENT WORK TO BE DONE. TOM MIX (MISSPELLED ON THE FAX) WAS CHANGED TO HAPPY TRAIL MIX BECAUSE THE CLIENT DOUBTED CUSTOMERS WOULD RECALL THE STAR OF PRE-WAR HOLLYWOOD WESTERNS.

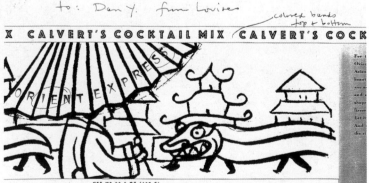

FOR THE FIRST TIME SHOWING HOW THE TYPE WOULD BE INTEGRATED "LIKE A BOOK JACKET." FILI ASKED FOR MINOR CHANGES TO THE SPACE FOR THE LETTERING. ALL THE INGREDIENTS WERE LISTED ON THE BACK. ALONG WITH A PANEL FOR "ROMANCE COPY."

THE FINAL LABELS
EXTEND RIGHT AROUND
THE CANS, MAKING ANY
ASPECT EQUALLY
SUITABLE FOR THE
FRONT, AND NO TWO
CANS, UNLESS THEY ARE
CAREFULLY LINED UP,
LOOK THE SAME.
PRINTING IS HANDLED,
CHARACTERISTICALLY, BY
THE CLIENT IN EL PASO,
ALTHOUGH PROOFS
MIGHT BE SENT FOR
CHECKING TO THE
DESIGNER.

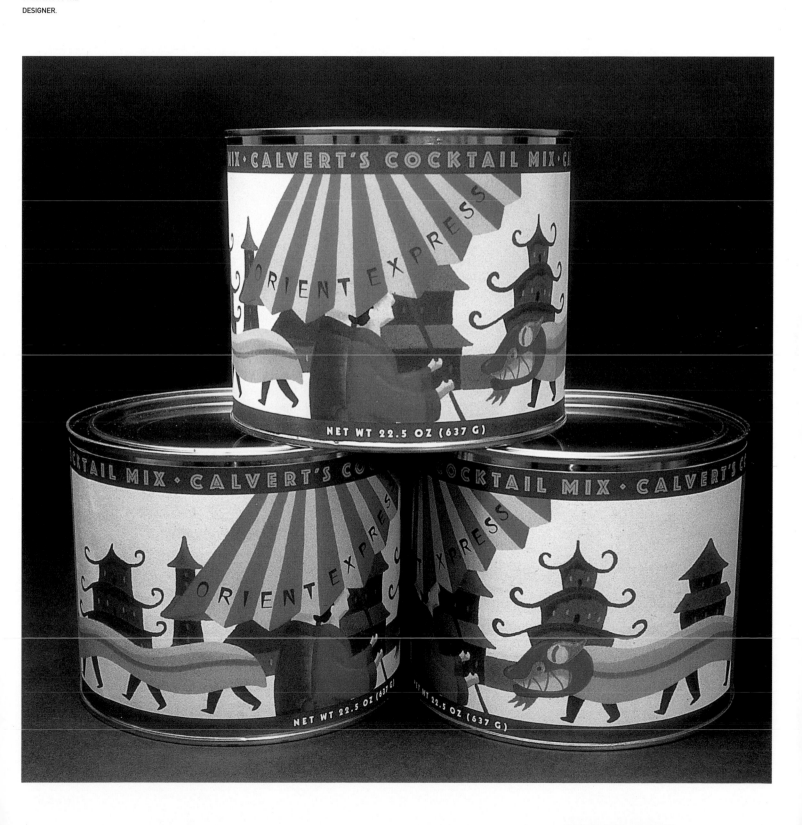

NRG could be the by-word for this four-year-old design company of seven designers, as well as the product—whose pack they had helped to catapult to Britain's "number one teenage energy" nutritional health drink for 1997. Although they did not invent the name, the design-led structure of the company and their enthusiasm **for this "dream brief"** certainly embodies it

THE ORIGINAL NRG BOTTLE BY HAYNES MACGREGOR HAD WIDE, SQUAT PROPORTIONS AND HAD BEEN WELL RECEIVED IN THE DESIGN INDUSTRY, BUT THE SIZE WAS NOT PERCEIVED AS GOOD VALUE FOR MONEY COMPARED WITH OTHER BRANDS.

AT FIRST, THE DESIGNERS "TRIED TO SEE HOW FAR THEY COULD GO" BY EXPERIMENTING WITH TYPE THAT REFLECTED THE CLUB SCENE AND MIGHT APPEAL TO THE DRINK'S YOUNG CONSUMERS. ALTHOUGH THIS "REVOLUTIONARY" DIRECTION DID NOT GAIN IMMEDIATE ACCEPTANCE, SOME ENERGY AND "NOISE" CERTAINLY SHOWS THROUGH IN THE FINAL DESIGN.

SmithKline Beecham (SB) is one of the world's leading healthcare companies. SB develops, manufactures, and markets pharmaceuticals, vaccines, over-the-counter medicines, and health-related consumer products, including Lucozade which has been a popular energy-enhancing orange drink since 1927. Although successful, there had been production problems with the previous bottle for its NRG variation. The decision was taken to repackage the drink in a slightly larger, 300 ml (about 10 fluid ounces), bottle used by its sister brand, Lucozade Sport. Because of the change of bottle shape, the existing graphics were not appropriate, and this provided the ideal opportunity to update the branding and keep abreast of market trends.

Fox Design had already done some work for the client, but this was its first major project. The brief was:"

- Re-package NRG in the new bottle format.
- Make sure that the product branding is appropriate for the target market—style-conscious 14- to 20-year-olds.
- Communicate the product type—a sparkling orange and passion fruit energy drink.
- Maintain the brand recognition/loyalty to avoid alienating existing consumers.

In addition, there was a new Lucozade logo to be accommodated, designed to be used vertically instead of horizontally, which was perfect for this thin shape.

As part of the first stage, the design team—Niel Fox, Paul Mountford, and Mike Harris—started by doing some research into the world of the 14 year old. They already knew the youth market through their work for Adidas, so they collected together the current music magazines, club fliers, video games, and street fashion, as well as examples of competitors' soft drink packs. They set about what they call "brand deconstruction," metaphorically breaking down the Lucozade bottle into its main components—type, color, logo, and so on—to identify the elements that they felt were the "key identifiers to the brand." Synthesizing the material they had collected, they defined the "key communication points" of the brief to themselves as "energy, youth, sparkling, orange, explosion."

For their presentation of ideas in stage one they felt they wanted to "stretch the brief to its limits in order to provoke discussion on the long-term development of the brand," so they worked up a series of NRG logotype ideas, "exploring the dynamism and sharpness of the letterforms," as well as introducing various patterned background effects that evoked their five key communication points.

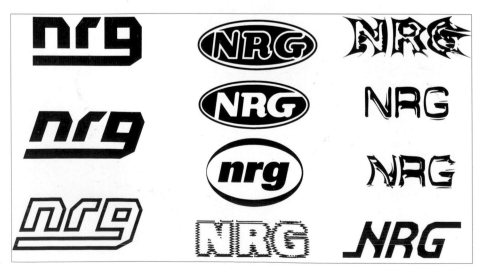

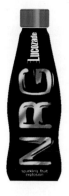
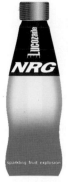

STAGE 1 PROPOSALS

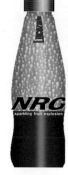
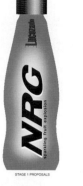
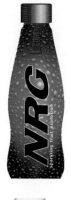

STAGE 1 PROPOSALS

USING FLAT PROFILES OF THE NEW BOTTLE SHAPE, MOUNTFORD AND HIS COLLEAGUES TOOK THE EXISTING NRG LOGOTYPE, AS WELL AS ONE OF THE MORE "CUTTING EDGE" FONTS, AND STARTED TO EXPERIMENT WITHIN THE SPACE. MOST RADICALLY, THEY INPUT A SERIES OF EXPRESSIVE BACKGROUNDS: EXPLOSIONS, SPARKLING, BUBBLES, AND OTHER PSYCHEDELIC REACTIONS THAT ANSWERED THE KEY COMMUNICATION POINTS.

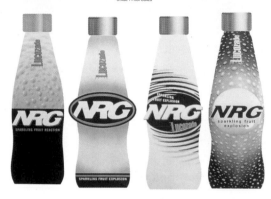
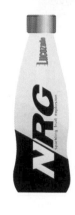
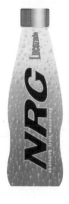
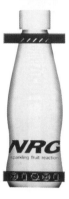

STAGE 1 PROPOSALS

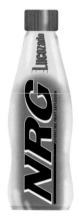
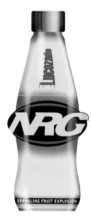
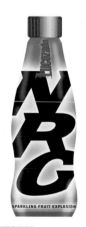
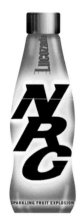

STAGE 2 - DESIGN DEVELOPMENT

CHOOSING TWO OR THREE OF THE ROUTES, THE CLIENT ASKED THE DESIGNERS TO PLAY AROUND WITH THE EXISTING TYPE, STACKING IT, ANGLING IT, AND ADDING A DROP SHADOW. IN ADDITION, THE BACKGROUNDS, WHILE NOT LOST, WERE REFINED AND TONED DOWN. "SPARKLING FRUIT EXPLOSION" REMAINED AND WAS JOINED BY THE NEW LUCOZADE LOGO.

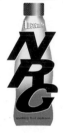

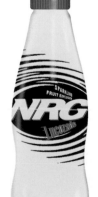
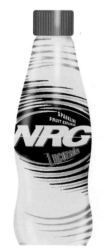
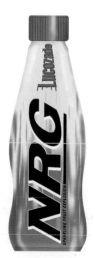
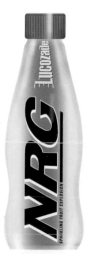

STAGE 2 - DESIGN DEVELOPMENT

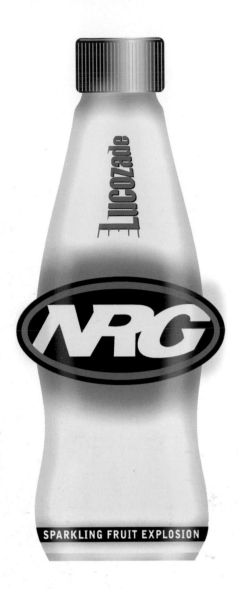

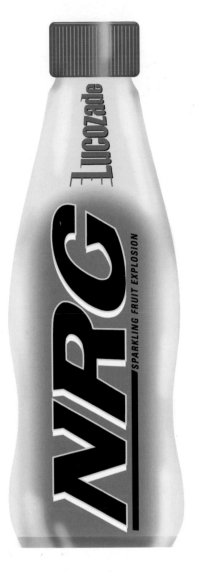

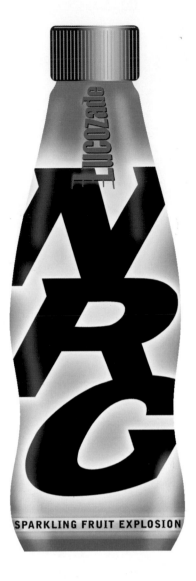

(*RIGHT*) AS IF IT IS EXPLODING OFF THE SURFACE OF THE BOTTLE. THE GRAPHIC IMPACT WAS CREATED BY MAKING THE TYPE WRAP AROUND, OUT OF SIGHT. THE DESIGN WAS FINALIZED AND PRINTED ONTO A PLASTIC SLEEVE THAT WAS THEN SHRINK-WRAPPED ONTO THE GLASS CONTAINERS.

THREE OF THE DESIGNS WERE FURTHER REFINED, AND, WITHIN A WEEK, VISUALS WERE PRODUCED FOR MARKET RESEARCH.

A THUMBNAIL SKETCH FROM ONE OF THE EARLY STAGES REMAINS AS A TELLING EXAMPLE OF HOW SOMETIMES THE FIRST IDEA YOU THINK OF IS THE BEST.

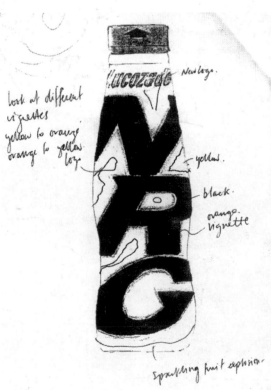

After two weeks they presented a series of computer-generated, actual size illustrations. From these, four were chosen, although Nick Craggs at SmithKline Beecham also accepted the validity of many of the longer term proposals. The next step was to explore the backgrounds and the type layouts and to start to refine them. In order to get good quality color and high resolution visuals, these four were output as Iris proofs. This took another two weeks, and from then, three ideas were refined further and prepared for market research in schools and clubs across the country.

Although they were not given any specific details, the results were good, and the final solution went to artwork so that dummy bottles could be produced for further research before the design went into production.

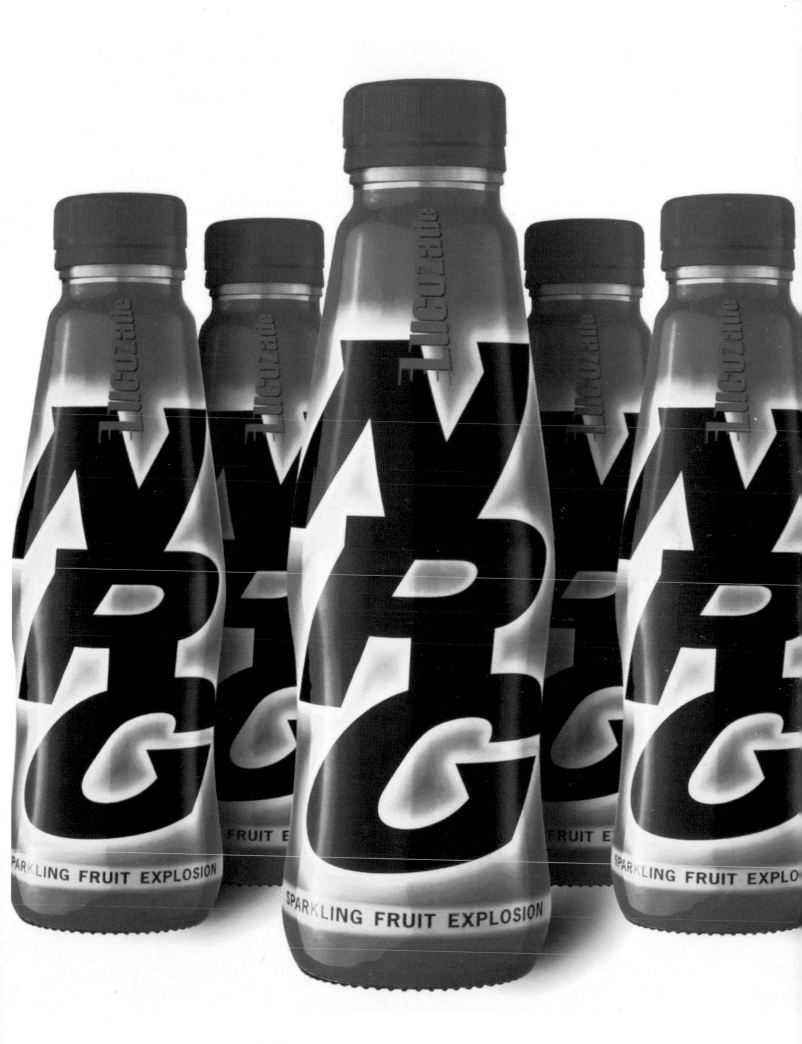

Travelight
In their third year at Bath Spa University College students are encouraged to spend part of their course submitting ideas for the Royal Society of Arts Student Design Awards. It gives them outside input, with commercial-based design assessments, and **an idea of what it is like to work to real briefs and tight schedules,** and there are good prizes

This was the first packaging job that Tammy Kustow had done. Until then, she had concentrated on typography and some photography, but she decided this job would broaden her portfolio. In addition, she would find out if she wanted to go into packaging as a career. The brief, which she chose from many, was to package either lightbulbs or horticultural bulbs, and eight other students in her class chose it too. The brief stated: "Create packaging for lightbulbs, which could encompass a multipack or cluster pack for sale by mail order."

The solution had to be able to accommodate any number of bulbs and had to take into account weight, size, and cost. This was September, and ideas had to be submitted by end December. One of the prizes was a three-month placement with the John Lewis Partnership, a long-established retailer, which includes Waitrose supermarkets.

In between working on a 10,000 word thesis on the relationship between modern and postmodern typography, Kustow began by working in a layout pad, writing down all her thoughts and preliminary ideas. "Lightbulbs are a fragile commodity, so mail order packaging must respond to weight, size, and strength issues." But why, she thought, would anyone want to send a lightbulb through the post? They are cheap and easy to buy and the postage would cost more than the bulb. What sort of lightbulb could it be? She concluded that, to make sense of the brief, they would have to be halogen or energy-saving bulbs, which are more expensive and less widely available. "They would appeal to domestic customers who were interested in innovation, quality, and environmentally friendly products in low volumes."

Considering all the possible materials she could use, Kustow listed tissue paper, straw, sand, foam, and even natural air. "How could this be used?" she noted on her pad. At the same time, thinking about possible names for the product, she listed prisms, prismatic, spectrum, and spectral and began to wonder if a prismatic triangle could work as a pack shape. She discussed it with her tutor, David Beaugeard, and they concluded that the bulb, set in a foam block, itself contained in a cardboard sleeve, was too uninteresting and required two pieces of packaging.

This brought her back to air. "The most natural form of protection in a compressed form," said her notes, which listed bubble wrap, compressed air, balloons (hot air and conventional) and, finally, "a bag containing air." "Suspending the bulbs inside [thereby] alleviating the rigors of transit." A packaging supplier's catalog led her to an advertisement for

"I CAME TO THE SOLUTION QUITE QUICKLY," SAYS TAMMY KUSTOW OF HER LIGHTBULB PACKS. "THE LIGHTWEIGHT PROTECTIVE PROPERTIES OF THE AIR BAG LEND THEMSELVES TO A PRACTICAL AND INEXPENSIVE FORM OF PACKAGING. THE NOVELTY FACTOR IS IMPORTANT TOO."

PRINTED IN FLUORESCENT ORANGE, THE STYLE OF FITTING— BAYONET OR EDISON— WAS ILLUSTRATED BY A PICTOGRAM.

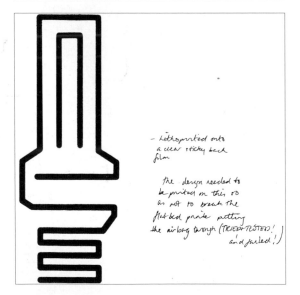

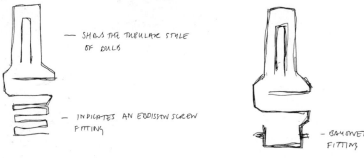

THE BAGS WORKED BY HAVING A DOUBLE-SKIN LAYER OF CLEAR PLASTIC. "ONCE YOU HAVE INSERTED YOUR CONTENTS, YOU SEAL IT UP AND INFLATE THE SURROUNDING OUTER SKIN THROUGH A VALVE PROVIDED. SUBSEQUENTLY, THE BAG CAN BE DEFLATED AND REFLATED AS OFTEN AS REQUIRED," KUSTOW EXPLAINS. TESTING THE SAMPLES TO SEE IF THEY WORKED, SHE NEEDED TO ESTABLISH (AND DID) THAT WHEN TWO OR THREE BULBS WERE PACKED TOGETHER THEY KEPT APART RATHER THAN KNOCKING AGAINST EACH OTHER. SHE EVEN SENT SAMPLES BY A PARCEL DELIVERY SERVICE TO TEST THEM.

THE LAST-MINUTE ADDITION OF THE ORDER FORM GAVE KUSTOW A CHANCE TO SHOW HER TYPOGRAPHIC SKILLS.

Air Box Packaging, a US company with a branch in Potters Bar, north London. When she telephoned for samples "they were very helpful" and sent her some in various sizes. To make her packs, she first had to scrub off the preprinted messages on the samples, which she did with white spirit.

Now all she needed was an identity and, of course, a name. But time was running out. It was two weeks before delivery date, and she still had to get the bags printed. Once again, her notes tell the story. Under "the identity" she listed "weightless travel bag" (a witty reference to traveling with a bag), "light weight," "traveling light," and finally "travelight" to connect the words. To decorate the bag she represented the contents in a diagrammatic way. But if it seemed straightforward, there were still problems to overcome in trying to print on the bags with the limited in-house facilities.

After her submission it was two or three months before a letter arrived to say that she had been shortlisted and that she should come to an interview, "When I went in, there was a huge table with a dozen or so people sitting around it. It was really scary," she says. They seemed surprised when she said it was the first packaging job she had done.

Nevertheless, six weeks later the good news came. She had been awarded the prize worth £3,000 to work in the John Lewis design studio, where she went on to design a dozen or so product packs. In the end, however, she decided to go back to typographic design, her first love.

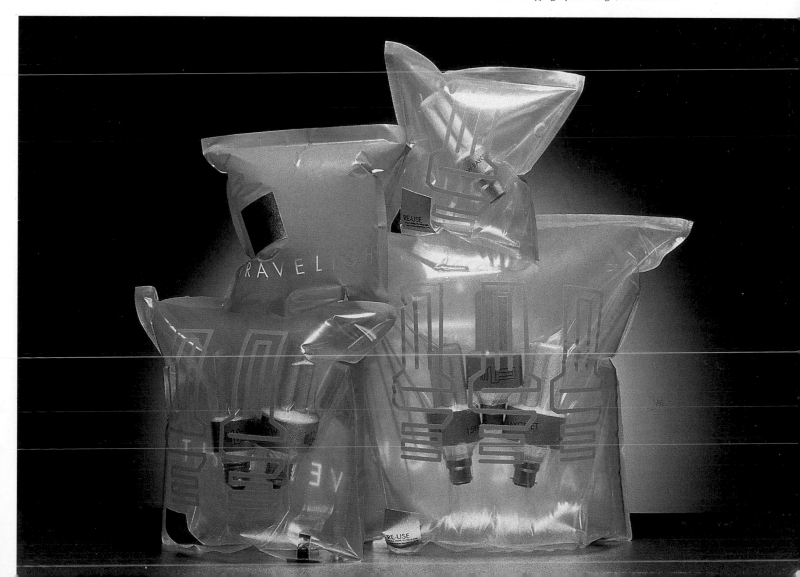

Beantown Soup Co
Big clients with generous budgets are what most designers like best, but small companies, even one-man bands, can also be appealing, especially if they are Italian ladies working in their own kitchen and **sending you delicious homemade soups**

WORKING EACH TIME WITH THE LETTER B, LOUISE FILI PRESENTED A RANGE OF LABEL IDEAS THAT GAVE AN UP-MARKET LOOK TO THE GRAPHICS. WHEN THE CLIENT REMINDED FILI THAT HER COMPANY WAS CALLED "THE" BEANTOWN SOUP COMPANY, SHE HAD TO BE PERSUADED THE DEFINITE ARTICLE DID NOT NECESSARILY HAVE TO BE INCLUDED ON THE PACK.

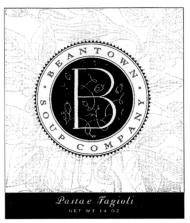
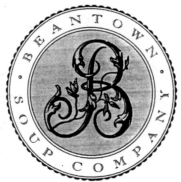

When Louise Fili, the New York-based packaging and book designer, first heard from Lisa Papandrea, a Boston housewife and cook, it was through another packaging company and a copy of Fili's brochure. Papandrea had been making her soups, a combination of beans, spices, and other dry ingredients, and selling them out of her Boston home for four years, using family recipes and "very commercial looking, very inelegant labels on cellophane bags," remembers Fili. Each soup came with its main ingredients and a recipe that was written with great charm and personality.

But for Papandrea it was a big step to use a professional and highly regarded New York designer, and she hesitated for a few months. At first she asked Fili—even before they met—to produce some logo ideas. "She really, really had no money, and I didn't even draw up a contract, it was just trust." Eventually, Papandrea traveled to New York, and they met. "She liked my ideas straight away," recalls Fili. "She was very appreciative and we got on really well."

Fili showed three ideas for a new label that would be used hanging from the existing bags as a halfway stage. "I persuaded her to accept the one I liked best," admits Fili. In addition, the labels were to be applied to seed packets, which Papandrea also sold.

At the same time, they talked about changing to boxes for the soups, and Fili's client expressed a liking for craft paper backgrounds. Fili had doubts. First, it would be difficult—not to say expensive—to reproduce the effect on cardboard.

ANOTHER DESIGN, THIS TIME LOOKING RATHER LIKE A WINE LABEL. "LIKING THE SOUP," RECALLS FILI, "WAS A BIG FACTOR IN MY DECISION TO TAKE ON THE JOB." ALTHOUGH THE PRODUCT WAS MADE IN BOSTON (THE HOME OF THE BEAN), FILI WANTED TO AVOID THE OBVIOUS BOSTON CLICHÉS.

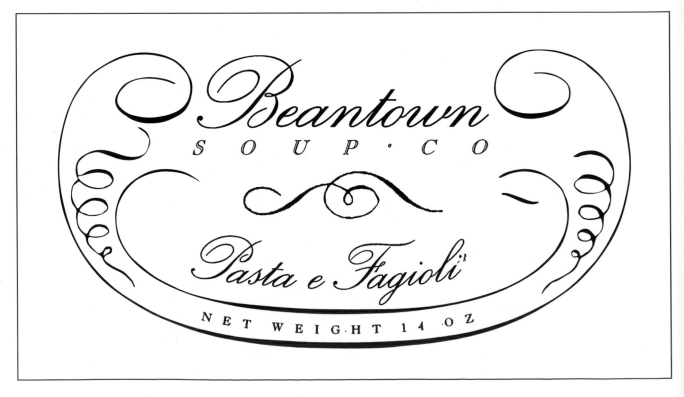

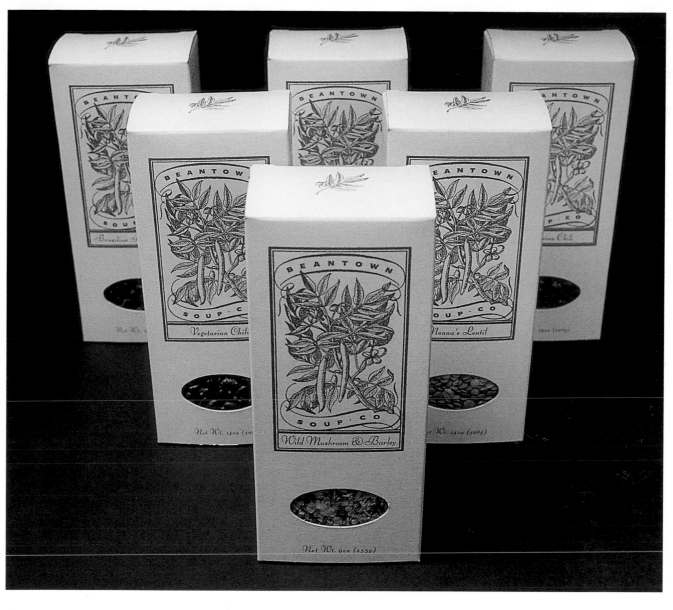

PART OF THE RANGE OF 17 SOUPS, ALL PACKAGED FOR ECONOMY IN THE SAME BOX DESIGN. IN ADDITION TO THE CONTENTS, CUSTOMERS WERE ASKED TO ADD EXTRA INGREDIENTS AND TOLD, IN VERY SMALL TYPE, THAT "2% OF THE PRICE IS DONATED TO ABUSED CHILDREN."

Second, Fili preferred an off-white base. Nevertheless, she produced a design using brown wrapping paper with an etching of a bean plant that she "just happened to find in a Dover book of old illustrations."

In an extraordinary sequence of events, the courier lost the parcel on the way to Boston, and Fili, with time running out, had to produce a second set of box mockups. Again, she showed one idea. "She was the perfect client. Working to a very tight schedule, she wrote all the copy for all 17 packs, and each one was different."

Fili had found a box manufacturer in Tennessee and there was "a lot of working back and forth." The products sell in "fancy stores and prestigious mail order catalogs" so the quality of the boxes was vital. There was no time for research, though when she has been working on food packs in the past Fili would likely "go down to Dean and DeLuca, and put it on the shelf with similar products to see how it looks."

When the trade fair opened, the Beantown Soup Company, with its "very pure, very nicely styled display", was the "talk of the show," and Lisa Papandrea was a success.

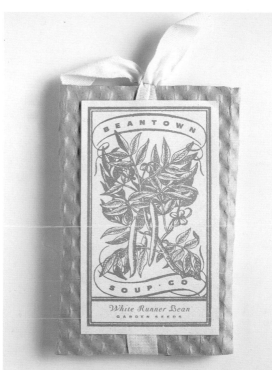

THE FIRST STAGE OF THE PROJECT WAS TO USE THE DESIGN ON LABELS FOR THE CELLOPHANE SOUP PACK AND SEED PACKETS—TINY HAND-TIED PARCELS OF EMBOSSED CRAFT PAPER. AS A RESULT, BUSINESS STARTED PICKING UP WITH THE HELP OF THE NEW LABELS, SO PAPANDREA DECIDED TO LAUNCH HER ENTIRE NEWLY PACKAGED RANGE AT THE NEW YORK FANCY FOOD SHOW IN THE SPRING OF 1997, JUST TWO MONTHS AFTER THE PROTOTYPE WAS DEVELOPED.

Boots Herbal

Having found that Trickett & Webb could evoke the process of aromatherapy by using color, Boots followed with an even more complex problem, a range of 15 herbal products, whose names described the benefits rather than the contents. "Asking questions at the briefing stage is really important," stresses Brian Webb, whose partner, Lynn Trickett ran this job. "Solutions tend to come about by gathering information, doing a lot of research, **rather than flashes of inspiration.**"

Sometimes there are exceptions

"What are we trying to say—and to whom?" they asked themselves in the first group brain storming session. In the words of the brief supplied by Boots: "Herbal medicine can be very confusing, and providing a clear path through this confusion is a potential brand discriminator. New users need clear, on-pack sign-posting to help them. If this is not available they are more likely to revert to conventional medicine, which is more familiar to them."

The design objectives were clearly stated, even down to the preferred order of information and the prominence of copy: "The design should eradicate confusion over product usage and benefits, providing clear product branding and ensuring that the symptoms and conditions feature prominently."

WHEN IT WAS TIME FOR BOOTS TO UPDATE ITS EXISTING HERBAL MEDICINES, THE BRIEF INCLUDED MAGAZINE CUTTINGS AND PHOTOGRAPHS OF THE INSTORE SHELVING ON WHICH THE PRODUCTS, TOGETHER WITH THE COMPETITION, WOULD SIT.

Example	Prominence	Copy
Boots	2	Boots logo
Herbal	3	Herbal statement
Restful Night	1	Product name
Tablets	3	Product type

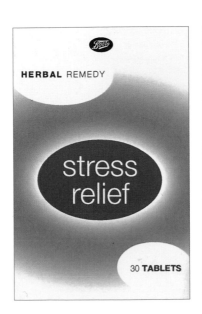

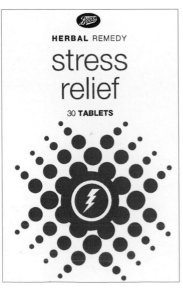

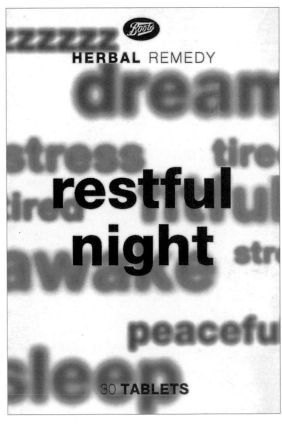

FUZZY TYPE WAS USED ON ONE OF THE IDEAS IN STAGE ONE, TO INDICATE STRESS RELIEF AND PEACEFUL SLEEP. BY CONTRAST, STRESS WAS ALSO SYMBOLIZED BY LIGHTNING BEING DIFFUSED BY A DOT GRAPHIC OR A FADING LOZENGE *(FAR LEFT)*. ON ALL THE PACKS, THE TOP AND SIDES WERE SHOWN AS GREEN—A COLOR KNOWN TO BE ASSOCIATED WITH HERBAL REMEDIES.

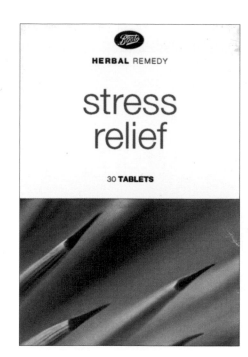

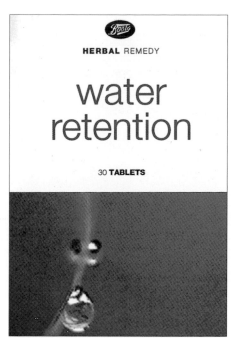

PICKING UP ON THE "GREEN FOR HERBAL" THEME, ONE SOLUTION EMPLOYED FULL-COLOR PHOTOGRAPHS OF VEGETATION. EACH ONE ILLUSTRATED THE SYMPTOM, HOWEVER, AND NOT THE CURE. IN ADDITION, THE DESIGNERS SUSPECTED THAT IT WOULD BE DIFFICULT TO FIND ENOUGH LEAF EQUIVALENTS FOR THE WHOLE RANGE.

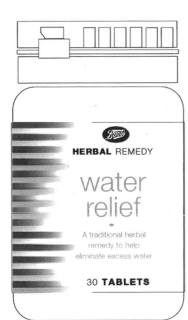

IF A PURELY ABSTRACT SOLUTION WORKED FOR THE AROMATHERAPY RANGE, WHY NOT TRY IT FOR THE HERBAL RANGE TOO, THE DESIGNERS REASONED. IN A FAR MORE STYLISH INTERPRETATION, STRESS SYMPTOMS WERE SOOTHED AWAY WITH DISSOLVING STRIPES THAT EXTENDED FROM THE PACK FRONT, ACROSS THE SIDE AND ONTO THE BACK. SO KEEN WERE THEY ON THIS THAT THEY ALSO SHOWED HOW IT WOULD WORK ON TUBS.

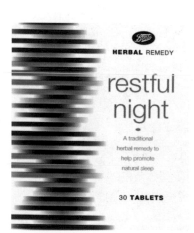

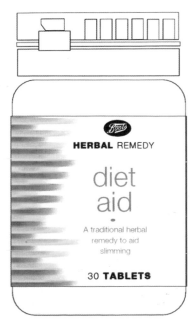

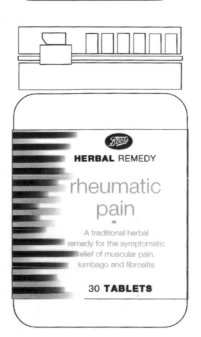

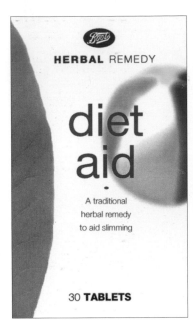

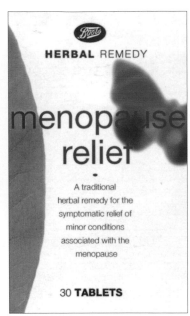

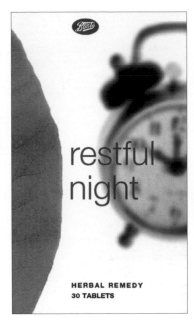

There were two ways of approaching the problem, they reasoned: "Either show the remedy or the benefit, but not the ailment—people don't want to know negatives." But how could they find a metaphor for a benefit? When Trickett & Webb presented its ingenious solution "everyone loved it," although the designers realized in the back of their minds that it wasn't quite right. The design showed a leaf (symbolizing herbal) and a hammer (symbolizing bruises). To prove that it could be extended, each variation kept the leaf, but Restful Night, for example, had an alarm clock, Water Relief had a faucet, and so on. But sensitive products need to have a sophisticated and gentle approach. The hammer, they reasoned, was the cause—so what was the cure?

Along with this set of ideas there were other, equally strong contenders, some with just type, some with graphic shapes, and one route using sensual photographs of leaves. In addition, one (which is still Trickett & Webb's favorite) showed how an extension to the earlier aromatherapy range might use two-colored stripes down one edge of the front surface. The client, however, thought that the herbal range needed a much broader appeal.

Stage two, therefore, saw them head to head, discussing the leaf and hammer route to see how it could be made to work. The white background was changed to pale green ("less clinical"), and the client provided all the factual copy that had to be included.

Ultimately, it was just a case of finding the right visual metaphors. Bruising became a plum, the menopause a butterfly, and diet a beach ball. "We weren't worried if it got a bit obscure," recall the designers. "After all, the product name had been listed as the most important element."

As with the earlier, aromatherapy range, the side became an important design feature, particularly when two packs

EVENTUALLY REPLACED BY MINT, THE GREEN LEAF PROVIDED THE "HERBAL SYMBOL" THE PACKS NEEDED, AND A STRONG GRAPHIC DEVICE THAT WAS BOTH NATURAL AND FRESH. IT ALSO LINKED THE RANGE TOGETHER, EVEN WHEN THE INDIVIDUAL PRODUCTS WERE NOT SEEN TOGETHER IN THE STORES. BY THROWING THE CLOCK AND HAMMER OUT OF FOCUS, THEY TRIED TO SUGGEST THAT THE CAUSE OF THE PROBLEM WOULD BE OVERCOME.

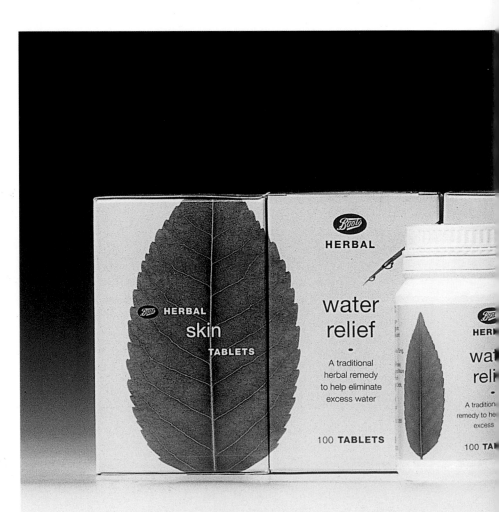

are seen together. "Apart from the leaf, there were no breakthroughs on this job. We just worked through it, step by step."

The results of the research came back and were "very positive, quite specific and incredibly useful."

- Change the leaf to make it look more like a leaf and less like a snow-pea.
- Make the symbols less harsh and more feminine.
- Increase the size of the word "herbal."

"When you get too close to a job," reflects Webb, "it is difficult to stand back. You need to get an unbiased opinion—if I ask my mum, she just says, 'That's nice, dear'."

Boots Herbal Water Relief Tablets
Made with natural herbal ingredients. Free from artificial flavours and preservatives, lactose, gluten and yeast. Suitable for vegetarians. Tamper evident and child resistant cap for extra security.
Active ingredients: Each tablet contains Uva Ursi 75mg, Clivers 75mg, Burdock Root 50mg.
Also contains: Calcium Carbonate, Sucrose, Parsley Root Powder, Talc, Maize Starch, Pre-gelatinised Maize Starch, Shellac, Acacia, Silicon Dioxide, Titanium Dioxide, Magnesium Stearate (Vegetable), Iron Oxide, Beeswax, Carnauba Wax.
Manufactured for
The Boots Company PLC Nottingham England
by Contract Pharmaceutical Services Ltd
William Nadin Way Swadlincote Derbyshire DE11 0BB
Product Licence held by
Modern Health Products Ltd.
Sisson Road Gloucester GL1 3QB
Text prepared 6/94 PL 1146/5005R 762001

Boots
HERBAL
water relief
A traditional herbal remedy to help eliminate excess water
100 TABLETS

Boots Herbal Water Relief Tablets contain a specially formulated blend of herbs to assist in the elimination of excess water stored in body tissues.
✓How to take Boots Herbal Water Relief Tablets
Check that the cap seal is not broken before first use.
Adults and children over 12 years: 2 tablets to be taken by mouth 3 times daily before meals. Do not give to children under 12 years.
DO NOT EXCEED THE STATED DOSE
If you take too many, talk to a doctor straight away.
If symptoms do not go away, talk to your pharmacist or doctor. ‡Do not take if allergic to any of the ingredients. Do not take if pregnant or breast feeding. This medicine may rarely cause an allergic reaction. If concerned or anything unusual happens, talk to your pharmacist or doctor. Do not use after expiry date shown on package. KEEP ALL MEDICINES OUT OF THE REACH OF CHILDREN
EXP:
BN:

Boots Herbal Menopause Tablets
Made with natural herbal ingredients. Free from artificial flavours and preservatives, lactose, gluten and yeast. Tamper evident and child resistant cap for extra security.
Active ingredients: Each tablet contains Parsley Root 60mg, Vervain 10mg, Senna Leaf 4mg, Dry Extract Vervain from 90mg, Dry Extract Clivers from 60mg, Dry Extract Senna from 10mg.
Also contains: Calcium Phosphate Tribasic, Celery, Talc, Acacia, Maize Starch, Hypromellose, Magnesium Stearate (Vegetable), Glycerol.
Manufactured for
The Boots Company PLC Nottingham England
by Contract Pharmaceutical Services Ltd
William Nadin Way Swadlincote Derbyshire DE11 0BB
Product Licence held by
Metabasic Products Ltd.
Sisson Road Gloucester GL1 3QB
Text prepared 1/95 PL 2452/5001R 762005

Boots
HERBAL
menopause
A traditional herbal remedy for the symptomatic relief of minor conditions associated with the menopause
100 TABLETS

Boots Herbal Menopause Tablets contain a specially formulated blend of herbs for the symptomatic relief of minor conditions associated with the menopause.
✓How to take Boots Herbal Menopause Tablets
Check that the cap seal is not broken before first use.
Adults: 2 or 3 tablets to be taken by mouth 3 times daily with water after meals. Do not give to children.
DO NOT EXCEED THE STATED DOSE
If you take too many, talk to a doctor straight away.
If symptoms do not go away, talk to your pharmacist or doctor. ‡Do not take if allergic to any of the ingredients. Do not take if pregnant or breast feeding. This medicine may rarely cause diarrhoea or an allergic reaction. If concerned or anything unusual happens, talk to your pharmacist or doctor. Do not use after expiry date shown on package.
KEEP ALL MEDICINES OUT OF THE REACH OF CHILDREN
EXP:
BN:

(BELOW) LAUNCHED SEVEN MONTHS AFTER THE FIRST BRIEFING, THE FULL LINEUP OF HERBAL MEDICINES GAINED TREMENDOUS STRENGTH WHEN SEEN TOGETHER, EVEN THOUGH THE LEAF WAS DISTORTED TO FIT DIFFERENTLY SHAPED CONTAINERS. THE SECONDARY "CURE" SYMBOLS BECAME LESS SIGNIFICANT. RESEARCH SHOWED THAT THE LEAF DESIGN WAS "PREFERRED BY ALL GROUPS AND WAS POSITIONED AS A MODERNIZED HERBAL DESIGN, FALLING BETWEEN TRADITIONAL OVER-THE-COUNTER AND PRESCRIPTION REMEDIES."

(ABOVE) ARTWORK FOR THE FINISHED LABELS SHOWS HOW MUCH COPY HAD TO BE INCLUDED. ALTHOUGH SOMETIMES QUITE OBSCURE, REMNANTS OF EARLIER IDEAS CAN STILL BE SEEN—DROPLETS ON A LEAF AND THE BUTTERFLY. —NOW IN SHARP FOCUS.

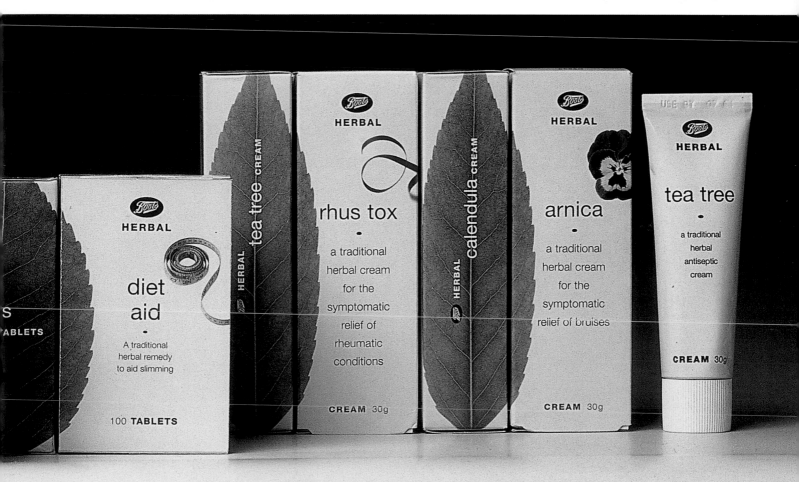

Bend in the River

The creative process takes all forms. Some designers get their ideas while the client is briefing them, others have to work at it for days and even weeks. Not many can claim to have thought of an award-winning solution while they were standing on a hill overlooking the River Rhine and recalling the title of a black-and-white **James Stewart western**

Unlike the film, however, this story had a shaky beginning, and it hinged on the personality of the designer and a project he had carried out before.

John Blackburn, with his team of 10, housed in a six-story Georgian house in the heart of London's Soho, was initially approached by a newly formed German wine consortium on the basis of his company's mold-breaking work for Harvey's Bristol Cream, the sherry in the blue bottle. German wine, like Bristol Cream, and sherry in general was once a world best seller—every household had some—but over the past 25 years this dominance had eroded through complacency and neglect. The taste had not changed, the labels had stayed the same, and so had the bottles.

Over the previous decade the market had been taken over by wines from the New World, first by those from California, closely followed by Australia. Suddenly, wine stores were full of new flavors and innovative packaging. The German wine producers soldiered on, but the bottom had fallen out of their once-lucrative market.

The consortium was formed (by Germany's leading wine producers) to address this unsatisfactory position, a bold initiative to see off their New World rivals.

"Fortune favors the brave," advised Blackburn, but what became clear from the consortium, or committee to give it a more accurate name, was that they already had fixed views on the direction they wished to follow; they wanted to copy what was already being done. Out was to go any semblance of their country's distinct and gracious flute-style bottle; in its place a Bordeaux lookalike was wanted. The design task, as they saw it, was to produce a series of attractive, modern labels each carrying their particular vineyard's name, endorsed by the consortium's corporate banner. What could be simpler? they asked.

DISTINCTIVE BOTTLE PROFILE EQUITIES
BY THEIR SHAPE YOU ONCE KNEW THEM

BURGUNDY BORDEAUX GERMANY

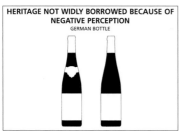

HERITAGE NOT WIDLY BORROWED BECAUSE OF NEGATIVE PERCEPTION
GERMAN BOTTLE

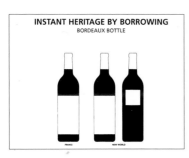

INSTANT HERITAGE BY BORROWING
BORDEAUX BOTTLE

FRANCE NEW WORLD

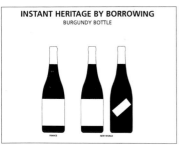

INSTANT HERITAGE BY BORROWING
BURGUNDY BOTTLE

FRANCE NEW WORLD

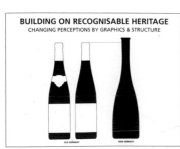

BUILDING ON RECOGNISABLE HERITAGE
CHANGING PERCEPTIONS BY GRAPHICS & STRUCTURE

OLD GERMANY NEW GERMANY

FIVE SELF-EXPLANATORY PAGES FROM BLACKBURN'S PRESENTATION TO THE CLIENT. "I HAD TO CONDITION THEM TO OUR IDEA—A STAND-OUT BOTTLE WAS THE KEY. PEOPLE RECOGNIZE SHAPES . THEY DON'T READ LABELS."

"CLEARLY COMMUNICATE GERMAN PROVENANCE AND CREDIBILITY WITHOUT BEING SUFFOCATED BY HERITAGE." SAID BLACKBURN, AS HE COMPARED THE SHAPE OF HIS NEW BOTTLE WITH THE EXISTING BOTTLES.

SHELF HEIGHTS
EXPLOITING THE DISTINCTIVE TALL BOTTLE TO THE MAXIMUM

PLAN VIEW OF SHOPPING AISLE
PEOPLE RECOGNISE BRANDS, THEY DON'T READ THEM

IN CASE THEY SAID THE NEW BOTTLE WOULD NOT FIT ON A SUPERMARKET SHELF OR IN THE REFRIGERATOR, THE DESIGNER CARRIED OUT HIS OWN SURVEY. "YOU HAVE TO QUESTION EVERYTHING."

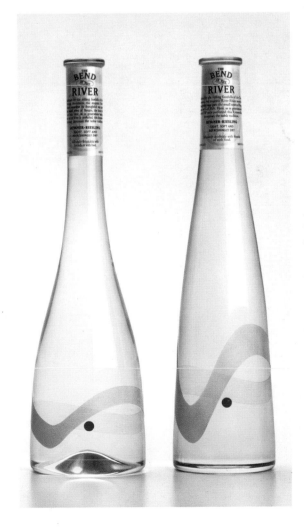

THE VIEW THAT LAUNCHED A NEW BOTTLE. AND PERHAPS A NEW ERA FOR GERMAN WINES.

View looking down the valley towards the vineyard on the Rhine

Blackburn argued against such a predictable approach, saying this was unlikely to tempt consumers away from what they are currently drinking and therefore would do little to transform their ever-dwindling market share. He even tried pandering to their patriotism by saying, "Surely such a proud nation that gave the world Beethoven, Goethe, Porsche, and Beckenbauer should be equally inventive with its wine, and not stoop to copy others regardless how successful!" All was in vain and Blackburn was left with no alternative but to decline the project.

However, one member of the committee, The Carl Reh Group, decided that the bold approach was what they wanted. Once a fee proposal was agreed, John Blackburn and design director Belinda Duggan were invited to the winery for a full briefing followed by a trip around the vineyards to soak up the atmosphere. "We had a bit of time to kill before our flight back home, so we stopped on top of a nearby hill by a lovely church where a choir of girls were singing." Below them was the Rhine, the "Bend in the River" idea was born. "I tend to like names that are not brand names," says Blackburn. "As soon as the thought came to me, I knew we were on to something. There seemed to be something right about it."

Back in London, Blackburn briefed his team to work out different concepts, in this particular case they came up with five. All had different brand names, the "Bend in the River" being one of them. Each design was directly related to each selected name, the only common factor being they all exploited the tall flute-type shape in one way or another. Asked why he was unable to show them, even now, he explained: "They're all still marketable, although from experience, I find clients seldom call ideas that were rejected first time around—but you never know. It wasn't that they

ATTEMPTING TO CREATE A CATALYST FOR CHANGE AND TO REVERSE DEEP-ROOTED NEGATIVE PERCEPTIONS OF GERMAN WINE. BLACKBURN HAD MODEL-MAKER PHIL EARL MAKE UP TWO VARIATIONS OF THE NEW BOTTLE. ON THE THINNER VERSION, THE SYMBOLIC RHINE GRAPHIC MEANDERS IN A MORE EXAGGERATED SHAPE AROUND THE BOTTLE AND ALSO EVOKES THE UNDULATIONS OF THE SURROUNDING MOUNTAINS. THE RED SPOT ON BOTH IS AN "R" IN A CIRCLE, DENOTING THE POSITION OF THE REH WINERY AT BINGEN ON THE RHINE.

were less good than the chosen design, they just tackled the brief from a different standpoint, which is what I believe alternative designs should do."

At Blackburn's there are no computers in the studio where the creative work is done; they are deliberately housed on a different floor. Blackburn continues: "The idea is paramount as I've yet to see an idea come out of a computer. As an efficient crafting tool it is without equal, but sadly it is often used as a seductive substitute for the all-important idea. Crafting should come at the end of the creative process, not at the beginning." To emphasize this point, Blackburn asks his designers to describe their idea in five words or less. If they can't, it can only be decoration not design, so it is rejected.

Working toward the presentation, Blackburn, who never presents sketches or flat visuals, had models made of each design. "I allowed for it in the budget," he says. At the presentation to the main board, which included wine producers, marketing executives, and salesmen, he spent well over an hour explaining the thinking behind the work—the "undercoat," as he calls it. "I love the theater of presenting ideas. I tell stories and do little tricks. It's important to get a reaction, a laugh. You musn't be afraid," Blackburn explains.

He called the presentation the "Renaissance of the Rhine" and listed his objectives as:

- **Create a new, contemporary, international German wine brand (inside and outside).**
- **Revive the brief in German wines once more**
- **Be the leader in creating a new perception of German wines.**
- **Overcome the "dull, uninteresting, formulaic, cheap, poor quality" image German wines currently have**
- **Create a brand for which consumers will happily pay $8.oo or more.**
- **Create packaging that is so innovative and seductive that consumers will have to pick it off the shelf and ultimately purchase the product.**

"Take the initiative, don't follow. Create a 'distinctive, protectable, campaignable' idea. Behave like a brand leader," he urged them. "Remember: 'faint heart never won fair lady'."

After the presentation, Blackburn gave them a copy. The client, overwhelmed by the wealth of choice he had been given, asked the consultancy's recommendation. "Not because I thought of it, I said our consensus would be "Bend" he says.

A day or so later the client wrote to say there was agreement. "Apart from the idea, the elegance of the bottle was an influencing factor" explains Blackburn. "This one is slightly taller than most other German wine bottles. It doesn't matter how good a product is, if it doesn't attract the eye, it counts for nothing. This one stands out like a fir tree in an orange grove."

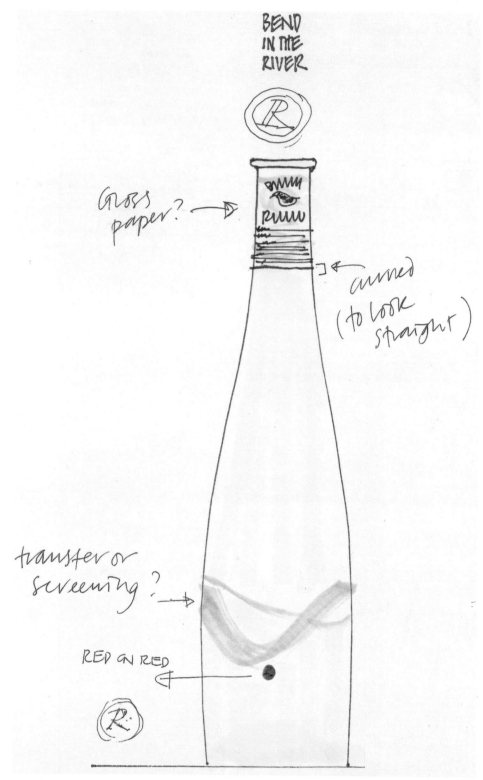

AN EARLY SKETCH OF THE NEW SHAPE. WITH ITS WRAPAROUND RIVER GRAPHICS AND ALL THE INFORMATION CONCENTRATED ON A TINY LABEL AT THE TOP.

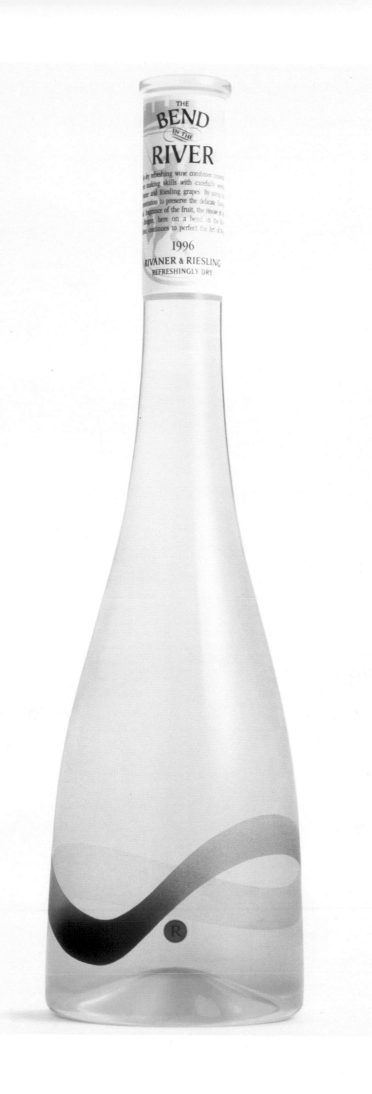

THE
BEND
IN THE
RIVER

...ly refreshing wine combines ...
... making skills with carefully ...
...er and Riesling grapes. By using ...
...mentation to preserve the delicate ...
... fragrance of the fruit, the House ...
...ngen, here on a bend in the ...
... continues to perfect the Art of ...

1996

RIVANER & RIESLING
REFRESHINGLY DRY

THE FINAL BOTTLE, USED
FOR THE LAUNCH OF A
NEW LIGHT, AND FRUITY
RIVANA-RIESLING, WAS
MADE BY DECO-GLAS IN
GERMANY IN A SLIGHTLY
GREEN-TINGED GLASS. IT
WAS TRANSFER-PRINTED
IN FIVE COLORS,
INCLUDING THE LABEL AT
THE NECK, WHICH HAD
THE CREST OF THE TOWN
OF BINGEN IN PALE BLUE
BEHIND THE DESCRIPTIVE
COPY. TO CAP THE WHOLE
EXPERIENCE OFF, EVEN
THE CORK HAD THE
"WIGGLE" OF THE RIVER
PRINTED ON IT.

Hydro

As a way of describing the design process, Landor used horticultural language drawn from the client's own fertilizer business. Once the seeds are sown, it is the in-between stages that guarantee the crop's success. The design platform was called "preparing the ground," while the creative concepts were the results of **"the growth of a good idea"**

As the world's leading supplier of specialized plant nutrition, Hydro Agri Specialities has introduced an evocative new graphic identity to symbolize its commitment to exceptional quality and service. The new brand identity has been designed by Landor, global design and branding consultants, and has been applied to its range of specialty products.

Although all the work was done in London, the initial contact with Hydro Agri Specialities came from Landor's partner company, Burson Marsteller in Oslo, Norway, which had been invited to pitch for a packaging job. Because they were primarily a PR consultancy, they brought in Meinhard Hausleitner, Landor's north European consultant, to take over. It was February 1997 when, convinced by one of Landor's previous case histories and capacity for complex packaging work, Hydro sent a brief.

If Hydro was to achieve the massive market growth for this unit that it planned, this was the moment to do it. King listed the project objectives as:

- Development of a distinctive profile and strong umbrella brand for the Hydro Agri Specialities using the name Nutriplant
- Communication of the core values and the relationship with the mother brand, Hydro
- Development of a segmentation system, which links the range but allows flexibility for local, market and/or product-specific issues
- Development of a system that would ensure that all employees and subsidiaries identify with the new positioning and umbrella brand.

When Landor and Hydro looked at potential growth areas and market trends in agriculture, they found that they varied

FROM A PAGE OF EARLY IDEAS, THIS PHOTOCOPY OF SOMEONE'S THUMBPRINT WAS THE EMBRYO OF THE FINAL SOLUTION. "I WANTED A MARK WITH AMBIGUITY," SAYS THE CREATIVE DIRECTOR, "WHICH WOULD WORK ON A NUMBER OF DIFFERENT LEVELS BUT STILL HAVE A LOT OF IMPACT."

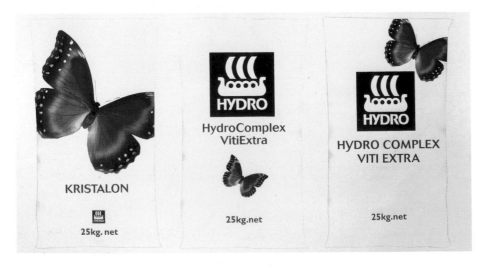

KRISTALON

HydroComplex VitiExtra

HYDRO COMPLEX VITI EXTRA

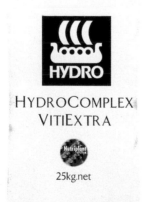
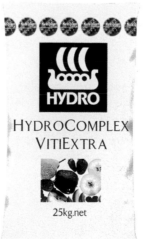

widely from country to country. The specialty fertilizer market was saturated in some countries, and in others there was great potential. Furthermore, long term, there was the opportunity of communicating the Hydro specialty offer to large multinational companies via the retail supplier chain who maintain long-term partnerships with their respective agricultural suppliers.

Referring to previous market research undertaken by Hydro, Andrew King, Landor's creative director and Landor, London, observed, "There was good brand awareness at the distributor level. Hydro is a very well-known brand with a stronger image in some markets such as the U.K. and Spain, than others such as Italy."

King remembers that the first thing he had to do was rewrite the brief and then devise a program by which the desired end could be achieved. This is when he produced his plant-growing analogy to explain to the client that it was not simply a matter of designing a package and producing a symbol for Nutriplant. Nutriplant was a name that Hydro was proposing to give to a range of crop-specific fertilizers and to the division that was to market and distribute them. The task was much more complex than most packaging jobs, and it was something that Landor, with its global expertise, understood immediately.

King said that "specialties, as a product definition, was a confusing term anyway, and that calling it Nutriplant would not help."

Nutriplant—Word Associations

Positives	Negatives
Plant nutrition, fertilizer	Generic, not too exciting
Green, taking care of plants	Norplan, the U.S. birth
Well tested	control implant
Trustworthy	Nutriplan slimming product
Food for all plants	Many names like this
Advanced biology, laboratory	Vitamins, health-care
Chemical, mass-produced	products
	Genetically manipulated soya

King recalls Hydro representatives from Italy, Belgium, Holland, and Norway at the first presentation. "I explained that it couldn't be just a quick-fix solution. They know about marketing and budgets, but it was the first time they'd undertaken a strategic packaging and branding job like this," he recalls. "They had a lot of learning to take on board." King added that "Hans Megard, the project manager, is Norwegian so he used his language skills to get under the skin of the organization. Hans interviewed Hydro product managers and learned what he could about the industry and its people." In the early stages, the project focused on all competitive information, which revealed that there is very little differentiation between fertilizer brands, with two or three large companies supplying most of Europe.

Lars-Ove Svensson, vice-president of Hydro Agri Specialities, helped drive the project from the client side.

Although the brief had asked for a design for a logotype for Nutriplant, King was pursuing a different route, devising a scheme of packaging that focused around a graphic device that communicated the ideal of the product rather than another confusing sub-brand. "My main job was to sell the idea to the corporate motivators, using it as a catalyst to change their way of thinking and become motivated to rationalize internally as well as externally." To explain his approach, King created some visual examples which he presented to Svensson and his colleagues. There were three routes: the first had a large yellow sun and the word Nutriplant; the second had a symbolic stamp of quality; and the third, which had no name but just a big butterfly, demonstrated that using a more emotive approach would appeal more to farmers and evoke the countryside and the environmentally friendly end results. Even though it was only a demonstration of an approach—King was not suggesting that they actually use a butterfly—Svensson could not accept it. "He thought we were mad," says King. "Although others responded to it being colorful and having a 'feel-good factor,' he felt it was possibly going too far."

King was not deterred. "We'd defined our own target," he explains, and immediately set about working up other ideas for elements that could replace the butterfly. At this stage, the client still wanted to keep the Nutriplant name, too. One week before the big presentation, King previewed the work to Landor's management team and made minor adjustments. He had six routes, each evoking a different aspect of the farmers' world: the yellow disc was adapted to evoke plowed fields, while squares symbolized fields from the air. The butterfly was still featured in there, and so was an enlarged fingerprint, an idea to represent the personal Hydro touch, and a stamp of approval signaling an exceptionally high quality product.

The presentation was planned to coincide with a meeting of all the company's divisional heads, which was held at Hydro's head office in Brussels. Hausleitner and King had been allocated 30 minutes in the day-long schedule to present what the client later said was "the most creative presentation they had had in a long time." To his great relief, everyone seemed to like the fingerprint solution, and expected him to go straight to artwork. King had to explain, however, that they needed "to go to the marketplace, to talk to agents, distributors, and farmers."

King and his team went to Italy, Spain, U.K., Holland, Norway, and France where they showed three alternatives. The squares, a microscopically enlarged leaf symbol, and of course the fingerprint, all of which were applied to fertilizer bags. None of them included the word Nutriplant. "We had to have something that communicated to the men out there in boots—there's no chance for post-rationalization," recalls King. "Either they understand it or they don't." Not only were the farmers very positive, but they were excited to be asked. The process took approximately two months and was very expensive but the findings proved invaluable," he says. Reporting back to the client, King presented two finalized

THESE THREE CONCEPTS WERE DEVELOPED TO CARRY OUT MARKET RESEARCH. THE MICROSCOPIC DISC HAD BEEN CHANGED TO MARRY A CIRCUIT BOARD WITH A LEAF STRUCTURE. THE LAND FROM THE AIR HAD BEEN SIMPLIFIED TO A THREE-COLOUR PAINTING, AND THE COLORS IN THE THUMBPRINT WERE REVERSED TO ECHO THE SKY AND THE LAND. "WE WERE ALL SURPRISED AT HOW WELL RECEIVED WE WERE," SAYS KING.

routes—the fingerprint and the enlarged leaf. Both were developed to take into account the structure of the pack and the other product information that had to be included, as well as being applied to other brands and different types of container. Everyone voted for the fingerprint solution.

Independent of this project, Landor had also been working on designs for Hydro's stand at a forthcoming trade fair in Amsterdam and, anticipating that the client would like the fingerprint too, had applied it to the stand's graphic panels which they showed at the same meeting.

"Now it was all systems go," says King, who still had to apply the concept to all the other specialty fertilizer brands and do artwork for nearly 50 different bags. "We produced the English applications and the client managed all the own-language variations themselves." Although it had not been asked for, King also produced a 20-page style guidelines brochure to show how all the other print work, including product sheets and brand literature, should look.

IN THE FINISHED APPLICATION, WHICH EXTENDED TO OVER 50 DIFFERENT PRODUCT CATEGORIES AND CONTAINERS, THE THUMBPRINT WAS TILTED AND PUSHED TO ONE SIDE. "WE FELT IT LOOKED TOO STRAIGHTFORWARD BEFORE," SAYS KING.

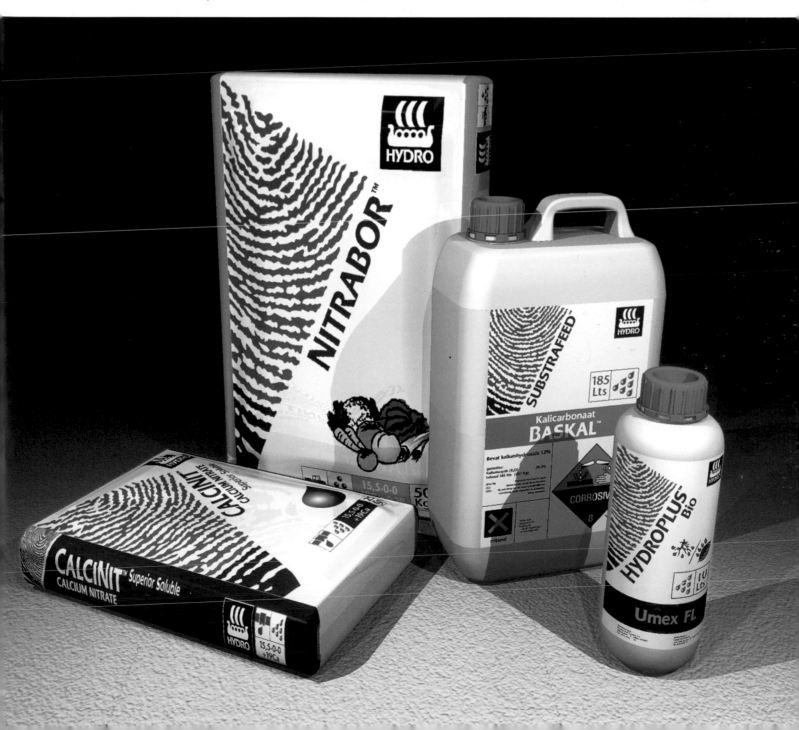

Frutte

"New age" beverages were an emerging market in Australia when Berrivale Orchards decided to launch a series of carbonated, fruit-flavored waters. The company already had a range of sports drinks (Isosport) and created a product that did not yet exist in Australia. The new drink would be lightly carbonated with a hint of fruit color, a strong aroma, and a taste of natural fruit. "Not too sweet. Nice, clean after-palate and **no gassiness experience post-consumption,"**

explained Berrivale To be sold in 10 fluid ounce glass bottles, the proposed flavors were lemon, lime, guava, black currant, apricot, peach, tangerine, and apple. The comprehensive brief also went on to describe the customer: a 20- to 35-year-old, "white-collar" woman, "educated and working, she is self-confident, body and fitness conscious, brand conscious, and socializes regularly."

Barrie Tucker, of Tucker Design in Adelaide, remembers that the brief was put initially to three designers. One was the bottle manufacturer, ACI Glass, but Tucker Design, with its extensive experience in fruit-juice packaging, was already working on over 200 products for Berrivale, so there was not much competition. At first they worked just on the name, but "two weeks later the client called and confirmed that we could design the bottle as well," recalls Tucker. So the project, a very important new launch, had three strands—the name, the bottle, and the label—and Tucker's design team, led by Barrie's son Jody Scott Tucker, started by buying all the competitors' products. From about six concepts, he narrowed it down to one shape "that we felt good with ... We prefer to show the client just one route, but we looked at some others on the way through," explains Tucker.

The name proved more of a problem. The designers presented a series of ideas in the form of names rendered in different typestyles and concepts. Verve was the only name that Berrivale liked, but it turned out to be already registered, so they went back to the dictionary and ever-

A SERIES OF FIRST SKETCH IDEAS BY JODY SCOTT TUCKER FOR A BOTTLE THAT WOULD "FEEL GOOD IN THE HAND." EVEN AT THIS EARLY STAGE THERE WERE LABELING IDEAS, INCLUDING ONE OF FROSTING ALL THE GLASS EXCEPT THE AREA AT THE FRONT THAT WOULD ACCOMMODATE THE GRAPHICS.

THERE WAS A FALSE START IN THE EARLY STAGES OF THE PROJECT WHEN, ASKED TO THINK OF NAMES AS WELL AS BRANDING, THE TEAM USED THE ALREADY COPYRIGHTED VERVE.

neck could be taller

less square

more taper needed

taller neck

Shoulders less square

straighten neck No taper out at bottom

body slightly longer.

more taper more elegant

accentuated heel

better but still not elegant enough for product.

Preferred shape

* Need to check labelling centred on emboss
* Emboss front + back only

Tucker Design

DON I HAVE ACCENTUATED THE HEAL TOO MUCH SHOULD BE SQUARE TO COPE WITH BOTTLES ON LINE

"WE'D DONE NEW BOTTLE DESIGNS BEFORE," SAYS BARRY TUCKER "SO THE ACTUAL SHAPE OF THE DESIGN STAYED THE SAME, EVEN WHEN IT WAS CLEANED UP TO THE CORRECT VOLUME."

ONE ALTERNATIVE WAS FOR AN OFF-CENTER PROFILE THAT INCORPORATED A FLAT SIDE ON WHICH THE BOTTLE COULD LIE IN ADDITION TO THE CURVED BASE, WHICH APPEARED IN THE FINAL VERSION.

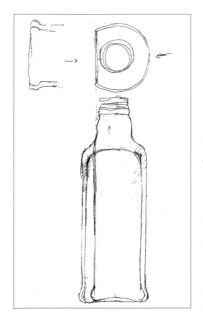

lime & tangerine

strawberries

MOTIV DESIGN, THE ILLUSTRATION STUDIO RESPONSIBLE FOR THE PAINTINGS OF THE FRUIT, SUBMITTED OUTLINE DRAWINGS BY FAX TO CHECK THE FINAL ELEMENTS BEFORE COMPLETING THE ARTWORK.

useful thesaurus and even looked at other languages before eventually choosing Frutte, a word with French derivation. This meant almost starting again with new ideas for the labels, but "it wasn't a huge amount of extra work."

Meantime, ACI Glass had taken the initial bottle sketches and started to produce engineering drawings and volumetric models. It was now time to finalize thoughts on the labels. Given the shape of the bottle, there was only quite a small area that was flat enough to carry the graphics, and any illustration had to fit that shape. Berrivale had provided all the names of the fruit, and because they were such a key part of the product proposal, it seemed obvious to illustrate them. Claire Rose, one of the designers in the studio, did the first drawings, but once they were approved, Motiv Design, an

illustration studio, did the finely painted artwork. Additional branding appeared at the bottom of each bottle, where the company corporate logo was embossed into the glass.

The product was launched with very little advertising or marketing support. It was just "noticed by its appearance." But appearance was the key to this segment of drinks, which are sold mainly in cafés where customers help themselves from glass-fronted refrigerators.

"From time to time I make a tour of cafés and sandwich bars," admits Tucker, "to ask people what they think and to look at the competition. It's holding on quite well." When they were briefed there were no discussions about Frutte's lifespan, but it seems to have "some quality," observes Tucker. "It still jumps off the shelf."

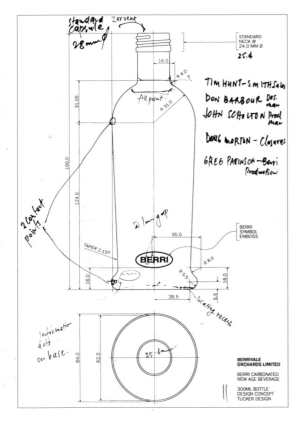

(ABOVE) THIS COMPUTER DRAWING BY TUCKER. SHOWS THAT THE INITIAL CONCEPT REMAINED IN ESSENCE DESPITE MINOR MODIFICATIONS (RIGHT) FOR PRODUCTION AND FILLING REQUIREMENTS.

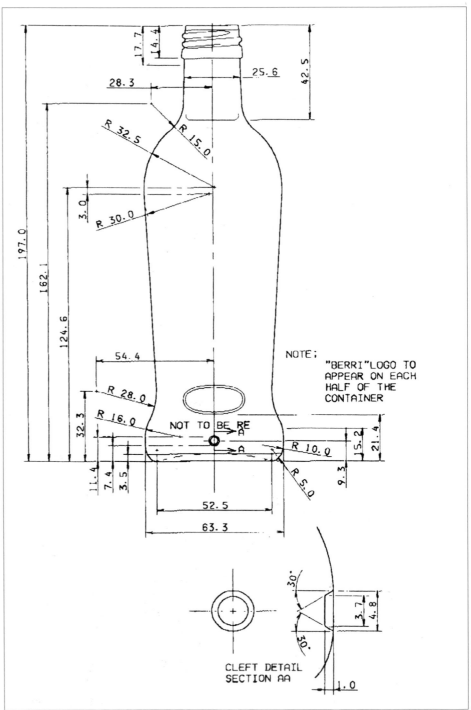

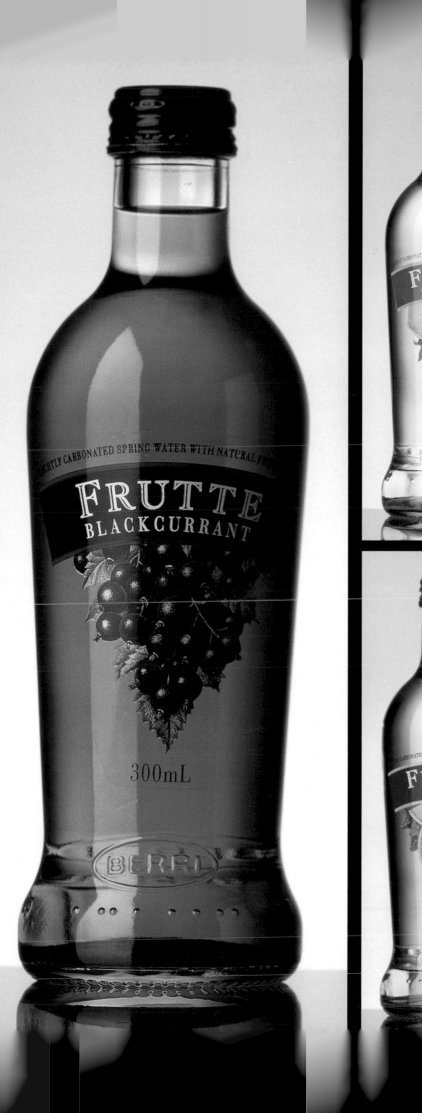
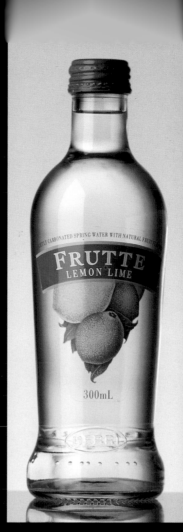
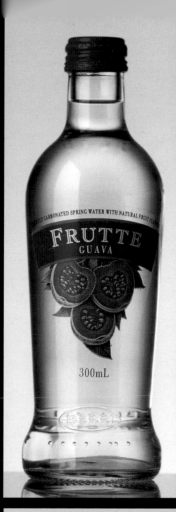
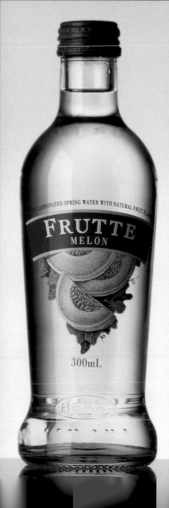
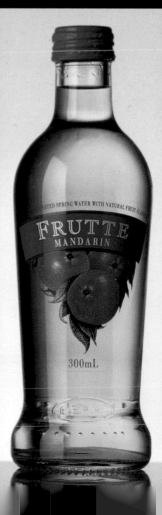

Mondéo

Sometimes during the progress of a major job that involves retail design, logos, menus, banners, T-shirts, and name creation, a packaging brief comes up at almost the last minute. When this happens, with all the other creative ingredients in place, a solution can sometimes emerge that is both spontaneous and fresh. Not an afterthought, but **the synthesis of everything else.** This is **just such a case**

The word Mondéo stands for "globe." The Seattle design company Hornall Anderson is often asked to think of names. In this project, the client, C. W. Gourmet Inc., which is based in Northern California, had an idea for a new type of restaurant that would bring together American, Mediterranean, and Eastern specialties—Texan, Thai, Indian, and Moroccan—which would be served in bowls or wrapped in flavored tortillas and provided fresh and fast.

Martin Culver and Brad Wells of C. W. Gourmet asked Jack Anderson to handle the whole job, including the interior architecture of the first site in Los Altos, California. Once they had got the name, the designers set about looking for a way of putting across the "global village" concept graphically. Jack Anderson explains it as "people from different parts of the world metaphorically sharing flavors." Anderson created a modern interpretation of the sort of hieroglyphics that might have been used on a cave wall—hand prints, figures, and, in particular, a combination of bowl and wrap that also evoked the globe. Rendered in a scratchy, dry-brush technique, they combined it with various styles of lettering, also hand drawn.

The identity had a casual, innocent look that they liked, and they carried it through onto menus and banners in the restaurant, where they also developed additional icons to represent soups, salads, and fruit juices. To underline the multicultural aspect, there were three icons for the foods—a

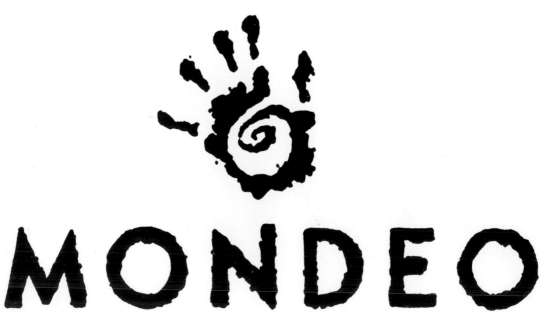

star (for American), a column (for Mediterranean), and a pagoda (for Eastern). They even looked at ways of carrying the feeling through onto the walls and floor.

Throughout all this, Anderson remembers that the client was "quite hands off." C. W. Gourmet wanted a complete interpretation of the concept and let the designers get on with it. As Anderson puts it: "They gave us a lot of rope and allowed us to break out of the box." Even the schedule was quite relaxed. Jack Anderson worked on it with David Bates and Sonja Max. "Because we had a very small budget, we had a small team, and approached it a bit more casually than if we'd had a more rigorous deadline," Anderson recalls.

As a way of giving customers a "piece of their experience" to take home, the client had the idea of producing a series of four sauces and relishes for sale in the restaurants. "It's a nice reminder and it brings them back," says Anderson. So suddenly, together with all the other aspects of the brief, there was packaging to do. Given that everything else was in place, the only thing missing was the bottle, and Anderson,

PRESENTATION
MOCKUPS FOR THE
MENUS HAD SPACE TO
EXPLAIN A "WRAP" TO
CUSTOMERS—"A UNIQUE,
HAND-HELD FOOD THAT
CONTAINS
INTERNATIONAL
FLAVORS AND SPICES,
WRAPPED IN A
COLORFUL TORTILLA."
LATER ON, THERE WOULD
ALSO BE MONDÉO
PRONTO—SHOPS
SPECIALLY DESIGNED
FOR TAKEOUT.

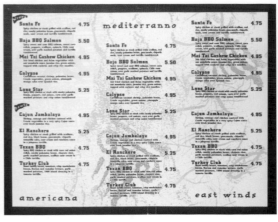

VARIOUS IDEAS FOR
BANNERS HIGHLIGHT THE
THREE FOOD INFLUENCES
WITH ICONS THAT WERE
LATER USED ON THE
PACKAGING. IN ADDITION,
A TOTEM POLE AT THE
ENTRANCE REINFORCED
THE "GLOBAL VILLAGE"
FEELING THEY WANTED.

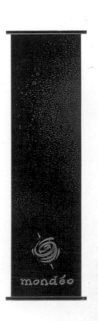

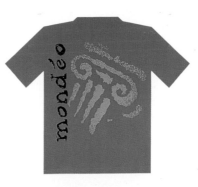

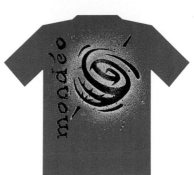

AN INEVITABLE AND IMPORTANT ASPECT OF ANY NEW RESTAURANT ARE THE T-SHIRTS. ALL THE MONDÉO STAFF WORE SPECIALLY DESIGNED T-SHIRTS, WHICH FEATURED EITHER THE CORPORATE LOGO OR THE REGIONAL ICONS. STAFF MORALE AND PERFORMANCE WERE IMPORTANT COMPANY PRIORITIES, AND FOREMOST IN MONDÉO'S MISSION STATEMENT WAS THE AIM TO "CREATE A FUN, DEVELOPMENTAL, AND SUPPORTIVE ENVIRONMENT FOR ALL TEAM MEMBERS."

with his huge collection of samples (see page xxx), knew just where to find it.

There were no preparatory sketches or presentation visuals. Anderson admits that because it was "a natural extension of all the other pieces, we just kind of did it." Rather than focus on one logo alone, the packaging consisted of all the components, using the regional icon to highlight and differentiate each product.

In production terms, the relatively small quantities meant that the designers had the luxury of using materials and techniques not normally available, and almost everything was done by hand. The labels were printed digitally, straight from the computer, and then torn by hand. Craft paper was used for the tops, which were printed with a darker color and the legend "fusion flavors" and then applied by hand and sealed with a paper band—"another opportunity to brand it"—which was given a quirky twist at the end.

The designers even had a say in the menu. "We were asked to try all the food and give them our opinion," says Anderson. "Martin Culver and Brad Wells really put their heart and soul into it."

(BELOW) EACH LABEL ILLUSTRATED THE BOTTLES' CONTENTS WITH ICONS THAT INCLUDED A PAGODA FOR ASIA (SPICY THAI PEANUT SAUCE), A COLUMN FOR THE MEDITERRANEAN (FIERY NORTH AFRICAN RELISH) AND A STAR FOR THE AMERICAS (BIG TEXAS BBQ SAUCE), AND A CUP ICON THAT REPRESENTED A GINGER ALE MIX (THE ONLY ICON/PACKAGING THAT DIDN'T EVOKE A CORNER OF THE WORLD). THE BOTTLES WERE SOLD ONLY IN THE RESTAURANT, AND THE LABELS WERE PRINTED ON RECYCLED PAPER. THE DESIGNERS HAD THOUGHT OF TYING EACH TOP WITH STRING OR RAFFIA, BUT IN THE END DECIDED TO GIVE THEM A "PONYTAIL TWIST" OF PAPER.

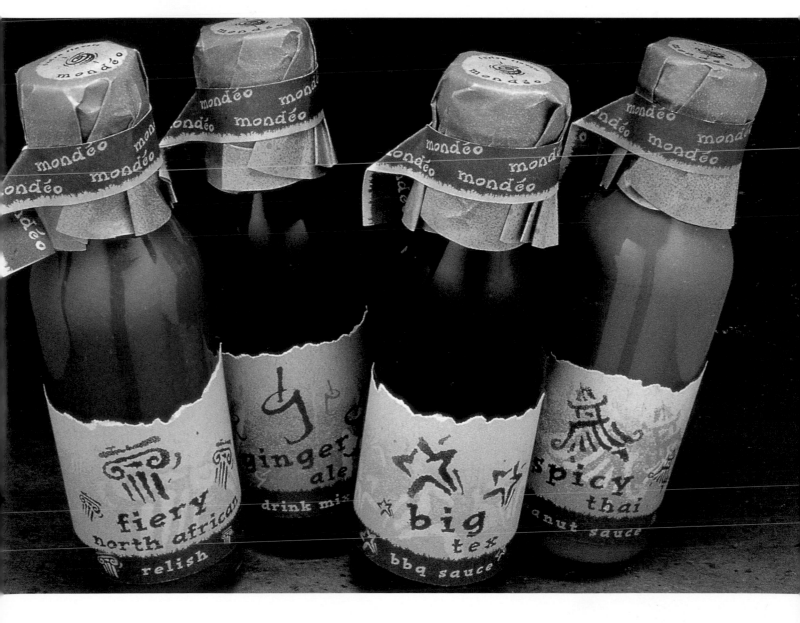

Boots Aromatherapy If you cover up the logo, will this packaging still look like a Boots product? That is one of the key factors when working on packaging for this long-established British retailer, which has a branch in almost every town. Innovative in its use of designers, the company has a roster of design consultants, among whom Trickett & Webb is a long-standing member

Brian Webb explains that there is no guidebook when it comes to working for Boots: "You begin to get a feeling for it—it's not something you can put into words and it's difficult to explain to new team members when they join ... We all want to push ahead and try new things, but within the 'gathered knowledge' of what we know about Boots. It's more about abstract feelings."

The same can be said of the brief they received to redesign a range of aromatherapy packs in 1995. "First, we had to understand how complementary medicines work. It is a growing market, both in the Britain and throughout the Western world, along with alternative therapies and a general awareness of environmental issues. The attributes of aromatherapy are partly physical, partly mental." The seriousness of the project came out in discussions Webb and his designers had with the Boots team—"Not a cosmetic and not an ethical pharmaceutical."

The market was already overcrowded with competitors' products, in fact, this was one of their starting points—looking at the competition, and analyzing the market and the customer profile. Customers were largely women aged 25 to 45, but there were also some from both older and younger age groups.

"How can you convert an abstract feeling—a visual analogy of physical/mental stimulus?" Boots could not have come to a better company. "We were excited. The more problem solving, the better," enthused Webb and his partner Lynn Trickett. They had two weeks to come up with first stage ideas, and Trickett and Webb and the team all sat around in the first-floor meeting room "with no phones" and started doing sketches. Webb recalls that even before this he had an image in his mind—strips of litmus paper—remembered from his school days. The way the color changes as the liquid goes up the paper seemed to symbolize the qualities of the products, and this led them to consider the effects of color when it is used in an abstract way.

Y

WHITE PACKS PRODUCED IN STAGE ONE WERE PICTORIAL AS WELL AS ABSTRACT ATTEMPTS TO ENCAPSULATE THE "PARTLY MENTAL, PARTLY PHYSICAL" QUALITIES OF AROMATHERAPY. AS WELL AS THE SIMPLE PRESENTATION OF THE PRODUCT DESCRIPTION. THE LATIN TRANSLATION WAS INCLUDED AS A WAY OF GIVING ADDED INTEGRITY.

USING A MAPLE LEAF AS THE SYMBOL OF NATURAL RESOURCES, THESE THREE ALTERNATIVES EXPERIMENT WITH THE SIZE OF THE LEAF, SOMETIMES OVERLAYING THE TYPE, SOMETIMES WRAPPING THE IMAGE AROUND ALL THREE SIDES OF THE BOX.

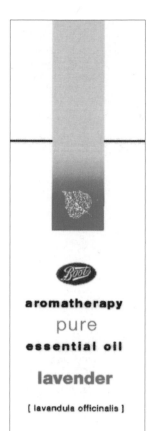

THIS EMBRYO OF AN IDEA RECALLS THE LITMUS PAPER IMAGE TO CONVEY A CHANGE, AS WELL AS BEING A USEFUL DEVICE FOR DIVIDING THE PACKS INTO RANGES. UNLIKE THE SPECTRUM, HOWEVER, THE COMBINATION OF THE TWO COLORS PRODUCED A THIRD UNEXPECTED HUE THAT EVOKED "THE FEELING THE PRODUCT GIVES."

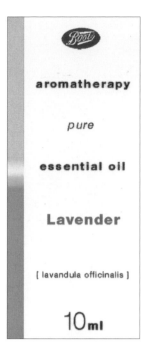

(RIGHT) ALTHOUGH THE MANDATORY BLUE LOGO WAS IN ITS CORRECT POSITION AT THE TOP, THIS WAS CONSIDERED TO BE A "NON-BOOTS" WAY OF HANDLING TYPE.

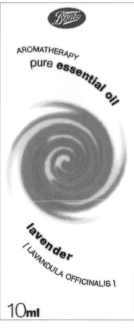

ALL SIX SIDES WERE INCLUDED IN THE LAYOUTS THAT DEVELOPED IDEAS FROM STAGE ONE, TO SEE HOW THEY MIGHT WORK ACROSS THE RANGE. GONE WAS THE MAPLE LEAF, AND A PALETTE OF COLORS HAD BEEN INTRODUCED FOR THE BOX TOPS.

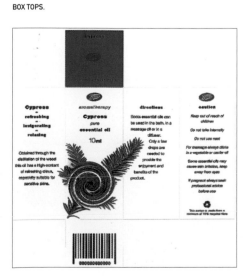

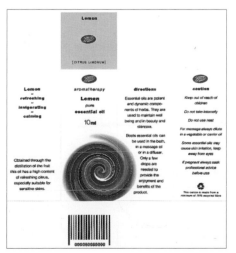

They pictured a thin band of two colors—one at the top and one at the bottom (the packs were all portrait shape) that made a third color when they met. They suggested that one color could represent the aromatherapy product range and one color could represent the family of aromas (there were too many aromas to have one color for each). Where the two colors fuse together, it became not the color a painter or printer would get but an unexpected third color that stood for the effect that aromatherapy produces.

At the end of stage one they had produced a range of 20 ideas, many of which the client never saw, and they showed between six and eight. "We very rarely say to a client, this is the only route you can take… we produce a series of visual demonstrations of the discussions we have had with the client, indicate the alternatives, and draw a conclusion." It's very important to Trickett & Webb that the client feels he owns the design and is part of the process. Everything seemed to lead to the litmus paper idea, but the client also liked two or three other routes. One solution involved a leaf that had been photographically distorted with a swirl, but in the end they decided it was "too cosmetic."

There followed a few days of internal discussions and approval stages at Boots. Nevertheless, the design was far from resolved, and although the designers had presented the color idea as a viable solution, in the back of their minds they knew they would have problems making it work. In particular, the limitations of the printing process (even supposing that they could produce the artwork) would create technical difficulties when it came to achieving the gentle blend of color they had visualized on the computer.

In order to justify the idea still further, they took the narrow front band and extended it to cover the whole of one side of each pack. In addition, they had to apply the same idea to much smaller bottle labels and much larger gift packs.

Despite this, Boots thought that the colors were not working hard enough to differentiate the group variations— citrus, herbal, and so on — and that the third color added to the confusion.

"It became a piece of art that wasn't easy to justify," admits Webb, so at the next presentation they went back with a solution using just two colors. In addition, words were used to help describe the differences and "time was spent on minor detail changes and copy amendments as the products themselves developed, and research was undertaken."

Meanwhile the printers produced "a lot of experiments. It was a theory we'd never put into practice," recalls Webb, and in the end artwork for the color blends, as well as for more than 25 packs, was produced on computer and each pack printed in five colors.

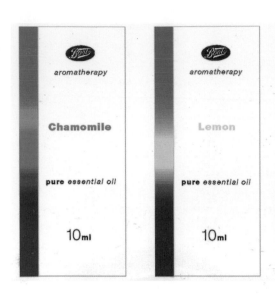
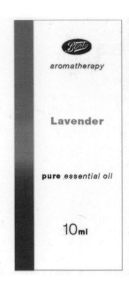
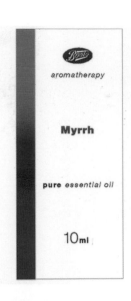
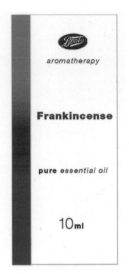

AS AN INDICATION OF THE COLORS, THIS SHEET OF VARIATIONS WAS PRODUCED ON THE COMPUTER. ALTHOUGH THE PACK SIZES OFFERED ONLY A LIMITED AMOUNT OF SPACE, THE IMPACT OF THE SIDES WAS CONSIDERABLE.

TWO OF THE COLORS WERE CONSTANT—ORANGE FOR AROMATHERAPY AND BLUE FOR BOOTS — WHILE THE PRODUCT COLOR, USED ALSO FOR THE TYPE, INDICATED THE FAMILY OF OILS.

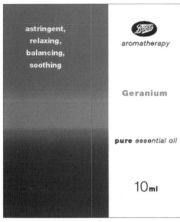
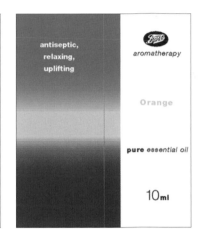

ONCE INSIDE THE BOX, THE BOTTLE LABELS FEATURED ONLY THE PRODUCT COLOR AND DIRECTIONS FOR USE.

THE FRONT FACES, ONCE THE NUMBER OF COLORS HAD BEEN REDUCED TO TWO, RESEARCH INDICATED THAT THE TYPE HAD TO BE INCREASED IN SIZE AND THAT THE COLOR CODING NEEDED TO BE IMPROVED. ON THE OPENED-OUT LAYOUT, (FAR RIGHT) COLOR WAS USED ON BOTH SIDES OF THE BOX.

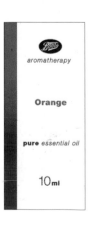
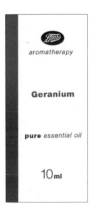

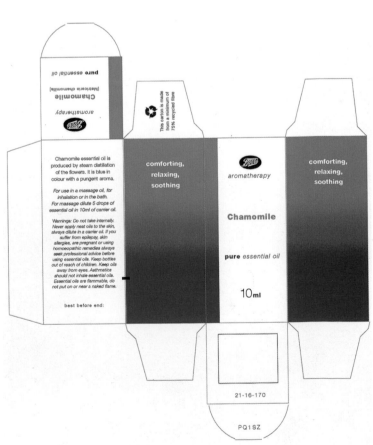

A TRIAL SHEET FROM THE PRINTER SHOWED WHAT TECHNICAL PROBLEMS OCCURRED TRYING TO MIX COLORS THAT ARE NOT ADJACENT IN THE SPECTRUM. SCREEN CLASH WAS AN UNEXPECTED ADDITIONAL HAZARD.

THE FINAL LINEUP OF AROMATHERAPY PRODUCTS HAD A CRISPNESS AND SIMPLICITY THAT BELIED THE DIFFICULT ROUTE THAT THE DESIGN PROCESS TOOK.

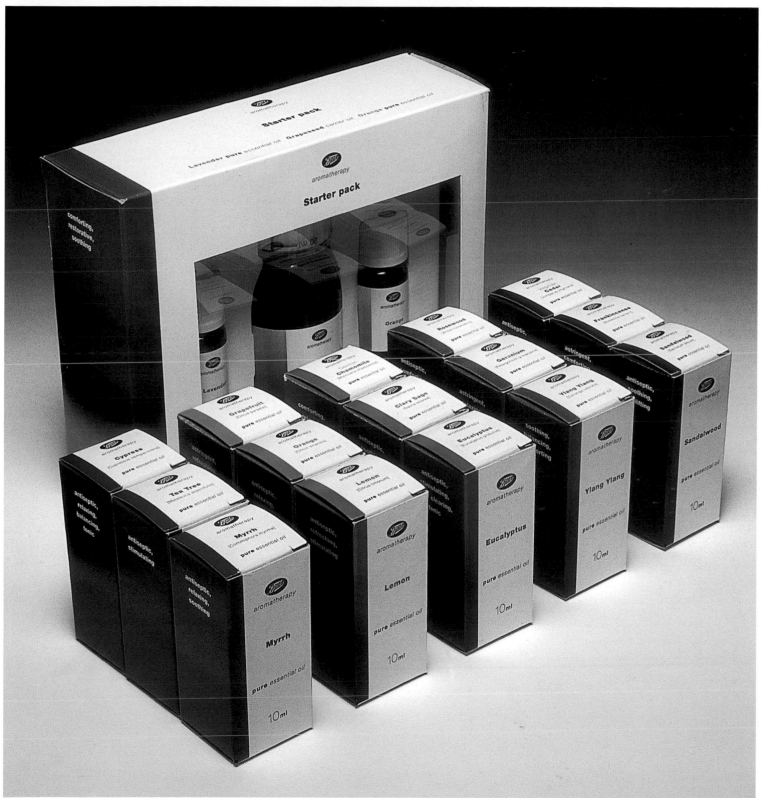

Chivas Brothers

Here is a designer who works with spirits. Over the past 10 years he has carried out branding jobs for most of the main distilleries, always building on his knowledge of packaging techniques. On this occasion, the brief was from a long-time collaborator, who said simply:

I've got this idea for a bottle that spins

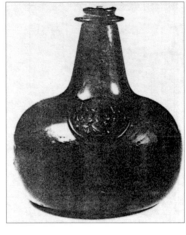

THE STARTING POINT WAS A GROUP OF OLD, HAND-BLOWN BOTTLES, IN BLACK GLASS, THAT DATED FROM ABOUT 1690. THIS ONE BEARS A ROYAL SEAL AND THE INITIALS OF RICHARD WALKER, WHO IS KNOWN TO HAVE KEPT THE KING'S TAVERN IN OXFORD.

It would be difficult to find a more respected client. Seagram's Scotch Whiskey portfolio (produced and distributed by The Chivas & Glenlivet Group of Paisley, Scotland) contains some of the oldest and finest whiskey brands in the world.

Gerry Barney, a partner at Sedley Place Ltd, the 30-strong London design firm, had worked for The Chivas & Glenlivet Group for the last four years, developing at least three new products (there are some he cannot mention yet). His client and old friend Tom Jago was at the time in charge of new product development at Chivas, but the two men had worked together in various companies since the early 1960s.

Jago was responding to an opportunity he saw for a new Chivas Brothers whiskey for the on-premises drinking market (clubs) in Asia and the countries of the Pacific rim, where he thought that the novelty of a bottle that could be spun might appeal. In a conversation in June 1994 Jago described the idea in "a half dozen words and said, can you work from that?" remembers Barney. Although Sedley Place handles corporate and interiors work as well as brand design, packaging, especially for the drinks market, is Gerry Barney's forte.

Barney knew instinctively that the bottle would have to have a low center of gravity if it was not going to fall over, and he recalled the shapes of old ship's decanters. In a book on antique bottles, he found black glass containers used by innkeepers in England in about 1690, which even bore the stamp of the tavern for which they were made. They had the correct displacement of weight. Jago had said that the name of the product could be "Revolver," but both men realized that this might lead to problems with the client's corporate guidelines, so "Revolve" was tentatively adopted instead, as a nickname for the brand which became known as Chivas Brothers 1801.

(LEFT) GERRY BARNEY DREW NINE ALTERNATIVE SHAPES, ALMOST TO ACTUAL SIZE. ALTHOUGH SOME WERE LATER ABANDONED, HE WAS TRYING A FIND A SHAPE THAT HAD A LOW CENTER OF GRAVITY SIMILAR TO OLD SHIP'S DECANTERS.

(FAR LEFT) THE FIRST SHAPE TO BE MADE INTO A MODEL HAD A GENTLY BEVELED BASE. AT THIS STAGE, NO ONE KNEW IF IT WOULD WORK, BUT IT WAS THE ONLY SHAPE BARNEY SHOWED IN STAGE TWO.

TAKING IT A STEP FURTHER, THE MODEL MAKERS WORKED OUT THE PRECISE VOLUMETRIC DIMENSIONS AND, IN A CUTAWAY VERSION (RIGHT), SHOWED HOW THEY HAD CREATED THE CORRECT WEIGHT TO SIMULATE THE CONTENTS. LATER, BARNEY DREW OVER IT HIS THOUGHTS FOR A PLUG IN THE BASE (RIGHT CENTER) IN THE THIRD VERSION (FAR RIGHT).

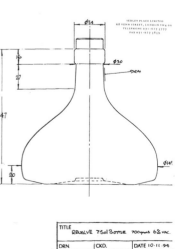

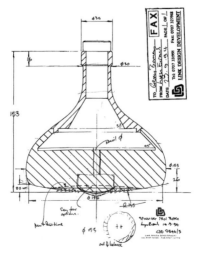

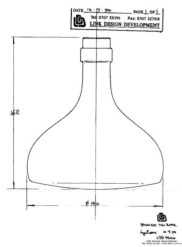

A SELECTION OF IDEAS FOR THE WOODEN STOPPER. BECAUSE OF THE COMPLEX AND CONTINUOUS CURVE OF THE BOTTLE, THE ONLY SPACE AVAILABLE FOR A LABEL WAS JUST BELOW THE TOP. "I'M SURPRISED THEY LET ME GET AWAY WITH IT," ADMITS BARNEY.

Barney started to work on some sketches, and a few weeks later he showed Jago a single outline shape. At this stage the discussion was between the two men—no one else at Chivas & Glenlivet even knew of the project's existence. Fees were agreed on a stage-by-stage basis. With no clear path to the end, no one knew how long the project would take or how much it might cost.

Barney began to think about volume. Until he had an accurate model of the shape, to the correct weight, there was no way he could be sure that the bottle would spin. So he talked to Lyn Evans at Link Design Development, with whom he had worked before. The model they made in resin had a beveled base, and was the correct volume, but it spun off its center and moved across the table instead of spinning on the spot. It was not going to work. On his shelf, among dozens of other bottle shapes, Barney found a small ball bearing and stuck it to the bottom of the bottle to give it a small point on which to spin. "I made it up as I went along," he admits. "It was trial and error."

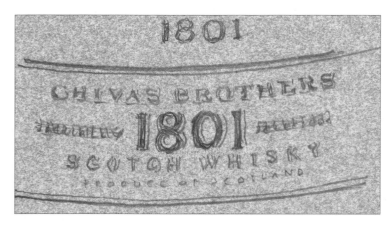

Nevertheless, this seemed to work, so he got the model makers at Link to replicate the shape but with the correct size of bottle and allowing a facility for the insertion of plugs of different sizes into the base. As it happened, the ball-bearing size worked the best. The bottle spun but remained in the same position. Next, they experimented with the liquid. In a similarly shaped, clear glass bottle they found that the liquid did not move about but stayed with the glass. "I'm not very clever at this sort of thing," confesses Barney, who enjoys what he calls "design accidents."

EVEN BEFORE HE HAD SELECTED A TYPEFACE, THE DESIGNER SKETCHED OUT IN PENCIL HIS IDEAS FOR THE LABEL GRAPHICS, WHICH, ALTHOUGH APPARENTLY STRAIGHT, WERE ACTUALLY IN A GENTLY CURVED BAND. THERE WERE SEVERAL ALTERNATIVES, INCLUDING ONE THAT USED THE PHRASE "EXTREME AGE" INSTEAD OF THE DATE.

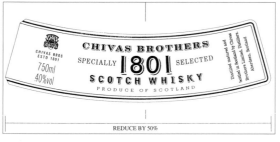

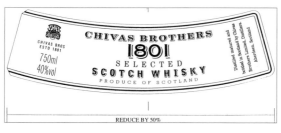

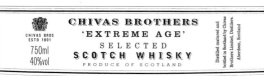

In the meantime, Gerry Barney worked on the graphics. He realized there was only a very small area, just below the neck, for a label. Because of the whiskey's extreme age, Jago had thought of calling it 1801, the year in which Chivas had been established, and they used Revolve in an almost decorative way, right around the center of the bottle. At the same time, Barney also set to work designing an assortment of wooden-topped cork stoppers. Everything came together on "dressed models," which were made in resin to represent exactly the size and weight of the finished, filled product and which would spin.

Jago showed the models to the president of The Chivas & Glenlivet Group as well as to the marketing

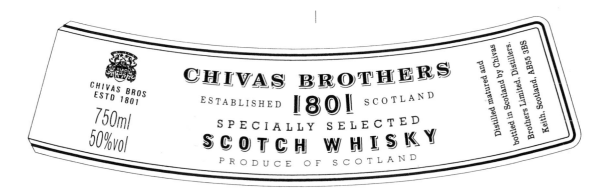

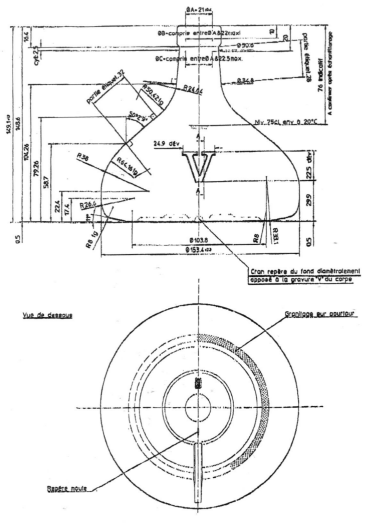

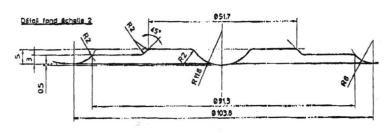

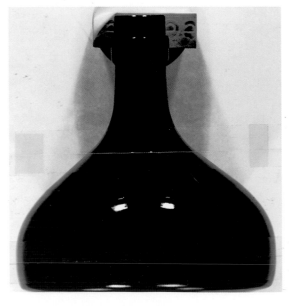

A PRODUCTION
PHOTOGRAPH OF THE
FIRST MODEL.

PART OF THE COMPLEX
WORK THAT THE BOTTLE
MANUFACTURERS, SAVER
GLASS, HAD TO DO WAS
TO CALCULATE THE
DIMENSIONS OF THE
BASE. THE SECRET
INGREDIENT HERE WAS
THE MINUTE DIFFERENCE
IN DEPTH BETWEEN THE
BALL IN THE CENTER AND
THE TWO OUTSIDE
SPHERES. SAVER STILL
FOUND THIS A VERY
DIFFICULT BOTTLE: IT
TENDED TO SINK AS IT
COOLED, AND THERE
WERE A LOT OF REJECTS.

IN THE FINAL SOLUTION
THE DESIGNERS
INCREASED THE SIZE OF
THE LETTER V, AS A
MARKER, PERHAPS, FOR
THOSE WISHING TO HAVE
SOME FUN WITH IT.
TO BARNEY'S SURPRISE,
THE BOTTLE SPUN
BETTER AS THE LEVEL OF
LIQUID WENT DOWN.

director and various colleagues, who all, recalls Barney, "got terribly excited." Even the production people at Paisley liked the idea.

Having client approval meant that the design team could now start to work with glass manufacturers and get their input. In January 1995, six months into the program, a major U.K. glass producer came back with a response that was less than satisfactory. The drawings it produced were completely different from the designer's, and it could not make the bottle. Barney remembers, "They said it was the closest they could get, but I didn't believe them. Normally you have to work beside them on the computer, telling them what to do." Saver Glass, a French company with which Barney had previously worked, did, however, manage to produce a bottle that maintained the very fine tolerances necessary for each one to spin in precisely the same manner.

To complete the presentation, Kit Cooper (one of Gerry's partners) prepared lots of sketches of ideas for point-of-sale items and started to work on the box. In order to make it a cube, Barney had increased the height of the bottle and cap a little and, because it was in special dark glass, the lower level of liquid would not show. Now that everything was agreed and Chivas Brothers and Sedley Place knew how the development was going, a schedule was drawn up, and a launch date agreed for late 1996.

"This was the most original bottle I've done," says Barney. "It's nice to get away from the convention of bottles as they are today. If it's going to work as a brand, it's going to work by building up its own culture."

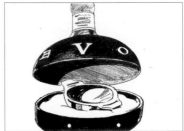

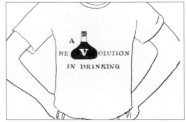

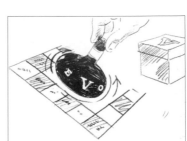

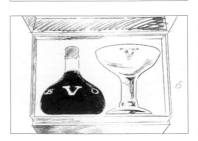

SOME OF THE DOZENS
OF SKETCHES
PRODUCED BY KIT
COOPER, A DESIGN
PARTNER AT SEDLEY
PLACE, FOR POINT-OF-
SALE MATERIAL TO
PROMOTE THE BRAND.
THE PRODUCT WENT
INTO THE MARKET AND
WAS "SELLING WELL
IN SELECTED AREAS."

TWO ALTERNATIVE
DESIGNS FOR THE CAP
AND THE LABEL FOR THE
BOX. WHICH WAS
INITIALLY PRODUCED AS A
GLUED-ON EMBOSSED
DESIGN BUT WHICH WAS,
BECAUSE OF THE HIGH
COST INVOLVED, PRINTED
IN SITU.

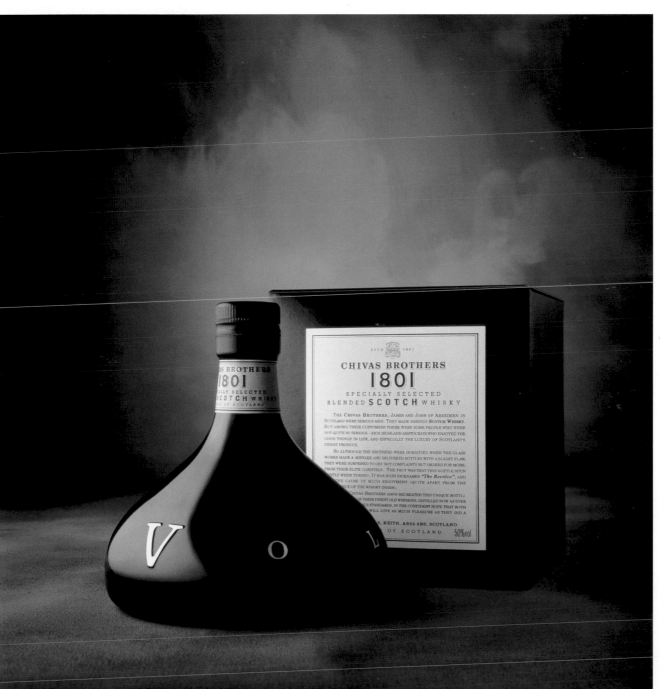

THE FINAL PROJECT,
ALTHOUGH IT LOOKED
BLACK, WAS IN FACT,
MADE IN DARK BROWN
GLASS BECAUSE BLACK
GLASS WOULD HAVE
BEEN TOO EXPENSIVE.
EARLY TESTS SHOWED
THAT THE SIZE NEEDED
FOR THE CAPACITY OF
THE LIQUID, EVEN
ALLOWING FOR
EXPANSION (WHISKY
EXPANDS IN HEAT), MADE
THE CONTAINER LOOK
TOO SMALL, BECAUSE
THE BOTTLE WAS OF
DARK GLASS, THE
DESIGNERS WERE ABLE
TO CONCEAL THE LEVEL
OF THE LIQUID AND MAKE
THE BOTTLE LOOK
LARGER, BEFORE
DELIVERY, EVERY BOTTLE
WAS CHECKED FOR SPIN
AND THE COST OF
REJECTIONS HAD TO BE
BUILT INTO THE PRICE.
THIS WAS, NATURALLY, A
PROBLEM FOR THE
CHIVAS BOTTLING LINES
AT PAISLEY, WHERE THE
OPERATION HAD TO BE
SEMI-MANUAL.

Superga

Daniel Weil does not have any secrets about his approach to a design project. In fact, he has been teaching students ever since he left the Royal College of Art and became a partner in Pentagram in London in 1972. As far as he is concerned, **the most important stage is before designing begins.** As the ideas come to him, he jots them down—notes, diagrams, anything that will act as a trigger to bring them back later

Weil says that he "gives the client 100 percent creativity, maximum efficiency." In this case, although the company was new to Pentagram, the client, Franco Bosisio, already knew Weil's work through a project they had done together when Bosisio was a director of Swatch.

Superga, an Italian shoe manufacturer, makes traditional leisure footwear—tennis shoes (for clay courts) and rubber boots. In order to energize the brand, Bosisio had begun to develop new lines with a more seasonal aspect, including totally new styles that utilized the natural aspect of rubber (which is the company's core product—it is in the rubber tire business) and would put the company back in the center of the leisure footwear business.

When Weil went to Turin to see the factory and look at the new prototypes, there was "no brief at all ... I had to imagine my job," which was to develop a visual brand strategy to support the company as it moved into fashion footwear. "Branding is about being different, having a discernible edge, a definable personality. So where should this impetus come from and what are its consequences? That is where the designer can play a vital role," explains Weil.

Right away he started to question the appropriateness of the traditional shoe box. Weil continues: "A design should not distort the usefulness of the package in order to establish a brand presence, but nor should it use a given structure without question just because it has always been so. Most shoe manufacturers favor a version of the rectangular box with a lid. It has a certain logic. With a minimum of width/size variations, it can accommodate a wide range of shoe styles. It

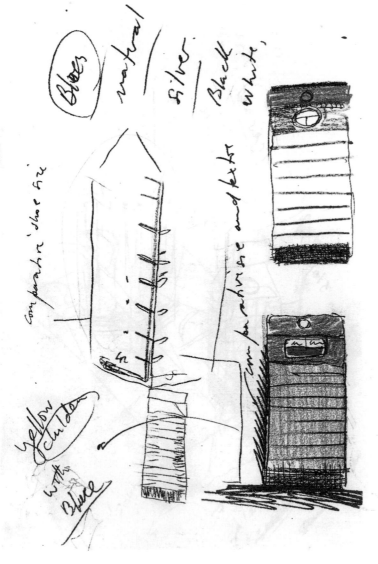

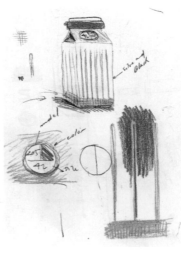

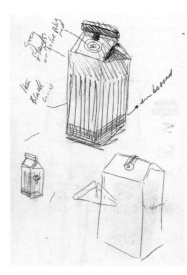

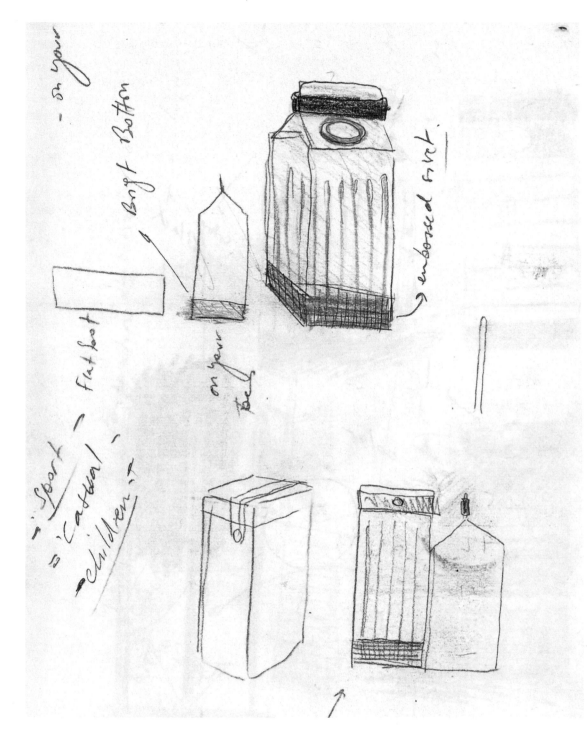

on your

Brigt Botton

Flat foot

on your
toes

embossed frt.

Sport
Casual
children

ALTHOUGH WEIL'S NOTEBOOKS RECORD WORDS AND IDEAS AS THEY COME INTO HIS HEAD, THESE DRAWINGS, DONE AT A LATER STAGE, START TO EXPAND ON THE ORANGE JUICE CARTON IDEA THAT FORMED ONE OF THE INITIAL ROUTES. SEVERAL CARTONS HAD A RUBBER BAND AROUND THE TOP TO HOLD THEM CLOSED, AND ON ONE THERE WAS THE FIRST EMERGENCE OF A PRESS-STUD FIXING. "ON YOUR TOES," SAID ONE NOTE ON A CARTON WHERE THE BOTTOM HAD BEEN TREATED WITH A BRIGHT COLOR BAND. COLOR WAS ALSO USED ON THE RUBBER BAND, ON THE RIBBED SIDES, AND ON A GRAPHIC INDICATOR OF THE SIZE, MODEL, AND COLOR OF SHOE. ONE IDEA, (FAR LEFT) NOT PURSUED, WAS TO USE A LINEAR CALIBRATION UP ONE SIDE TO INDICATE COMPARATIVE SHOE SIZES.

(BELOW) PANTONE SWATCHES WERE COMPARED WITH PRINTER'S COLOR PROOFS DURING THE PRODUCTION PROCESS. THE BOXES WERE PRODUCED IN BRITAIN BY CREST CARTONS.

EXTENSIVE TESTING WAS CARRIED OUT WITH DIFFERENT INKS ON DIFFERENT CARDS IN ORDER TO GET THE CORRECT COLOR MATCH.

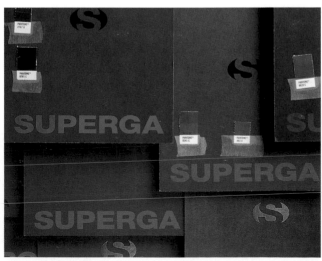

stacks easily and can be bulk-loaded for ease of distribution. But what of the down sides? Apart from the fact that all shoe boxes are much like each other—no brand personality here— what do you do with the box when it is no longer needed, either because price reductions have sacrificed its durability or because of our disposable culture? Where do you put its unnecessary bulk? And instore, how do you make the contents accessible? How do you reach the size that is at the bottom of the pile?

Even on his way back in the plane, Weil had begun jotting down his thoughts, but he did not brief his team for two or three days. "Usually I wait until I have decided which way to go. I like to start with a clear direction." But the timetable was very tight: within two months he had to have finished packs to be in production within four months.

His breakthrough came when he was buying a carton of orange juice. "I looked at the container and thought, that's it!" It had all the right messages —it was natural and he recognized that the same form "could be doing something else."

Working with a materials researcher, Weil soon discovered that the same form came in even bigger sizes, and he knew that he had found the solution. "I like real things—they're part of our accepted vernacular." A few days later a manufacturer sent in a whole box of over 50 containers, all the same size, for him to experiment with. "The construction was the most interesting part," recalls Weil, and he imagined that it might have other features. In particular, it had to be opened and closed again, and it needed to be collapsible.

Following Weil's sketches, his assistant, Six Wu, a young designer specializing in three-dimensional work, made up cardboard mockups with different closure ideas. However, Weil did not want to show just one direction to his client— "people can't make up their minds unless they see more than one idea," he reasons.

The first presentation, three weeks after the briefing, had about five ideas: one box with a rubber-band closure, one with a flip top, one with a press-stud and pull tabs, one soft pack with folded fabric, and one involving a plastic tube. All the boxes were made up in press board with bright colors and discreet graphics. Weil deliberately did not overbrand them, bearing in mind the potential after-use the boxes could have.

The client immediately said yes to the pull-tab solution,

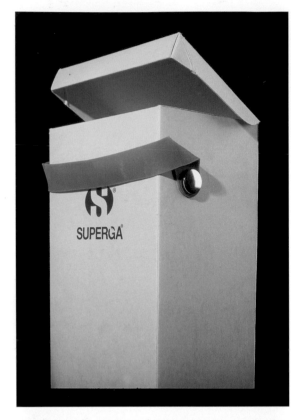

ALSO FROM STAGE ONE, THIS BOX HAD A FLIP TOP THAT WAS HELD CLOSED BY A RUBBER BAND, AGAIN MADE FROM THE CLIENT'S RAW MATERIAL. BOTH THE INSIDE AND OUTSIDE WERE PRINTED THE SAME COLOR

THE GRAPHICS WERE KEPT DELIBERATELY DISCREET, AND WEIL SAW THE SOLUTION AS A "KIND OF MILK-CARTON-MEETS-DOCTOR'S-BAG."

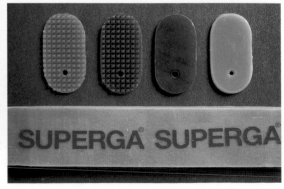

THE TOP AND BOTTOM OF THE RUBBER TABS, A UNIQUE PATENTED MECHANISM THAT ALLOWED THE BOX TO BE OPENED BY PULLING RATHER THAN PRISING IT APART. "WHEN THE BEGINNING IS GOOD," OBSERVES WEIL, "IT'S NO ACCIDENT WHEN YOU GET TO THE END."

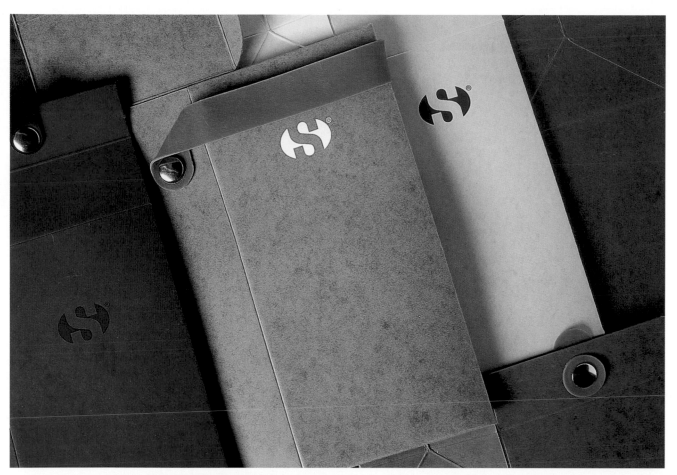

THE PACKS WERE MOCKED UP IN VARIOUS COLORS AND DEVELOPED AS PART OF THE STAGE ONE PRESENTATION. USING A "CRASH LOCK BOTTOM," THEY WERE ALL CAPABLE OF BEING TRANSPORTED FLAT, AND QUICKLY AND EASILY ASSEMBLED.

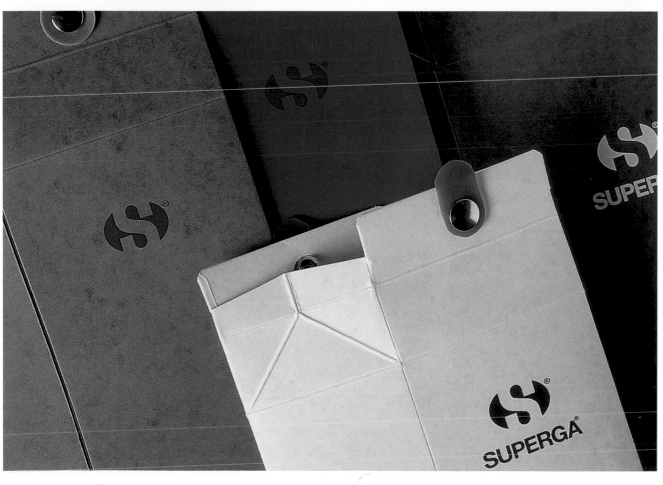

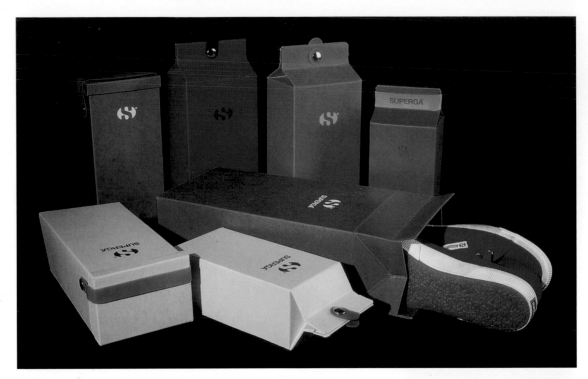

THE FULL RANGE OF ALTERNATIVES INCLUDED ONE PAIR (FAR LEFT) THAT WAS SEALED BY A BRANDED RUBBER BAND RATHER THAN A PRESS-STUD. THE COLORS SERVED TO INDICATE THE VARIATIONS AVAILABLE FOR SEASONAL CHANGES AND RANGE DELINEATION.

and talks started with the logistics people sourcing a manufacturer, finding machinery that could insert the press-studs, and selecting the best material.

In a major cost-cutting exercise, the existing 50-odd sizes of shoe box were rationalized and reduced to just 15. The tabs were provided by Superga, made from the same rubber as the shoe soles, and larger versions of the box for bigger boots and a simpler version for cheaper shoes were developed.

Weil thought of the box as a little personal locker: "The instore scenario has been addressed by the fact that the opening is on the narrow edge of the box. The carton can be snapped open and the shoes taken out without removing the box from the pile on the shelf. Order is maintained, accessibility is improved."

More importantly, the new cartons cost no more than a regular shoe box to produce, and they suggest an ecological afterlife, for files and other storage. Behind the Superga shoe box innovation is a belief that no packaging system should be taken as given. The designers' remit is to look for a new perspective, question processes that may have been unchanged for generations, and revisit solutions with a new eye or from a new cultural angle and regenerated industries. Even the most consolidated systems, established originally by sound logistical considerations, are worth revisiting and can be imbued with a revitalized marketing attitude.

The first production run was 200,000 boxes, after which Weil and his team made some small improvements to the detailing. The second run was 3 million—the products were "to sell all over the world." The client is happy and "the customer loves it, but the shop-keepers hate it—a new culture, a different system. There is no such thing as the perfect pack, but to serve a brand, any pack must deliver the brand with renewed energy if it is to be of any value at all."

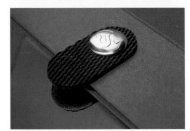

THE PRINTERS THOUGHT THAT PENTAGRAM WAS CRAZY TO BE USING A GLOSS ON THE INSIDE NOT THE OUTSIDE OF THE CARTON, BUT WEIL WAS THINKING OF AN INNER TRAY, WHICH WOULD SLIDE MORE EASILY ON A SHINY SURFACE. IN THE END, IT WAS RULED OUT BY COST.

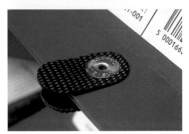

FROM THE FIRST PRESENTATION OF IDEAS, THIS MOCKUP SHOWED THE PRESS-STUD FIXING THAT ALLOWED THE SHOES TO BE REMOVED AND PUT BACK WHILE THE BOX WAS EITHER STANDING OR LYING FLAT.

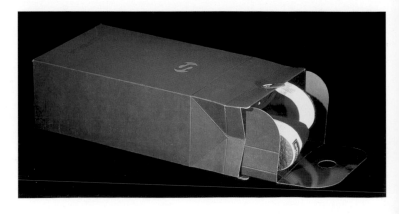

STACKED FLAT ON THE SHELVES IN STORES OR IN THE WAREHOUSE, EACH BOX HAD A BLIND-EMBOSSED RECTANGLE TO INDICATE THE POSITION OF THE SIZE AND STYLE LABELS AND CODES, THEMSELVES THE SUBJECT OF MUCH DISCUSSION IN THE PRE-PRODUCTION STAGES.

TWO SIZES OF BOX FROM THE FINISHED RANGE FOR FALL/WINTER, TO BE REPLACED BY RED AND SILVER LATER.

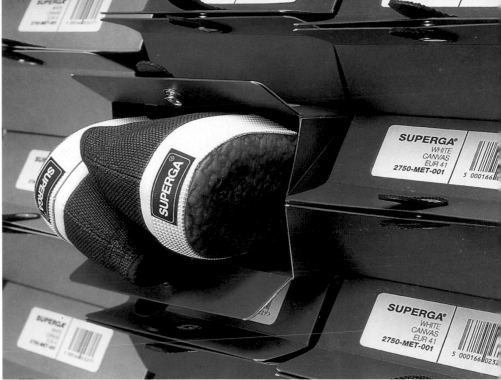

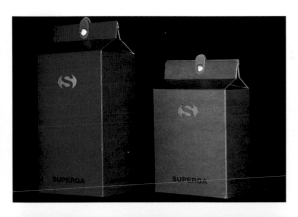

(RIGHT) FOR KNEE-LENGTH BOOTS, TWO RUBBER SNAP TABS SUPPLEMENTED THE METAL REINFORCED HANDLE.
(BELOW) A LOCK-IN SEAL THAT NEEDED NO TABS AT ALL.

Alta Designers love to have a tale to tell. It makes things much easier if the client comes to them with an authentic story to work with. Nevertheless, Jack Anderson, a partner at Hornall Anderson Design Works Inc. in Seattle admits that seven times out of ten they have to help clients to create the interest.

But how do you animate ordinary water?

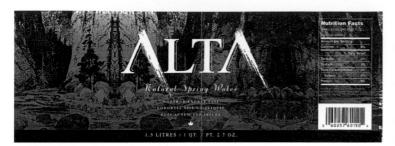

IN ONLY A FEW DAYS THE DESIGNERS AT HORNALL ANDERSON CAME UP WITH IDEAS FOR BOTH A NEW LOGO AND A NEW LABEL, WHICH GAVE THE CLIENT A TOE-HOLD IN THE MARKET.

THIS ETCHING *(RIGHT)* OF BOULDER CANYON EVOKED THE RIGHT IMAGE OF A RUSHING MOUNTAIN STREAM. BUT, BECAUSE IT WAS NOT WIDE ENOUGH, IT HAD TO BE REVERSED AND REPEATED ON EACH SIDE.

In this case history, the story unfolds in two parts. Anne and Andy Evans and Hornall Anderson were already working together on a completely unrelated undertaking—a brochure for a race-car—when this project came up. The Evanses had been partners in a small water company that owned a natural spring in the Gold River basin area of northern Vancouver Island, and they were in the middle of an acrimonious dispute. They knew that whichever of the two groups was the first to get the product out into the market could claim ownership of Alta, the name that was at the center of the argument. To say that there was a tight schedule would be an understatement—there was panic. They had four days to come up with designs for a label that could be applied to a stock bottle, and four or five days to produce it.

Working with Larry Anderson and Julie Keenan in the studio, Jack Anderson prepared some quick ideas for a logo, which they registered, and they found a stock etching of a mountain stream to put it on. "It was a nice label but not anything like the final design," explains Jack Anderson. In three weeks they had Alta Water on retail shelves, and had won their race.

With hindsight, they realize that their opponents were probably not even aware of what they were doing, but it showed what was possible, and it laid the foundations for stage two.

With more time and a new budget, Hornall Anderson worked on some more ideas for a logo, which they applied to various label formats. There were two possible routes: they could find a stock bottle with a good shape and apply a new, well-designed label; or they could design a custom-made bottle and apply a new label. In the end they did both. They decided to produce a new label, apply it to a stock bottle as an interim measure, much as they had already done but with

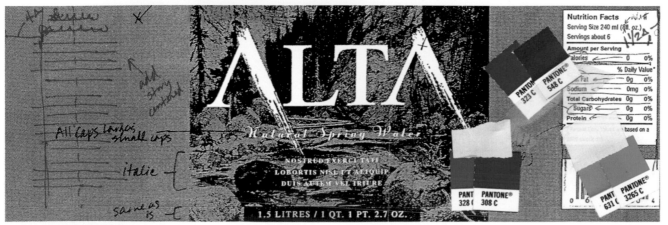

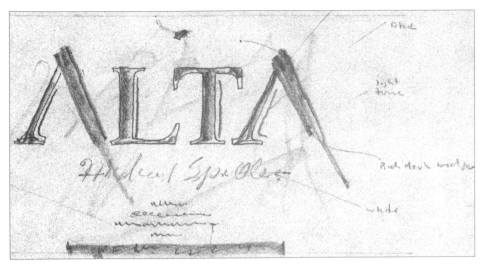

more time for development and consideration, then, once a bottle had been designed and produced, they could apply the new graphics to the new bottle.

The Evanses agreed, but there was one problem. They loved the first Alta logo that Anderson had designed and, in their enthusiasm, had applied it to their other business, car-racing. "We liked it, too," admits Anderson, "but we didn't love it." Nevertheless, although they tried other ideas, the clients refused to change it.

Having looked at the competition, the designers noticed that most producers put opaque labels on their bottles and that there were many with pictures of rivers, waterfalls, and the like. They also noticed how boring still water looks in a bottle. They wanted Alta to look cool, refreshing, and active, and they started to create a total package," not just an ordinary bottle with a label wrapped around it," Anderson explains. "We were trying to create a new experience—a product with real graphic allure."

In the way that they always work, the entire team at Hornall Anderson shared the project and discussed ideas together. They wanted to evoke "fast-moving, turbulent, fresh water," and as ideas emerged, they pinned them all up on a large wall (a huge garage door to be precise), "like a schematic Da Vinci drawing." In fact, Anderson remembers, "we got the idea quite quickly, and then studied it to death."

On a PET (clear plastic container), they created swirling curves, folds, wrinkles, and indentations, which seemed to bring the water to life. "We had a number of people on the team who had a three-dimensional eye and could draw," says Anderson. Onto this vision of frozen turbulence, the team applied a translucent graphic image that had more swirls, and a white (or clear) logo against a graduated blue background. They knew how important the form of a bottle was. In research for other packaging projects, they had seen customers touch and even fondle the bottles. "We were able to show that the marketing message of a new product doesn't have to reside in the label alone," recounts Anderson.

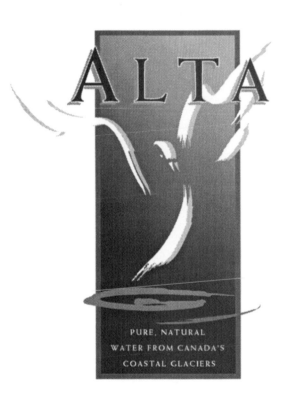

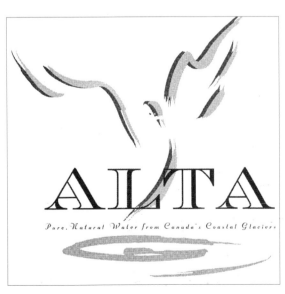

REFLECTING THE COLD MOUNTAIN REGIONS IN WHICH THE WATER ORIGINATES, THE TYPE HAD AN ICE-BLUE HALO AROUND IT, AND THE CREATION OF SWIRLS AND FOLDS IN THE PLASTIC ANIMATED THE WATER, CLEVERLY ALLOWING IT TO CATCH THE LIGHT AS WELL AS THE EYE.

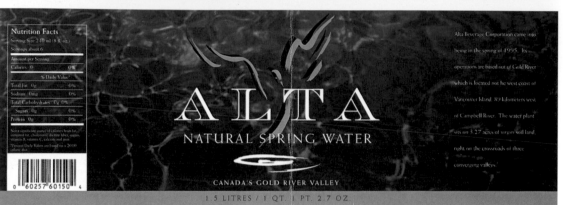

IN CASE AN INTERIM BOTTLE HAD TO BE USED, THIS GROUP—SELECTED FROM TWICE AS MANY ALTERNATIVES—TRIED VARIOUS TYPEFACES AGAINST A RANGE OF BACKGROUNDS TO SEE HOW MUCH ANIMATION COULD BE EVOKED, AS WELL AS POSITIONING THE BRAND AS A "SUPER PREMIUM" PRODUCT.

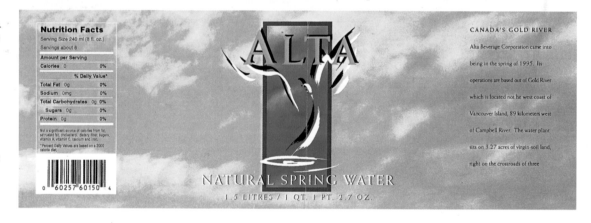

DRIVEN BACK TO THE ORIGINAL BRUSHSTROKE LOGO, THIS WAS ONE OF A SERIES OF COLOR TESTS, PRODUCED WHILE THE DESIGNERS WERE EXPERIMENTING WITH A WATERY PHOTOGRAPHIC BACKGROUND.

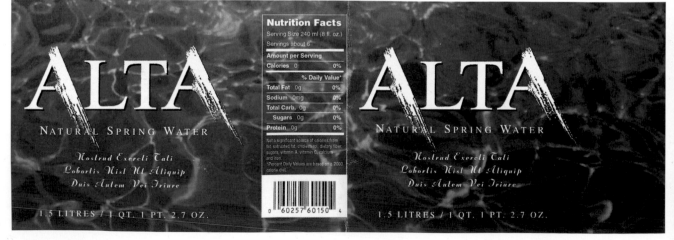

Virgin Vie

Water tumbling over pebbles, the graceful lines of a Chinese roof, and Venetian glass were the timeless, universal inspirations for this range of cosmetics and toiletries. Dieter Bakic, who has 30 years' experience of design says: **"You have to be a specialist,** know the market, and the technical possibilities. You can't design cars one minute and cosmetics the next"

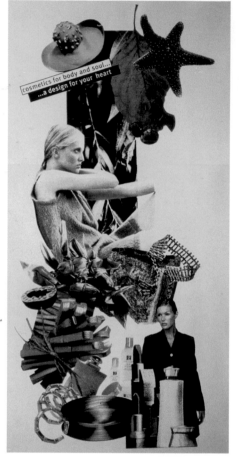

A SERIES OF NINE MOODBOARDS, PREPARED BY THE DESIGN TEAM, ILLUSTRATED THE QUALITIES OF THE VIRGIN CUSTOMER.

Bakic says that he designs cosmetics packaging 24 hours every day, and he is one of the world's leading designers in this field and one of the founders of a packaging museum in Heidelberg. In his office in Munich he has also assembled a private collection of over 1,000 cosmetics packs—anything that is interesting, innovative or inspirational. "I like to 'share' them with clients—to get their reaction to certain things," he explains. At the same time, when this project began, he already knew of Virgin's founder, Richard Branson, and got a copy of his biography. "I did a lot more research and started to get excited. I saw an opportunity to do something quite special and different," he says. In fact, he had already had the idea, even before he got the client. In the way these things happen, he didn't have to start from scratch and search for ideas. "Ideas come to me at any time when I'm traveling around, perhaps at one o'clock in the morning—from a lamp or a tree," he says.

In this instance, his clients, Liz and Mark Warren, spent two days with him and his team at his studio, explaining their concept for a totally new brand of cosmetics and toiletries that would be sold in dedicated retail stores, via mail order, and through direct selling. Their target market customers were men and women aged between 17 and 75. They had a written brief, and they had prepared a comprehensive list of products and had a very clear idea of what they wanted. At this stage, the new development (as yet unnamed) was shrouded in secrecy, and the members of the team had to sign a confidentiality agreement before they could proceed.

Over the next two weeks, they developed the first ideas. "At first, I worked on my own on the character process, in this case for the color line, until I'd got my ideas worked out,

SOFT ORGANIC MOVEMENT, LIKE A WAVE, WAS REPRESENTED ON ONE OF THE PRESENTATION BOARDS BY VARIOUS JAPANESE ELEMENTS, SUCH AS A COOLIE HAT AND A ROOF.

ALTHOUGH THEY WERE NEVER SHOWN TO THE CLIENT, THESE EARLY DRAWINGS OF A POWDER CASE, A NAIL LACQUER BOTTLE, AND MASCARA AND LIPSTICK CASES SHOW HOW THE SHAPE EVOLVED IN THE "COLOUR LINE." THE CROSS ON THE LIDS INDICATES HOW THEY WERE INTENDED BE SCULPTED INTO A SUBTLE "V.".

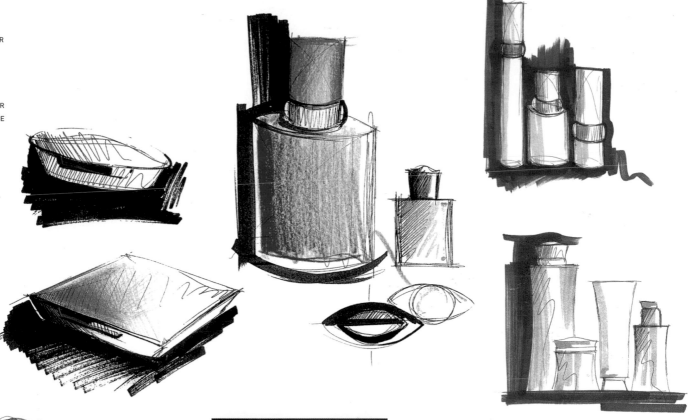

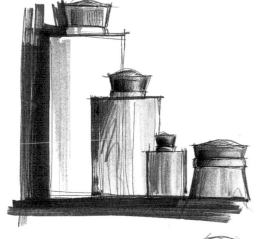

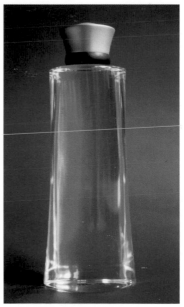

(BELOW) THREE MODELS OF THE "COLOR LINE" PRODUCTS WERE SHOWN TO THE CLIENT TO DEMONSTRATE THE WIDE VARIETY OF PROFILES. ALTHOUGH DRAWINGS WERE PRODUCED FOR EVERY STAGE, VIRGIN VIE WAS SHOWN ONLY THE COMPLETED MODELS.

WHEN IT CAME TO THE "TREATMENT LINE," DIETER BAKIC TRIED APPLYING THE "WAVE" CURVE TO THE SIDES OF THE BOTTLES AND JARS (TOP RIGHT), BUT HE DECIDED THAT THE CHARACTER WAS TOO STRONG. THE STRAIGHT-SIDED VERSIONS (RIGHT) WERE MADE UP IN MODEL FORM TO SHOW THE CLIENT. IN PLAN VIEW (ABOVE) THE BOTTLES CAN BE SEEN AS "EYE" SHAPES.

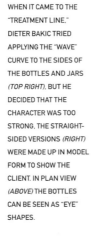

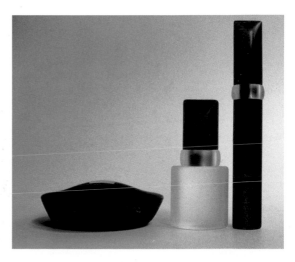

AN EARLY IDEA FOR THE
PERFUME RANGE WITH
BOTH SIDES REFLECTING
THE CURVED "WAVE"
MOTIF, HAD A ROUND
AND A SQUARE PROFILE,
AND DIFFERENT CAPS.

THE "M" AND "W"
REPRESENTED
VARIOUSLY IN THE OTHER
DESIGNS, HERE REPLACE
THE CURVED SIDES. ALSO
HERE, THE IDEA OF
SCULPTING THE BASE
OF ONE SIDE WIDER AND
THE BASE OF ONE SIDE
NARROWER MADE ITS
FIRST APPEARANCE.

and then I evolved it into the rest of the range," says Bakic. His team developed his rough drawings before making a set of two "form" models in blue lucite, like Venetian glass. "We usually produce between 20 and 40 sketches." As a sort of motif, the designers sculpted a "V" into the cap of some products and a sinuous curve into others. For their first presentation, the team showed only four models to the client, the two form models in blue and two in white lucite, which gave a good impression of the final glass finish.

Bakic was pleased with the results, and the client liked them, too—the different sizes and shapes looked like a family and sent a clear message to the customer. The "wave over a stone" influence was evident in the shape of the powder compact and emerged again later in other products. As a decorative element, "each neck was given a 'wedding band' to break the contour, and to provide an element of color that could help differentiate ranges," explains Bakic. There were a lot of products to be packed, so the concept had to be very versatile. In the second presentation, the models they showed were for the skincare range and the "wave" was reflected again in the caps and lids, but this time the sides of the squat jars were angled in the opposite direction to the cap, to make a concave profile. In addition, the designers sketched out every product on the client's list. "Everything worked out as we wanted it to," recalls Bakic.

When it came to the perfumes, things took a different turn. Eau de Vie for women and Eau de Vie for men are two individual yet synergetic blends working in harmony and yet each with their own distinctive personality. "They lead the trend for a return to the traditional with a contemporary feel." The bottle design had to reflect these characteristics. "We took the wave and cut it off, making two forms that we put together, side by side or back to back—two different perfumes, one for men, one for women, in bottles that complemented each other, the same but opposite," says Bakic of the complex shape.

In addition, the designers had the added bonus of a comprehensive collection, all seen side by side in one store,

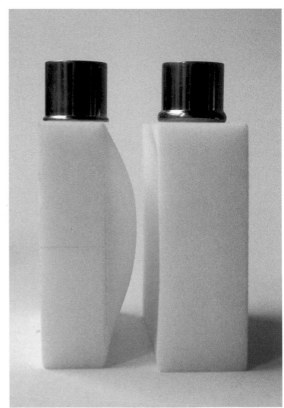

THE DESIGNERS WANTED
TO EVOKE A "SPECIAL
COUPLE" FOR MEN'S AND
WOMEN'S
FRAGRANCES—THAT IS,
TWO DIFFERENT BOTTLES
THAT COMPLEMENTED
EACH OTHER. ONE OF THE
FIRST IDEAS (ABOVE
LEFT), SHOWING TWO
SIZES AND TWO
DIFFERENT CAPS, WAS
QUICKLY REPLACED BY
THE IDEA OF TWO
MATCHING BLOCKS
(LEFT), ONE CURVING IN
AND ONE CURVING OUT
ON ONE SIDE.

"ONE BOTTLE. TWO SIDES.
TWO FRAGRANCES."
EXPLAIN THE DESIGNERS
OF THE FINAL ROUTE. THE
"M" WAS THE SHAPE
CARVED SUBTLY INTO THE
SIDE AS A RESULT OF THE
V ABOVE, AND THE CAP
COORDINATED WITH THE
REST OF THE RANGE.

A SERIES OF PHOTOGRAPHS OF THE MODELS DEMONSTRATES THE EVOLUTION OF THE PERFUME BOTTLES. THE DESIGNERS KNEW THAT THE PRODUCTS, ENTITLED EAU DE VIE, WOULD BE DISPLAYED ON THE SAME SHELF, SO THEY COULD HAVE SOME FUN WITH IDEAS FOR SEVERAL BOTTLES TO FIT TOGETHER, SIDE BY SIDE, OR BACK TO BACK.

HAVING GOT THE SHAPE OF THE BOTTLE, THE DESIGNERS TURNED THEIR ATTENTION TO CAP IDEAS, TRYING DOZENS OF SOLUTIONS BEFORE DECIDING ON THE FINAL ROUTE, IN WHICH THE "WAVE" TOP, MADE FROM A TRANSLUCENT MATERIAL, ALLOWED LIGHT IN, TO BE REFLECTED BACK BY A METALLIC SURFACE INSIDE—LIKE SUNLIGHT PASSING THROUGH WATER.

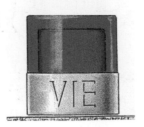

without any confusion from competitiors' products. In its final form the perfume bottle had a complex shape that was easier to mold than to draw, so the team made foam models and then lucite models, which were shown to the client.

Bakic remembers that a lot of work went into the cap. How big should it be? What proportions should it have? Should the sides be straight or radiused? Should it be colored or not? What material should it be?

By now, two months had gone by since the first briefing. "That's about normal," says Bakic. "It was a good progression—a really liquid development." Models were made of every shape, and, over the next few months Bakic spent three or four days each week in London, working with the Virgin team—now numbering over 20—which was developing and sourcing product. Every detail had to be worked out with suppliers, from the size of the brush in the nail lacquer polish to the inserts of the cases.

"Everyone was very professional. There was no tension and everything was well managed. I've never seen anyone, anywhere, undertake such an enormous project in such a short timescale. Liz and Mark Warren were fantastic. They knew exactly what they wanted—they had a vision and they stuck to it. Some clients have no idea what they want, and they become very insecure, but the Warrens were not afraid to make decisions. Everyday they made the right decisions and they never wavered," says Bakic. "One wrong decision, and everything else would have been wrong as well. Everywhere I go in the world, people talk about them. They will continue to add on different lines and play with the concept."

(RIGHT) THE FINAL FRAGRANCE BOTTLE, WITH ITS FROSTED "M" AND "W" AND WITH TRANSLUCENT CAP, INCORPORATED MANY OF THE QUALITIES OF THE ORIGINAL INSPIRATION OF "WATER TUMBLING OVER PEBBLES," INCLUDING, WHEN THEY WERE PLACED SIDE BY SIDE, THE SUBTLE CREATION OF A WAVY LINE. IT WAS MADE IN FRANCE BY POCHET ET DU COURVAL.

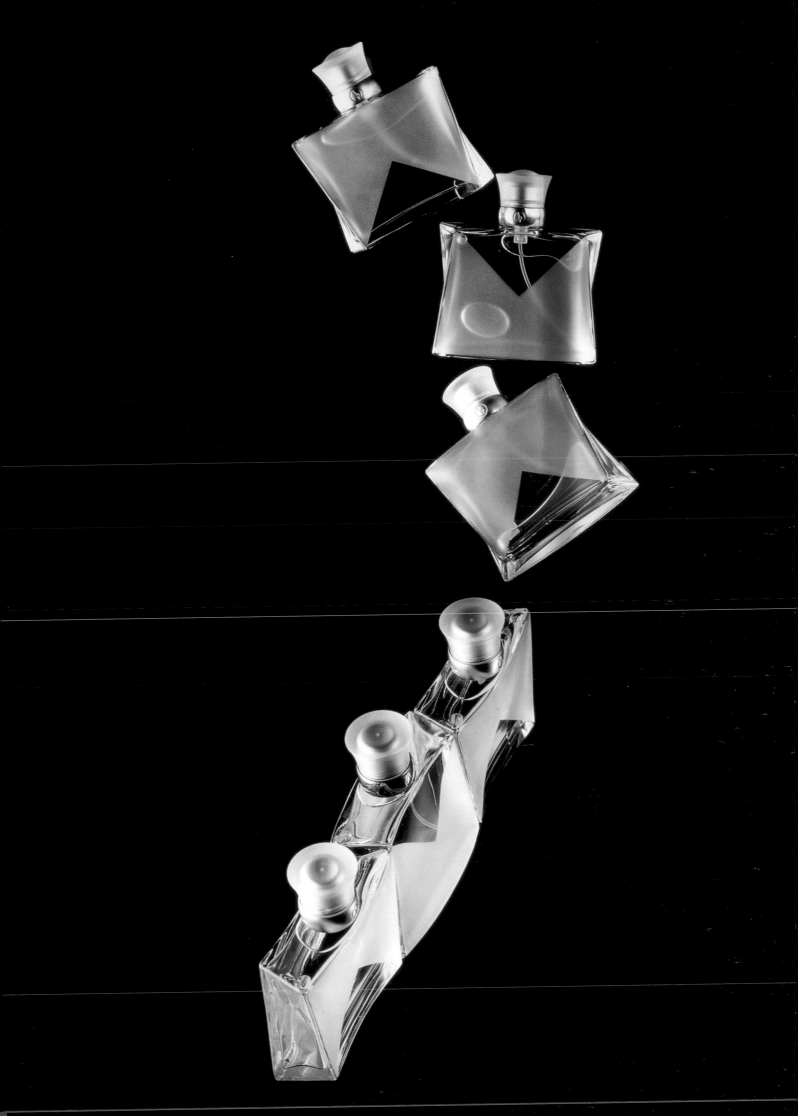

Black Wattle

"When this product came along, it begged to be given the full treatment. The modest design budget was blown out of the water, at our expense, but the investment in marketing turned out to be beyond our wildest dreams," says Ian Kidd, the Australian designer, whose studio in a leafy suburb of Adelaide was responsible for the design. It's something that is impossible to explain, but every now and then **a design is produced that captures everyone's attention and wins all the awards.** "Even now, I can't think what is so special about it," remarks the designer

The client, Cellarmaster Wines, was well known for its high quality mail-order business, selling selected wines under winery brand labels, but it had not previously been involved in marketing its own products. The huge international demand for Australian wines was bringing under viticulture thousands of acres of land in areas not formerly recognized as being within the traditional appellations. Mount Benson, near Robe, south of Adelaide, was just such an area, but Cellarmaster Wines was so impressed with the potential for the wine being produced there that it commissioned Ian Kidd to package the brand as a premium wine. It was to be known as Black Wattle.

Kidd knew the area around Mount Benson well. It was quite near a little fishing village he regularly visited for vacation, but it was not regarded as a wine-growing area, so it would be necessary to have a map on the bottle to give it authenticity. Black wattle is an Australian plant, a type of Acacia, which has a very dark trunk. The vineyard was a small, young concern, producing a particularly good wine that would, in a few years, have great potential. The whole area was, in fact, to become a flourishing new wine-growing region, but at the time Cellarmaster Wines first became involved, there was much to be done.

Kidd already knew Cellarmaster, having worked on labels for other wines it sold, and he was briefed by Heather Mitchell at Cellarmaster. The client did not have a large budget, which was normally determined by a ratio of volume/profit. As usual, the wine would be sold only through Cellarmaster's mail-order business, not in stores. "If the wine

EACH TYPOGRAPHICALLY REFINED ELEMENT CONTRIBUTED TO THE OVERALL IMPACT OF THE BOTTLES. THE BLACK WATTLE WAS DRAWN IN THE STUDIO BY KARIN SEJA, AND GERBEN VAN DER HOEK WORKED ON THE OTHER ELEMENTS.

THE SUCCESS AND THE BALANCE OF THE SOLUTION DEPENDED ON THE COMBINATION AND PLACEMENT, AND ON THE SHAPE OF THE ELEMENTS—CIRCLES, BANDS, AND BARS—AS WELL AS THE SPACES BETWEEN THEM. THE BACK LABEL, (*ABOVE*) TELLS THE STORY OF MOUNT BENSON, "AUSTRALIA'S NEWEST PREMIUM WINE-GROWING REGION."

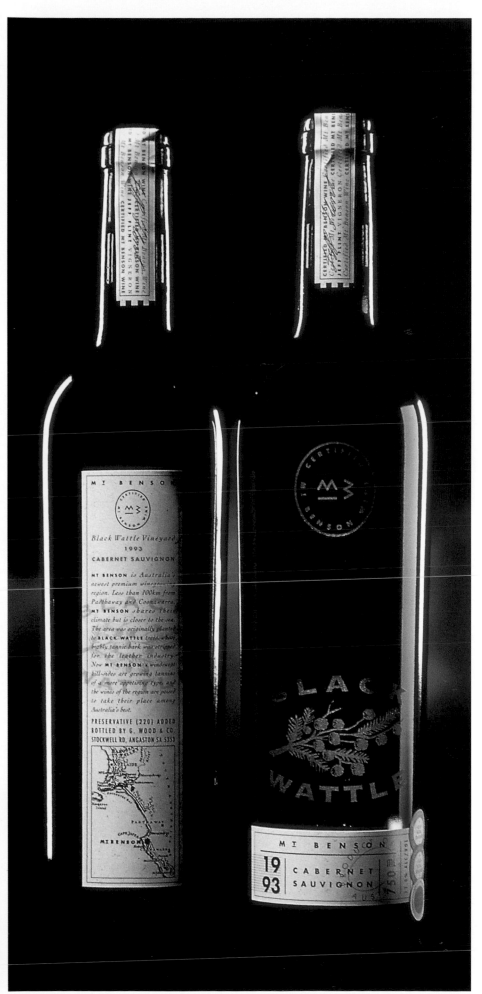

has legs, it could last for years," explains Kidd. It was to be a premium priced Cabernet Sauvignon, "positioned in the boutique category, where we felt," Kidd continues, "that consumers would respond favorably to beautiful and sensitively detailed imaging."

Kidd's way of working was to handle all the client briefings, write fee proposals, allocate a senior designer to act as project manager—this time it was Karin Seja—and work on initial sketches. After that, it is left to the team to do all the detailed design work and "finesse" the solution. "I keep an eye on it, but I don't go the distance hands on," he admits.

For this project, as with most of those handled by Kidd, only one solution was developed and shown to the client. But the idea consisted of five different elements in a number of different mediums:

- The bottle, which was sourced from a selection of special shapes imported into Australia from European glass manufacturers
- The neck label, which was applied by hand and featured the signature of Jeff Flint, Vigneron Certified Mount Benson Wine
- The Black Wattle stamp and an illustration of the wattle flower, which were silk screened onto empty bottles to look and feel as if they were etched into the surface of the glass
- The body label, which was applied by machine when the bottles were full
- The back label, (also applied by machine), which was a long, thin shape and contained lots of information, this being one of Kidd's hallmarks, as well as the regional map

The key to the overall success of the solution and something that the client appreciated was the need for the elements to be carefully aligned, which is "something that the production-line people hate," admits Kidd. "I don't think the client believed the product was as special as we believed it could be—we detected an opportunity and really made it work." Even before the wine had been launched, it started to win design awards. Although Kidd is very critical of self-referential design indulgence, he admits that the success of the design "was way in excess of any reputation it will build for its wine." The client was so pleased that they decided to hold the wine back so that it could be partnered by a white

ON THE FRONT OF THE BOTTLE THE ILLUSTRATION OF THE BLACK WATTLE OWED ITS INSPIRATION TO LATE 19TH-CENTURY COMMERCIAL ART IN AUSTRALIA. SINCE ACID ETCHING IT ONTO THE GLASS BOTTLE WOULD HAVE BEEN "EXCESSIVELY EXPENSIVE," IT WAS SCREEN PRINTED TO GIVE A SIMILAR IMPRESSION, BOTH VISUALLY AND PHYSICALLY. TO DATE, THE DESIGN HAS PICKED UP MORE THAN FIVE MAJOR AWARDS.

Whittard

This is the story of a design project that breaks all the rules. A range of products with nothing in common except the client's name and logo. And yet, underlying each group of teas and coffees, preserves and cookies, is an impeccable sense of proportion, an **expert use of illustration,** and an **unerring wit** that gives each product a unity and strength

Ian Logan is the graphic designer who, with his passion for antique packaging forms, almost single-handedly revitalized the U.K. can container industry in the 1970s. Not only did he design packs for clients in the traditional material but, with his own company, reproduced original designs and lovingly rekindled the genre with money-boxes and toffee cans shaped as London buses, country cottages and even Harrods, the department store. At the same time, his blend of historic references and contemporary techniques won him many design awards.

William Hobhouse, the managing director of Whittard, had been in retailing for 15 years before he joined Whittard, moving from ties to teas and becoming a tea and coffee broker. He knew Ian Logan's design company and had seen many of his designs when, in 1993, he approached "the tin box man" to work on their first commission together. It was, recalls Logan, a "fairly ordinary floral design," but it sold well and was the first of a long and successful collaboration.

At that time Whittard had only four or five stores. Now there are 100. There was never a moment when the designers sat down to design a concept for the brand: "Somehow it just evolved—we've never had a brainstorming session or a review." Perhaps this is the secret of its appeal. Sometimes the brief comes as a phone call, sometimes it is written and accompanied by blanks (samples of the proposed style of pack), but sometimes the designers will be asked to research a pack as they did for a range of biscuits.

First stage concepts will usually take about four weeks, although occasionally there is a panic, as with the special commemorative designs for V.E. Day, when the designers had only three days. Logan admits that occasionally he will think

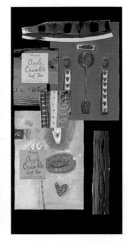
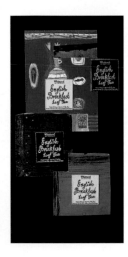

THESE PRESENTATION BOARDS, FOR THE FIRST STAGE OF A RANGE FOR FALL/WINTER COFFEES, TEAS, AND COOKIES, GIVE A GOOD IDEA OF THE WAY LOGAN WORKS. THERE IS NO PACK TO SPEAK OF, BUT THE COLLAGE OF COLORS, ILLUSTRATION STYLES, AND LETTERING DESIGNS GIVE A VERY CLEAR IMPRESSION OF WHAT THE DESIGNERS HAVE IN MIND.

MORE PRECISE PACK DESIGNS WERE DEVELOPED FOR STAGE TWO. (LEFT AND RIGHT) BUT STILL USING A COLLAGE OF AN ILLUSTRATOR'S PORTFOLIO, CAREFULLY CUT AND PASTED TOGETHER. THE PACKS HAD TO LOOK SUITABLY "CHRISTMASSY" WITHOUT BECOMING OUT OF DATE IMMEDIATELY THE SEASON HAD PASSED.

On the eighth day
of Christmas
my true love sent to me
EIGHT MAIDS A·MILKING
seven swans a·swimming
six geese a·laying
five gold rings
four calling birds
three French hens
two turtle doves
and a partridge
in a pear tree

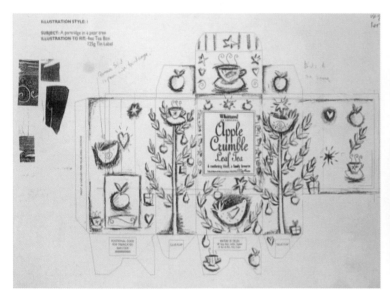

SPICED IMPERIAL LEAF TEA SHOWS HOW THE DESIGN CONCEPT WAS ABLE TO EVOLVE OVER DOZENS OF PRODUCTS WHILE GIVING EACH ONE ITS OWN INDIVIDUALITY.

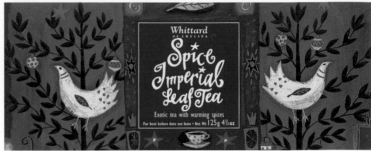

(LEFT) FOR A RANGE OF FLAVORED ESPRESSO COFFEE BEANS, LINDSAY TURNHAM PRODUCED A SELECTION OF IDEAS USING ILLUSTRATIONS THAT, FOR THIS STAGE, SHE DREW HERSELF. EACH ILLUSTRATION INCORPORATED AN AREA FOR THE TYPE, THOUGH IN SOME CASES THAT, TOO, WAS HAND DRAWN.

of the perfect solution right there, during the briefing, though he never says what it is. In the office is a team of eight designers appointed to projects, and although the ethos of the company is well defined, Logan is always looking for fresh talent, listing enthusiasm and inquisitiveness as the most important attributes he looks for in students.

Alan Colville is the creative head of the studio, but the designers allocated to the project do all the day-to-day liaison. First concepts—sometimes only one—are likely to be presented flat, as a collage of elements that might include special lettering, graphic devices, and examples of illustrations. The designers will call in an illustrator's portfolio and photocopy examples they think might be appropriate, as well as having recourse to the extensive reference library on the floor-to-ceiling shelves down one side of the studio. Ian Logan can usually be relied upon to know precisely where to locate a particular piece of visual material.

The second stage will involve further fine tuning, commissioning an illustrator to work on the final artwork, and talking to the printer (or finding a printer, in the case of new pack shapes). Because cans have to be produced in vast quantities, designs are often applied as wrap-around labels on the same form, which allows stores to sell small quantities for special events at very short notice.

Of all the ingredients in the designs they have produced, the imaginative use of fine quality illustration, (often telling a story as it extends onto all six faces), is a consistent theme.

Looking at a portfolio of finished work, Logan feels that the results have "worked out well," although he is wary of getting into a rut with a very rigid theme and values the opportunity to come up with surprises now and then.

"I always think, 'How is it going to look in the shop?' I see retailing as a type of theater—if you enjoy the product, you look forward to the next one. If we've made people smile, then we've done our job." With 75 new products a year and their sights set firmly on plans to develop stores in Europe and the Far East, the client must be smiling too.

(RIGHT) BASED ON THE PORTFOLIO OF WORK THAT ILLUSTRATOR MICHAEL SHEEHY SENT IN, THE DESIGNER PRODUCED SKETCHES TO SHOW THE AREA AND TYPE OF DRAWING SHE WANTED, LEAVING ENOUGH LATITUDE FOR THE ILLUSTRATOR TO INTERPRET IT IN THE WAY HE WANTED.

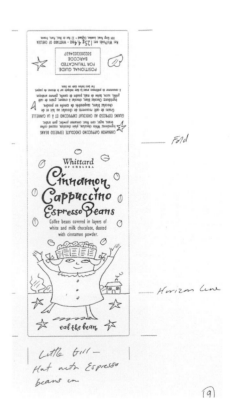

THE THREE STAGES OF
PRODUCTION SHOW THE
DESIGNER'S BRIEFING
SKETCH TO THE
ILLUSTRATORS,
FAULKNER AND NAYLOR,
ALONG WITH SOME
CUTTINGS TO SHOW THE
COLOR PALETTE, (FAR
RIGHT), AS WELL AS THE
ILLUSTRATOR'S ARTWORK
WITH OVERLAYS FOR THE
TYPE, AND FINALLY, THE
PRINTED LABELS, WHICH
WERE TO BE WRAPPED
AROUND THE STANDARD
TINS OF TEA.

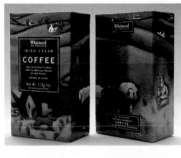
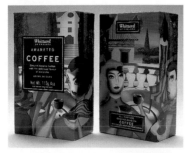

AN ENTHUSIASM FOR
ILLUSTRATION AND A
CONFIDENCE IN THE
PROCESS OF
COMMISSIONING AND
BRIEFING, DEVELOPED
OVER MANY YEARS,
RESULT IN A SERIES OF 20
DIFFERENT COFFEE
PACKS, EACH ONE
CLOAKED IN AN ALL-
OVER PAINTING THAT
ELEVATES THE BOX TO
THE LEVEL OF A
PRECIOUS KEEPSAKE.

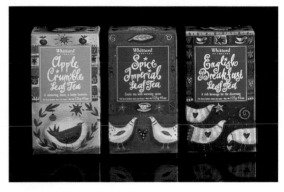

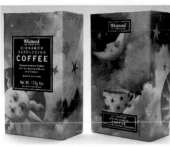
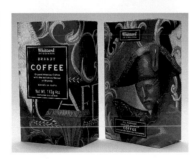

(ABOVE) THREE DESIGNS
FOR BOXED TEA HAD
ILLUSTRATIONS THAT
USED BIRDS INSPIRED BY
THE 12 DAYS OF
CHRISTMAS IN AN ALL-
OVER DESIGN THAT WAS

PERFECTLY
COMPLIMENTED BY
WHIMSICAL HAND-
DRAWN LETTERING BY
LINDSAY TURNHAM AT
THE IAN LOGAN DESIGN
COMPANY.

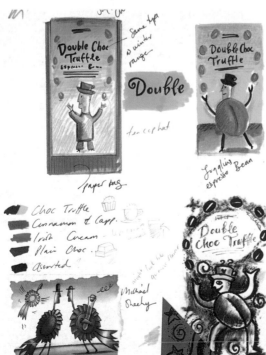
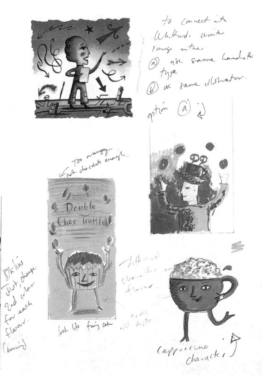

A SHEET OF EARLY
SKETCHES COMBINEED
BITS OF SHEEHY'S
ILLUSTRATIONS, WITH
ROUGHS BY THE
DESIGNER, SCRAPS OF
LETTERING, AND
THOUGHTS AND
OBSERVATIONS THAT ARE
REVEALING IN THEIR
CANDOR. "BORING" IS
WRITTEN BESIDE THE
DOUBLE CHOC TRUFFLE
CHARACTER.

THE FINAL PACKS CAN BE
SEEN OVERLEAF.

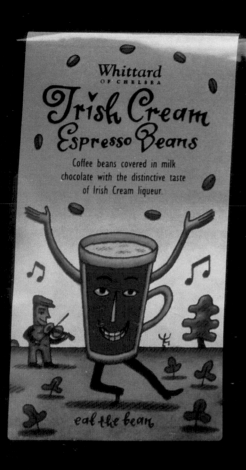

Whittard
OF CHELSEA

Irish Cream
Espresso Beans

Coffee beans covered in milk
chocolate with the distinctive taste
of Irish Cream liqueur.

eat the bean

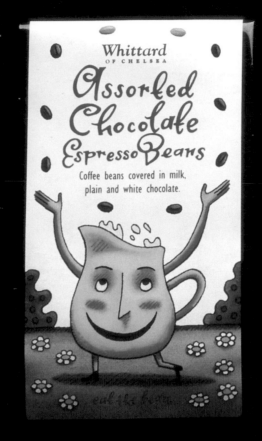

Whittard
OF CHELSEA

Assorted
Chocolate
Espresso Beans

Coffee beans covered in milk,
plain and white chocolate.

eat the bean

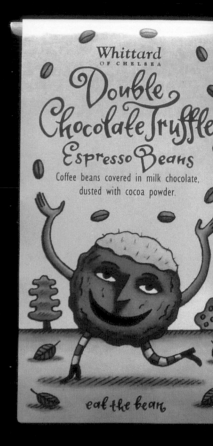

Whittard
OF CHELSEA

Double
Chocolate Truffle
Espresso Beans

Coffee beans covered in milk chocolate,
dusted with cocoa powder.

eat the bean

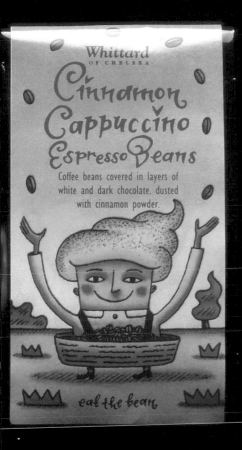

Whittard
OF CHELSEA

Cinnamon Cappuccino Espresso Beans

Coffee beans covered in layers of white and dark chocolate, dusted with cinnamon powder.

eat the bean

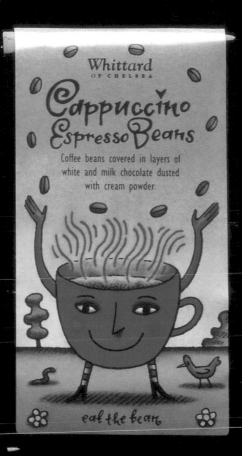

Whittard
OF CHELSEA

Cappuccino Espresso Beans

Coffee beans covered in layers of white and milk chocolate dusted with cream powder.

eat the bean

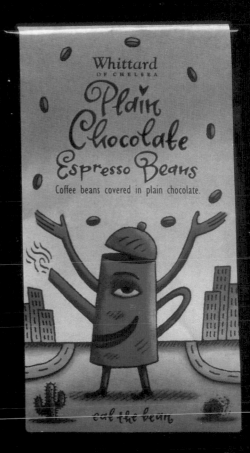

Whittard
OF CHELSEA

Plain Chocolate Espresso Beans

Coffee beans covered in plain chocolate.

eat the bean

Boston Acoustics
Referring to the creative process, designer Bruce Crocker says

"we're hunters and gatherers. We create a scrapbook for each project, and we throw everything in there,

idioms, metaphors, sometimes pictures photocopied from old books, or drawings of random thoughts.

The answer is usually embedded in there somewhere. After that, it's a matter of

'distillation and discovery'

Crocker and his small team of designers, based in Brookline, Massachusetts, have worked with this client, Boston Acoustics, in nearby Peabody for nearly 10 years, and they handle everything from advertising, point of sale, posters and catalogs, to packaging. The catalog work, which is on-going, is done on a retainer, but for the remainder, Crocker says he produces "*à la carte* estimates." There is a natural continuity, and the work tends to be cyclical. Although Boston Acoustics does not work with Crocker Inc. exclusively, Crocker provides the majority of their marketing materials. Crocker says, "Our pricing is competitive. We charge the same prices as we did five years ago, and there is a certain symbiotic advantage to the history of our relationship. It's great for us—a win-win situation."

Having invested in this long-term arrangement, Crocker works differently with Boston Acoustics. "Ira Friedman, head of marketing and sales at Boston Acoustics, and I read each other's minds a bit, so we can go in very rough with a lot of quite preliminary sketches rather than working on one or two very tight executions."

Instead of a brief, he will discuss strategies in an initial meeting, sometimes well in advance of the development of the final product, and then confirm it with a creative brief that is little more than note-taking. Crocker is a great believer in letting a project evolve, and he will even warn clients that he is likely to keep making improvements—"fine tuning," as he calls it—right up to the final printing stage. "I don't think many studios take this position, it tends to make people nervous," he admits.

DESIGNER BRUCE CROCKER'S SCRAPBOOK OF THIS PROJECT HAD DRAWINGS AS WELL AS WORDS, INCLUDING "ROAD MAP W/VIVALDI," WHICH LED TO ONE OF THE TWO FINAL SOLUTIONS. HE WILL ALSO REFER TO SKETCHBOOKS FROM PREVIOUS PROJECTS. THE EMOTIONAL ASPECT OF LISTENING TO MUSIC, FOR INSTANCE, MIGHT LEAD THEM TO AN UNRELATED JOB FOR A HEALTH CARE PRODUCT FOR IMAGES OF EMOTIONS.

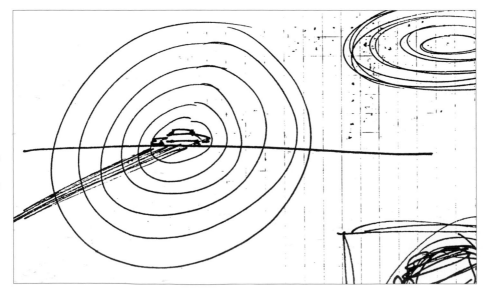

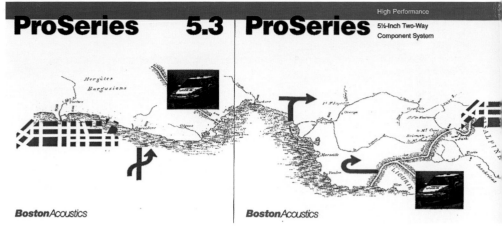

ProSeries 5.3 ProSeries

High Performance
5½-Inch Two-Way
Component System

BostonAcoustics **Boston**Acoustics

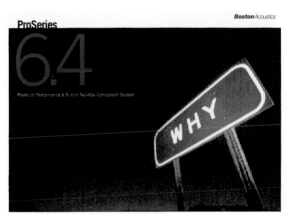

ProSeries **Boston**Acoustics

6.4

Premium Performance 6.5-inch Two-Way Component System

On this occasion, the product—a series of high quality, high priced car audio speaker systems—was to be displayed in boxes in up-market audio acoustic outlets. So it was more important to define the category (for cars) than the product, on the box. Added to that, Crocker was also briefed to design a point-of-sale display to accompany the launch.

During this early stage, "information is flowing and changing," says Crocker. "We have to remain flexible as product developments occur. Something might happen in the markets—it's a highly competitive business and 100% confidentiality must be maintained." Although Crocker is very "hands on"—"I stay in the trenches," he says—he was working with designers Tony Leone and Robert Krivicich, project manager Amy Leavitt and production manager, who interfaced with the box manufacturers.

BEFORE THE THREE QUARTER VIEWS OF THE PACKS WERE DONE, CROCKER SHOWED THE CLIENT THESE ALTERNATIVES FOR THE PRO-SERIES CAR AUDIO SPEAKER SYSTEMS. THE MAP OF THE ROAD IDEA HAD BECOME THE FRENCH COASTLINE, COMPLETE WITH STREET MAPS AND ROAD SIGNS, AND THE "WHY" SIGNPOST DIRECTION WAS INSPIRED BY FRIEND AND PHOTOGRAPHER BILL GALLERY.

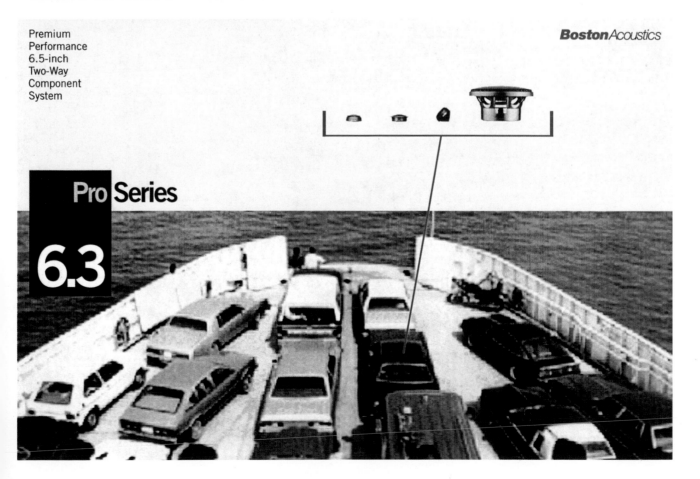

Premium
Performance
6.5-inch
Two-Way
Component
System

BostonAcoustics

Pro Series

6.3

On many projects the team will also include a copywriter. Crocker spent his early career in advertising on Madison Avenue and says, "Words are critical to our work process. They stimulate and influence visual ideas and are key in the art of persuasion."

Crocker's studio contains a very extensive library with thousands of art books. "I'm a used-book nut—not just graphic books, but anything that's visually orientated—and I use books as triggers for other metaphors and other images," he explains. So he goes thorough books, photocopying images. "Flip, copy; flip, copy—sometimes dozens of books." He also draws—"not that they're great drawings, just cryptic ideas"—that remind him of a thought or an approach, and he expects his designers to do the same.

"The big problem these days is that people use computers too soon, before they've engaged in the tactile process, which I believe enhances the human component of our work. I like designers to have peripheral interests other than graphic design—to play music or collect matchboxes or watch movies—sucking in our culture, not just referring to a certain design annual, page 82." When he interviews a new design applicant, he will ask to see something of their other interests. "Show me horizontally what makes you tick."

Eventually the scrapbook process yielded four potential solutions, in particular an idea of a road map with a piece of music, and a 1940s photograph by Paul Rand for the Auto Car Co. of steering wheels, taken from a book called *Thoughts on Design*. "We threw these chicken scratchings into the computer and started to work them up." Generally, Crocker will show a client four or five directions, each one visualized as a three-quarter view of a pack. "Usually, they will buy the direction we're selling them, but clients like to see several ideas, and sometimes I show things to explain the process, so they understand why I've rejected them. Sometimes I'll say in a presentation, 'here are four ideas, but only two are for sale'."

On this occasion, Friedman reacted straight away to the steering wheel idea. "It was an immediate hit," recalls Crocker, who told the client where the original pictures came from and that he intended to try and get the rights. He contacted Paul Rand, "who graciously supplied us with a faded old photostat that had been screened with a 65-line screen and was retouched with a few gobs of white-out. We spent thousands of dollars retouching it electronically, resulting in gargantuan files partly because of all the rotations, various sizes and colors of the steering wheels." Nevertheless, Crocker was undeterred. "I never copy work. Either I go to the source or move off in another direction."

When the product was finally launched, it created curiosity, since it was the only one packaging that did not visually describe what was in the box. Since then, the range has been extended to four different models, the 6.43 being the latest version. The earlier products are now due for re-packaging and re-launch.

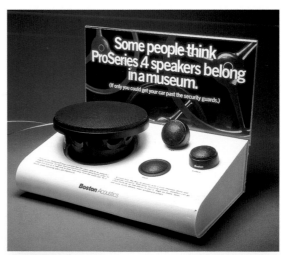

BECAUSE THE PRODUCT WAS SUPPORTED IN-STORE BY DEMONSTRATION POINT-OF-SALE. THE DESIGNERS WERE UNDER LESS PRESSURE TO REPRESENT THE CAR AUDIO SPEAKER SYSTEM ON THE BOX.

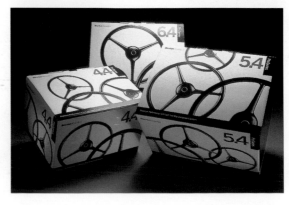

ON THE THREE DIFFERENT SIZES OF BOX. THE SIZES AND PATTERNS OF THE STEERING WHEELS (PROBABLY FROM A TRUCK) WERE ALL DIFFERENT. "BELLS DID RING WHEN I FIRST SAW THE PICTURE. BUT I LIKE IT AS MUCH FOR THE FEELING IT EVOKED. AND THE WAY IT USED WHITE SPACE WAS APPROPRIATE." EXPLAINS CROCKER.

THE FINAL PACK WAS
PRINTED ON
CORRUGATED E-FLUTE
BOARD IN FOUR COLORS
PLUS ONE METALLIC INK
FOR THE NUMBERS. "IT
ENDED UP PRETTY TIGHT
TO THE ORIGINAL THREE-
QUARTER ROUGH." SAYS
CROCKER.

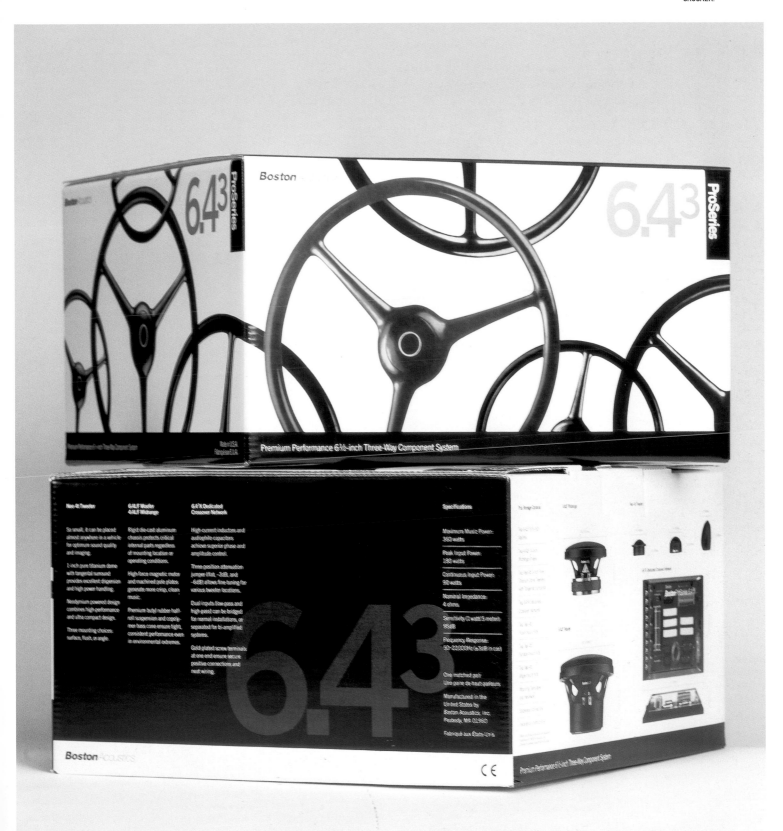

Gleneagles

"Packaging is a tactile and sexy medium, you can fondle it and caress it, in a way you can't a TV commercial or a newspaper or press ad." says John Blackburn, whose company, Blackburn's Ltd created this water bottle. When presenting to clients he always makes models of his designs and in more than 25 years he has never presented a visual: **"You can't get emotional about a flat piece of paper!"** This attitude stems from his very first packaging brief, back in the early 1970s, when he was asked to design a bottle for Cockburns Special Reserve Port, now a world brand leader.

Blackburn, an ex ad-man, then knew little about the art of constructing a label so he did the next best thing and went out and brought an appropriate bottle and "just stuck things on it," he confesses. The end result was very caressable and went on to change the perceptions of port. Since then, his company has been responsible for some of the world's most significant pack designs, and the shelves and walls of Blackburn's London townhouse office are crammed with dozens of awards.

One of his recent successes was the "blue bottle" for Harvey's Bristol Cream Sherry. Chris Zanetti, his client and managing director at Gleneagles, was the marketing director at Harvey's at the time. The Gleneagles spring, although situated across the road from the famous hotel and golf course, has a different owner; the hotel complex belongs to Diageo, the spring to Allied Domecq—so much rivalry demanded different identities.

The hotel uses an eagle for reasons that would appear obvious, but in fact the name Gleneagles derives from the French "Glen Eglise" (the glen of the church) with not an eagle in sight! John Blackburn's saw little mileage in pursuing this obscure ecclesiastical theme and opted to create their own.

John Blackburn and design director, Belinda Duggan, were invited to Scotland by Zanetti to view the spring. "It was early January," he recalls, "the middle of winter, raining sideways,

VARIATIONS ON THE RAINBOW COLOR COMBINATIONS, SIZE, AND PROPORTION WERE PREPARED IN AN ATTEMPT TO FIND A METAPHOR FOR THE PURITY OF THE WATER.

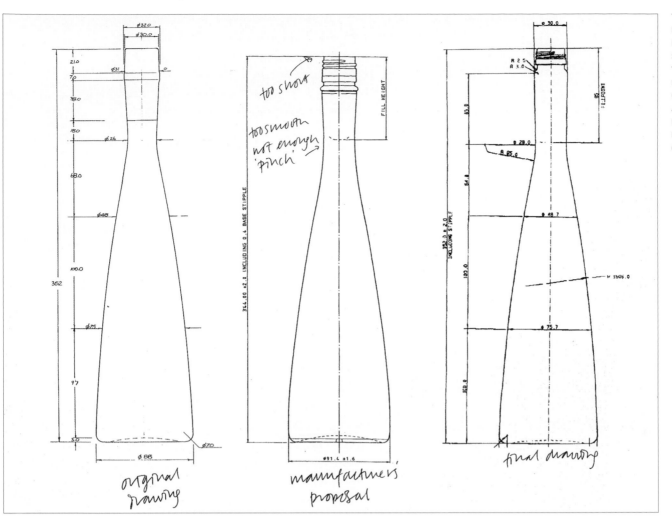

original drawing

manufacturers proposal

final drawing

THE PROGRESS OF THE
BOTTLE, FROM INITIAL
DESIGN, WHICH HAD
SWELLED OUT SLIGHTLY
TOWARD THE TOP, TO THE
MANUFACTURER'S
COMPROMISED
ADAPTATION, TO THE
FINAL VERSION, WHICH
PLACED LESS EMPHASIS
ON THE SCREW TOP.

and bitterly cold too. The spring wasn't much more than a hole in the ground, so it was little help to our creative juices." The pair returned to London wondering what to do and questioning whether the world needed yet another bottled water. "What we needed was an angle," Blackburn explains.

The angle they took was to avoid supermarkets completely, taking the lead from Ty Nant water, which sells mainly to restaurants. "Why don't we design a bottle that sells *exclusively* to the world's top restaurants; but a water that doesn't dominate the environment in the way the rich blue of Ty Nant does—one that harnesses, compliments, and doesn't upstage the many different environments." In addition, the rarity of the brand was very important. "How could it be in top restaurants, if it was selling in supermarkets, too?" they reasoned.

Setting to work, Duggan came up with the idea of a rainbow. "No one had used it on water, opting instead for the predictable mountain ranges and flowing streams. It seemed to us the perfect metaphor—especially when positioned over the "G" of Gleneagles—for what was special about this particular mineral water," says Blackburn. The phrase "Beneath the Rainbow" followed. It had a bit to do with Judy Garland and all that, admits Blackburn.

Although they did not want the bottles to look intrusive, neither did they want them to disappear. "Let's make the

LOOKING AT THE MARKET
COMPETITION,
BLACKBURN OBSERVED:
"WE DECIDED THERE
SHOULD BE NO
MOUNTAINS."

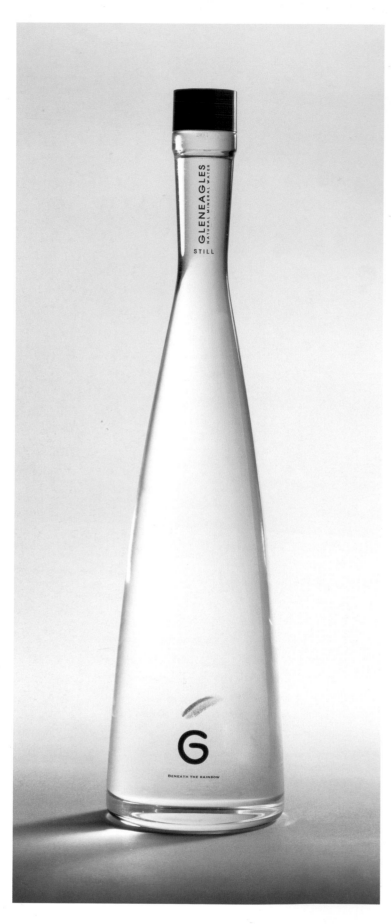

bottle taller than the average water bottle, so it will tower and be seen above the clarets and the chardonnays," Blackburn suggested to Roberta Oates, the designer in his studio who worked on the bottle shape. She made two or three pencil sketches of ideas, and then put them onto computer to establish the correct volume. To add to the feeling of exclusiveness, Blackburn wanted the bottles to be made in cosmetic glass. "It's the highest quality, and there's less distortion in the manufacturing process," he explains. "It's more expensive, of course." But, because his customer was the restaurateur not the general public and was not mass volume, the better quality would be seen to enhance the restaurant environment and could become a selling factor.

So when the day came to present the bottle, he explained the restaurant concept with an acrylic mockup that had the same weight and the same feel as glass. "You couldn't tell the difference," he says, quoting the U.S. advertising genius Bill Bernbach: "Never give the client what he wants; give him what he thought he could never have."

"I knew Chris. I felt confident that he'd like our approach," says Blackburn, "and like Cockburn's Port, 25 years before, it was the only design that was presented. We spent a huge amount of time on the groundwork preparing the client for what was to follow. I wanted to give him a tingle at the base of the spine, and I did."

Both design and concept were approved and the next step was to sell it on to the Allied Domecq Chief Executive, Tony Hales, who after all held the purse strings. "I knew we only had a few minutes, so I stage-managed a place setting at the end of the boardroom table to look like a restaurant. As there was only one of him we produced a miniature version, paid for out of our own pockets, and sat him down to dine, so to speak. He picked it up and smiled and I knew we were there. Attention to detail and a bit of theater go a long way. What was also interesting is that this little episode spawned the introduction of the 330ml (about 9 fluid ounces) version, which is now distributed to boardrooms around the world," enthused Blackburn.

Blackburn's team did dimensional drawings on computer and sent them to the bottle manufacturer Stolzle Flaconnage, in Austria. The graphics were screened directly onto the glass. "I'm anti-paper labels," says Blackburn, who wanted to make sure that nothing detracted from the glass.

To launch the product, they succeeded in getting it on every table at the International Hoteliers Conference, at the Hilton Hotel in September 1997, nine months to the day of its inception. The perfect birth, you might say.

THE ACRYLIC MODEL, (LEFT), MADE BY FREELANCE MODEL MAKER PHIL EARL, WAS INTENDED TO LOOK AND FEEL EXACTLY LIKE THE FINISHED ARTICLE. THE GLENEAGLES "G" ALSO SYMBOLIZED THE MOUNTAIN AND THE PROGRESS OF THE WATER AS IT MEANDERS TOWARD THE SPRING BENEATH.
THE FINISHED BOTTLE, DESIGNED TO "TOWER ABOVE THE CLARETS AND CHARDONNAYS," ALSO REPAYS CLOSE SCRUTINY WITH DELICATE TYPOGRAPHY, SENSITIVELY POSITIONED AND SCREENED DIRECTLY ONTO THE GLASS.

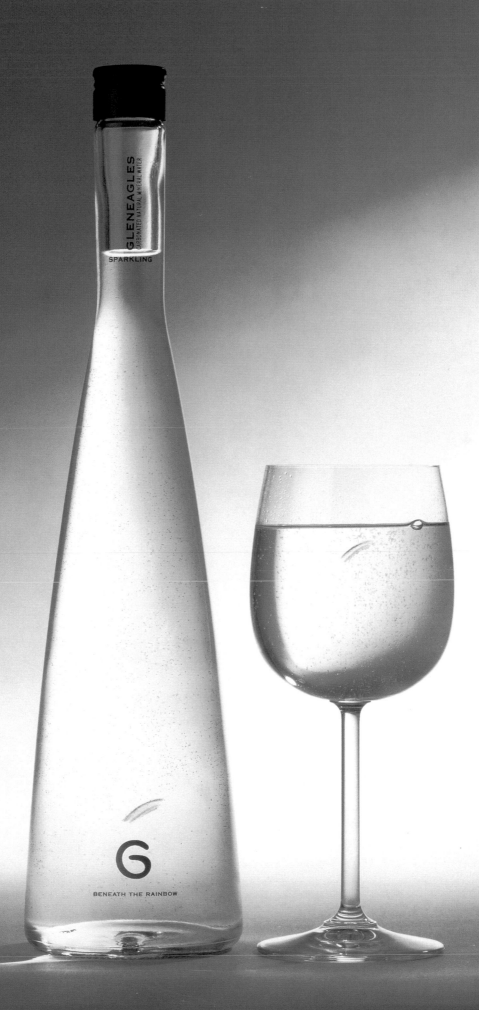

Carluccio's

In this unique collaboration, the designer and client worked hand in hand, and developed practical solutions right there and then, a process that eliminated the need for presentations and alternative ideas but demanded the highest degree of confidence in the designer's abilities, as well as mutual respect which every designer craves

THE TINY FOOD SHOP SELLS ALMOST ENTIRELY OWN-BRAND PRODUCTS AND FRESH FOOD PRODUCED IN THEIR BASEMENT KITCHEN.

Carluccio's is a tiny food store in London's Covent Garden, built on the reputation and expertise of leading Italian chef, author, and television presenter Antonio Carluccio and those of his wife Priscilla, whose marketing and merchandizing skills were acquired while she was working with her brother Terence Conran at the Conran Shop. Starting from scratch, they have developed and sourced (in Italy) a range of over 150 products—all branded and packaged for the store—to sell alongside farm produce, prepared foods, and fresh pasta. They run a flourishing mail-order business, and they sell through 100 outlets across Britain, Ireland, and Canada.

Once a year—generally in February—Priscilla Carluccio sits down with her designer, Jonathan Stewart, and together they review the new products and evolving packaging ideas. "Sometimes I'll have an idea for a pack or even a sample, but sometimes we can't get what we want and have to think again. Working with relatively small quantities restricts everything we do." The products develop gradually. "The price of the label and the pack has to be added to the price of the product, so we have to be careful not to make things too expensive," Carluccio explains. By now she knows about most packaging and what it costs.

Once a professional photographer, Priscilla Carluccio uses her camera as a notebook, snapping images wherever she

PAINTED ON AN OLD SHOP WALL IN SOUTHERN ITALY, THIS JUMBLE OF LETTERING HELD THE KEY TO THE AUTHENTIC ITALIAN FEEL OF THE FINAL PACKS.

SITTING TOGETHER WITH HIS CLIENT, JONATHAN STEWART STARTED SKETCHING LAYOUTS FOR THE WRAPAROUND LABELS. "THE FACT THAT HE'S NOT EXCLUSIVELY A PACKAGING DESIGNER," OBSERVES PRISCILLA CARLUCCIO, "MEANS THAT HE BRINGS SOMETHING SPECIAL TO IT."

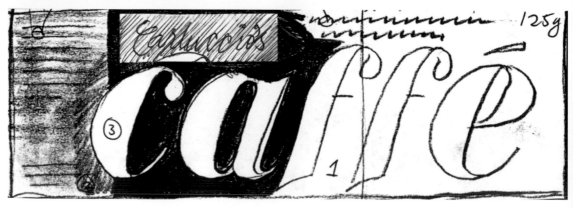

caffè
ciocc olata

SINCE NO TYPEFACE EXISTED THAT QUITE RESEMBLED THE ORIGINAL, STEWART CUT LETTERS OUT OF BLACK PAPER TO GIVE A SIMILAR HANDMADE FEEL. THE FIVE VARIATIONS WERE: NEAPOLITAN COFFEE GROUNDS; NEAPOLITAN COFFEE BEANS; AROMA AMARETTO; AROMA ORANGE; AND

ONCE THE LABEL DESIGNS WERE AGREED, STEWART AND CARLUCCIO SET THE COPY AND COMPOSED THE LAYOUT TOGETHER ON THE MAC. THEY DELIBERATELY DIDN'T WANT THEM TOO SLICK OR MASS-PRODUCED. TO CHECK THE COLORS, THEY USED LASER PRINTS. AND, IN THE FINAL PRINTING, CHANGED THE PAPER FROM MATTE TO GLOSSY TO GET A MUCH RICHER BLACK.

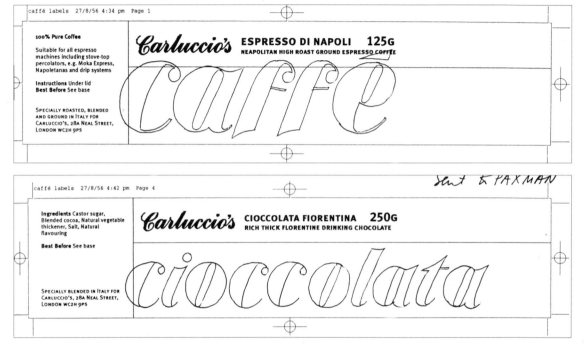

goes. "I photograph anything of interest or that could be used—from a sausage display or a vast tart, to a window or a doorway, or a piece of pottery." Together, she and Stewart go through these notebooks and discuss ideas. "Sometimes I give Jonathan scraps of paper—anything for inspiration." This process also extends to others in the company—even the chefs get ideas in this way.

During their session in February 1997 they were discussing a new range of espresso coffee, when Stewart's eye fell on a picture of some old lettering on a wall in Puglia. With his pencil, he started sketching ideas. The coffee, a special blend of arabica and robusta beans, which Antonio Carluccio had developed, was unique in Britain, where most single-bean products seem bland compared with the Neapolitan original that he wanted to import. The two beans together give a kick that produces a special espresso flavor without making it high in caffeine, like most "short roast" commercial blends.

The product needs to be bought in small quantities and drunk while it is fresh. It could be sold in either packets or tins, but Priscilla Carluccio—thinking ahead to how it would

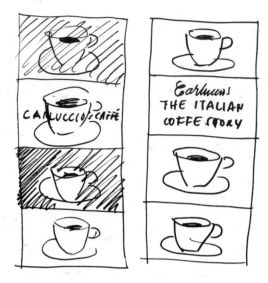

SKETCHES FROM
STEWART'S LAYOUT PAD
SHOW SOME EARLY IDEAS
FOR THE INSTORE LEAFLET.
DEADLINES WERE TIGHT
BECAUSE "ITALY CLOSES
DOWN FOR THE WHOLE OF
AUGUST, SO PRODUCTS
HAD TO BE SHIPPED BY THE
END OF JULY."

be stacked on the shelves —preferred (4 ounce tin, which is smaller than normal coffee products. As well as ground coffee, the range was to include Florentine drinking chocolate and a Neapolitan coffee bean that had, because it expands, to be sold in a foil packet.

Looking at the blank sample tins, both Carluccio and Stewart liked the unadorned metal surface, and recognized that it had an honest, straightforward quality that they wanted to retain. So Stewart evolved a label of printed paper that came only halfway up the tin, leaving the rest blank. Whenever she can, Priscilla Carluccio prefers to show the actual contents, although in this case that was impossible.

From these first sketches, the solution evolved in a fairly straightforward way. The lettering, so large that it wrapped right around the tin and out of sight, meant that customers would pick it up and appreciate the feel of the tin, its weight and quality. In addition, little, round, fold-out leaflets, trapped under the plastic, resealable lids, explain the coffee story and give "important steps for a perfect cup."

Instore, there is an additional leaflet that tells the Italian coffee story as well as espresso cups and saucers that carry the same graphics, and a genuine Napoletiana coffee-pot, whose honest aluminum sides, although they didn't realize it at the time, perfectly reflect the qualities of the coffee tins.

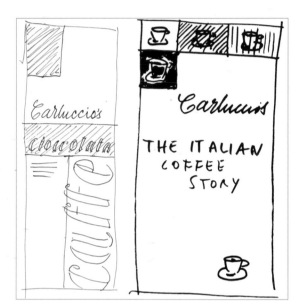

TINS OF COFFEE WERE
PACKED AND SHIPPED TO
BRITAIN, WHERE THE
PAPER LABELS WERE
APPLIED, PRINTED IN
FOUR COLORS PLUS
GOLD, THE PROCESS
THREW UP QUITE A FEW
COLOR MATCHING
PROBLEMS, HAVING
WORKED ON THE
PRODUCTS FOR 18
MONTHS BEFORE THE
BRIEFING, THE FINAL
DESIGN WAS COMPLETED
AND THE PRODUCTS
LAUNCHED INSTORE IN
JUST OVER SEVEN
MONTHS.

WITH A THICK BRUSH,
STEWART PLAYED
AROUND WITH A SERIES
OF CUPS BEFORE
CHOOSING THE FINAL
ONE (FAR RIGHT) FOR THE
LITTLE SIX-PAGE
LEAFLET THAT WENT IN
THE TOP OF EACH TIN.

TRADE SECRETS OF GREAT DESIGN

Carluccio's CIOCCOLAT
RICH THICK F

ciocc

Carluccio's

Carluccio's ESPRESS
NEAPOLITAN

Car

Carluccio's ESPRESSO
PURE ARAB

cal

CARLUCCIO'S CAFF
Carluccio's Caffè Espresso di Napoli
Neapolitan high roast ground espresso
coffee. For all espresso machines
including stovetop
percolators.

Carluccio's
Cioccolata di Fighettina

Method
(MAKES ABOUT 6, 50ML ESPRESSO
SIZE CUPS)

Place 500ml of cold full fat milk in a heavy
bottomed pan. Stir in 3 heaped tablespoons
(90g) of powder and bring to the boil.
Lower heat to a simmer and stir chocolate
continuously for 5-8 minutes. For best results use
a whisk. The chocolate should thicken to slightly as
it is stirred. When it is thick enough to coat the
back of a spoon, remove from heat. It will
continue to thicken as it cools. Serve in
warm espresso cups. Delicious served in
with Carluccio's Baci di Dama.

Premium Lehmann Wines

When the marketing manager of a medium-sized but influential wine maker in South Australia asked Ian Kidd and his design team to undertake design work for a set of seven mid-price red and white wines, **he asked him for evolution, not revolution**

In the past, the founder had been largely uninterested in the packaging and marketing of his wines, and, as a result, although the product was excellent, sales had not realized their full potential. The old labels had been carried out in an amateurish way—"messing around with scissors and type"—and the existing design was, remembers Kidd, "huge, ugly, and masculine—black, gold, and white." Nevertheless, the packaging did have an element that Kidd, who has been designing prize-winning graphics for the wine industry since 1970, thought worth keeping: the queen of clubs, which had become identified with Peter Lehmann's products. "The brooding black and gold labels on Lehmann's wines were never going to be helped much by evolution," remembers Kidd. "Further, it has been our experience that clients do not go the distance with this type of change. The cost of gradual change is prohibitive, and a disrupted marketplace is deprived of the opportunity to become familiar with, and confident of, a label that comes with longevity. The consumer can cope favorably with change but progressive change over a period of a few years can confuse. Why do they need to do this? Is the product not successful?"

So Ian Kidd decided to "chance his arm" and put his money on the queen of clubs. Completely ignoring the brief, apart from this one element, he and a senior designer, Dinah Edwards, had the idea of decorating the labels with works of art. This idea was not new—companies often "throw irrelevant paintings on labels"—but the client's association with the Barossa music festival, their promotion of art through exhibitions and their own extensive art collection made it entirely appropriate. In addition, the idea of asking artists to provide their own interpretations of the queen of clubs made it an unusual continuation of Lehmann's image. As Kidd says: "Unique positioning strategies are always difficult to develop in Australia's wine industry, where there are about a thousand companies and more starting business every month."

The design all came together quickly, so they did not pursue any other routes. "It was our first and only idea—we only investigate other concepts if we feel the solution is not solving the problem." Even then, they show only one idea to the client. "Choices give people problems," explains Kidd, and continues: "When clients come to us, they are seeking professional advice. You don't expect your doctor to offer you a choice of alternative diagnoses. We will have thrashed out all the variables, and only work up the final solution, unless it's a corporate identity—that's the only exception and

RIGHT. IN THEIR OWN WAYS, EACH ARTIST SENT IN SKETCHES OF THE QUEEN OF CLUBS. THE PAINTINGS HAD TO INCLUDE THE CLUB SYMBOL FROM A REGULAR PACK OF CARDS AND A GLASS OF WINE, WITH RESULTS RANGING FROM ABSTRACT TO TRADITIONAL.

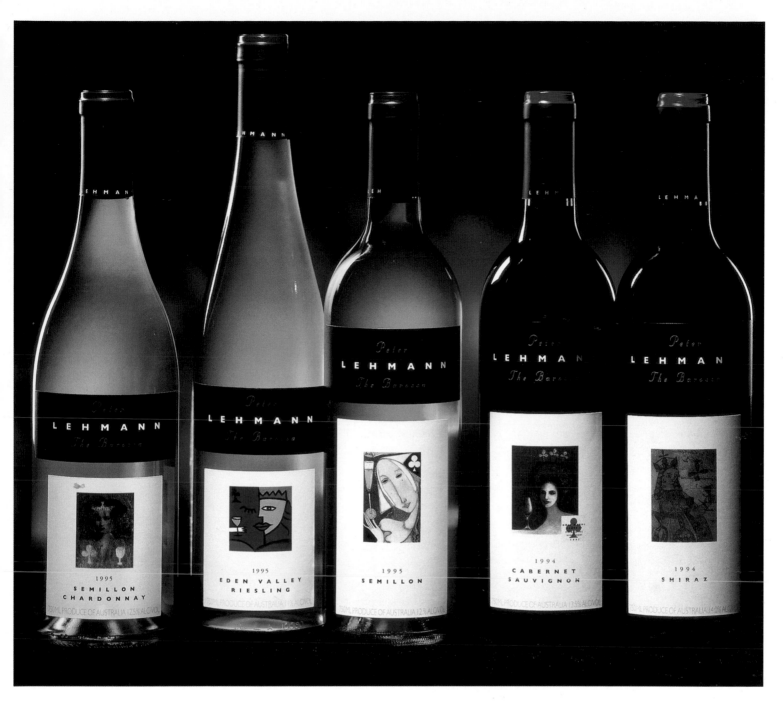

only in few cases. If the client insists on seeing two or three ideas, it means we have to take to fully worked-up form ideas that we consider to be inferior, and we would charge the client for this extra work."

For the first Lehmann presentation, Kidd and his team used traditional bottle shapes and finished label mockups with copy written by Kidd. The client's marketing manager, Robert Edwards, was supportive but worried that the Lehmann family would not "buy anything radical." In fact, he was so nervous that he asked Kidd to present the ideas and explain the strategy. Around the table, Peter Lehmann, his wife, Margaret, and son, Doug (senior executive), were joined by two or three wine makers. "They all gradually realized that they were looking at something they all really liked," remembers Kidd. They were all so shocked, particularly because, recalls the client, "it was the first time we had all

ever agreed on anything to do with packaging".

The idea came through the meeting "completely unscathed—it was a big breakthrough." Back in their Adelaide studio, the designers approached 15 or 16 young artists and asked each to submit a painting. Some were thrilled and delighted at the prospect of having their work seen more widely; some responded with long, businesslike contracts about the copyright; and others didn't respond at all. Kidd and his team had no difficulty in choosing the final seven, and they have, in fact, kept some for later use.

When it came to exporting the product, however, there were, says Kidd, some unforeseen problems. "Two of the labels included exposed breasts, which were considered unacceptable in the U.K. and U.S.A. Much to the chagrin of our design team and the artists, these had to be painted over to demonstrate a modicum of monarchal modesty. Oh dear!"

THE LINE-UP OF FIVE LABELS HAS A STRONG FAMILY RESEMBLANCE WITHOUT BEING IDENTICAL. A LABEL ON THE BACK TOLD THE STORY OF THE PAINTINGS. AND IT WAS CARRIED THROUGH ONTO A BROCHURE AND INTO THE ADVERTISING. THE RANGE GREW TO 10 WINES IN ALL. AND THE ORIGINAL PAINTINGS WERE AND HUNG IN THE WINERY'S TASTING ROOM.

The Bath House Ltd

The four directors of The Bath House Ltd all met at art college in the 1980s. When they left, Gareth Marshall and Pauline State set up a publishing company called Picture Palace Cards, and Abigail Horner and Nigel Brooks set up Horner & Brooks Design Studios, producing freelance work for ceramic and home-furnishing clients

SINCE HORNER & BROOKS WERE NOT WORKING FOR ANYONE BUT THEMSELVES, THERE WERE NO ALTERNATIVE PACKAGING SOLUTIONS. THEY CUT UP BITS OF ONE OF THEIR OWN GIFTWRAP, AND MADE A NEW PATTERN THAT CENTERED ON ONE IMAGE BUT THEN SPREAD RANDOMLY ACROSS ALL SIDES OF THE BOX, USING FRAGMENTS OF HANDWRITING AND PINK STRIPES

THE DEVELOPED DESIGN FOR THE FOAM BATH BOX, SEEN LAID OUT FLAT, SEEMS TO TELL A STORY. THE IMAGES WERE PAINTED INDIVIDUALLY AND THEN MOVED ABOUT, AGAINST PAINTED STRIPES AND BITS OF OLD FABRIC, UNTIL THE COMPOSITION SEEMED TO FIT. SPACE WAS LEFT FOR TYPE TO BE DROPPED IN AND SEVERAL DRAWINGS WERE REPEATED, AT DIFFERENT SIZES.

THE LAYOUT FOR THE BATH GRAINS ENVELOPE USED COLOR PHOTOCOPIES TO INSTRUCT THE PRINTER HOW TO POSITION THE VARIOUS ELEMENTS, WITH EXTRA BITS OF COLOR AND STRIPES USED TO FILL IN THE GAPS.

Horner & Brooks was also designing for Picture Palace from the early days, and the team developed a strong working relationship which culminated in a distinctive visual identity for Picture Palace. This identity has become the "trade mark" of Picture Palace, and still continues to be the mainstay of the company's success, which now has 1,500 outlets in the U.K., and also exports four fifths of its product worldwide. This range currently consists of over 250 cards, books, giftwrap, and stationery, 90 percent of which is designed by Horner & Brooks.

Horner & Brooks continued to develop their successful freelance design company, working for a variety of prestigious clients including Laura Ashley, Marks & Spencer, French Connection, and Wedgwood, as well as selling internationally through a variety of design agents. Their unique working relationship has created a strong and intuitive collaboration combining experience and versatility to create an original and highly successful team.

They were, however, beginning to feel frustrated working to other companies' briefs. "The clients don't trust designers enough to let us get involved in the marketing and with decisions about the materials being used, which will ultimately change the whole look of the design," says Brooks. "The positive experience of working with Picture Palace made us realize the potential of being more involved in production decisions, and that our input benefitted the final products."

Although they were an important part of the team at Picture Palace, Horner & Brooks were increasingly beginning to think about manufacturing their own products, independently of but not in competition with their colleagues. After looking into a variety of packaging related gift products, toiletries seemed to be the logical path to take. As designers, the natural way to proceed was to put pencil to paper and start the visuals for the packaging. Horner & Brooks' working methods involved collecting visual references from their existing giftwrap designs and pasting imagery onto mockup three-dimensional packaging. Research for packaging looked at contemporary food storage as well as more nostalgic packaging from the 1940s. The idea of producing toiletries that also had the quality of food-related products was very appealing; lotions that looked like milk or cream, and soaps that looked like fresh pale butter. The results were very promising. An initial range of designs was produced and became one of The Bath House's first collections. But two things stood in their way. First, pursuing this direction might mean that they would, if it were

ONE OF THE GREETING CARDS THAT HORNER & BROOKS PRODUCED FOR PICTURE PALACE CARDS THAT PREDATES BUT ANTICIPATES THE PACKAGING.

successful, have to give up their other design work. Secondly, there was much about production and distribution that they did not know. So the whole idea was put on hold.

During a design meeting between Picture Palace and Horner & Brooks in October 1996, Marshall and State had mentioned that they were thinking of introducing a small range of packaged soaps, and it then became obvious that since Horner & Brooks were also interested in developing toiletries, the four should form an equal partnership, which became The Bath House.

Building on the huge amount of research that Horner & Brooks had already done, The Bath House found a manufacturer in Devon and went to visit the company, taking a list of questions. "We had no idea about lead times or what the toiletries might cost," admits State. "The visit answered many of our worries, and we were really pleased with the production facilities and the quality of the company." Horner & Brooks had all the products roughed out for the first range—which was a based on a citrus fragrance—and had sourced an old-fashioned bottle with a porcelain swing stopper. The aim was to launch the product at Top Drawer, British giftware show in spring 1997. Developing and testing the products alone would take three to four months. By now, the schedule was getting tight.

Horner & Brooks, who had designed the first packaging range by painting fragments of images and putting them together as a collage, had the added pressure of coming up with the second design, which they had by now decided should be based on lavender. "We wanted the packaging to have a timeless quality, as if they were beautiful objects we had found and put together to tell a story. The narrative aspects of our illustrations develop a theme," explains Brooks. The illustrations were complemented by handwritten titles "Royal Lavender" and "Citrus Garden." Conventional typography would have been too stark. Together, all the

THE PROFILE OF A MEDITERRANEAN GIRL, LAYERED ON STRIPES AND TEXTURES, AND SURROUNDED BY A CITRUS PATTERN, FORMED THE WRAPPER FOR THE RICH VEGETABLE-BASED SOAP.

THE Bath House LTD

THE BATH HOUSE WAS CHOSEN FROM A LIST OF 10 NAMES, INCLUDING 'THE LITTLE STORE ROOM' AND 'UP FROM THE COUNTRY.' NIGEL BROOKS DID SOME SKETCHES OF A STYLE OF WRITING BEFORE COMMISSIONING TONY JOHNSON TO DRAW UP THE FINAL LETTERING, WHICH WAS APPLIED TO ALL THE PRODUCTS AND STAMPED INTO THE SOAP.

THREE INDIVIDUAL ELEMENTS PHOTOCOPIED WITH INSTRUCTIONS FOR THE PRINTERS. WORKING WITH CERAMICS HAD TAUGHT HORNER BROOKS HOW TO WORK WITHIN QUITE SMALL SPACES.

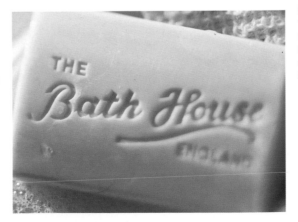

packaging—some boxes, some bottles, and some flat sachets, all different heights and different sizes—made a varied composition. Most importantly, some were complex and some were very simple and plain—a creamy white bar of soap or an almost unadorned bottle beside richly detailed boxes and wrappers.

The designs for the second fragrance had to complement the citrus collection, yet also introduce a totally new theme. The initial lavender series was completed quite quickly, after which Horner & Brooks had a short vacation. On their return, however, when they looked at their work with a fresh eye, they decided that it was not quite right— "a bit heavy, perhaps." "Sometimes, one thing can be critical," observed Brooks. "The position of a bee and using painted stripes instead of colored fabric, in this instance made all the difference." Once they had got the overall pattern, they adapted it, condensed it, and extracted elements to apply to the whole range.

During the final stages leading up to the launch, there were all kinds of last-minute panics. In particular, there was a problem with the rubber washers on the bottles, which were supplied as orange and had to be replaced by hand with white ones at the eleventh hour. To complete the presentation, The Bath House had designed an instore display and the stand for the exhibition. Adjoining Picture Palace, it had creamy white woodwork, blue counter, and an old fashioned bath tub, to set the product in context. The stand had to coordinate with the Picture Palace display while maintaining its own strong identity. "It was important that our existing Picture Palace customers knew that there was a link between The Bath House and Picture Palace. It meant that they would be reassured about the service The Bath House would offer and the quality of the product," comments State.

And next? Perhaps more fragrances, another two next year, although the packaging may not be as complex. They would like ultimately to include other bathroom products and then, perhaps, have their own shops. "We're good at tuning in to new markets, and it's exciting to do something different," says Brooks. But they certainly do not plan to aim for the mass market. "It's nice to put something out into the market and not be motivated by making cash." In fact, the initial investment was paid back in the first six months but was quickly reinvested in new products. No one expects to pocket any money for at least another five years.

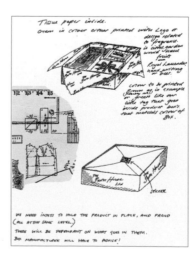

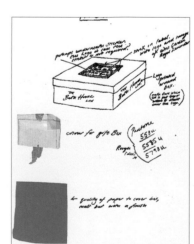

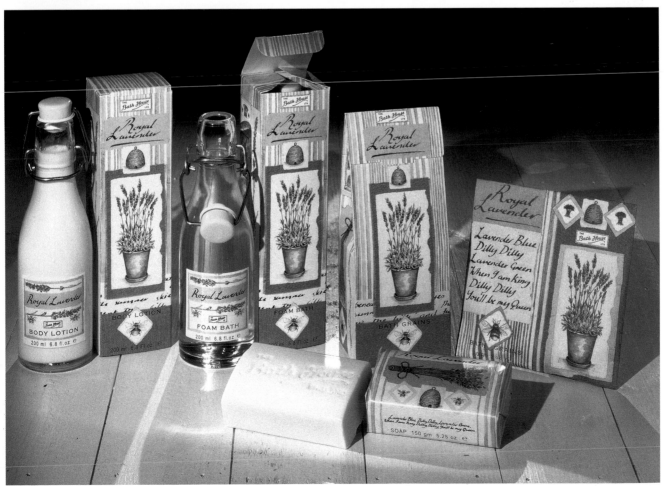

THIS PHOTOGRAPH OF
THE CITRUS GARDEN
SHOWS HOW THE LABEL
ON THE TRADITIONAL
BOTTLE CO-ORDINATED
WITH THE BOX.

(*LEFT AND OVERLEAF*)
THE FINAL LINE-UP OF
PRODUCTS WAS
SHROUDED IN SECRECY
EVEN FROM THEIR
AGENTS UNTIL THREE
WEEKS BEFORE THE
LAUNCH. BUT THEY HAD
THE ADVANTAGE OF AN
ALREADY EXISTING
MARKETING AND
DISTRIBUTION
STRUCTURE WITHIN
PICTURE PALACE AND A
LONG LIST OF STORES,
BOTH LARGE AND SMALL,
THAT MIGHT SELL THE
NEW RANGE.

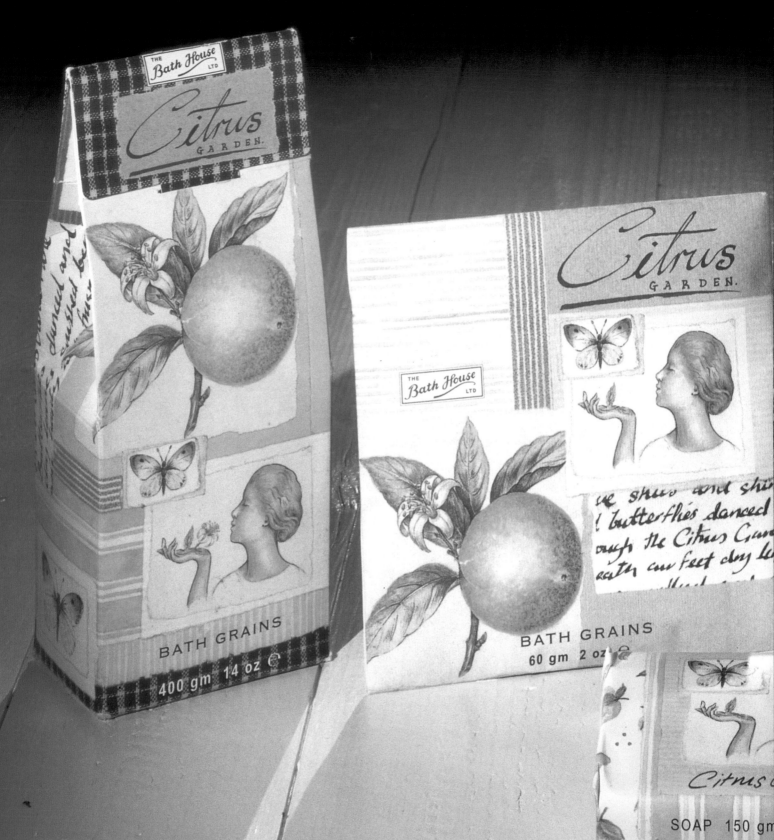

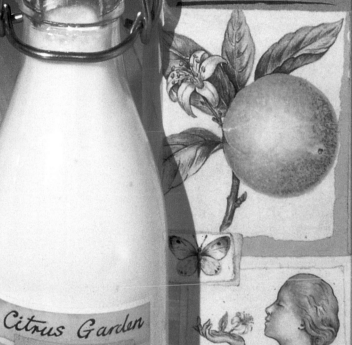

Citrus
GARDEN.

Citrus
GARDEN.

Citrus Garden

FOAM BATH

FOAM BATH

200 ml 6.8 Fl oz e

Citrus Garden

BODY LOTION

200 ml 6.8 fl.oz e

BODY LOTION

200 ml 6.8 Fl oz e

THE
Bath House
LTD

THE
Bath House
LTD

Citrus Garden

FOAM BATH

200 ml 6.8 fl.oz e

Starbucks Frappuccino

Working with Starbucks is a constant learning process, but over the years the designers at Hornall Anderson have developed an understanding of the company's culture and have become **"stewards of the brand."** Even so, when it came to this new collaboration with Pepsi Cola, Hornall Anderson nearly did not get the job

Starbucks opened its first coffee shop in Seattle in 1971. Since then, the company philosophy—"Everything we do begins and ends with coffee"—has spearheaded an expansion that now includes 1,000 retail outlets throughout North America and several in Tokyo. In addition to this joint venture with Pepsi Cola, Starbucks also works with Dreyer's Grand Ice Cream, and provides coffee to I.T.T. Sheraton Hotels, Westin Hotels & Resorts, and United Airlines. The company's environmentally responsible policy means that it even rewards customers who bring in their own coffee mugs.

On this occasion, Pepsi took the lead and commissioned another design company—nothing wrong with that—but when the results came back, Starbucks' response was, "They're not us." So Hornall Anderson, which had worked on a lot of projects for Starbucks over the previous three years, was asked to take over. The brief called for a brand identity for Frappuccino, a coffee milkshake that was already a success in the Starbucks shops and that, with the Pepsi Cola distribution network, was to be sold, bottled, through grocery stores, delis, gourmet cookshops, and in gas stations. A further objective was to develop a unique brand identity, which not only positioned Frappuccino as a new beverage but as a new beverage category in the marketplace. Pepsi Cola provided the contained, a wide-mouthed bottle, which was reminiscent of the old-fashioned American milk bottles and which Jack Anderson, who was running the project, called a "gulpable."

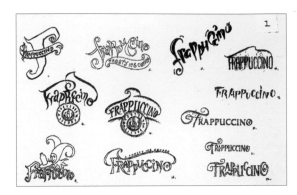

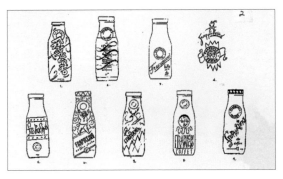

ALL IN BLACK AND WHITE, THESE EARLY EXERCISES IN WORKING ON THE LOGO WERE A COMBINED EFFORT BY THE TEAM. THE NEXT STEP IN THIS FIRST, TENTATIVE STAGE WAS TO CONSIDER THE DECORATION OF THE WHOLE BOTTLE. IN ADDITION TO LIVELY LETTERING, SPRITELY CHARACTERS, SUCH AS A COURT JESTER AND A PIERROT, WERE INCORPORATED. AS A BACKGROUND TO THE GRAPHICS *(ABOVE RIGHT)*, SWIRLS, SPIRALS, AND ICICLES WERE LINED UP. ACTUAL SIZE SHAPES *(RIGHT)* COMBINED THE DIFFERENT IDEAS "THERE WAS NO REAL ORDER OF PRIORITY IN THESE FIRST SHEETS," RECALLS ANDERSON, WHO SHOWED THEM ALL TO THE VICE PRESIDENT OF STARBUCKS TO GET FEEDBACK.

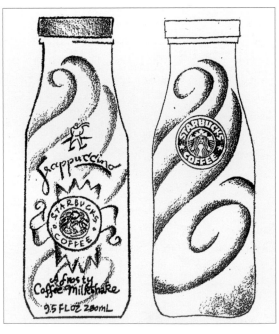

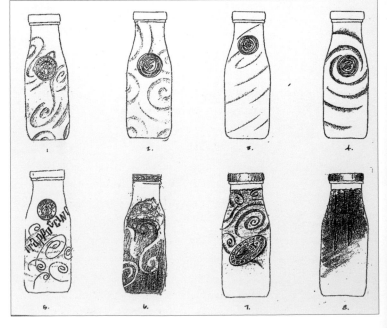

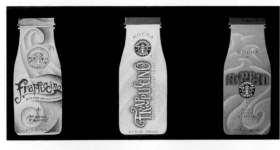
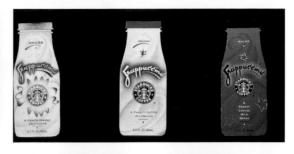

NOW MOVING INTO COLOR, A SERIES OF BOTTLES TOOK THE ELEMENTS FROM THE SUBLIME TO THE CHAOTIC, WITH COFFEE LEAVES AND BERRIES, DANCING TYPE, AND SWIRLING BACKGROUNDS. EACH BOTTLE RETAINED THE STARBUCKS LOGO AS AN IMPORTANT FEATURE AND DEVELOPED THE SHADED LAYERS OF MILKY COFFEE. "TOO MUCH COFFEE AND NOT ENOUGH FOCUS ON THE MILK," WAS ONE REACTION. AT THIS STAGE, BOTH THE SCHEDULE AND BUDGET WERE "FLEXIBLE."

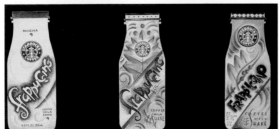
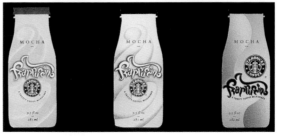

TAKING ONE OF THE DESIGNS AS THE CLOSEST, EVERY ELEMENT WAS DEVELOPED SEPARATELY. THE LETTERING WAS DRAWN UP BY STUDIO DESIGNER GEORGE TANAGI AND SCANNED INTO THE COMPUTER, WHERE RED AND GREEN DOT SHADOWS WERE ADDED TO EVOKE THE ITALIAN HERITAGE OF CAPPUCCINO.

But there was one major problem: although the drink tasted delicious, tests had shown that the ingredients separated in transit, leaving visually unappealing layers of coffee and milk. To overcome this, the entire bottle had to be covered in a preprinted, Fuji-wrap label, which meant that there would be lots of room for graphics.

At first, Jack Anderson's only brief, apart from the product details, was "here's the name, do your magic." He was, of course, working with someone he knew well—Scott Bedbury, a very astute marketing man, who was vice president of Starbucks. The product already had a name, a clever blend of the words frappé, iced or cooled liquid, and cappuccino, the froth-topped, milky Italian espresso.

Anderson allocated a team of five designers in the studio to work on the project. Julie Lock, Jana Nishi, Julie Keenan, Julia LaPine, and Mary Chin Hutchison knew it was a fun drink which was liked by both kids and adults, so their first ideas tried to put personality into the typefaces. All the lettering ideas at this first stage were drawn by hand as they started to create the lively feeling they were looking for. Anderson explains that he works very hard to retain the craft of design: "It's a constant struggle to keep them off the computer. The brain works faster with a pencil, and I don't

like to freeze an idea too quickly. The computer is an important part of the mix, but too much of it and hand skills dwindle away."

Brainstorming sessions were also an important part of this early work. With such a large team, it was decided to hold review meetings every day in a neutral area, where they laid out all the work on the floor and encouraged other staff members to come and look. "I don't like people to hold things too close for too long," says Anderson. "We encourage borrowing and sharing of ideas, and we hold 'sharette' critiques. It's all very informal—sometimes small meetings take place in hallways."

These first ideas combined a number of significant ingredients in quick pencil renderings.

• The very important Starbucks logo, which was designed in 1978 by Terry Heckler;

• Lines of swirling liquid, a graphic element that had started off as a "notion of steam" and been used on all sorts of items in the shops, from tissue paper to shopping bags and gift boxes. Turned upside-down, it also worked quite well in evoking milky, frothy coffee;

• The name Frappuccino;

• The flavor and other statutory information.

IN ADDITION TO
EVERYTHING ELSE,
FEDERAL REGULATIONS
MEANT THAT ACCURATE
INFORMATION HAD TO BE
INCLUDED ON BOTH BACK
AND FRONT. THE
REGULATIONS ALSO
DICTATED THE SIZE AT
WHICH THE INFORMATION
HAD TO BE GIVEN. THESE
REGULATIONS WERE SO
IMPORTANT THAT
ATTORNEYS FOR BOTH
PEPSI COLA AND
STARBUCKS HAD TO
APPROVE THE ARTWORK.
SHOWN AS FLAT SHAPES,
DAYS OF WORK WERE
SPENT DETERMINING THE
EXACT SHADE OF COLOR
AND GRADUATION FROM
TOP TO BOTTOM.

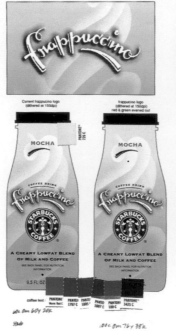

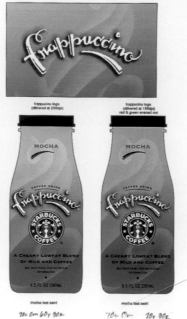

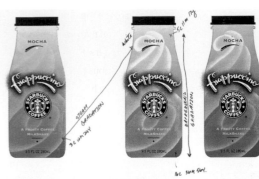

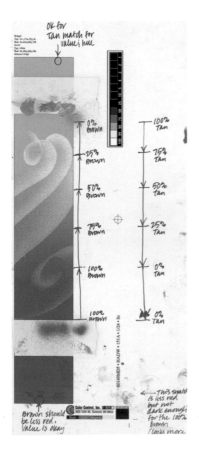

GENERATED BY COLOR
CONTROL INC., THE
COLOR HOUSE
RESPONSIBLE FOR SOME
OF THE TESTS. THIS
CHART HAD A COLOR
SWATCH ON THE TOP TO
COMPARE THE ACCURACY
OF THE COLOR. THE FINAL
FUJI-WRAP LABELS
WERE PRINTED BY
ROTAGRAVURE.

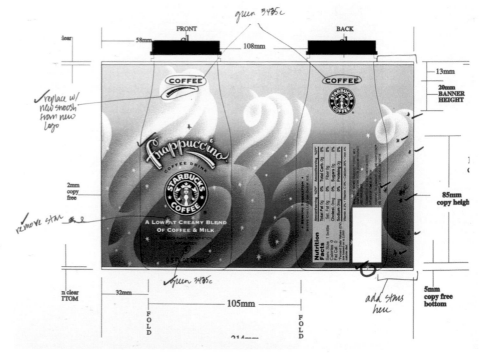

SOME OF THE DOZENS OF
COLOR TESTS THAT WERE
DONE ON THE COMPUTER
AND THEN PROOFED TO
GET THEM AS ACCURATE
AS POSSIBLE.
COMPLICATED
CALCULATIONS CAN BE
SEEN STILL ATTACHED TO
THE TOP.

Anderson showed their first ideas—probably about nine to 12"—to Scott Bedbury, who also sent them to Pepsi in New York. "We got a pretty fast response." If there were any negatives, it was that there was "too much focus on the coffee plant, (i.e. the leafy berry bush), and not enough focus on the coffee flavor mixed with milk," recalls Anderson, whose next stage was to start detailed studies of each aspect. How would the exact lettering look? How obvious should the background swirl be? How could they differentiate between the flavors, initially coffee and mocha?

A large element of the design was the graduation of the background color as it rose toward the top. Anderson explained: "We were producing a road map for a whole series of flavors to follow." Because computers do not always reflect accurately the final color, various tests and trials of graduated color were carried out, which was a vital stage when he was trying to match the colors of the product. During the final stages, the Pepsi product development team and Hornall Anderson production team pushed it through. Looking at the final result, Anderson admits that "it was an interesting journey to be part of." He adds: "You have to know what to change and what not to challenge. then add creative value to it.

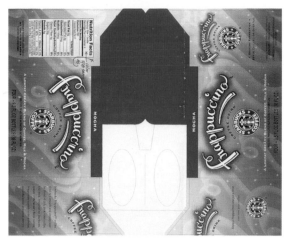

WHEN IT CAME TO APPLYING ALL THE GRAPHICS TO THE FOUR-PACK, THE GRAPHIC SWIRLS, WHICH WERE ADAPTED FROM EXISTING GRAPHICS IN THE COFFEE SHOPS, WERE AN IDEALLY FLEXIBLE BACKGROUND. EXTRA DOTS AND STARS WERE ADDED ON THE COMPUTER.

(BELOW) THE FINAL DESIGN WAS, IN JACK ANDERSON'S WORDS, "A PRETTY CLASSY-LOOKING THING." THE BOTTLES WERE NOT ROUND BUT SQUARE WITH ROUNDED SIDES AND ROUNDED TOP AND BASE. THE WORDMARK HAS NOW BECOME A BRAND IN ITS OWN RIGHT WITH ITS OWN PERSONALITY. AND, MOST IMPORTANTLY, IT HAS SPANNED THE RANGE OF MARKET OUTLETS AND "GAINED A LOYAL FOLLOWING."

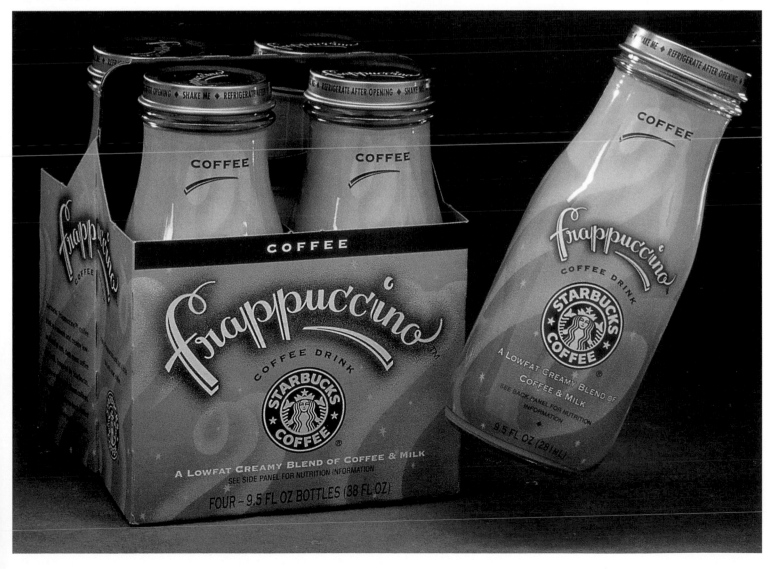

Tony's Freezer Cocktails

Normally, the designers get together with the marketing team and, perhaps, the advertising agency for a few drinks at the end of a project. **In this case, the drinks came first.** United Distillers, a division of Guinness plc, is an ongoing client of Tutssels, which has produced both packaging and brand literature for them. When, in September 1996, United Distillers invited Tutssels to Scotland to join their marketing people, they had already been doing customer

research for four or five months The working title for the project was Ice Caps. It was a range of "high-quality frozen cocktails, straight from the freezer (crushed ice slush texture)," which was going to be targeted at women (18- to 45-year-olds), who would like a classic cocktail at home but were a bit unsure about making them. The brand values were listed as "authenticity, mystery, hedonism." Not only were United Distillers creating a new product with a new name in a new type of pack, but they were looking for a new market too.

The team was asked to try dozens of drinks with different flavors in unlabeled glasses and to give their reactions. Six were chosen, on the basis that three would be launched initially, with the others kept for later.

Back at the design studio, Tutssels' Marcus Jones and his team spent days thinking up a long list of names, and they started to make the fashionable connection to the American cocktail lounge of the 1930s, the colors of Miami Beach, and the retro automobile design and Modern-style American kitchen. From there, the sexy curves of the 1950s' Frigidaire were only a short step away.

The imagery would appeal to the target age group and would look good in the supermarkets and liquor stores where the drinks would be sold. It also coincided with the current trends in retro-style kitchen equipment. There were 10 designs in the first concepts presentation, which took about

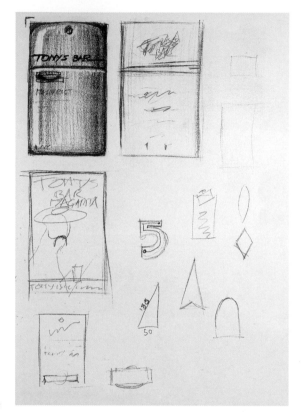

THE FIRST APPEARANCE OF THE REFRIGERATOR IDEA WAS ON A PAGE OF WORDS AND DIAGRAMS.

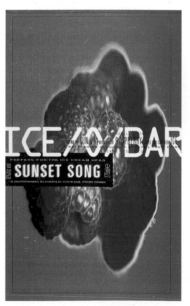

FULL-ON, TRENDY TYPE AND VIBRANT, DISTORTED FRUIT PHOTOGRAPHS PITCHED THE PRODUCT AT A YOUNG MARKET, WHILE STILL HINTING AT THE REAL FRUIT CONTENTS. LAYERS OF INFORMATION WERE PRESENTED IN MAGAZINE STYLE TYPOGRAPHY.

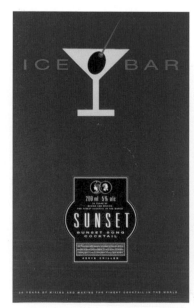

NEON LETTERING AND "DRINKS LABEL" GRAPHICS WERE COMBINED ON A GRADUATED BACKGROUND TO EVOKE THE 1940S' COCKTAIL LOUNGE OF RAYMOND CHANDLER.

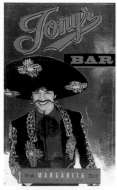

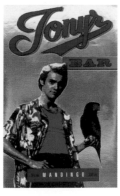

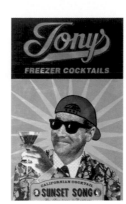

ANOTHER THEME THAT DID NOT MAKE IT PAST THE FIRST PRESENTATION WAS THE IDEA OF TONY THE TROPICAL CASTAWAY, TONY THE MEXICAN MARIACHI, AND TONY THE BARTENDER IN THE FUNNY HAT.

IN THIS ALTERNATIVE FROM STAGE ONE, THE OLIVE HAD EMERGED FROM THE COCKTAIL GLASS TO BECOME THE THEME OF THE PACKS. ITS HOLE FORMING THE FOCUS FOR THE CAREFULLY POSITIONED, IF UNDERSTATED, PRODUCT NAME.

IN THIS SOLUTION THE ICE-O-BAR LOGO SEEMS TO GLOW OUT OF THE BOTTOM OF THIS OUT-OF-FOCUS NEON. THE ELEGANT, CIGAR-LABEL-STYLE BANDS WRAP AROUND THE TOP TO DENOTE THE FLAVORS — STRAWBERRY DAIQUIRI, MANGO DAIQUIRI, AND CLASSIC MARGARITA.

PASTEL-COLORED "ICE BOXES" UTILIZED THE AMERICANA STYLING OF HARLEY EARL AND THE REFRIGERATOR DESIGNS OF THE 1950S. THE DELICATE AIR-BRUSHED HIGHLIGHTS AND SHADOWS GAVE THE FLAT GUSSET PACK AN ADDED DIMENSION.

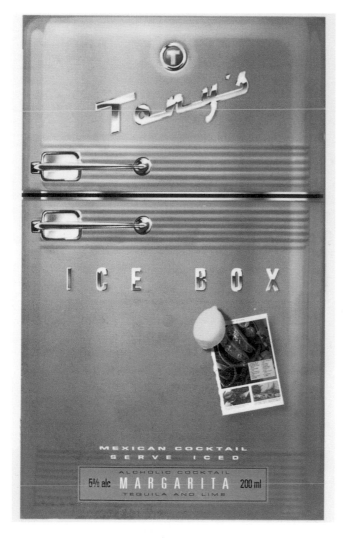

three weeks to come together, but an early page of pencil scribbles shows that they also thought of ice sculpture, cocktail shakers, and a rolaskating (sic) barmaid.

The name Ice Caps had changed to Is-O-Bar and Ice Box, and the ideas, a mixture of scrap art and highly finished lettering, were presented as same size flat sheets. The Mexican character ideas were considered to be "too tongue in cheek," but the refrigerator solution was liked by the client for its wide-ranging and light hearted appeal.

During the two-week development stage, the idea emerged of using refrigerator magnets to highlight the three flavor alternatives. Marcus Jones scoured junk shops, picture libraries, and old books for refrigerator references, and even searched the BBC's props department. He also started to look behind the refrigerator, wondering if seeing the contents through a cutaway in the back might be fun.

The final choices went off for several weeks of customer research, and although there was some confusion about the names of the products and the contents (the refrigerator magnets needed to work harder), consumers saw it as "original, intrusive, and engaging." Illustrator Syd Brak was commissioned to produce the almost three-dimensional air-brushed refrigerator drawings as well as the strawberries, parrots, and palm trees that would be the magnets.

All that remained was to prepare the final artwork, which was developed with packaging technologist at United Distillers, Bill McCarthy, so that it could be printed by photogravure and still retain the vibrancy.

DEVELOPMENTS
INCLUDED
STRENGTHENING THE
"TONY'S" LOGO AND
COMBINING IT WITH A
"CHROME" PRODUCT
DESCRIPTION. THE TOP
AND BOTTOM HAD ALSO
BEEN ROUNDED OFF
AND HIGHLIGHTS
EMPHASIZED, IN THIS
ALTERNATIVE COLOR
VERSION, WHICH
EXTENDED THE RANGE
TO SIX.

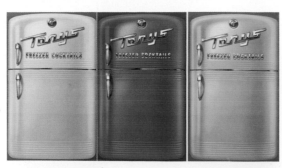

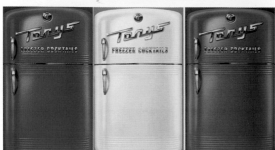

AMONG THE IDEAS FOR
POINT-OF-SALE PRO-
MOTIONS THAT THE
DESIGNERS PRODUCED,
WAS A "BLOCK OF ICE"
THAT HELD THREE PACKS,
AN ON-SHELF "FREEZER
COMPARTMENT," AND
SEVERAL FLOOR
STANDING
"REFRIGERATOR"
DISPENSERS.

ATTENTION WAS PAID TO
EVERY TINY DETAIL,
INCLUDING THE BADGE,
THE REFRIGERATOR
HANDLES, AND THE
CHROME-EFFECT
LETTERING, WHICH WERE
DRAWN AT LARGE SCALE
AND THEN REDUCED.

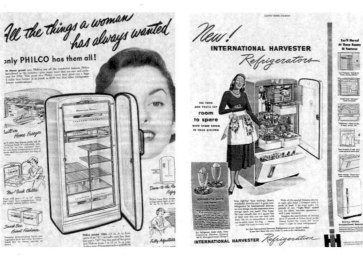

PAGES OF
MOUTHWATERING
REFERENCES EVOKE THE
AMERICAN KITCHEN OF
THE 1950S, ALTHOUGH
MOST OF THESE
CUTTINGS CAME FROM
BRITISH MAGAZINES AND
INCLUDED DUBIOUS
BRAND NAMES SUCH AS
PHILCO, NORGE, AND
INTERNATIONAL
HARVESTER.

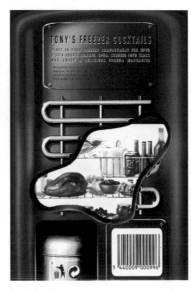

(LEFT) ALTERNATIVE
WAYS OF PRESENTING
THE BACK OF THE PACK
INCLUDED A VIEW OF THE
CONTENTS AS WELL AS
PLACES FOR PRODUCT
COPY, BAR CODE, AND, ON
ONE SOLUTION, THE RE-
CYCLE AND WASTE
SYMBOLS APPLIED TO
THE REFRIGERATOR'S
MOTOR.

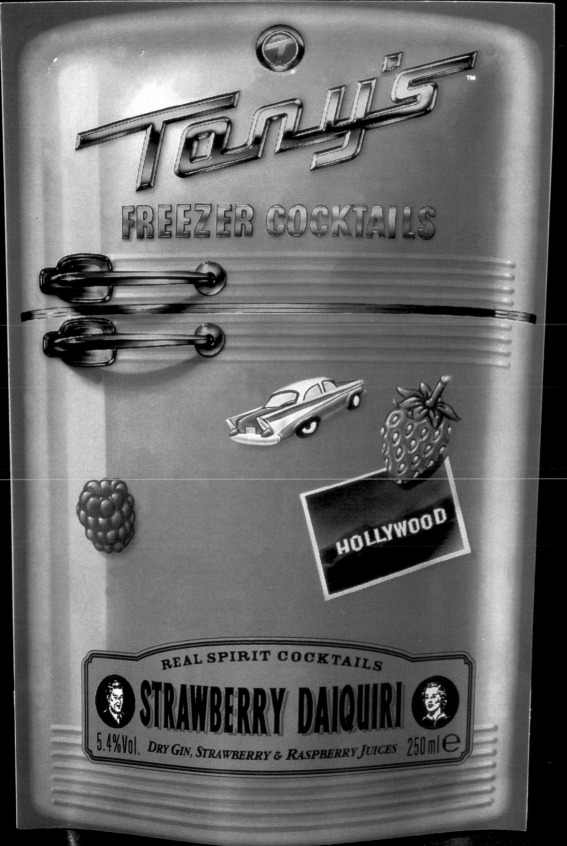

Bartletts

Although she did not realize it, putting beautiful old photographs of fruit onto bottle labels combined the three design skills that Louise Fili has spent her life perfecting: **immaculate typography,** from her early days with American typographer Herb Lubalin; **classic book** illustration, reflecting her work as art director at Pantheon Books; and **finely focused packaging,** refined by her years of running her own small design company

Having worked for two years from her home, Fili is now based in a studio on New York's Fifth Avenue. When she decided to look beyond her design work on book jackets, and because she is a good cook from an Italian family, architects recommended her for restaurant graphics, and an agent approached her to work for wineries on the East Coast. In 1992 her second enquiry came from a company called Bartletts, a small winery in Maine run by a young couple, Bob and Kathe Bartlett, which was getting good marks for its fruit wines.

Despite the fact that her quote was not expensive, the Bartletts thought that at that stage the investment needed was too great and told Fili that they would call her back in three months. In fact, it was three and a half years, but the Bartletts were quite ambitious. They knew it would involve revamping their entire packaging, not just the design of the labels.

So Fili traveled to Maine. The winery is a personal operation in which the Bartletts did almost everything. Although they made large quantities, it was out of season, so there was not a lot to see. Nevertheless, Fili knows that "it is important to visit a client on site—you can talk face to face."

BUSINESS CARD, LETTERHEAD AND ENVELOPE ALL CARRY THE SAME PEAR IMAGE THAT FILI FIRST SHOWED AT THE INITIAL MEETING. SELF-ADHESIVE LABELS WERE USED AS AN INITIAL TEST TO EXPLORE THE QUALITY.

(*BELOW*) THIS EARLY ALTERNATIVE SHOWS HOW THE DESIGNER TRIED TO INTEGRATE TYPE AND PICTURE BEFORE DECIDING TO KEEP THE TWO SEPARATE.

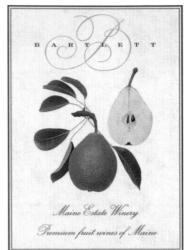
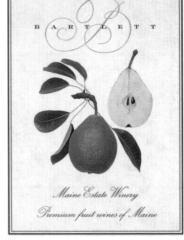

FILI EVENTUALLY FOUND THE SPRAY OF BLUEBERRIES GROWING IN THE WILD IN THE WOODS. OF ALL THE WINES, THIS IS THE ONE RELEASED ONLY IN NOVEMBER EACH YEAR. IT IS MADE BY A PROCESS OF CARBONIC MACERATION THAT IS UNIQUE TO BARTLETTS.

Pear Wine
semi-dry

A premium New England fruit wine

Produced & Bottled by Bartlett Maine Estate Winery
Gouldsboro, ME • BW3 • Alcohol 11.5% by Volume

(*ABOVE AND LEFT*) BARTLETTS ALREADY HAD LABELS—WATERCOLORS DONE BY A FRIEND THAT WERE PRINTED IN FIVE COLORS, WITH A DIFFERENT ILLUSTRATION ON EACH FLAVOR. BUT FILI THOUGHT THAT BOTH THE PAINTINGS AND THE HAND-DRAWN CALLIGRAPHY HAD BECOME DATED. "THEY WERE A BIT 1970S" AND DIDN'T REFLECT THE TOP-OF-THE-LINE PRODUCT INSIDE."

Honey Wine
s w e e t

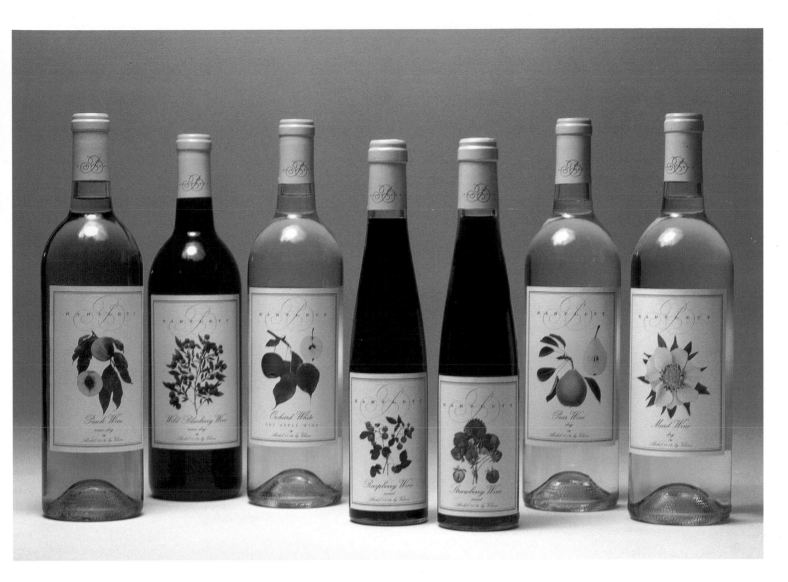

To make the best use of her visit, Fili didn't go empty handed. She knew it might be the only time that she and the Bartletts would meet, so she took samples of illustrative treatments and a piece of script of the letter B. "I figured they'd either love it or hate it, and it was better to find out right away," she reasoned. "I didn't show them everything, and I was careful about the order I showed things," explains Fili. She included two old, hand-tinted photographs she had bought in a flea market on Sixth Avenue for $10 each—a pear and a peach. The Bartletts liked them, so this "got me started," says Fili.

Clients are often nervous about change, but Fili had rationalized and then replaced every element on the existing labels, so there would be a relationship to the constituent parts that people were used to seeing.

When she got back to New York, Fili created a fresh problem for herself. In order to follow the route she had suggested, she now had to find 17 more labels in exactly the same style and there was n'ot any leeway in the budget for new illustrations. She started to comb antiques markets, picture libraries, and old bookshops. Before long she found other illustrations, all produced as a series in 1910. At first, she just found torn-out pages as she ticked off, one by one, the fruits on the client's list.

Eventually her search for all the fruit illustrations had exhausted every resource, and she had even found a couple when she had been on holiday in Paris. However their technique—hand-colored black-and-white photographs—wasn't the same. Finally, her desperate search for wild blueberries, which may have been thought too ordinary to include in the 1910 series, led her one Sunday afternoon to the woods behind her house in the country. She picked a bunch of the fruit and rushed back to New York, where photographer Ed Spiro photographed them and Ralph Wernli replicated the turn-of-the-century style by retouching the color.

Even while work on the design was under way, Fili started to contact printers. The Bartletts did not want to apply the labels with glue—"too messy"—so that meant pressure-sensitive labels printed on rolls by the flexographic process, which is "very primitive," and it is quite difficult to find printers to do it. In fact, Fili managed to locate only two, one in Oregon and one in Canada. Using the client's letterhead and a label by Fili that reflected the wines as a test, she finally decided on Dana Labels in Oregon, but even then, she had all the color separations done herself. "In the end you have to do as much as you can for the printers—that way there are fewer disappointments."

FILI AND HER TWO ASSISTANTS IN THE STUDIO WORKED AT COMBINING ALL THE NECESSARY ELEMENTS ON ONE SMALL LABEL. THEY WORKED WITH THE PEAR AND THE PEACH, PREPARING SEVERAL VARIATIONS. WORKING WITHIN GOVERNMENT REGULATIONS WHILE KEEPING THE LABELS SIMPLE AND ELEGANT WAS QUITE TRICKY, AND FILI HAD TO SEND OUT LASER PRINTS FOR APPROVAL. FORTUNATELY, THERE WERE TWO LABELS ON EACH BOTTLE, SO THE ONE ON THE BACK CARRIED MOST OF THE MANDATORY INFORMATION. IT WAS A TIME-CONSUMING PROCESS. THE GOVERNMENT MADE MORE CHANGES THAN THE CLIENT DID.

Boaters

This, recalls the designer Ian Logan, is one of those jobs where "I had the solution right there in the meeting while the managing director of Boaters, Richard Affleck, was briefing me. Of course, I didn't tell him what it was, but **everything I've ever done has been intuitive**, my gut reaction has always paid off"

In this case, it paid off for the Boaters Coffee Company Ltd too. They had already worked with The Ian Logan Design Company on their first foray into the flavored coffee market when, following the redesign of a range of 12 packs, sales leapt by 60 percent in two months.

The company first met Logan not at a design event but at an international food fair where Logan's company had a display. It is something they have been doing for the past 20 years—in fact, since the days when Logan was a producer of containers as well as a designer of them. "We don't always get work, but sometimes it pays off to make the effort, even a few years later," he confides.

For the second range of coffees the brief included a sample white pack made in the United States, called a "zip valve" pack, which had two special features: a tiny resealable valve in the back that let you smell the aroma without letting in air to spoil the contents, and a two-tier strip-off top with a resealable zip for continued freshness at home. These gave the product a tremendous added appeal because they had never been used for coffee before, and they allowed customers to experience the distinctive aromas, the main product benefit. The new range was intended to be butterscotch toffee, mocha orange, Irish cream, and rich hazelnut flavored coffees.

Logan had a passion for the work of illustrator Chris Wormell, who works with wood-cut and lino-cut techniques in the style of English book illustrator William Nicholson and the German poster designer of the 1900s, Lucian Bernhard. In fact, he had commissioned Wormell for a number of projects over the years. "He's one of the finest wood-cut artists in the world," is Logan's assessment.

From a book by Chris Wormell called *The Cook's Journal* they photocopied an illustration of a coffee pot and cup that perfectly captured the feeling they were looking for. Logan sets a lot of store by this first stage. He enjoys the research aspect and spends a lot of time looking at shops, museums and archives. He says it is usually the most expensive stage in terms of design fees, but they always solve the problem at stage one. Sometimes one designer is allocated to a job, sometimes two or three, and occasionally the whole studio gets to work as a team.

The graphics were to be applied as labels onto preprinted flat containers that would be produced in the United States. They could have had colored labels on a white pack, but the real drama came from making the packs black, which

PAGES FROM ILLUSTRATOR CHRIS WORMELL'S BOOK WERE USED AS PART OF FLAT COLLAGE CONCEPT BOARDS THAT CONVEYED THE DESIGNER'S APPROACH.

"BIG, BOLD, CLOSELY CROPPED" SAYS A PENCIL NOTE BESIDE ONE OF DESIGNER SARAH HINGSTON'S SKETCHES TO BRIEF THE FINAL LINO-CUT ILLUSTRATIONS.

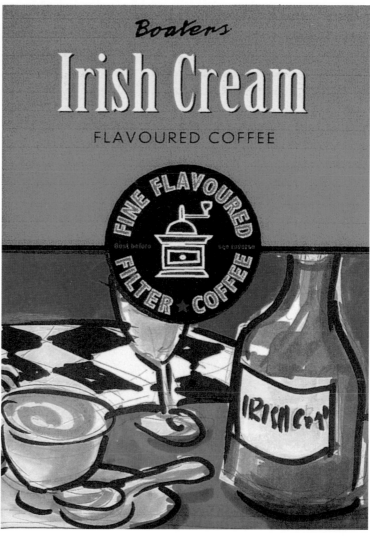

ALTHOUGH LOGAN'S INITIAL VISION SPECIFIED THE TYPE OF ILLUSTRATION, WORK STILL HAD TO BE DONE IN STAGE ONE ON LAYOUT IDEAS AND WAYS OF USING THE TYPE. ONE PAGE OF ROUGHS WAS VIRTUALLY COVERED WITH WORDS—"HEAVENLY FLAVOR, RELISH THE EXPERIENCE, MADE WITH PASSION, SINK INTO THE EROTIC AROMA"—AND THIS LED TO THE IDEA OF A LITTLE LINE OF COPY ABOVE EACH DRAWING ON THE FINAL PACKS.

AS AN ALTERNATIVE TO THE ILLUSTRATION ROUTE, SOME OF THE FIRST DESIGNS JUST HAD A TYPOGRAPHIC LABEL ON A BLACK STICKER, WHICH BLENDED IN WITH THE BLACK BACKGROUND.

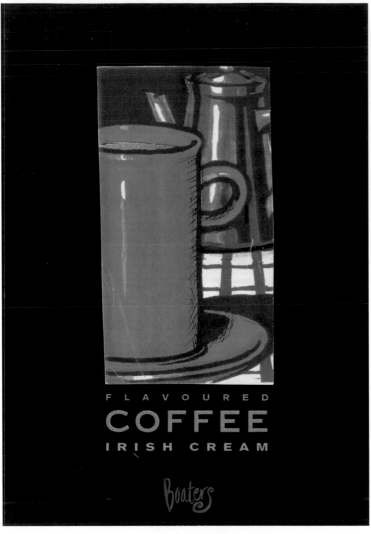

FLAVOURED
COFFEE
IRISH CREAM

Boaters

FLAVOURED
COFFEE
BUTTERSCOTCH
TOFFEE

WHEN STARTING WORK ON A NEW PACK, LOGAN WILL OFTEN ASK WHERE IT IS TO BE SOLD RATHER THAN TO WHOM. HE LIKES TO KNOW THE LEVEL OF THE POTENTIAL MARKET AND THE ENVIRONMENT IN WHICH THE PRODUCT WILL BE SEEN. *(ABOVE)* THIS PRESENTATION ROUGH HAD ALL THE INGREDIENTS IN PLACE: THE BLACK BACKGROUND, THE STRONG BUT TIGHTLY CROPPED DRAWING, AND THE VARIOUS LEVELS OF INFORMATION.

integrates the drawings, makes the whole pack look bigger, and gives the impression of high quality.

The client was "a bit surprised" but Logan's enthusiasm convinced them. He also took the packs to show, a leading supermarket chain in the U.K., which thought they looked great. "That did it. No customer research—that's the nice thing about working for small companies. Market research is sometimes useful, but often waters things down."

The first stage is usually done with sketches, which might then be scanned for development and application. The next stage for Boaters was to brief the illustrator to work on roughs of all four lino-cuts, each one depicting an aspect of the ingredients and emphasizing a different color. Unusually, the designers have been able to collect a lot more sales information than might normally be possible. The product was, of course, an immediate success, going into 350 large supermarkets, as well as other retailers. Sales in the first six months were $80,000, climbing to exceed the $240,000 projection for the first year.

A more immediate indication of the coffee's appeal came during the launch at a recent international food fair. One by one all the samples were stolen from the display. The client was "overjoyed."

INSTEAD OF USING THE ILLUSTRATION AT FULL STRENGTH, THIS IDEA SHOWED WHAT WOULD HAPPEN IF IT WERE TONED DOWN TO A MONOCHROMATIC BACKGROUND PATTERN THAT LINKED EACH FLAVOR VARIANT. THIS TIME, THE WHOLE LABEL BECAME A CRINKLED-EDGE RECTANGLE.

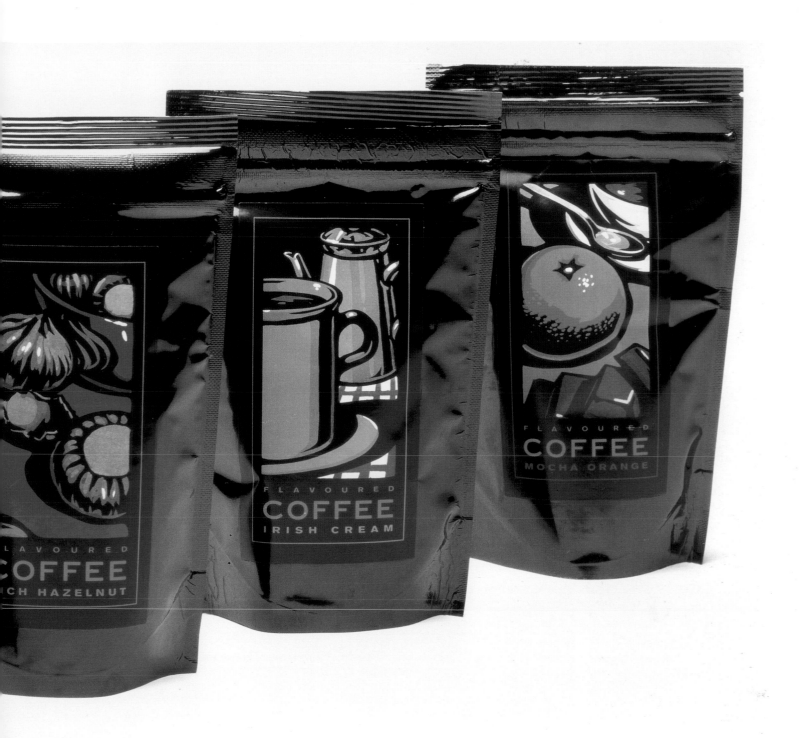

FLAVOURED
COFFEE
NCH HAZELNUT

FLAVOURED
COFFEE
IRISH CREAM

FLAVOURED
COFFEE
MOCHA ORANGE

BECAUSE THE
ILLUSTRATION STYLE
WAS SO STRONG, EACH
PRODUCT HAD TO HAVE A
COMPLETELY DIFFERENT
COLOR EMPHASIS SO
THAT THEY DID NOT
MERGE TOGETHER.

Sparkling Ice

How many of the projects described in this book start with no brief, just enthusiasm, commitment, and lots of ideas? Here is another. In this example, the company, Talking Rain, had a range of flavored, carbonated water drinks that sold in Club superstores throughout the United States. Jack Anderson knew them well. He and his company, Hornall Anderson Design Works Inc., in Seattle, had done a lot of work for the beverage industry, and he had a whole wall of competitors' products, divided into

quenchers, gulpables, and sippers

In the case of Sparkling Ice, the bottle was unusual—"Not very good, and about to be kicked out in favor of something else," remembers Anderson—when John Stevens and Doug MacLean of Talking Rain came to see him in 1993. It was all fairly informal. Stevens, the proprietor of Talking Rain, and MacLean, who was in charge of research and development and operations, told him their story and the problem they were having "selling water." The first series of flavors included cherry, apple, peach, and berry, in both regular and light (diet) versions, in bottles and cans. The client described the bottles, which held 12 fluid ounces, as "big gulp" bottles.

There were 22 design concepts in the first presentation, recalls Anderson. "Some involved dogs and sleds," but two ideas caught the client's attention. One had the word "Ice" in big, bold type, while the word "Sparkling" was played down. "Ice is the word," explained Anderson. "It's unique to the company's category. What happens when they want to do a non-sparkling version?" For a while Anderson worked up two ideas. "But not for long. Pretty soon, Ice got general acceptance. It took a number of rounds to get it buffed out," he adds, referring to the design development. At the same time the designers presented a bottle with a frosted glass texture—perhaps the secret design element—on the outside.

Stevens and MacLean, together with Nina Morrison, who was in charge of marketing at Talking Rain, were, Anderson

A SERIES OF SIMPLE BLACK BOARDS MADE UP THE STAGE-ONE PRESENTATION, WHICH TOOK THREE WEEKS TO COMPLETE. THE PROFILE OF THE BOTTLE HAD BEEN DRAWN AND PHOTOCOPIED SO THAT VARIOUS GRAPHIC LAYOUTS—ALL IN BLACK AND WHITE—COULD BE APPLIED. ALTHOUGH MOST DESIGNS GAVE GREATER EMPHASIS TO THE WORD "ICE" THAN TO "SPARKLING." ONE SOLUTION (BOTTOM ROW FAR RIGHT) CAUGHT THE CLIENT'S EYE.

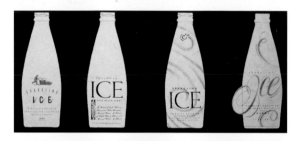

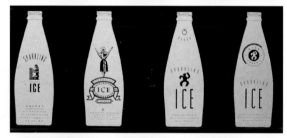

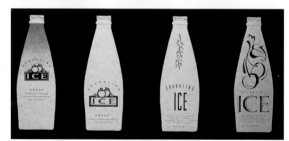

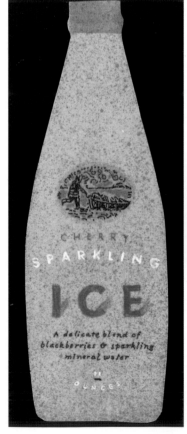

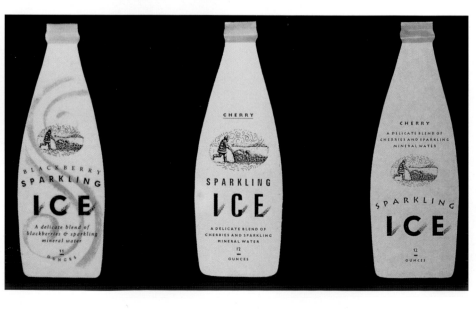

TAKING ONE OF THE SIMPLEST TYPOGRAPHIC SOLUTIONS, THE DESIGNERS TRIED TO SIMULATE THE EFFECT OF A FROSTED GLASS BOTTLE BY SPRAYING TINY GRAY DOTS ONTO TRACING PAPER.

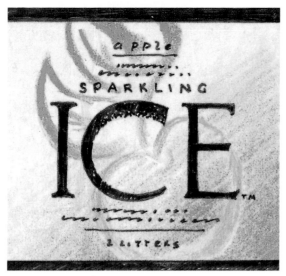 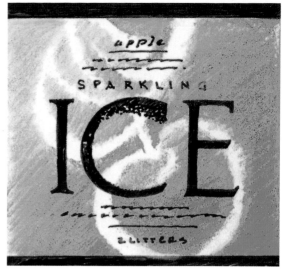

 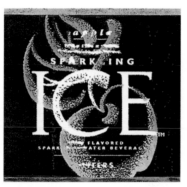

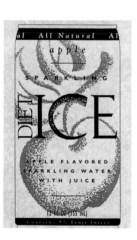 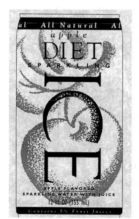

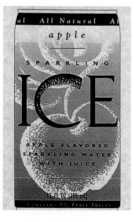 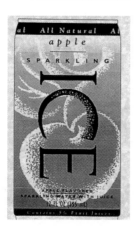

WHEN IT CAME TO THE CANS, THIS SERIES—PRESENTED AS BLACK-AND-WHITE COMPUTER PRINTS—SHOWED HOW MANY VARIATIONS OF TYPE LAYOUT WERE POSSIBLE. FROM THERE, THEY MOVED INTO COLOR, USING CRAYON SHADING AND DRY-BRUSH TECHNIQUES TO EVOKE THE FROSTED GLASS OF THE BOTTLES.

remembers, "really in there with us." They loved the idea and helped Anderson and his colleagues find a glass factory that could produce the effect they wanted by blasting the bottles with tiny beads of glass. This became "the canvas for the first range."

Working on the designs in the studio at Hornall Anderson was senior designer Jana Nishi and her team, although Anderson likes to be closely involved in all the projects. There is a free exchange of ideas within the studio. Anderson calls it "Mr Potato-head design—everyone adds different elements to build up a picture. An idea doesn't belong to any one person."

Although the first presentation showed four flavors, Anderson kept in mind that any solution would need to have the potential to be adapted to many more. He wanted the bottle to be so beautiful that "a secretary might keep it on her desk to put a flower in."

Eventually, the studio found a company in Canada that could produce the graduated frosted effect they wanted, but in the meantime the graphics were developed on paper wrapped around cans and applied to shipping crates. "The simplicity of the first range was a big help," recounts Anderson. "If you know too much at the front side, it paralyzes you."

Needless to say, there were no focus tests and no advertising budget. Initially, Talking Rain sold the product from the trunks of their cars. "It was a very hand-to-mouth company at that stage. They just went to a Club store or a Costco and put the product on the shelves, and customers started to buy it, so the stores loved it too," explains Anderson.

The bottles sold the product and the company has prospered. The most recent additions to the company's range are root beer, tropical fruit flavors, iced teas, all now offered in 16-fluid ounce bottles as well as cans, and the product has gone from warehouse-type stores to the highly competitive retail environment, and "evolutionized" the beverage industry.

REVERSING THE
DIRECTION OF THE
LETTERING, THE SAME
COLOR SHADING—THIS
TIME WITH DIFFERENT
FRUIT DRAWINGS—WAS
APPLIED TO THE CANS, A
WHITE BACKGROUND
BEING USED FOR THE
LIGHT (DIET) VERSION.
NOTES WRITTEN ALL
OVER THE PROOFS—
SUCH AS "TOO MUDDY"—
WERE FOR THE PRINTER'S
ATTENTION.

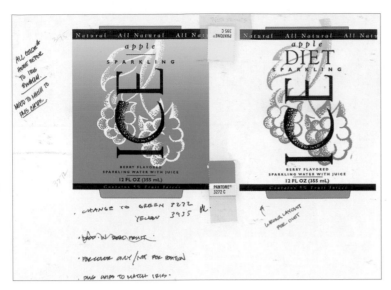

THIS SHEET OF PROOFS,
FOR WHICH THE SAME
APPLE ILLUSTRATION
WAS USED, SHOWS HOW
COLOR COULD BE USED
TO DIFFERENTIATE
AMONG SIX DIFFERENT
FLAVORS.

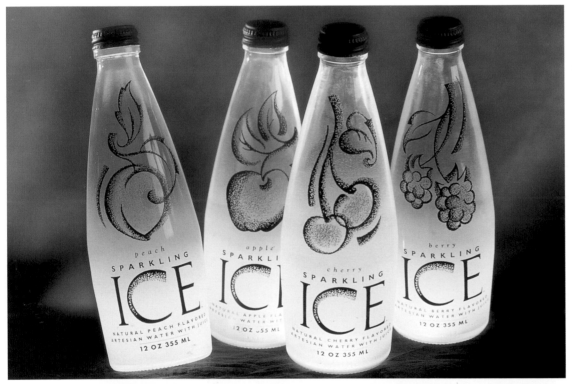

THE FIRST SERIES OF FOUR
16-FLUID OUNCE, "BIG
GULP" SPARKLING ICE
BOTTLES HAD TWO UNIQUE
ELEMENTS: GRAPHICS
WERE ENAMELED ON THE
BOTTLE, AND THE SURFACE
WAS BLASTED WITH TINY
BEADS OF GLASS.

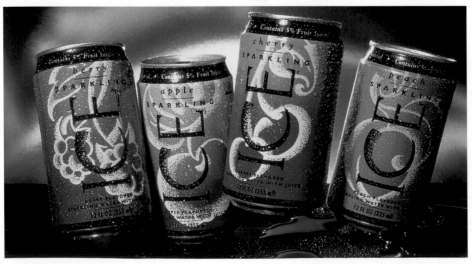

THE FINAL CANS FROM
THE INITIAL LAUNCH OF
FOUR FLAVORS HAD THE
WORD "ICE" RUNNING
FROM BOTTOM TO TOP SO
THAT THE TYPE STOOD ON
ITS HORIZONTAL BASE.
WHEN SALES INCREASED,
THE CLIENT WAS "VERY
GENEROUS IN HIS
ACKNOWLEDGEMENT OF
THE DESIGNER'S ROLE,"
RECALLS ANDERSON.

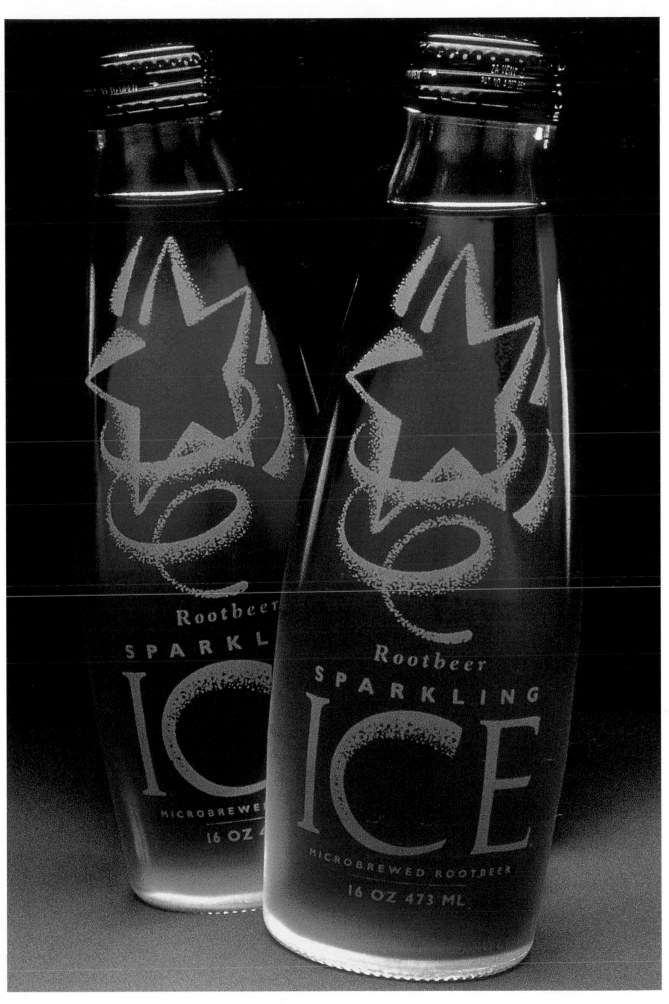

SEVERAL YEARS LATER, THE LATEST PRODUCT IN THE FOURTH GENERATION OF THE DRINKS, WHICH NOW INCLUDE TEAS AND ORANGE DRINKS, WAS ROOT BEER. FROM THE BEGINNING, JACK ANDERSON KNEW THAT THE BOTTLES COULD BE BEAD BLASTED, BUT WHAT HE DID NOT KNOW WAS WHETHER THE EFFECT COULD BE GRADUATED. ALTHOUGH IT IS MORE WIDELY DONE NOW, AT THE TIME THE TECHNIQUE WAS AVAILABLE FROM ONLY ONE MANUFACTURER IN CANADA. INSTEAD OF THE DRAWINGS OF FRUIT, THIS VARIATION HAD A STAR MOTIF, TO GIVE IT AN "ALL AMERICAN" FEEL.

WH Smith Stationery Range

Most client briefs include a fundamental description of the product to be packaged, but when Trickett & Webb began work on this new range of stationery, the products grew out of the design solution chosen by the client. Like most large retailers in Britain, WH Smith has a roster of designers, and this was not the first job that Trickett & Webb had undertaken for the company, and nor was it the first time the designers had **delved into the nostalgia drawer for a solution**

Brian Webb enjoys researching historical design material almost more than any other stage of a job, and he often spends his weekends in museums and libraries. "Looking at what's been done before," he explains, "can often bring to light forgotten techniques as well as solutions."

The design company has often used printed ephemera as inspiration. It once designed a range of men's gifts including shoe cleaning, D.I.Y., and car-cleaning kits for Marks and Spencer, which were inspired by "pulp fiction" book covers. These were so popular that one store sold out its stocks within an hour. In the end, the tins went on selling, even after the shoe-cleaning supplies ran out.

There was no brief for this project, just a letter asking the designers to produce ideas for a series of gift ranges: "Think of different areas of the home." The products were due to be completed, produced, and in stores by August 1996, eight months after the briefing, although they were not specifically targeted at Christmas sales.

Each of the five ideas was "backward looking"—that is, based on nostalgia—and presented on flat presentation

(*RIGHT*) USING THE SAME FLAT SHAPE OF A BOX OF NOTECARDS AND ENVELOPES, THE FIRST PRESENTATION SHOWED SO MANY ALTERNATIVES THAT WH SMITH WAS OVERWHELMED. EACH CAME WITH ITS OWN UNIQUELY CRAFTED LABEL, SOMETIMES REFERRING TO THE SOURCE OF THE PATTERN. "THE MORE STORY YOU CAN CREATE, THE MORE SATISFYING IT IS TO THE CUSTOMERS," EXPLAINS WEBB.

(*ABOVE*) MAKING OVERALL PATTERNS THAT COULD BE CUT AND WRAPPED ACROSS VARIOUS ITEMS OF STATIONERY, THE TEAM USED THE FULL RANGE OF NOSTALGIC IMAGERY —INCLUDING STAMPS. THIS IS ONE OF THE DESIGN FIELDS IN WHICH TRICKETT & WEBB'S WORK HAS BEEN MOST WIDELY SEEN.

UTILIZING VARIOUS
COLLAGE TECHNIQUES
AND A LOT OF COLOR
PHOTOCOPIES, SOME OF
THE PATTERNS HAD
SEVERAL VARIATIONS TO
SHOW THEIR FLEXIBILITY.
SINCE THE PRODUCTS
WERE EPHEMERAL, THEY
COULD BE MORE
SEASONAL THAN USUAL
AND, IN THE WORDS OF
THE CLIENT'S INITIAL
LETTER, "AS EXTREME AS
YOU LIKE."

THE GARDENER'S
YEARBOOK

boards. The work took three weeks. "They asked for two weeks," remembers Webb, "but we wanted a month, and we split the difference."

A favorite route of the designers was the 1950s ephemera idea, but there were also various floral solutions and patterns made from scattering envelopes, matchbox labels, lottery tickets, and even jeans' labels across colored backgrounds. They recall that "the reaction was stupendous—they wanted to do them all. They seemed to hit a nerve with them."

At this stage there was still no list of products, but the designers had suggested possible ideas and sketched out pens in terracotta pots, garden diaries, boxes of envelopes and even fridge magnets. The garden seed package was everyone's favorite route, and it seemed to suggest a wider range of applications with a broader appeal than some of the other ideas. The target market was women aged 25 to 45, but the product was supposed to appeal to children, too. The final line-up was of about 12 products, often based on existing forms, and manufacturers were sourced by the buyers at WH Smith, although the designers also suggested some extras too.

(ABOVE AND LEFT) THREE VARIATIONS ON A COVER FOR THE GARDENER'S YEAR BOOK SHOW THE IDEA OF USING NOSTALGIC SEED PACKAGE-TYPE ILLUSTRATIONS, AND A FIELD OF SUNFLOWERS THAT EVOKES THE SAME FEELING.

DRAWING ON THE THEME OF GARDENING, TRICKETT & WEBB HAD MANY PACKAGING IDEAS, PRESENTING BOTH STATIONERY AND KITCHEN ITEMS IN WAYS THAT RELATED TO THE GARDEN.

ALTHOUGH NOT USED IN THE END, WEBB AND HIS TEAM CARRIED THE SEED PACKAGE IDEA THROUGH TO SHOW PRICE LABELS .

(RIGHT) ALTHOUGH THE PRODUCTS WERE ALL DIFFERENT, THE THEME AND THE GRAPHIC SOLUTION MEANT THAT BOTH PACKAGED AND NON-PACKAGED GOODS BELONGED TO THE SAME FAMILY, AND CRATES AND TERRACOTTA POTS COULD OFFER FRESH SOLUTIONS TO BROADEN THE APPEAL OF THE RANGE.

The idea for the seed package turned out to be simple and straightforward. Although it was based on cigarette card illustrations and seed packages, for copyright reasons all the illustrations had to be newly painted, which was done by a company called Westcott Design that specializes in illustration for textiles. There were six different paintings, and these were "scattered" across a background of old engravings of garden tools, to produce a pattern that could be cut and wrapped into various permutations on various products. The designers recall that there was a "huge discussion about what flowers to use, and which ones people would recognize."

The concept was also applied directly to products such as diaries and notebooks, aprons, and other fabric items, for which no packaging was needed at all. By March 1996 all the artwork was ready for the printers and manufacturers, but Webb and his team remained involved right through the production process, checking specifications, passing color proofs, and generally making sure that no detail had been overlooked.

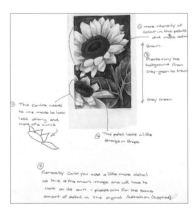

(LEFT) SEVERAL STAGES IN THE PROGRESS OF THE SUNFLOWERS, FROM A POLAROID FOR REFERENCE, TO DEVELOPMENT NOTES FOR THE ILLUSTRATORS. (BELOW LEFT) WITH THE HELP OF THE COMPUTER, THE DESIGNERS PRODUCED TWO WIDELY DIFFERENT PATTERN LAYOUTS WITH WHICH THEY COULD EXPERIMENT.

TRADE SECRETS OF GREAT DESIGN

Dewars

Most designers relish the first stage of a design project more than any other; doing the research, looking for inspiration, holding brainstorming sessions, and scribbling down exciting ideas. So what sort of designer is it who **hands over this truffle to a group of inexperienced college students** in four Scottish art schools? Not only that, the designer persuades the client, United Distillers, **to offer cash prizes to the three winners**

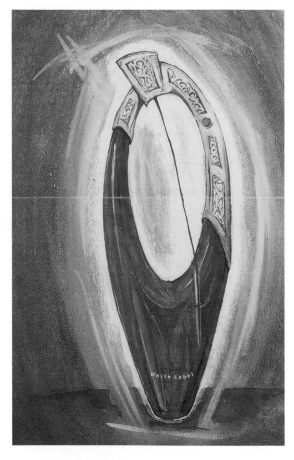

THE WINNING DESIGN, ILLUSTRATED BY FIONA BURNETT, WHO WAS AT THE TIME A THIRD-YEAR STUDENT OF GRAPHIC DESIGN AT THE DUNCAN OF JORDANSTONE COLLEGE IN DUNDEE. THE DECANTER DREW ON CELTIC ART FOR ITS INSPIRATION AND TIMELESS APPEAL.

The answer is Glenn Tutssel, veteran packaging and brand builder, whose design company, Tutssels, has been responsible for some of the most successful and famous identities around, not to mention picking up some of the most prestigious design awards since its foundation in 1993. But once you know that Tutssel spends two or three days a month as visiting lecturer and external assessor at several colleges, the idea makes more sense.

The brief was to design a special decanter for the 150th anniversary of a Scottish whiskey manufacturer. Dewars has a 100-year history of producing celebratory containers to mark special occasions, and this one, more special than most, was to be produced as a limited edition of 1,846 and sent to the rich and famous decision makers of the world.

Art school students in Dundee, Aberdeen, Edinburgh, and Glasgow were asked to visit the Dewars Museum, in Leven, Fife, and to provide concept ideas that were "new, modern, and different." The submissions should, it was stipulated, reflect the core values of the Dewars anniversary—timelessness, quality, and spiritedness—and the unique contemporary positioning of the brand around the world. The submissions could be in the form of completed pieces or models, artwork, or detailed designs. If drawings only were submitted, they should include side, top, and three-quarter elevations. Submissions should also include a written rationale (one or two paragraphs) for the design and a short written account of why the chosen materials were environmentally friendly. All submissions, it said, should include designs for an appropriate box or carton.

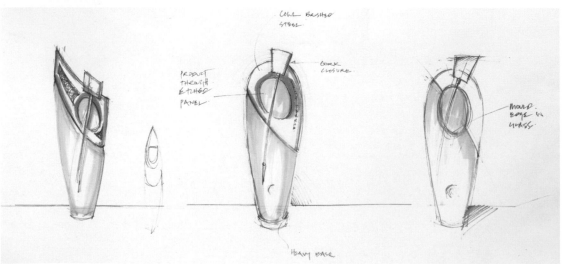

THREE PEN AND INK DRAWINGS SENT TO THE CLIENT TO SHOW HOW THE BOTTLE MIGHT BE FORMED WITH A HOLE IN THE CENTER. THE CAP WAS HIDDEN INSIDE THE REMOVABLE PIN, WHICH WAS LOCATED IN A "RECEIVER." ATTACHED TO THE GLASS.

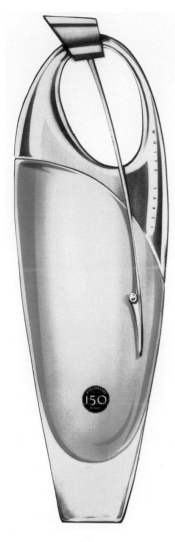

THREE PRECISELY
RENDERED
ALTERNATIVES EMERGED,
EACH OF WHICH
REDEFINED THE
ORIGINAL IDEA. ONE
STILL HAD A HOLE IN THE
CENTER, AND SEVERAL
HAD A HEAVIER GLASS
BASE. THE BROOCH AND
THE METAL CAP HAD
BEEN SIMPLIFIED,
REMOVING THE CELTIC
DECORATION SO THAT
THE PEWTER COULD BE
CAST MORE EASILY.

A SERIES OF TECHNICAL DEVELOPMENT DRAWINGS FOR THE DECANTER. ON ONE *(ABOVE)* THE PROFILE INDICATES THAT THE HOLE HAD NOW BECOME A "RECESS" ON BOTH THE FRONT AND BACK, WHILE ON ANOTHER *(FAR RIGHT)* THE BOTTOM OF THE METAL BROOCH WAS CLIPPED TO A DIMPLE FORMED IN GLASS.

BURNETT'S ORIGINAL PROPOSAL INCLUDED A DARK BLUE STURDY CARD BOX, MADE FROM RECYCLED MATERIAL. THE ANNIVERSARY DATES WERE EMBOSSED ON THE TOP, WHILE INSIDE, THE BOTTLE WAS TO BE WRAPPED IN LINEN.

Of the 300 entries, Tutssel and the five other judges liked the submission from Fiona Burnett, a student at Duncan of Jordanstone College of Art in Dundee, for its blend of Celtic heritage and contemporary form. In her short written rationale, Burnett directly addressed the three key aspects of the brief.

Timelessness? Celtic art in itself is timeless, with its popularity even today. This gives the design a classic, stylish appeal. Quality? The elegance of the elongated form and the delicacy of the decoration give the design a sense of quality. Spiritedness? The flowing, oval shape seems far from inanimate. And on pouring, the whisky would swirl beautifully through the gentle curves.

Although the sketches she produced were not very practical, they provided the impetus to use the shape of a Scottish brooch . "We were only really looking for a direction," Tutssel says. "It wasn't a working drawing, and it needed a bit of development to adapt it to suit production. Her drawing was very feminine and decorative, and we played with the design to make it appeal to both sexes while keeping its beauty. To devise a working drawing for something like this, the designer has to understand glass, volume capacities, and stress points."

For a start, Burnett's designs showed a hole in the bottle, which would have proved impracticable, because this hole would have increased the size of the packaging and made the base very thin which would not make the bottle capable of standing up. This was changed to an opaque, etched, sand-blasted effect in the form of a transfer, which was placed on the bottle to give the impression of a hole.

Burnett had the opportunity to work with Tutssels' deputy creative director, Nicholas Hanson, and his team during the development stage. Steven McDonald, head of production at United Distillers, was able to help with practical considerations and cost constraints.

Another aspect that made the solution unusual was the precise marriage of steel and glass, which meant that the dimensions had to be adjusted back and forth between the glass and the metal suppliers. Originally, Tutssel had imagined that pewter would be used, but this proved impracticable.

The bottles were made in France and shipped over to the U.K. for the metal to be fitted precisely. They then went to Scotland to be filled. The whole process took seven months, with two months required for filling, labeling, boxing, and shipping.

In retrospect, Tutssel wonders if they might not have made more capital of the handmade aspects of the production techniques, given that, as a limited edition, its budget provided opportunities not normally available to package designers. Each decanter cost approximately $80 to produce. Customer research is more difficult on a project of this kind, because the recipients are heads of state, prime ministers, and movie stars—and the first one went to the Queen of England.

IN THE FINAL DECANTER
THE PIN WAS HELD IN
PLACE FROM ITS FIXING
POINT ON THE CAP, AND
THE INTEGRITY OF THE
CENTRAL HOLE WAS
RETAINED BY FROSTING
THE OVAL. THE MOST
DIFFICULT ASPECT WAS
SOURCING THE PEWTER,
AND AT ONE STAGE THE
DESIGNERS THOUGHT
THAT THEY MIGHT HAVE TO
RESORT TO PLASTIC,
WHICH WOULD HAVE FELT
LIGHT AND WARM TO THE
TOUCH. THANKFULLY A
MORE AUTHENTIC
MATERIAL WAS USED.

Dewar's
FINEST SCOTCH WHISKY

40%vol 75cl

The Conran Collection

This solution to own-brand packaging is **almost shocking in its simplicity,** especially when you know that Conran briefed a design team led by Morag Myerscough, who was more used to working on 80-foot murals and site hoardings and who had never designed packaging before. Although Conran himself was closely involved in the whole design process, Myerscough admits "it was touch and go at one point."

(*ABOVE*) BY LAW, EACH LABEL HAD TO INCLUDE: THE NAME OF THE FOOD; LISTED INGREDIENTS; DURABILITY INDICATION (I.E. "USE BY"); STORAGE CONDITIONS; REGISTERED OFFICE OF THE MANUFACTURER OR SELLER; PLACE OF ORIGIN; AND INSTRUCTIONS FOR USE. THIS LABEL IS ONE FROM THE FIRST STAGE, WHICH MYERSCOUGH CALLED "PHOTOGRAMMES."

(*ABOVE*) RUSSIAN BONDS AND COUPONS WERE COMBINED WITH MAGAZINES CUTTINGS TO EVOKE A FRESH APPROACH TO OWN-BRAND PACKAGING THAT, IN LINE WITH THE NEW STORE, HAD ITS ROOTS IN THE PAST.

(*RIGHT*) NOT EXACTLY THE HONEY BEE THAT CONRAN HAD ASKED FOR, THIS LABEL IDEA COMBINED A SIMPLE PHOTOGRAPH WITH A BLOCK OF COLOR TO DENOTE RANGES OF PRODUCTS.

When it opened in May 1997, Blue Bird was to be Conran's most ambitious undertaking to date, the renovation and refurbishment of a 15,748 square foot garage in London's King's Road, which he envisaged as a food and grocery store, a farmer's market, a kitchen shop, a 240-seat restaurant, and a private dining club. In April 1996 Conran interviewed three consultants to work with him and his in-house team of architects, interior and graphic designers at CD Partnership in Butler's Wharf, itself one of Conran's more far-sighted visions.

The brief was "incredibly difficult," Myerscough recalls, even though, at that stage, no one anticipated the scale of the undertaking: packaging 160 new food products from pasta to jelly through olive oil to chocolate, as well as designing the Blue Bird identity and applying it across signage, stationery, tableware, print, and promotional material. Myerscough already had her own small studio, which she was not prepared to let go, so she accepted the commission on the basis that she would work on the Conran project three days a week in the CDP studio with Dan Thomas, an in-house designer. A second in-house designer, Charlie Thomas (no relation) soon joined the team.

Myerscough relished the opportunity for a fresh challenge, something that was as ambitious in scale as her murals. Conran, in turn, wanted a rather less "designed" approach than the Harvey Nichols packaging that Michael Nash had produced, and he wanted the results applied to "real food, not fashion food." Unencumbered by any preconceived approaches, Myerscough just did what she thought was right, "without thinking about the practicalities."

She presented the first idea two or three weeks later to Terence Conran and the Conran Shop buying team. This involved what she called "photogrammes," but "it was scrapped—too designerly!" Working more closely with Conran, she developed a second idea, this time using only type and color. "People think that designers get it right straight away, but it doesn't work that way," observes Myerscough. This idea, too, was rejected—for "looking like Pantone swatches"—and, although Myerscough was "confused and disappointed," she did not try to sell the idea, knowing that the "decision should be emotional." It may be that it had taken Myerscough longer than she anticipated to settle down into her normal way of working, having been uprooted from her studio environment and set down among architects and interior designers.

LIKE A PAGE FROM AN ART STUDENT'S SCRAPBOOK, THIS SHEET OF SENSITIVELY ASSEMBLED FRAGMENTS TURNED THE TIDE ON THE PROGRESS OF THE PROJECT. INCLUDED WERE OLD COUPONS, TICKETS, PATTERNS, AND BITS OF TYPE TAKEN FROM THE DESIGNER'S EXTENSIVE COLLECTION. IN PARTICULAR, THE JAR AT TOP RIGHT CAUGHT EVERYONE'S EYE.

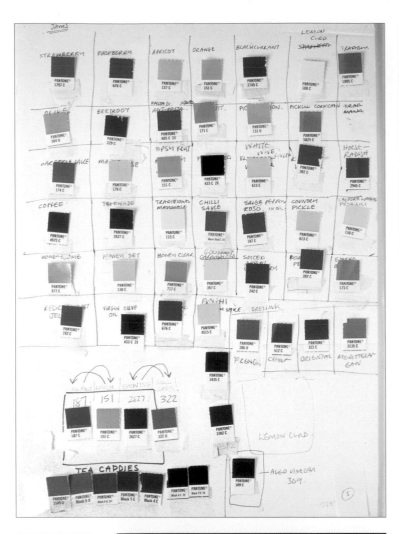

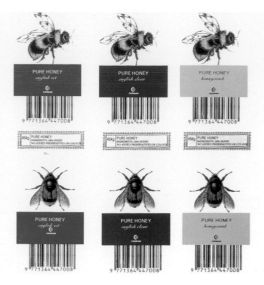

Over a holiday weekend, Myerscough returned to her studio and its cluttered atmosphere of old shop-fitting cupboards stuffed with cuttings, reference books, and memorabilia. She had to have a new idea by the following Tuesday, and she kept hearing Conran's parting shot: "I want to see a bee on a honey pot." It was so literal, she thought, the antithesis of her normal working practice of approaching things laterally. But she knew it was probably her last chance, so this time, instead of working on dummy packs, she drew out dozens of jar shapes on large sheets of white card and "just let it happen." A breakthrough came when she decided to let the food show as much as possible, and "since the bar code is a necessity and not an afterthought, as it is often treated, why not make it a feature?" In addition, to keep the jars clear, she moved all the copy onto a label on the lid whenever she could.

Everyone was relieved on the following Tuesday morning. Conran was "really pleased" because it answered his brief to keep things simple and to allow the product to be the message, not the packaging. He thought that using little labels (cut up from old Russian bonds) made it look French, and he had his bee—in fact, it was a crab, but it showed how the literal idea of an illustration of a product or an ingredient could be treated in a graphically simple way. Myerscough was clear that she wanted photographs, not illustrations, shot simply on white backgrounds. Almost as an afterthought, on one jar she put just the bar code and a pear—a combination of function and description that was pleasingly radical.

To complicate things, by this time there were a lot more people to consult, both from the Conran Shop and from Blue Bird because the Collection (as it became known) would have to sell in both. Perhaps inevitably, some people were more keen than others on the presentation.

The next stage was to make a mockup of one item from each range. First, however, the designers needed samples of the proposed containers, which were still being decided on at regular "jar reviews," and each jar and bottle came with its own restrictions, label areas, and application criteria.

Seven months into the program, Myerscough and the two Thomases presented 50 or 60 designs. "I remember they were all laid out on a huge table, with loads that hadn't been seen before, including vinegar." At this stage, there were still quite a few alternatives. Some products had a bar code and a picture; some had a bar code and a block of color and no picture; some had a block of color and a picture, but no bar code; and some had all three. "There was a big argument—who wanted what," recalls Myerscough. In addition to all this, there were food labeling regulations to consider, which ruled that "within the same line of vision, the title, the weight, and the 'best before' details all have to appear," but "they do not have to be in front of you at the first moment you see the product," explains Myerscough.

Although there was still more to be done, Conran thought the concept was "terrific," and the team were given the go-ahead to produce final artwork. Conran was still heavily involved, giving directions and looking at developments almost every day. By now it was December—five months to

opening day. There had been no market research, and no one quite knew how the Collection would look until everything came together on the shelf the week before Blue Bird opened. Everyone trusted Conran's intuition, and Myerscough, who had been told that her designs had to work when they were seen next to competing brands, was quite surprised when she saw the collection all together in one block on dedicated shelves. Although she had always kept in mind how each would look in people's kitchens, she was less sure how they would work in the new store environment, which was yet another unknown quantity. When you see the Collection in Blue Bird, what you most remember are the fresh sauces and homemade jellies, quality ingredients in simple jars—the packaging delivers a clear, direct statement

As a final word, Conran wrote a personal note to all the architects and designers who worked on the project: "I view it as the most interesting and exciting thing that I have ever done in my life, and I hope that you are very proud of your individual contributions—thank you."

A STRIP OF LID LABELS, SOME WITH THE BAR CODE AND PART OF THE MANDATORY INFORMATION, AND SOME WITH THE CONRAN COLLECTION LOGO, WHICH HAD ALREADY BEEN DESIGNED. HAVING PRODUCED ALL 98 VARIANTS ON THE COMPUTER, MYERSCOUGH REMEMBERS SITTING AT HOME WITH CHARLIE THOMAS JUST A FEW DAYS BEFORE CHRISTMAS CUTTING AND STICKING THEM ALL ON FOR THE PRESENTATION.

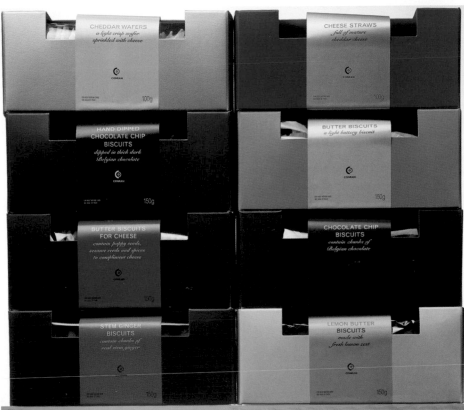

WHEN THE BLUE BIRD STORE OPENED IN LONDON'S KING'S ROAD IN MAY 1997, ALL THE PRODUCTS WERE BOLDLY DISPLAYED ON SIMPLE SHELVING THAT ALLOWED THE COLOR OF THE PACKS, IN THIS CASE COOKIES, TO CREATE THE GREATEST IMPACT.

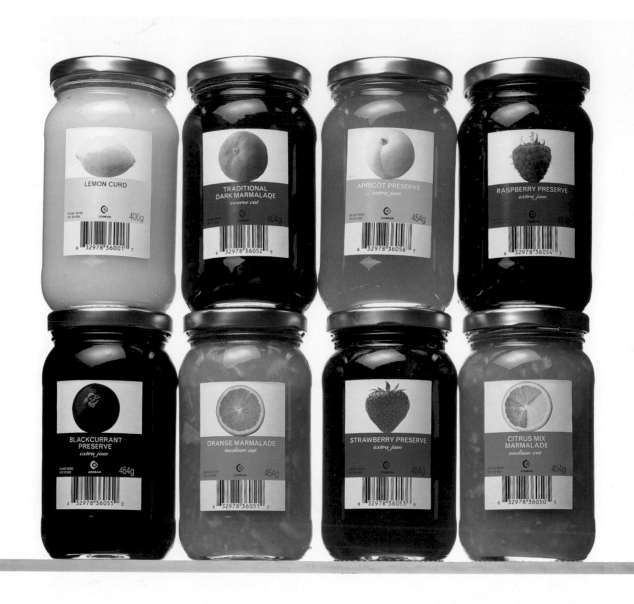

THE AIM OF "LETTING THE FOOD SHOW THROUGH AND KEEPING THE PHOTOGRAPHS AND THE TYPE AS SIMPLE AS POSSIBLE," IS WELL ILLUSTRATED IN THIS SERIES OF PHOTOGRAPHS OF THE FINAL PRODUCTS, EVEN TO THE EXTENT OF RETOUCHING A SLICE OF ORANGE SO THAT IT INCLUDES THREE TYPES OF CITRUS FRUIT. MYERSCOUGH WANTED TO LET EACH PRODUCT PHOTOGRAPH MAKE ITS OWN FORM AND SHAPE.

(OPPOSITE) CONRAN PARTICULARLY WANTED TO USE CONTAINERS OF SIMPLE SHAPES ONLY. THIS RANGE OF VINEGARS ESCHEWS SOME OF THE IDEAS FROM THE GROUP IN STAGE TWO, WHILE STILL FITTING IN WITH THE PICTORIAL SOLUTIONS. IN RETROSPECT, MYERSCOUGH FEELS THAT MORE USE COULD HAVE BEEN MADE OF DIRECT SILK SCREENING OF INFORMATION ONTO GLASS.

THE INSPIRATION FOR THE TEA CANS CAME FROM TERENCE CONRAN AND HIS PASSION FOR CIGAR BOX LABELS, ON WHICH THE GRAPHICS WRAP OVER THE CORNER AND DOWN THE SIDE. IN THE SAME WAY, THESE CANS SEEM TO BE DESIGNED TO BE KEPT AND REUSED. SO OBVIOUS ARE THEY TEA CADDIES THAT THE WORD TEA HAS BEEN OMITTED.

IN A COINCIDENCE THAT NO ONE COULD HAVE FORESEEN, THE CONTENTS OF THE PRESERVED ORANGE INCLUDE A SEGMENT THAT FALLS PERFECTLY IN LINE WITH EACH LABEL, GIVING THE PACKS A FLOURISH.

Crabtree & Evelyn

More than 300 points of sale in 40 countries across the globe, including the U.S.A., Canada, Britain, France, and Japan, selling thousands of products and requiring hundreds of new packaging solutions each year. **How could one British designer be responsible for all this?**

Peter Windett was only 26 years old when, about 25 years ago, he started to work on this now legendary project with Cyrus Harvey, who at the time had a small but flourishing boutique in Cambridge, Connecticut, under his Brattle Theater, a small room about 10 square feet, from which Harvey sold soaps that he bought in Switzerland and France. While he was on a buying trip in London, Harvey was looking for a British manufacturer to add to his stock, but when he saw some packs that Windett had designed, he decided instead to create his own brand with his own packaging. Windett explains: "He wanted to evoke an image of English heritage and tradition, and to use London in the name to establish a cachet. It needed to have solid origins and to avoid the Victorian look, which was thought too obvious. Besides, it's not the only period in history with strong graphic images. After a lot of research, we were inspired by John Evelyn (1620–1706), a noted English diarist. He was a traveler, a writer about food, and a horticulturist,

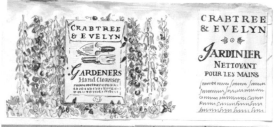

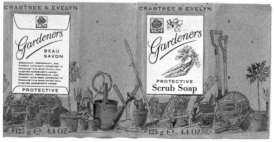

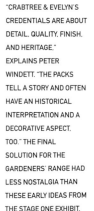

"CRABTREE & EVELYN'S CREDENTIALS ARE ABOUT DETAIL, QUALITY, FINISH, AND HERITAGE," EXPLAINS PETER WINDETT. "THE PACKS TELL A STORY AND OFTEN HAVE AN HISTORICAL INTERPRETATION AND A DECORATIVE ASPECT, TOO." THE FINAL SOLUTION FOR THE GARDENERS' RANGE HAD LESS NOSTALGIA THAN THESE EARLY IDEAS FROM THE STAGE ONE EXHIBIT.

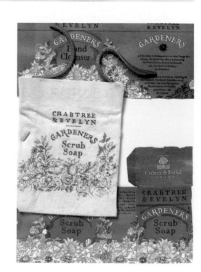

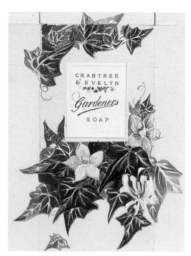

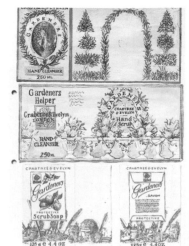

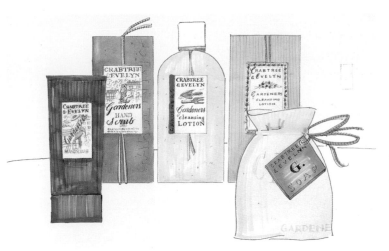

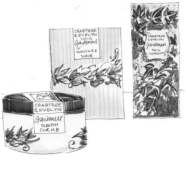

INVESTIGATING VARIOUS
TYPES OF MATERIAL.
THESE SKETCHES ON
LAYOUT PAPER WERE
MADE TO SHOW HOW A
RANGE COULD BE
CREATED USING
DIFFERENT CONTAINERS
AND, IN SOME CASES,
DIFFERENT LABELS.

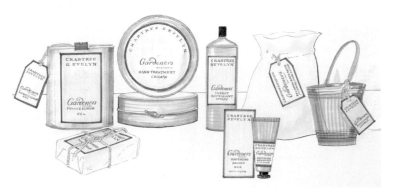

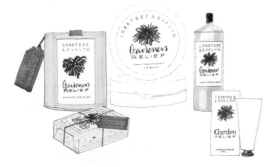

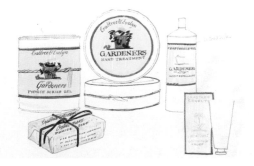

and he landscaped many English parklands. A contemporary of his, named George Crabtree, provided the now famous graphic identity.

So two men from history inspired two men from retailing, and over the next two or three years the new brand began to overtake the rest of Harvey's business. But the real expansion came in the 1970s when Crabtree & Evelyn expanded its sales overseas and opened its first U.S. store, which Windett also designed. "That was the time," says Harvey, "when we looked at marketing around the world and decided we'd have to go vertical—to design the product, make it, distribute it and be in control of the retail outlet."

Windett's concept for the packaging was to make illustration the most central element, followed by typography and then text, which was informative and educational. "The illustrations tend to tell a story, to portray an image—not just of the products but of their history or geography," he says. In that respect he acknowledges the collaboration he has had with his client. "Cyrus is an exceptionally astute businessman with a wonderfully creative and very visual mind. He knows art and design from every period, and this makes things much easier, particularly when we're discussing ideas over the phone."

So how did this recent product range come about? "About four or five years ago I thought of the idea of a range of products based on the gardener's needs," recalls Windett. "We had regular review meeting every six to eight weeks, when we discussed the progress of projects and considered new ideas. I may have done some initial rough scribbles. In itself, the idea was not new—there were garden-related products around—but they tended to be quite low price and functional, or not at our level of gift merchandise . There was some uncertainty whether this group of customers— gardeners—would want Crabtree & Evelyn products. Then, as the years went by, the market started to change. Smith and Hawkins in America brought out a much more sophisticated garden accessories mail order catalog; Americans became aware of aromatherapy; they grew lavender in their window boxes particularly in the cities and became aware of the

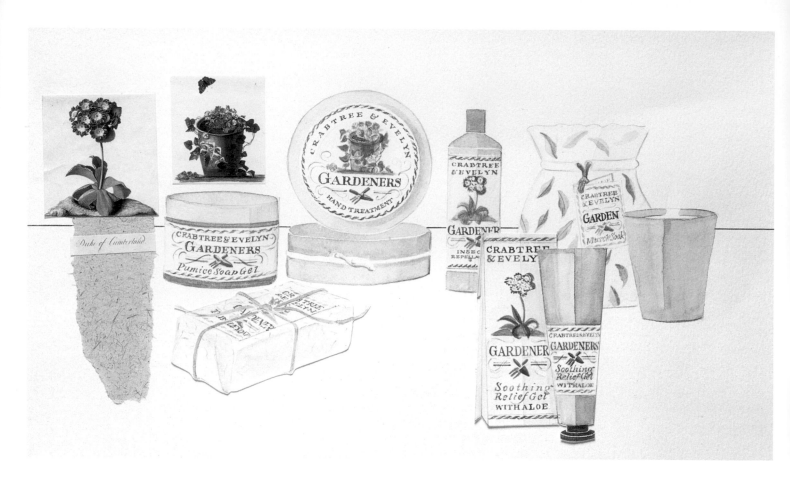

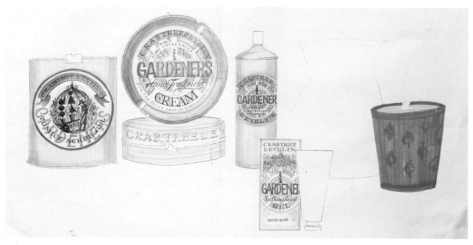

benefits of plants. There were new garden books and magazines, and garden stores, and the market expanded and became enormous.

Windett kept plugging away at the idea as the types of products changed and the range evolved to be more about function and purpose, to cater for this new type of gardener. Windett remembers being in a meeting when the "gardeners" moment arrived. "We were planning new products for the next two or three years. (You need a certain amount of newness each year or it shows in the sales figures)." It was 1996. Someone said: "Let's have another go at it and see if we can produce something that excites everyone." Sue Jonas, vice president of Product Development, said she would look at some product ideas, and two or three months later little pots of stuff started arriving—a hand scrub or a skin shield from the laboratory in Connecticut."

From the written specifications, Windett and his designers knew the type of products and they also had a timetable—the launch date was scheduled for April 1997.

"Line to be geared to cleansing, soothing, healing, and protection," said a contact report at the time. "Containers will all be oversized, utilitarian but luxurious, natural, tactile." Product ideas include: pumice hand scrub, soap bar, hand treatment, Aloe vera soothing relief gel, natural bug repellant.

At this stage, Windett looked for shapes of packs and types of material rather than at specific containers. "The range had to stand out in the shop, but at the same time it had to look as if it belonged with the rest of the range. We were uncertain at that point just how different it should look."

(ABOVE) DEVELOPED FROM STAGE TWO, THESE THREE ROUTES FORMED THE FINAL PRESENTATION AND INTRODUCED THE ILLUSTRATIONS OF LAURA STODDART THAT GAVE THE RANGE A DIFFERENT LOOK AND APPEAL. "THE CONTAINER IS THE MEETING POINT BETWEEN THE PRODUCT AND THE CONCEPT," SAYS THE BRITISH DESIGNER.

The next presentation was decisive. The designers showed three ideas, including one based on the work of illustrator Laura Stoddart, whose drawings had been appearing in the recently launched Gardens Illustrated magazine. "Everyone in the meeting fell in love with them and with the humor her figures have. We showed a lot of tearsheets of her work and samples of recycled papers and related materials. Her personality turned out to be just right for the job. She added her own ideas when we met to brief her."

At this stage the project was turned over to the project coordinator in the U.S.A., where all the product was made. "It was," says Windett, "a relatively short time frame. Products had to be in the stores, together with promotional material, by May. A lot of rationalization went on to finalize the range and the containers themselves had an intrinsic appeal, so they did not need to be hidden in a box. There was also some debate about the copy on the packs. In England we don't say 'bug repellant'," said the designer. "We always used English words and spellings."

"It turned out to be one of the biggest successes Crabtree & Evelyn has had. It was the right look at the right time and marked a clear shift away from the more fussy packaging styles the company had used."

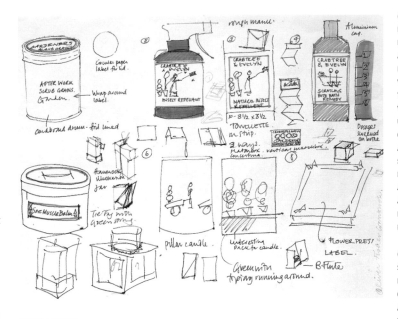

(ABOVE) A PAGE OF SKETCHES THE TEAM PRODUCED AS THEY DEVELOPED MORE SPECIFIC CONTAINERS FOR THE FIRST RANGE OF PRODUCTS.

(BELOW) APART FROM TRADITONAL GARDENING IMPLEMENTS, THE WINDOW DISPLAY TO LAUNCH THE PRODUCTS, INCLUDED CUT-OUTS OF LAURA STODDART'S ILLUSTRATIONS.

((OVERLEAF LEFT) THE FIRST RANGE OF PRODUCTS IN THE HAND AND BODY-CARE RANGE INCLUDED THE SCRUB BAR WITH PUMICE, HAND THERAPY, HAND SCRUB WITH PUMICE, GARDENERS UV SHIELD, SKIN REMEDY, OUTDOOR BURN STICKS AND THREE VEGETABLE SOUPS. "SIX IS A GOOD NUMBER TO START WITH, AND THEN WE NORMALLY ADD OTHERS 18 MONTHS LATER TO GIVE NEWNESS," EXPLAINS WINDETT.

(OVERLEAF RIGHT) THE SECOND RANGE ADDED FIVE PRODUCTS TO THE GROUP. PART OF THEIR ACCEPTIBILITY WAS THAT THEY APPEALED TO PEOPLE WHO WERE NOT SERIOUS GARDENERS. THE CRABTREE & EVELYN GARDENERS RANGE WAS AWARDED A GOLD FOR BEST USE OF ESTHETICS IN THE BRAND DESIGN ASSOCIATION AWARDS OF 1998, NEW YORK.

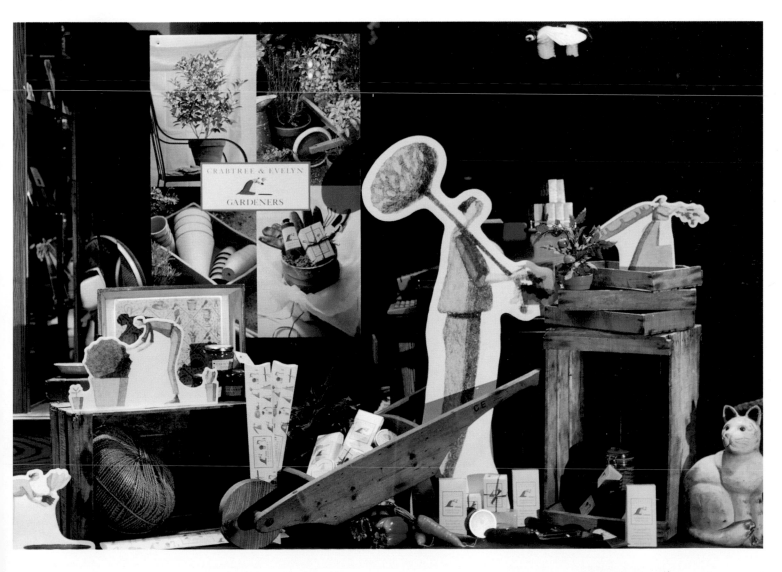

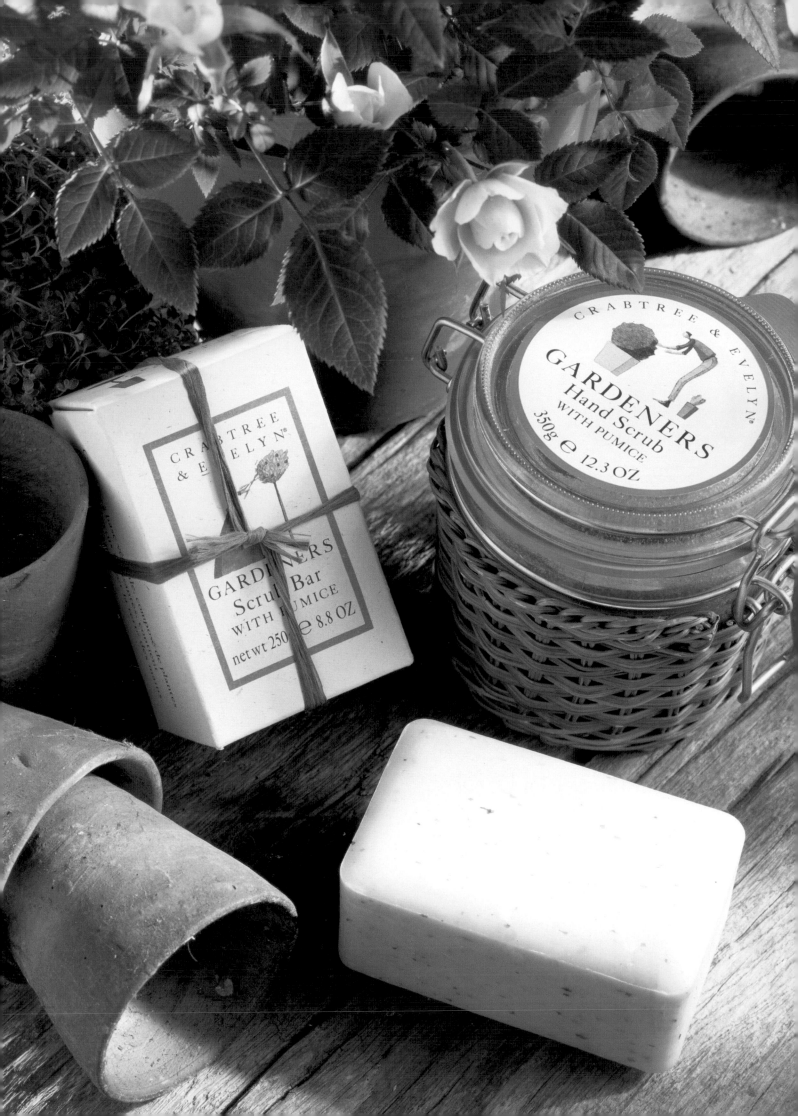

CRABTREE
& EVELYN

GARDENERS
Scrub Bar
WITH PUMICE
net wt 250g ℮ 8.8 OZ

CRABTREE & EVELYN

GARDENERS
Hand Scrub
WITH PUMICE
350g ℮ 12.3 OZ

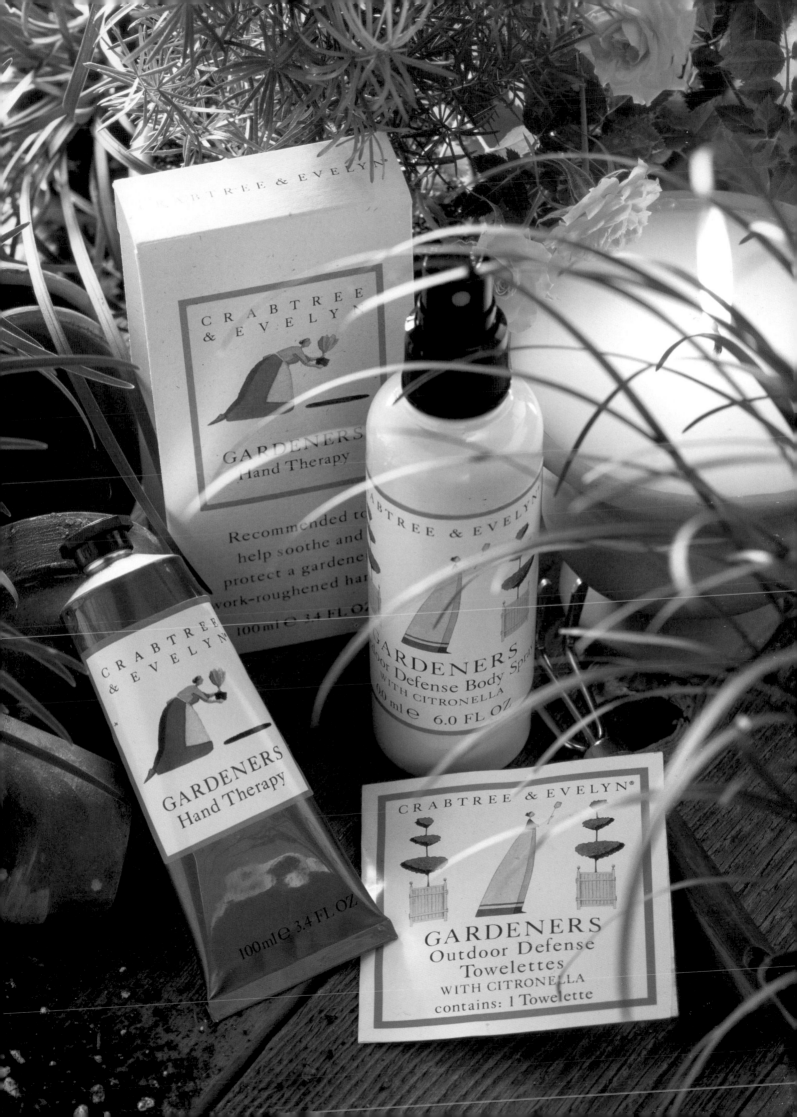

Heals

When he briefs his designers, James Pyott shows them the products and the containers and explains the task at hand. If the client has asked for avant-garde or classic or contemporary designs, he first tries to find out what they mean and **whether that is what they really want**

(LEFT) USING TYPE AS ILLUSTRATION, THIS SOLUTION LOOKED DECORATIVE ENOUGH TO BE A GIFT AND FUNCTIONAL ENOUGH TO BE PRODUCT WORTHY.

(LEFT) THIS GROUP WAS STRUCTURED "LIKE AN OFFICIAL LABEL OR A GOVERNMENT WARNING ON A PRODUCT," EXPLAINS JAMES PYOTT.

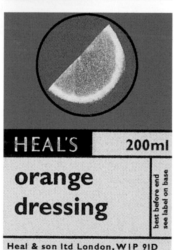

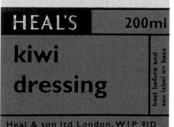

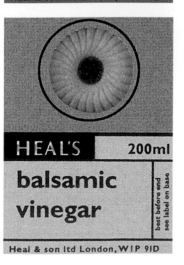

"I also tell the designers what hasn't been said by the client," says Pyott, who runs Pyott Design Consultants, with a small young team in a studio near his home in South London. He has been working with the London store Heals for over three years now and has packaged many of their products. This project called for the design of a series of labels for the food range, which is aimed at the gift trade, and though it sells best at Christmas, Heals did not want it to look too seasonal.

Heals is a long-established home furnishing store, with its roots in the Arts and Crafts tradition, but it needed to broaden its appeal. "Now that there are three shops, it has shifted much more to the contemporary end of the market, and that applies to products as well as to store design," explains Pyott. "Heals doesn't want to be modern, but it has to keep pace with the high street stores and big department stores. A younger generation—better educated and more affluent—has grown up, and Heals is moving slowly towards that market." This eight-week project started in June 1998, with a meeting between James Pyott, Janice Webster, merchandise director at Heals, in charge of all products, and Claire Grey, the store's food buyer, Pyott wanted to find out if the extensive range on which he had previously worked had changed at all, if there was any sales feedback and if there was a new direction to take. He wanted to know if Heals "had moved on stylistically" from what he had done before. "There were," he says, "about 10 groups in various categories—oils, vinegars, pestos, jams, chutneys, and specific Christmas products." Some he had designed before, and some were new additions. Webster also had samples of every product (over 100) and the empty bottles Heals had selected to pack them in. "I wanted to know how far they felt we could push the next range down the contemporary road. The products are chosen to appeal to me and my friends, but also to my mum and dad," Pyott continues. "In a way, that's their weakness. Heals try to keep everyone happy. Our designs have to find a middle ground."

Webster explained the idea behind the range—some single items and some gift sets—and the general principles underlying Heals's reasons for selecting them and how and where they would be merchandized. "It's a market I understand well," says Pyott, who took everything back to his studio. "I like to live with a brief for a while—to get the atmosphere of the range and come up with an overall image."

Pyott prepared a fee proposal and outlined what he was going to do and how many options he would show. "I don't really have a standard number— sometimes it's three routes, sometimes it's ten. As many ways as possible of answering

strawberry
conserve

200ml

best before end see label on base
heal & son ltd london, wip gld

blackcurrant
conserve

200ml

best before end see label on base
heal & son ltd london, wip gld

orange
marmalade

200ml

best before end see label on base
heal & son ltd london, wip gld

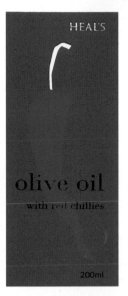

olive oil

with red chillies

200ml

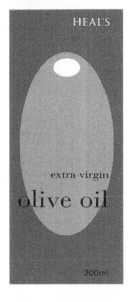

extra virgin
olive oil

200ml

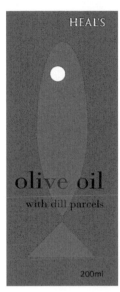

olive oil

with dill parcels

200ml

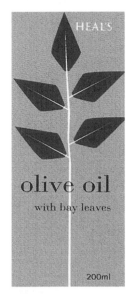

olive oil

with bay leaves

200ml

(ABOVE) ABSTRACT PATTERNS AND GREAT COLOR SCHEMES OFFERED PLENTY OF POTENTIAL FOR VARIATIONS. BUT BECAUSE NO PRODUCT WAS SHOWN, THIS DESIGN WAS REJECTED AT AN EARLY STAGE.

WITH MORE THAN 100 ITEMS IN THE RANGE, THE DESIGNERS HAD TO FIND A WAY OF BUILDING IN VARIETY AS WELL AS SIMILARITY WITHIN THE LIMITED BUDGET. "YOU CAN'T DESIGN THAT MANY PACKS IN EIGHT WEEKS, FROM BRIEFING TO ARTWORK," SAYS PYOTT.

HEAL'S
orange marmalade

200ml

best before end–see label on base
heal & son ltd london, wip gld

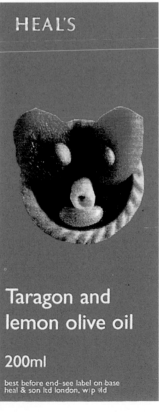

HEAL'S

Taragon and
lemon olive oil

200ml

best before end–see label on base
heal & son ltd london, wip gld

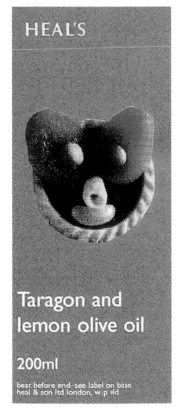

HEAL'S

Taragon and
lemon olive oil

200ml

best before end–see label on base
heal & son ltd london, wip gld

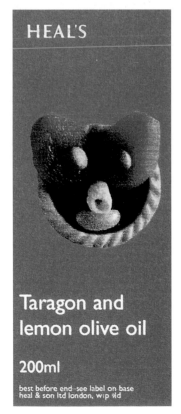

HEAL'S

Taragon and
lemon olive oil

200ml

best before end–see label on base
heal & son ltd london, wip gld

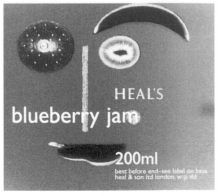

HEAL'S
blueberry jam

200ml

best before end–see label on base
heal & son ltd london, wip gld

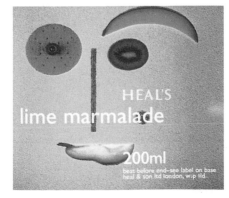

HEAL'S
lime marmalade

200ml

best before end–see label on base
heal & son ltd london, wip gld

((ABOVE, TOP, AND RIGHT)) FOURTEEN DIFFERENT DESIGN ROUTES WERE SHOWN TO HEALS AT THE STAGE ONE PRESENTATION. EACH ONE RENDERED IN TWO OR THREE VARIATIONS AND IN HORIZONTAL AND VERTICAL FORMATS.

SIX DESIGNERS WORKED ON THE RANGE, EACH CONTRIBUTING A DIFFERENT APPROACH AND DEMONSTRATING, IN A WAY CLIENTS RARELY SEE, HOW MUCH VARIATION IS POSSIBLE. "THE PRODUCTS ARE ESSENTIALLY IMPULSE BUYS, SO MAKING THEM LOOK INCREDIBLY DESIRABLE AND ATTRACTIVE SEEMED MORE IMPORTANT THAN DESCRIBING THE CONTENTS." EXPLAINS PYOTT.

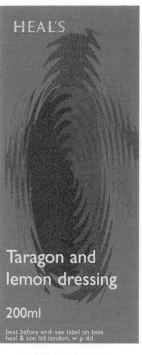

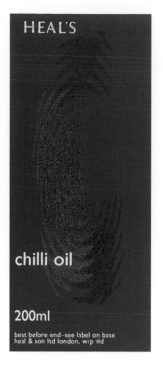

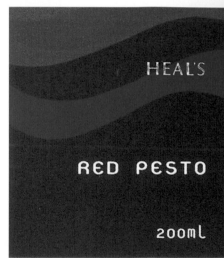

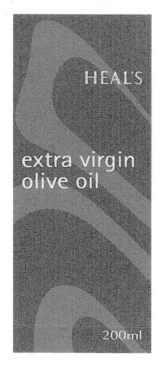

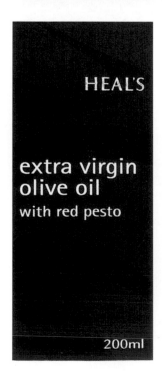

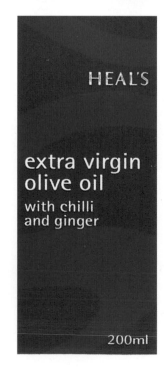

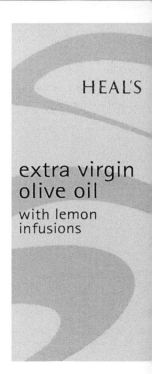

TRADE SECRETS OF GREAT DESIGN

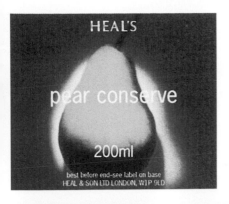

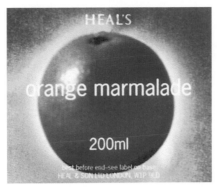

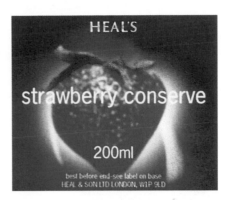

(*LEFT AND BELOW LEFT*)
TWO MORE INGREDIENT-
BASED IDEAS FROM THE
STAGE ONE PRESENTATION.
AT THIS POINT, THE CLIENT
CONSIDERED MIXING UP
ALL THE IDEAS, AND USING
AN EXAMPLE FROM EACH
OPTION.

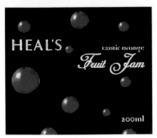

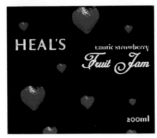

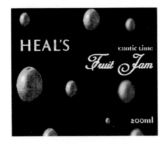

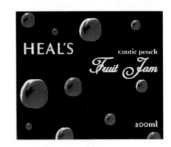

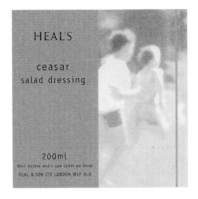

(*LEFT AND BELOW LEFT*)
THIS EVOCATIVE ROUTE
WAS ONE OF THE
DESIGNER'S FAVORITES.
BUT THE CLIENT FELT
THAT IT WAS A BIT TOO
MODERN AND THAT
OLDER CUSTOMERS
MIGHT NOT RELATE TO IT.

'THE MAIN PURPOSE OF THE
FIRST PRESENTATION IS TO
GET THE BRIEF RIGHT AND
TO ESTABLISH A CORE
FEELING FOR WHAT THE
CLIENT IS AFTER AND WHAT
THEY'RE HAPPY WITH. WE
BATTLE OVER THE ONES WE
THINK HAVE SOME MERIT,
EVEN IF THE CLIENT CAN'T
SEE IT AT THE TIME. WE TRY
NOT TO PREJUDGE WAYS OF
ANSWERING THE BRIEF,"
SAYS THE DESIGNER.

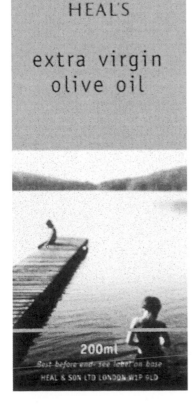

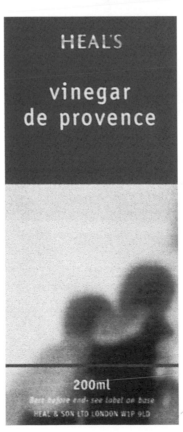

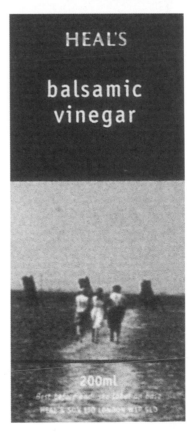

the brief. I generally lead my team in a particular direction that I think the client will like. With Heals there's a sense of humor and a degree of English eccentricity that we play on. The shapes of the containers—in this case classic Kilner jars and simple, modern, Italian glass bottles—also determine how modern we can be. There was no core language. Each group had a different bottle or jar shape, so they had to have a different label shape, too."

The next day Pyott spent half an hour considering possible routes, and then he briefed his team. "Some things occur to me as I'm explaining the project," he says. "Certain things just crop up when I'm in mid-flow, and the designers contribute too. It's quite lively. Most of the things I think of aren't there at the end of the project, but they help get us there." Everyone spends half a day designing—some people are more illustrative and some have a more typographic approach."

Pyott then cuts the team down and merges all the ideas, and designers are assigned to a single aspect.

"After a day or two, I go round and look at the work. I decide to stop it or let it go on. Sometimes we may not get going in earnest until two days before the presentation. We like that—everything else gets cleared out of the way, and we work frantically over that short period. The last afternoon is the best. Having the deadline on us helps everyone to focus and become more concise. Things become quite black and white at that stage. We mount up all the ideas that we think are okay and decide if some are not worth presenting. It's likely that one or two might not get shown. Also, we can see the spectrum of ideas and pick the better ones. The project is not finished by any means. The ideas wouldn't win any awards, but they're not done with that in mind. This is going on every day in our studio. We have things we've worked on but didn't resolve, and we may go back to them later for another job."

The first presentation was, says Pyott, "really good at focusing on where Heals wanted to be. Generally it is only at the first presentation, when they see what they don't like, that the client's own views begin to crystallize and they can articulate how they perceive the range and the design developing. They didn't like the very abstract designs but went for one that conveyed the product ingredients in a modern way, with quite classic typography."

During the presentation Pyott put the labels on the containers, and Heals liked the idea of mixing designs—using examples from each solution. "It wasn't what we'd been briefed to do, but it had a freshness. Each one was appealing for a different reason." Within the timescale, however, it was impossible to orchestrate and resolve all the design issues. In addition, it did not look like a branded range, so they went back to the idea of one design.

"One thing that kept coming through again and again was the need to show what the products were made of," says

Pyott, who left all the roughs with the client for a couple of weeks before he got the go-ahead to develop one of the illustration routes and show—in the next presentation—a much more resolved series for every kind of label. "At this stage it was almost artwork," says the designer, who, because of budgetary constraints, had to produce all the illustrations inhouse. "Initially, the drawings were quite abstract images, but in the client's search for a more descriptive label they had to be fine-tuned a bit more. Before we knew it, we had a great deal of work to do. Martin Bacon did them all on a computer in our office. It's one of those jobs when the first one takes a day, but you can do 50 the next day. We didn't charge for doing all the drawings," continues Pyott. "Some projects are worth designing beyond the brief and the budget. As a company, we're willing to put in 110 percent to do it right."

THE LABELS WERE ALL PRINTED IN THE UK BY PAXMAN PRESS AND THEN DISTRIBUTED TO THE VARIOUS SUPPLIERS IN THE UK. BECAUSE OF THE INTENSITY OF THE COLORS, THE DESIGNS WERE GROUPED BY HUE SO THAT IT WOULD BE POSSIBLE TO EXERCISE TIGHTER CONTROL OVER THE PRINTING PROCESS.

(LEFT AND RIGHT) WORKING ON ADOBE ILLUSTRATOR, DESIGNER MARTIN BACON PRODUCED ILLUSTRATIONS WITH 1950S STYLING BUT IN TODAY'S FASHION COLORS. HEALS FELT THE SLIGHTLY ABSTRACT DESIGNS WERE THE RIGHT SOLUTION, SO THE DESIGNERS COULD GO AHEAD AND USE COLOR AND SHAPE TO DEFINE THE INDIVIDUAL INGREDIENTS WITHOUT HAVING TO INDICATE THE PRECISE CONTENTS.

sweet onion confit

Ingredients: Onions, Red Wine Vinegar, Sugar, Spices.
Once opened, keep refrigerated. For Best Before End: See label on base of jar.

Handmade for: HEAL & SON LTD, LONDON W1P 9LD

310g℮

HEAL'S

blueberry & orange preserve

Ingredients: Sugar, Blueberry, Orange, Lemon.
60g of sugar per 100g. 40g of fruit per 100g.
Once opened, keep refrigerated. For Best Before End: See label on base of jar.

Handmade for: HEAL & SON LTD, LONDON W1P 9LD

340g℮

HEAL'S

breakfast coffee 294142

Selected blend of East African,
South and Central American ground coffee.
Vacuum Packed.

HEAL & SON LTD, LONDON W1P 9LD

227g℮

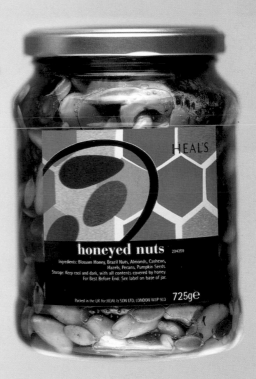

HEAL'S

honeyed nuts 294259

Ingredients: Blossom Honey, Brazil Nuts, Almonds, Cashews,
Hazels, Pecans, Pumpkin Seeds.
Storage: Keep cool and dark, with all contents covered by honey.
For Best Before End: See label on base of jar.

Packed in the UK for: HEAL & SON LTD, LONDON W1P 9LD

725g℮

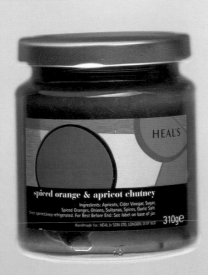

HEAL'S

spiced orange & apricot chutney

Ingredients: Apricots, Cider Vinegar, Sugar,
Spiced Oranges, Onions, Sultanas, Spices, Garlic Salt.
Once opened, keep refrigerated. For Best Before End: See label on base of jar.

Handmade for: HEAL & SON LTD, LONDON W1P 9LD

310g℮

Nikon a manufacturer well known for its professional cameras, wanted to launch a range of low-cost compact models into an already crowded market, in which most of the packaging looked the same.

The compact camera had to be the hero of the pack but the designers at Brewer

Riddiford wanted it to have "Nikon-ness"

First, however, explains George Riddiford, managing partner at Brewer Riddiford, the London design consultancy, they had to decide what "Nikon-ness was"

Over the past 20 years cameras have shifted from the preserve of the enthusiast and the "consultancy purchase" to being a stylish accessory and a marketing phenomenon in the 1990s, with processing technology and new types of film ensuring good quality photography is a popular family pastime, and cameras a relatively cheap impulse purchase, on a par with fashion accessories. This is the market that Nikon wanted to enter and with prices as low as $60 for the new models.

"Nikon has a fantastic reputation," continues Riddiford. "A Nikon is the professional's choice. For example, the photographer in the film Apocalyse Now had several well used Nikons around his neck. We had to convey this special nature of Nikon when compared to the other Japanese camera brands. It would be expected to offer something more challenging, even for an everyday, low-cost, fun camera." His client, Tim Hunnable, Nikon U.K.'s marketing manager, just said: "You're the experts—you tell us." They

WORDS AND DIAGRAMS ARE CRAMMED ONTO THIS LAYOUT PAGE FROM THE DESIGNERS' FIRST MEETING, WHEN THE CURVED PROFILE—TAKEN FROM A HOUSE. AN ARROW AND A JAPANESE CALLIGRAPHIC CHARACTER—STARTED TO APPEAR. THERE ARE ALSO NOTES SUCH AS "PROTECT ... EXPOSE ... CUSHION ... PRECISE YET RELAXED ... NEATLY PRESENTED ... NO MESS".

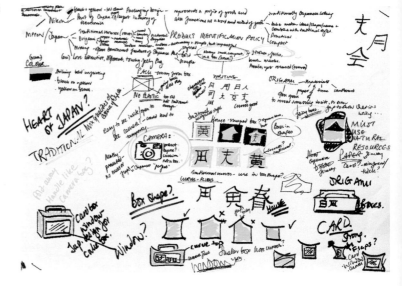

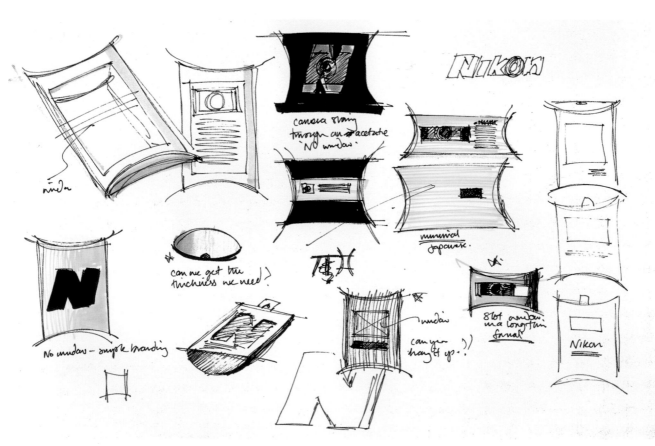

WORKING IN BLACK AND YELLOW PEN WITH A CURVED PACK SHAPE. THE DESIGNERS WONDERED IF THEY COULD GET THE THICKNESS THEY NEEDED OR IF IT COULD BE HUNG UP. "AT THAT POINT, WE CRACKED IT IN AN AFTERNOON," RECALLS GEORGE RIDDIFORD.

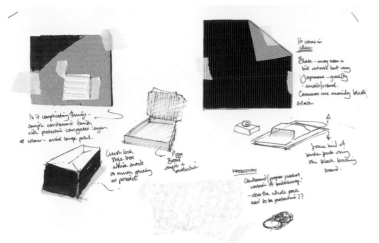

ALTHOUGH THEY HAD THREE OR FOUR OTHER OPTIONS IN OTHER MATERIALS, THESE WERE PUT TO ONE SIDE AS POSSIBILITIES FOR LATER DEVELOPMENT ONCE THE CLIENT SAW THE PILLOW PACK SOLUTION. THE DRUM IDEA (RIGHT) CAME TO LIGHT AGAIN WHEN NIKON ASKED THE TEAM TO CONSIDER IDEAS FOR THE ZOOM RANGE.

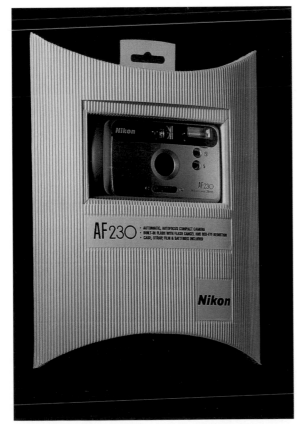

(RIGHT AND OVERLEAF) THE FINAL SOLUTION WAS DIVIDED BETWEEN TWO STYLES OF CAMERA. AND AT THE LAST MINUTE IT WAS REALIZED THAT, ALTHOUGH IT HAD A "EURO HOOK", IT WOULD HAVE TO STAND UP IN SOME STORE DISPLAYS. "WE HAD TO ADD A PLASTIC SLEEVE, WHICH WAS FLAT AT THE BASE," EXPLAINS RIDDIFORD. "BUT IT WAS A MINOR CONCESSION TO MAKE."

had no preconceived ideas," says John Brewer, who worked beside Riddiford, with John Wynne and Richard Haywood. It was an open brief to do something different but with good Nikon branding and make it strong enough to sell the product off the shelf. It was a "browse and pick" market.

The designers did some research and found that the packs were "all pretty samey." Some manufacturers were trying to make their packs more fun. There were the ubiquitous blister packs, a clam shell which held the camera and its accessories, and hung from a hook. "But they were all doing the same kind of things. There was nothing that said ` Come and look at me'," says Riddiford.

This is where the Nikon-ness came into their discussions. "We sat down together and spent half a day with layout pads, just jotting ideas down and allowing people to come up with lateral thoughts and solutions—anything goes at this stage. We had collected all the photographic magazines and taken snaps during our visits to stores, and we filled the room with examples of great photojournalism and stock photographic books. We had also asked professional photographers we knew what they thought about Nikon."

Their instinct said that they should steer clear of all generic references— "no photographs on the pack"—and look toward Japanese attributes. "Calligraphy and origami and materials such as recycled card were important too," says Riddiford. "We considered the environmental side as well. The object of the first meeting was to get off to a good start so that people could go away and create the packaging."

The first presentation went well, but Riddiford thought that there was still something missing. "We had to find ideas that included an aspect of structural interest while not incurring high packaging costs." Back at the studio, Haywood had been working with Wynne, swapping ideas and looking at various three-dimensional pack samples they had collected. Haywood, a structural specialist, had brought in a necktie pack from a fashion store, which they called a pillow pack. "It had a simple crash-lock mechanism, and it got us thinking about the care and ingenuity that every Nikon product gets," says Riddiford. A pack that had an interesting but simple construction method might convey those qualities and reflect Japanese origami techniques, but it needed another element as well.

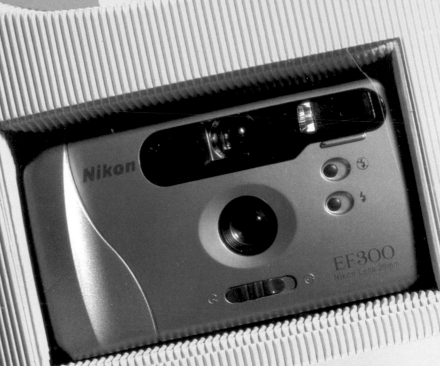

EF300

- AUTOMATIC, FOCUS FREE COMPACT CAMERA
- BUILT-IN FLASH WITH FLASH CANCEL AND RED-EYE REDUCTION
- CASE, STRAP, FILM & BATTERIES INCLUDED

Nikon

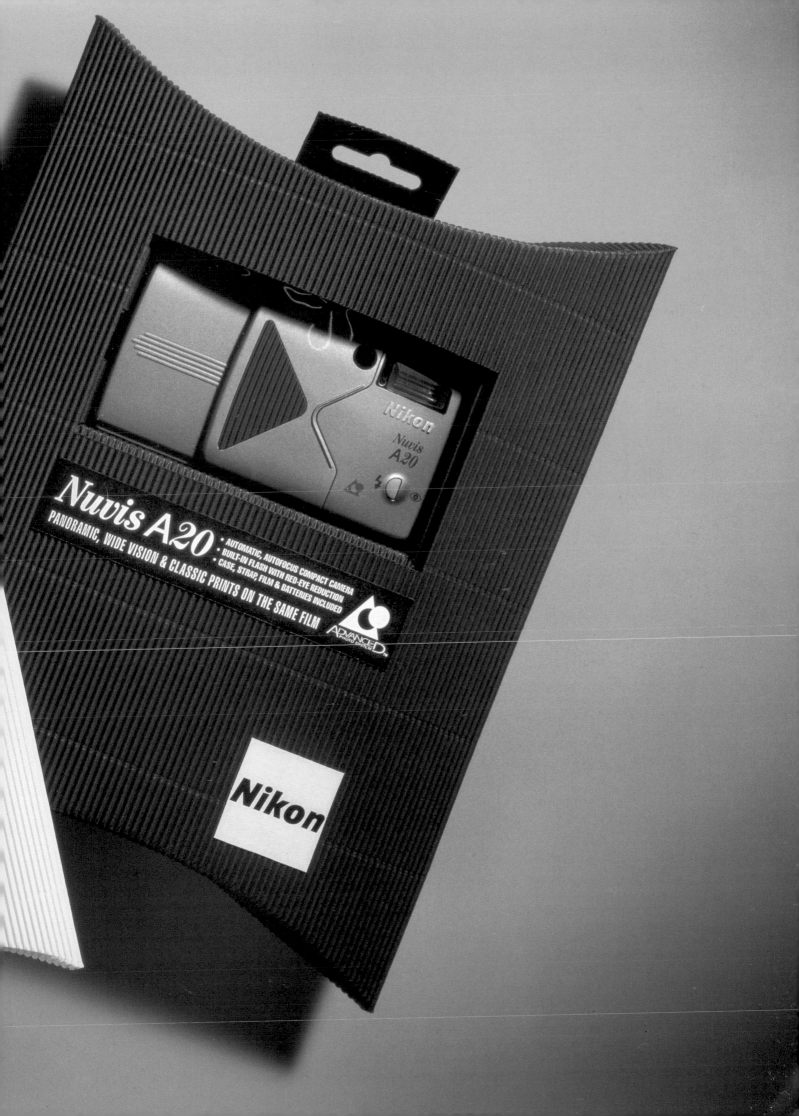

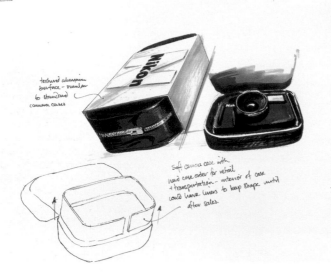

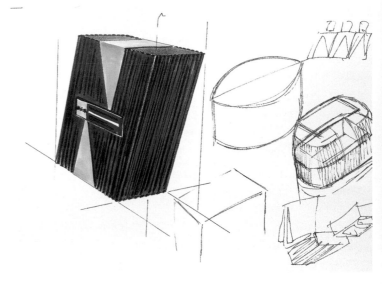

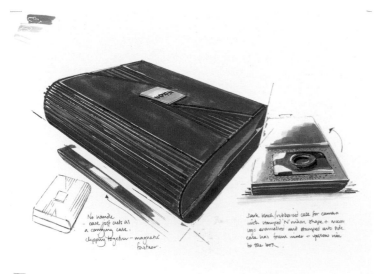

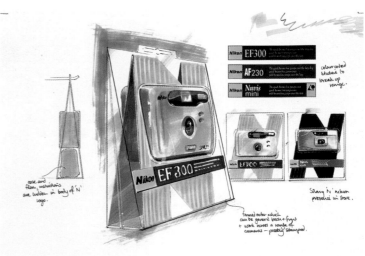

TRADE SECRETS OF GREAT DESIGN

ALTHOUGH THE SECOND
RANGE OF MORE
FLEXIBLE PACKS WAS
FOR CAMERAS COSTING
UP TO $400, THE
DESIGNERS STILL
CONSIDERED USING
RECYCLED MATERIAL AND
CORRUGATED CARD.

The day before the second presentation a paper manufacturer, G. F. Smith, sent in some new samples of paper and card. Among them was a corrugated board available in several colors, including yellow. "Until then, we had been working in brown recycled corrugated card, but we'd noticed yellow cropping up again and again as part of Nikon's identity- although not on the existing boxes, which were gold," explains Brewer.

Now they had both the technique and the material, they went back to the client with just one solution. "In retrospect, we didn't realize what we had stumbled on nor how powerful this pack would be," admits Riddiford. "The client couldn't put it down and everyone was thrilled at its high impact, low cost, and ease of assembly."

It was decided not to carry out any customer research. "They took it around to show their key trade customers, and instinctively everyone loved it," says Brewer.

But the story was not over. In January 1998 the designers were asked to consider more new models from Japan that would be higher up the range. "We didn't know the sizes or what they looked like," says Riddiford. "But our brief was to produce a pack design that was flexible enough to take eight different sizes of camera, plus various camera bags, batteries, strap, and film." This time the products were regarded as less of an impulse purchase and, would require consultation with a retailer. Point of sale was still important, particularly in window displays, where reinforcing Nikon's attention to detail and leading edge product design was the key, and this is where the designers got their lead. The new packs acted as a three-way podium for shelf or window display, as well as

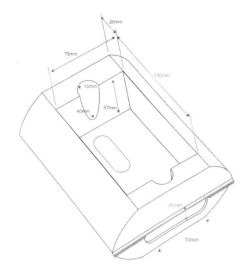
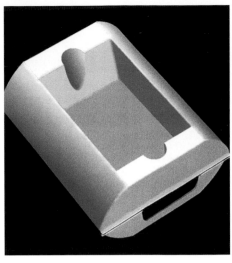

protecting the product in transit. This time, the stimulus came from a corrugated card waste basket, which Wynne brought into the office. "It had plastic formers at each end to make it incredibly rigid," says Riddiford. "The internal construction of the pack was as important as the exterior."

Again, they considered the materials as an integral part of the design. "In contrast to the high-tech camera, we made the inner pack from material that was quite crude so the camera would stand out more. What better than the lowly egg-box as a strong and environmentally friendly way to protect the delivcate contents? The inner tray was therefore made of egg-box material, pulped, recycled newsprint.On the outside, of course, we still used the corrugated yellow card. We helped to create a new identity for Nikon, which now 'owns' this material and color, and styling in its packaging."

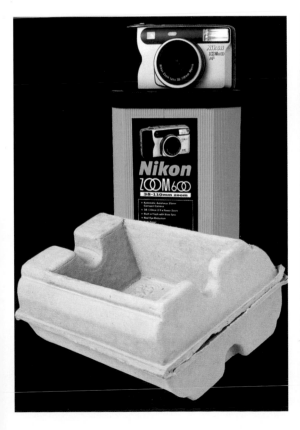
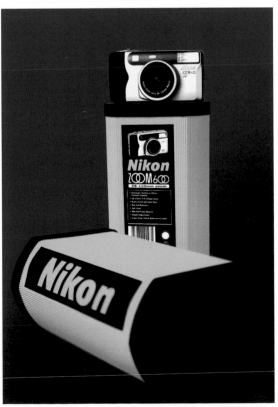

NICKNAMED THE POD DESIGN, THE PACK DOUBLED AS A DISPLAY PLINTH FOR THE MORE EXPENSIVE MODELS AND COULD BE USED SIDE- OR END-UP AND AS A SYSTEM OF BUILDING BLOCKS—THE WIDTH WAS HALF THE LENGTH.

Secret Weapon

During the rigorous selection process that Superdrug used to identify its roster of design consultants, 20 contenders were asked their opinion of their would-be client, and later, gathered at a racecourse with all the retailers, suppliers, and printers, the top five presented again to each other. "It was interesting," says Bruce Duckworth. **"We were the only ones to focus on creativity"**

Turner Duckworth is a transatlantic duo, running studios in London and San Francisco. They pride themselves on being able to "produce effectiveness with grace, sales with wit, and originality with relevance." They say of the two-office, 20-people team: "Each studio works with the other as if sharing a single desk. We both work on the same accounts, for the same people; and through the marvels of technology, we even work on the same piece of paper."

On this occasion the client was based in England, but the first meeting—when 20 consultancies were each given an hour to present its credentials and the findings of its research into the Superdrug stores and own-brand packaging—was held in a central London hotel.

"Until then," says Duckworth, "all Superdrug's packaging had been designed inhouse. In our report we said that there was room in the pharmacy market in the U.K. for someone to be more approachable than Boots (the market leader. see page 34) and provide more fun. We put value in the equation, too," Duckworth recalls, referring to Superdrug's reputation for competitive prices.

Two weeks later they were invited to attend the Epsom Racecourse meeting, a few miles from the Superdrug head

THESE FOUR BOARDS FORMED THE FIRST CLIENT PRESENTATION AND, WHEN SHOWN TO TEENAGE SCHOOLGIRLS, GAVE THE DESIGNERS THE FEEDBACK THEY NEEDED. THE FIRST (*RIGHT*), BASED ON THE 1970S' TV SERIES *CHARLIE'S ANGELS* (GIRLS IN CONTROL) SYMBOLIZED DIFFERENT PERSONALITIES—SPORTY, DISCO, AND STAY-AT-HOME—BUT TEENAGERS THOUGHT THEY WERE NOT RELEVANT. "TOTALLY NAFF" WAS ONE DESCRIPTION.

"LICENSED TO THRILL" (*FAR RIGHT*) DID QUITE WELL IN RESEARCH, AS DID THE "DEVIL YOU KNOW." (*BELOW RIGHT*) FOR WHICH THE DESIGNERS USED A FLAME SYMBOL, A DRAWING OF A GIRL DEMON, AND A TRIDENT, WHICH, TOGETHER WITH THE SMALL CAN OF SOLID PERFUME, WERE TO BECOME INTEGRATED INTO THE FINAL SCHEME (*BELOW FAR RIGHT*). THE LAST BOARD, "AIN'T NOTHING BUT A SHE THING," WAS ABOUT THE REBEL, A GIRL WITH A "NAUGHTY ATTITUDE BUT A TOUCH OF CHARM."

office. "All the client's buyers, their key suppliers, the printers and repro houses were there for the presentations and each design company exhibited their work."

Each designer had been given the same brief—for a teenage haircare styling product. "We each wrote a list of the most important things that we thought should be included in a brief and now use a synthesis of this as a format for all Superdrug work," says Duckworth.

"The first stage always includes three concepts, one of which is chosen for development to final design in stage two. We produce artwork guidelines and commission any illustration or photography that might be required. Then Superdrug does all the artwork inhouse," he says.

A week later they got their first brief from Design Manager Neil Pedliham, for a product called Scrunch, which needed a new name and a new image. "By then we'd probably proved ourselves," says Duckworth. Then in late spring 1997 the brief arrived for Secret Weapon, a range of fun toiletries targeted at school-age girls.. The buyer responsible for the product, Sarah Day, produced a form outlining the product objectives, the background development and competitors' details.

"A lot of fashion stores—GAP, Benetton—had own-brand toiletries, and 'Girl Power' was at full strength. Even though some of the Superdrug stores had been redesigned, they were not seen as 'cool' by this audience. What we had to do was produce ideas for the coolest range of toiletries so that when kids saw them, they would go buy them, and at the age of 14 they'd be 'captured' from then on," explains Duckworth.

The product list included body wash, shower gel, body contour, body scrub, body spray, eau de toilette, lip balm, lip polish, bath foam, and various accessories, including

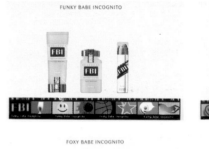
FUNKY BABE INCOGNITO

FANTASY BABE INCOGNITO

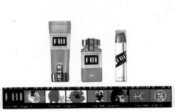
FOXY BABE INCOGNITO

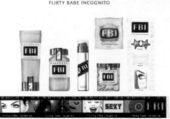
FLIRTY BABE INCOGNITO

THE FBI PRESENTATION HAD A DIFFERENT "BABE" PERSONALITY FOR EACH FRAGRANCE, REPRESENTED BY DIFFERENT-COLORED PACKS, INGREDIENTS, AND ATMOSPHERE PICTURES. THE COPYWRITING, WHICH WAS DONE BY THE BEAUTY EDITOR OF THE TEEN MAGAZINE *SUGAR*, INTRODUCED A "BIT OF FUN" TO THE RANGE.

THE SECOND ROUTE OF STAGE TWO WAS ABOUT "GIRLS IN CONTROL" AND USED ICONS THAT MATCHED THE FOUR FRAGRANCES TO FOUR CONTRASTING PERSONALITIES— DREAMER, WILD, LIVE, AND TEASE. THE PACK SHAPES, WHILE DIFFERENT THAN THE FIRST GROUP, WERE STILL BASED ON OFF-THE-SHELF FORMS BUT WITH THE ADDITION OF SOME NONSTANDARD CLOSURES. THE PHRASE "TRIED AND TESTED ON MEN" PROVED SO POPULAR IN RESEARCH THAT IT WAS APPLIED TO THE FINAL GROUP.

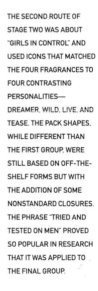

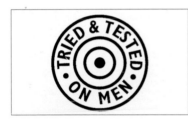
TRIED & TESTED ON MEN

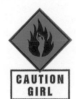
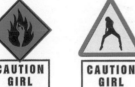

The only fragrances so irresistible to men they carry a warning

fragrance candles. The first step for the design team in understanding the audience was to talk to Amy, the teenage daughter of one of their designers, and some of her friends. They produced a series of four concept boards, which used images cut from magazines and included "girls in control," "the devil you know," and "the rebel"—aspects of mood and attitude rather than personality. "We had a lot of learning to do," remembers Duckworth, who sat in on the consumer research groups the client conducted.

A few weeks later the second presentation drew on their findings and showed four routes. The first—inspired by a Spice Girls-type quartet of girls with contrasting attitudes—showed a series of pack shapes and "film-frame" graphics, headed Flirty, Foxy, Fantasy, and Funky. The second, "Tried and Tested on Men," took caution signs and applied them to "girls in control" style icons, which were drawn on a variety of pack shapes, including a bullet-shaped lip polish. "Secret Weapon" was the title of the third and preferred route, which focused on "the devil within," and the first presentation board listed the four deadly sins, each one representing a different fragrance:

- Lust—become a temptress
- Envy—overcome your friends with jealousy
- Desire—be luscious, cool, relaxed, and admired
- Pride—be active, revitalized, confident, and ready to tackle anything or anyone.

"We needed to do a bit of tweaking to make them fit," confesses Duckworth, who used a little trident in the logo and drawings of demon characters that reflected the personality of each range. "It was these that they really identified with and hit the right balance between evil and cute," he says, recalling the subsequent research groups.

After that, they took their presentation out to three local schools and, in informal sessions with boys and girls they confirmed their earlier findings. "They liked the devils," says

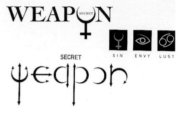

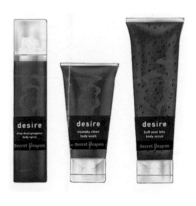

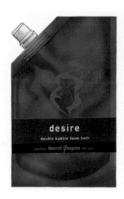

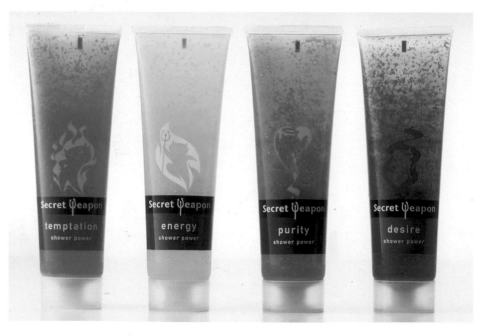

Duckworth, "but they didn't like the names Lust, Envy. They also liked the roundel 'tried and tested on men,' and this was salvaged and retained as a stamp on each pack."

Although the manufacturer, Dewhirst Toiletries, had given them samples of tubes and bottles, Duckworth and his creative director were able to suggest colors and cap and closure ideas, and a small can for solid perfume.

"We had to think of names for the variations and try to introduce ideas with a 'bit of attitude,'" says Duckworth. "The client was very open to our ideas and agreed to put the name Superdrug very small on the back, rather than on the front." During the design development stage the studio finalized all the elements and mocked up 40 dummy packs for a full presentation to an audience of client, manufacturers of all components and printers. "It gave the client the reassurance of knowing that it was the right product and the right design," Duckworth recalls.

Every three months all the design groups in the roster hold a meeting to present to each other two pieces of recent Superdrug work, which they compare with the mission statement and award marks out of five. "There's a real openness about it," says Duckworth, who admits that on this occasion they got top marks and "won the champagne."

(BELOW AND OVERLEAF) THE TINY METALLIC POUCHES FOR THE DRY PERFUME RANGE WERE SOURCED FROM ITALY. "WE WANTED SMALL ELEMENTS THAT GIRLS COULD TAKE TO SCHOOL OR BRING OUT AT THE DISCOS AND BECOME A TALKING POINT. THESE LITTLE 'PINGS' IN THE RANGE MADE IT MORE EXCITING," DUCKWORTH EXPLAINS.

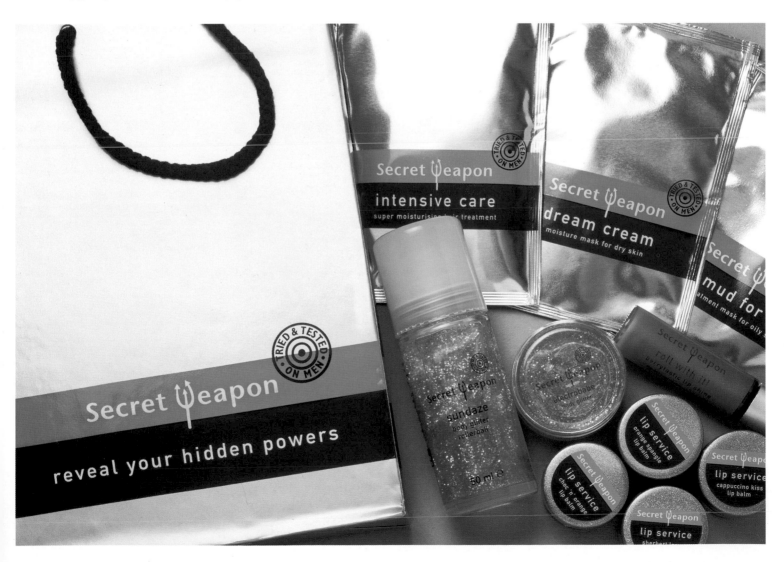

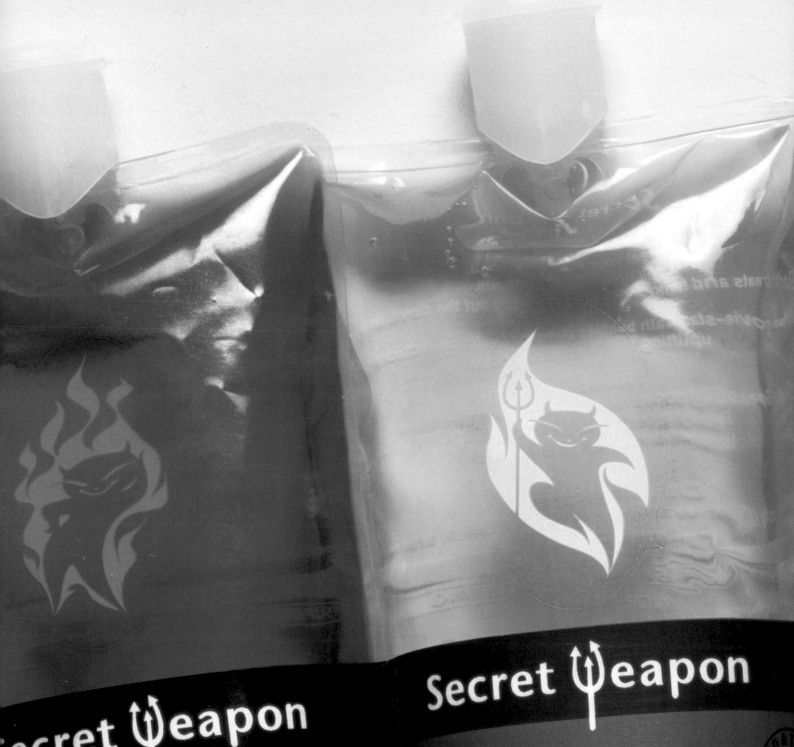

Secret ⚜eapon
temptation
bubble wrap bath soak

Secret ⚜eapon
energy
bubble wrap bath soak

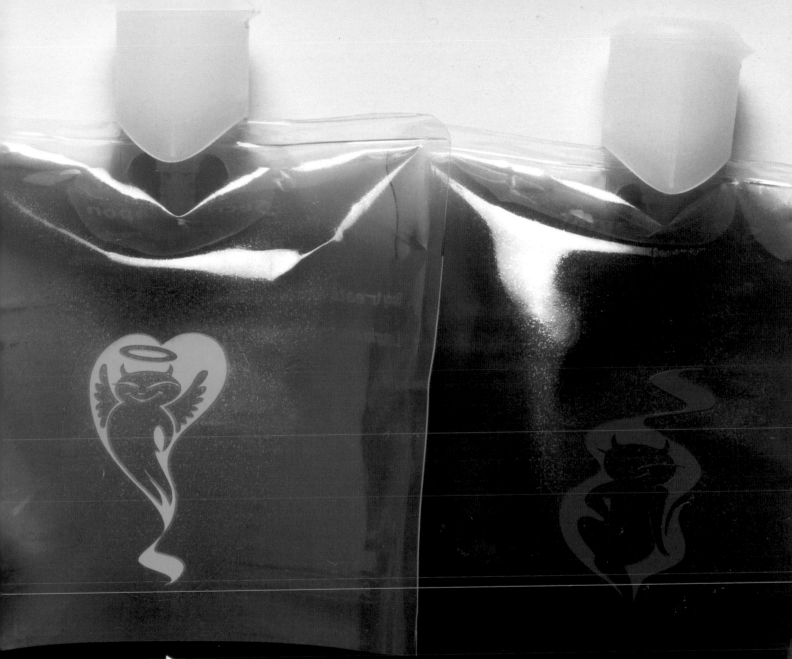

Secret ⚔eapon

purity

bubble wrap bath soak

Secret ⚔eapon

desire

bubble wrap bath soak

Ballantine's Purity

The competitive creative pitch was a symptom of the 1990s. Marketing executives, made nervous by the large fees charged by design companies, particularly for corporate identities, but encouraged by the number of companies competing for a job, demanded a preview of designers' ideas and approach, particularly if **they themselves did not quite know what they were looking for until they saw it**

Michael Peters Ltd (MPL), which had been in the business for 25 years and was, according to their brochure, one of the "best known brand identity design consultants in the U.K.," was used to pitching and competing with other design companies and was geared up to do so, although not, MPL stresses, without an appropriate fee. The company had three divisions—packaging, corporate identity (including literature) and retail design—and more than 55 people, half of whom were designers. Teams quite often work together on a multi-disciplinary job or pass on a client from one division to another.

In January 1994 Allied Domecq was intending to launch a new Ballantine's malt whiskey into the prestige duty-free Asia Pacific market in conjunction with DFS—Duty Free Shoppers, who control and run duty-free shops in the region, and whose endorsement of such new products is mandatory—and wanted a new bottle that would appeal to young customers. The brief explained:

"The ultimate Scotch whiskey will have all the distinguishing features to be instantly recognizable as Ballantine's yet be such a clear departure from all existing packaging in the sector that it will surprise and delight consumers. The proposition will offer a bridge between super premium Scotch whiskies and XO cognacs—not a compromise between the two but a positive blend of two historically discrete sectors."

MPL marketing consultants took the initial verbal brief and distilled the details into a design brief that was fed back to the client and used to focus the design team.

"The bottle shape needs to anchor consumers' perceptions in this quality/price bracket but be sufficiently different to command a premium and to create a category in its own right."

A young team of four designers, led by the creative director Roger Akroyd, got the brief and were given three days each to produce initial ideas using layout pads—"no straying onto the Mac yet." The designers had to come up with ideas for a bottle and a gift carton. To complicate matters, the target market was international travelers in the Asia Pacific regions, notably Chinese, Taiwanese, Japanese and Korean buyers, most of whom had a different perception of "quality." In particular, the Chinese and Taiwanese are accustomed to a more overt use of gold and embellishments, which are not high on a designer's list of ingredients.

(*BELOW RIGHT*) BEFORE THE CLIENT SAW THE FIRST BOTTLE IDEAS, A TECHNICAL CONSULTANT, LINK DESIGN, COMMENTED ON THEIR FEASIBILITY. AGAINST ONE CALLED ZEPPELIN, THE CONSULTANT SAID: "NEVER BEEN DONE BEFORE—A PRODUCTION NIGHTMARE." A LINE-UP OF FIVE IDEAS THAT DID NOT MAKE IT WERE ALL MODERN INTERPRETATIONS OF THE CLASSIC DECANTER.

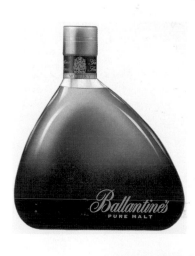

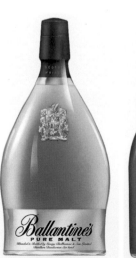

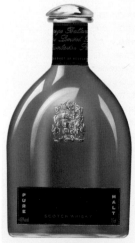

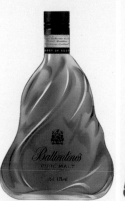

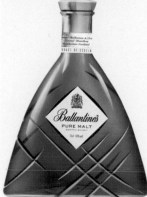

FOLLOWING THE STAGE ONE PRESENTATION, TWO SHAPES WERE IDENTIFIED FOR FURTHER DEVELOPMENT. THE SHIP'S DECANTER (RIGHT) WAS LATER FOUND TO BE "DIFFICULT TO POUR, BECAUSE OF THE DIFFICULTY OF GRIPPING ANYTHING BUT THE NECK AND THE FACT THAT THE NECK IS FAR WIDER THAN THE NECK OF MOST BOTTLES." THE DROPLET SHAPE, (RIGHT) ON THE OTHER HAND, WENT ON TO DO WELL IN THE RESEARCH PROCESS, ALTHOUGH, CURIOUSLY, ONE REPORT NOTED THAT "ONLY A FEW RESPONDENTS ACTUALLY PERCEIVED THAT THE DESIGN IS OF A TEARDROP AND THESE FEW ARE BALANCED AGAINST A FEW OTHERS WHO THOUGHT THAT THE DESIGN WAS OF A BULLET HITTING ITS MARK."

ANOTHER PRESENTATION BOARD SHOWED SEVERAL VIEWS OF THE SHIP'S DECANTER IDEA. THE CIRCULAR BOX INCLUDED A PLINTH TO RAISE THE BOTTLE DISPLAY AND "PURE" HAD BEEN ETCHED INTO THE BASE OF THE BOTTLE.

Nevertheless, the team developed "a wide range of conceptual material early on," recalls Akroyd. "Some were over the top cost-wise, but we wanted to try everything that had some merit." He reviewed it all on the fourth day and then gave the team three or four more days.

In three weeks he went to the presentation with nine concepts. "Normally we'd show fewer, but, given the brief, it was a wide-ranging exploration at this stage."

Richard Gowar, marketing director of Ballantine's, came to the presentation and was "pleased with the thinking and quality" of the material. The ideas were shown as highly finished, air-brushed visuals with rub-down graphics as well as two-dimensional drawings of the cartons. Gowar picked out two solutions—a ship's decanter shape and a droplet idea—before taking everything away for discussion.

Two weeks later MPL got the go-ahead. Both ideas were to be progressed. The droplet shape—designed in the shape of a drop of water, the purest of liquids, standing on a plinth within a carton that represented ripples of golden whiskey—had been inspired by a piece of folklore in a book on the distillery's history:

"Legend has it that in the fifteenth century, an abbot knelt on a stone beside the Black Burn, which flows by Miltonduff distillery, and blessed the waters. Thereafter, the drink distilled from them was christened "aqua vitae." To make the idea clear, the text "The water of life" had been added around the base of the plinth.

Although the bottle progressed without too many hitches, the gift carton, at one stage a cylindrical container, underwent a lot of changes. "The original intention was to create a carton that was sympathetic to the bottle shape, such as a circular form. However, there were practical issues of feasibility and cost," reflects Akroyd. With duty-free products of this kind, which are sold mainly as gifts, the outer packaging is perceived to be a key part of the whole communication. With no other promotional support in this very competitive market, the instore presentation was critical.

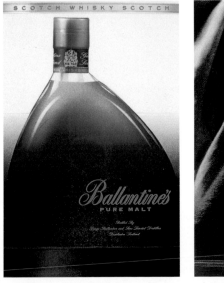

THREE BOX SHAPES, EACH WITH A DIFFERENT GRAPHIC INTERPRETATION OF THE BRIEF—"AS BALLANTINE'S PURE MALT WILL INITIALLY SELL ONLY THROUGH DUTY-FREE (WHERE THE "GIFTABILITY" APPEAL IS SO IMPORTANT), THE CARTON WILL BE A KEY ELEMENT OF THE BRAND PRESENTATION. CARTON DESIGNS SHOULD BE INNOVATIVE, BOTH GRAPHICALLY AND STRUCTURALLY."

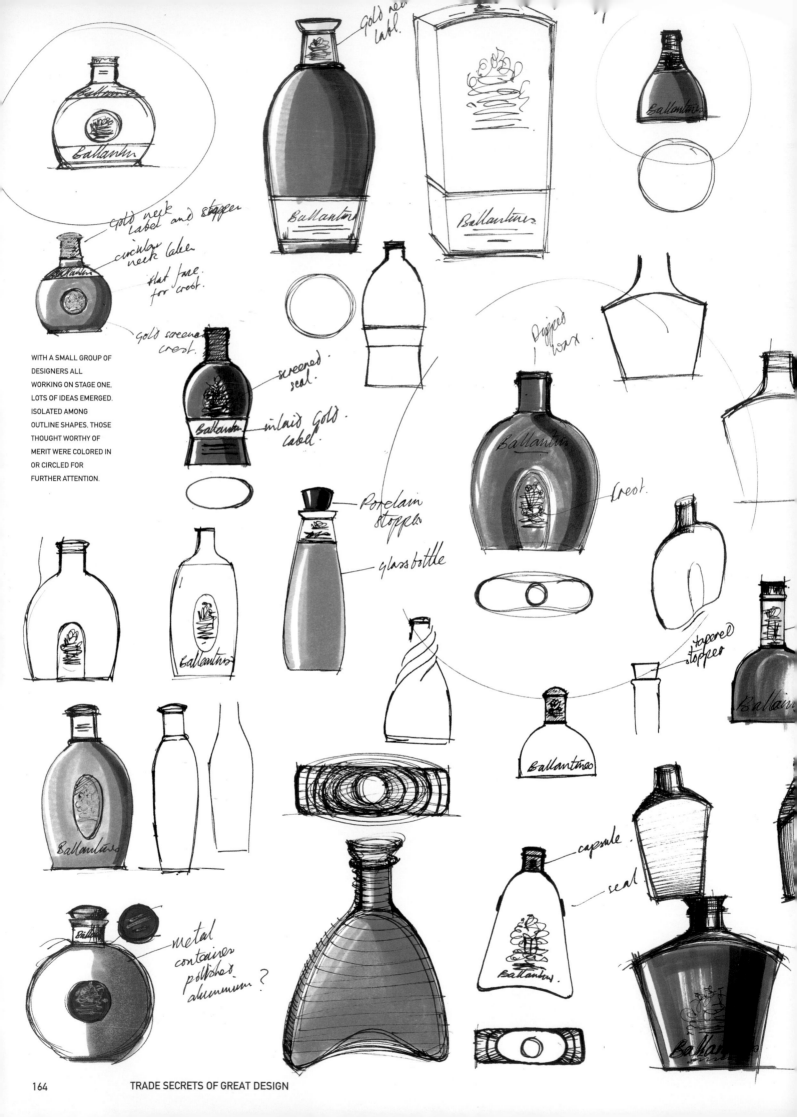

Gold neck label.

Gold neck label and stopper
circular neck label.
flat face for crest.

Gold screened crest.

screened seal.

inlaid Gold label.

WITH A SMALL GROUP OF DESIGNERS ALL WORKING ON STAGE ONE, LOTS OF IDEAS EMERGED. ISOLATED AMONG OUTLINE SHAPES, THOSE THOUGHT WORTHY OF MERIT WERE COLORED IN OR CIRCLED FOR FURTHER ATTENTION.

Porcelain stopper

glass bottle

Dipped wax.

Crest.

tapered stopper

capsule.

seal.

metal container polished aluminium?

TRADE SECRETS OF GREAT DESIGN

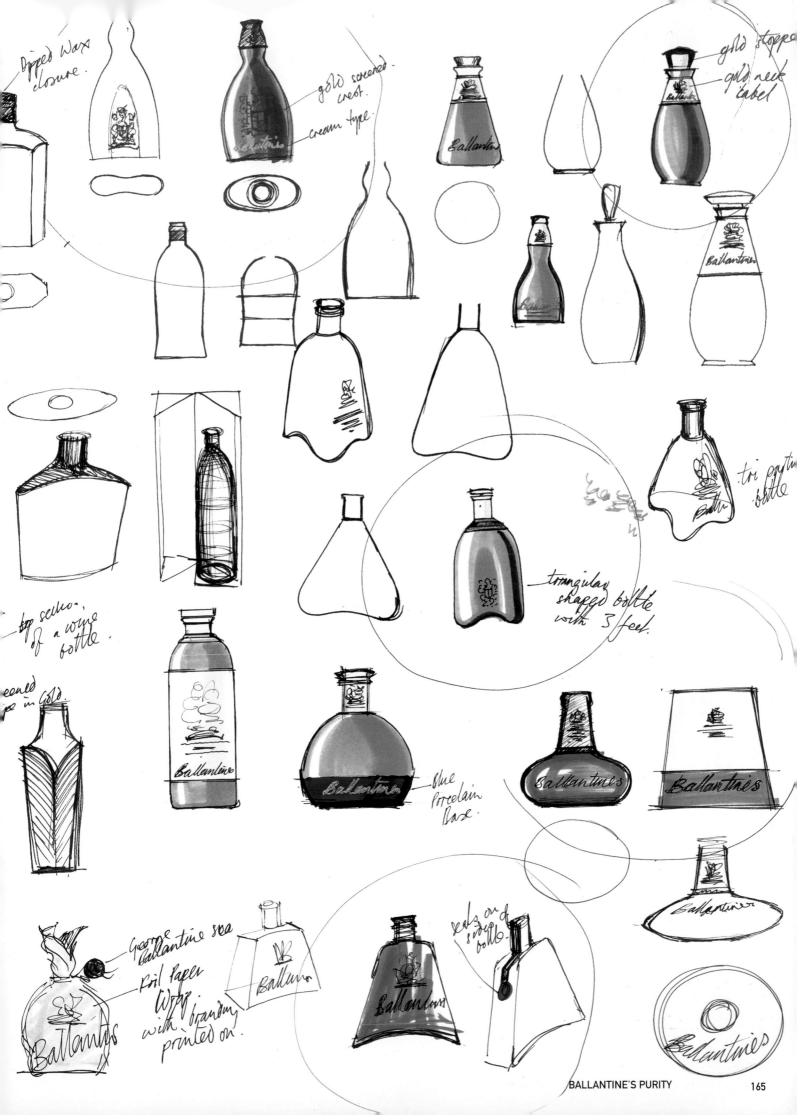

Dipped Wax closure.

gold screened crest.

cream type.

gold stopper

gold neck label

top section of a wine bottle.

screened type in Gold.

triangular shaped bottle with 3 feet.

tri partite bottle

Blue Porcelain Base.

George Ballantine sea Foil paper Wrap with brandy printed on.

seals on side of bottle.

Ballantine

Ballantines

Ballantines

By the end of April 1994 and the second presentation, the two bottles had been made up as three-dimensional resin mockups with graphics in place and with carton, which by this time had been redesigned.

Contrary to expectations, MPL were still in competition and had to wait while all the alternatives went off to Asia Pacific for customer research. At last, on June 15, 1995, Richard Gowar wrote to tell them that the droplet idea had come out of the research best. But there was more work to do: "The key issues for us to address in developing the idea are:

- Overall "bulkiness of the design" and specifically:
- How do we improve handling ability without losing the integrity of the design?
- How do we reduce the size and weight of the base while retaining the creative idea?
- How can we reduce the size of the carton?
- How can we communicate the design concept—the "drop" of pure malt—more clearly?
- How can we achieve closure inside the cap?"

The Chinese and Japanese tend to have smaller hands than Europeans, and they had found the bottle too large. "It needs to be slimmer, easier to hold and easier to pour," said Gowar. It was decided to reduce the bottle size from 75 cl to 50 cl. In addition, a lot of research was carried out into the perceived meaning of the word "purity," which was used as a sub-brand on the bottle. Although "purity" meant "crystal clear water" to Japanese minds, it also conjured up "virginal, clear, and unexploited"—far from the meaning of pure malt whisky.

Despite this, research found no problems as the word "purity is not familiar to Japanese consumers", and "pure", as in "pure malt", was well known in the whiskey market.

Smaller resin models were made and more research done. The new box now opened in two halves, revealing the bottle sitting on its ripple plinth. The models were shown to DFS and the signs were good.

The client's own technical facility was now involved, sourcing box and bottle manufacturers, and by now MPL was producing its fourth set of resin mockups. "Even though the margins on this type of product are fairly great, there were still tight restrictions on the cost of the box," explains Akroyd. The bottles were to sell at over US$80 each.

"At this point it was important to keep hold of the integrity of the concept. Everyone was making changes, and a lot of meetings took place in Hong Kong without us," he says.

By January 1996 everything was signed off. Artwork was produced for the carton, the bottle, and a leaflet that sat in a slot behind the bottle. The next five months were taken up with production. The first samples arrived in May—just 17 months after the first briefing day. At first, Allied Domecq produced only 70,000: "They didn't go wild in case it didn't take off," but such were the optimistic indications that MPL had already been briefed to start work on another major brand for Ballantine's.

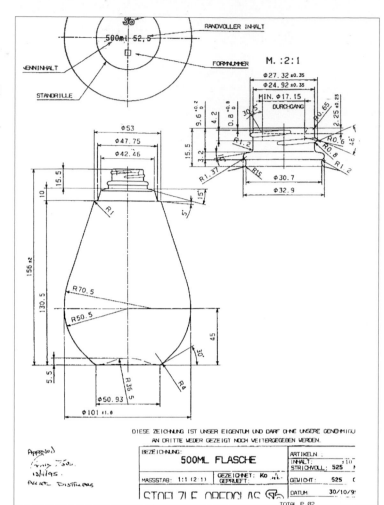

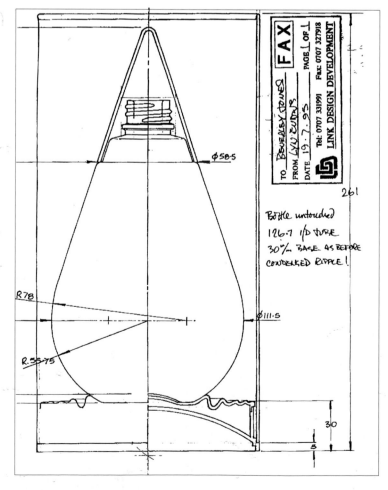

COMPUTER DRAWINGS BY LINK DESIGN WERE SENT TO BOTTLE MANUFACTURERS FOR QUOTES AND FEEDBACK. "WE HAD TO MONITOR THE PROCESS CLOSELY… AS MANUFACTURERS ARE INCLINED TO CHANGE THE SHAPE OF A BOTTLE TO SUIT THEIR PRODUCTION NEEDS." IN THE END, STÖLZLE, AN AUSTRIAN GLASS MANUFACTURER, SPECIALIZING IN QUALITY PERFUME BOTTLES, GOT THE JOB. THE DRAWING REVEALS THE COMPLEXITY INVOLVED IN DETAILING A CAP THAT HAD A BUILT-IN REGISTER ALLOWING IT TO SCREW TO THE SAME POINT EVERY TIME, SO THAT THE LETTERS (WHICH WERE ADDED LATER) ALWAYS LINED UP.

(RIGHT) THE FINAL FORM OF THE BOX, MADE BY ARMSTRONGS IN SCOTLAND, HAD TWO SECTIONS THAT OPENED OUT TO REVEAL THE BOTTLE. AN IDEAL DISPLAY SOLUTION SINCE IT INCREASED THE PRODUCT IMPACT THREEFOLD. INSIDE THE BOX, THE RIPPLE PHOTOGRAPH BY KELVIN MURRAY WAS ACTUALLY OF A MODEL MADE IN PERSPEX BY MODEL-MAKER TIM WEAR.

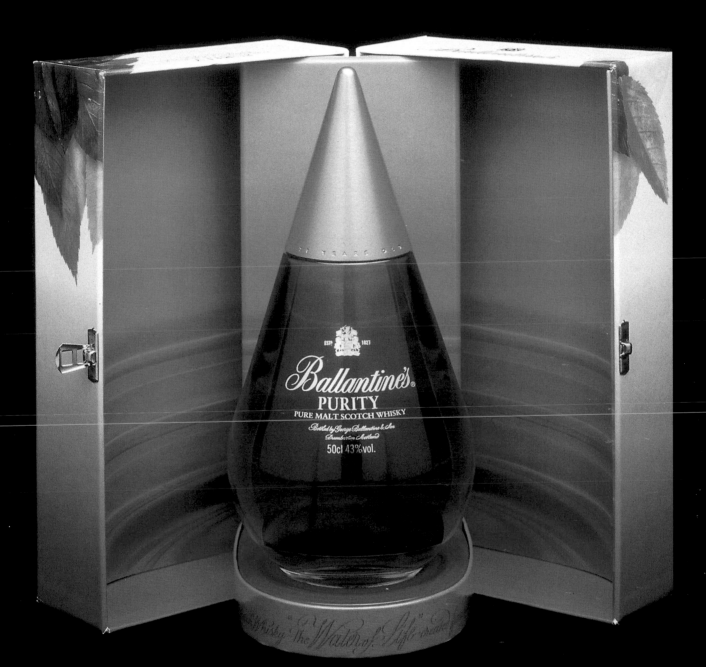

Bond, James Bond

In the world of perfume packaging it seems that almost anything is possible, from a Gallic torso to a sculpted shard of crystal. On this occasion, drawing on the rich legacy of the James Bond stories, **it might even have been a secret fetish object or a flying saucer**

Although it seems extraordinary, when AB R. Barlach bought the rights, there had never before been a James Bond perfume. Nor had this Swedish company ever produced a perfume, having hitherto been successful in the business of cosmetics distribution. In contrast, Desgrippes Gobé & Associates, an image management and strategic design consultancy based in Paris, has had years of experience in the business of perfume design as well as in mass-market product design and packaging, brand identity and retail architecture design.

Creative director Sophie Farhi has been with Desgrippes Gobé & Associates for many years and directs the creative teams on all perfume and cosmetics projects. "Before we could start design work," she says, "we had to explore the possibilities of the James Bond brand. There were a lot of exciting possibilities, and the values associated with James Bond ranged from prestige and luxury to adventure. Although it could easily have had a mass-market appeal, the decision was taken to position this perfume in selective distribution with an upmarket, prestigious presentation: James Bond—myth of a modern hero—sense of seduction."

"Easy to imagine as a man's perfume, we at first had to make it a feminine brand, even though a masculine range was to follow later." Working with her marketing team, Farhi spent two weeks exploring, in words and pictures, the universe of James Bond. "There were a lot of books and, of course, all the movies," Farhi says, remembering the concept boards they produced.

"We wanted the client to understand all the different values of the brand, and, by presenting them visually, we could choose together the direction to take," she says. Several of the concepts were based on the themes of luxury and tradition, and one concept was centered on mystery. In addition to one board on James Bond the person, and one on the James Bond universe, there were four potential routes the designers could take:

• Mystery—a mysterious kind of shape whose purpose is not readily discernable. A small object to keep in your pocket like a secret for spies. A piece of precious luxury—not exactly a bottle—perhaps like a smooth round bowl with no apparent cap. An object belonging to the world of espionage, hidden parts, and secret codes.

• Accomplice—the second approach was based on a very personal object that James Bond might carry, like a talisman or an intimate fetish object. A custom-made accessory personalized for James Bond, which might be

"EXTRAVAGANT, UNEXPECTED, STARTLING"—ASPECTS OF JAMES BOND THAT THE DESIGNERS APPLIED TO THEIR PACKAGING IDEAS. THESE TWO SHAPES COMBINED METAL AND GLASS INTO AN EXOTIC PENDANT OR TALISMAN.

THE UNIQUE NATURE OF THE OBJECT—BOTH INTRIGUING AND LUXURIOUS—WAS SEEN AS JAMES BOND'S AID TO SEDUCTION. ONE DESIGN (*ABOVE FAR RIGHT*) HAD A METAL BAND THAT, WHEN CLOSED, FORMED AN OUTLINE AROUND THE GLASS CONTAINER.

INITIALLY, THE DESIGNERS CONCEIVED A BOTTLE IN GLASS AND BRIGHTLY COLORED METAL—RED RECALLING A ROSE WORN IN THE BUTTONHOLE—"A MODERN WAY TO INTRODUCE COLOR TO THE BOTTLE," SAY THE DESIGNERS, WHO FINALLY CHOSE GOLD AND SILVER. THE REAL CHALLENGE WITH THESE TWO SHAPES BECAME THE MARRYING OF METAL AND GLASS IN SUCH A PRECISE FASHION. THE SHOULDER AT THE TOP (*ABOVE*) WAS CREATED TO CONCEAL THE SMALL SPRAY MECHANISM.

FOAM MODELS SHOW HOW THE DESIGN WAS ADAPTED TO A SPRAY BOTTLE AND A MINIATURE VERSION.

ALTHOUGH THEIR FIRST CHOICE WAS A TRANSPARENT CONTAINER, THE TEAM HAD TO PURSUE CARDBOARD BOXES AND OFF-THE-SHELF SOLUTIONS BEFORE THEY GOT THE GO-AHEAD FOR THIS CLEAR PLASTIC DRUM WITH SILK-SCREENED BLACK LETTERING. THE BASE HAD A SHAPED WELL THAT SUPPORTED THE BOTTLE AT AN ANGLE.

given to a woman of his choice, thus becoming a precious private accomplice.

• Seduction—a perfume that James Bond might offer to a woman to seduce, to challenge and surprise her at the same time. The refined game of love and seduction, perhaps involving complicity or rivalry, which carries a hint of "showing off" as well.

"Although we didn't pursue this direction, in the end we thought of the sophisticated technology, duality of roles, and—since James Bond is a winner—using something based on the idea of a game."

All the concepts offered rich expression, and, in the end elements from each were chosen. It is essential to find a consensus between the designer and the client concerning the visual vocabulary, and this process helped Barlach to express things they had not thought of or that might be missing. Later, since at this stage there was still no perfume, it served as a means of briefing the perfumers.

Farhi then briefed Véronique Moretti and Eric Douance, the design team selected to carry out the three-dimensional creative research phase, on the direction to take. Far from being difficult, "it was very exciting and everyone was happy and upbeat," she recalls. In two weeks, shapes started to emerge and the client got the first glimpse of some pretty radical ideas. "The schedule was very tight—and although we always feel there is not enough time, we managed to present about 25 ideas," says Farhi. She also explains what a problem it can be to keep up with what else is on the market and to know what to avoid. "We keep an extensive up-to-date library of pictures of perfumes and cosmetics, but we can never be sure that someone else, somewhere in the world hasn't had the same idea at the same time."

Of the bottle ideas shown to the client, most could not stand up on their own, and this became a key factor. The client was excited. One or two looked like objects you might hang from your belt, and others could be spun like a top.

As the work progressed, it seemed to be coming down to what became known as the flying saucer shape, with its combination of steel (realized in matt gold-metalized polypro) and glass. "It is important to be aware of technical difficulties in advance so we can help the client to find the

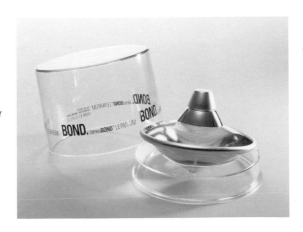

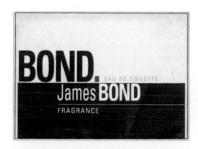

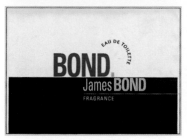
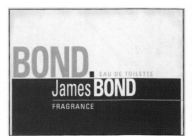

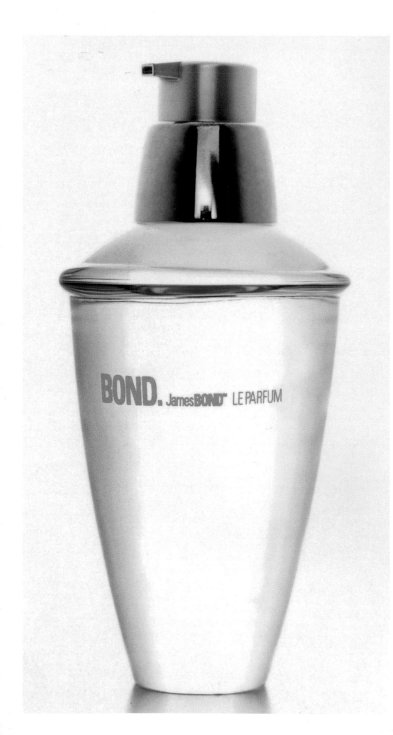

right manufacturer. Therefore we warned them that it was going to be difficult to make," says Farhi.

Having chosen the design, the team now started to work in volume, sculpting models for the 2 fluid ounce and 4 fluid ounce bottles in yellow polystyrene foam. "There were a lot of variations before we found the exact shape," says Farhi, who, over the next 10 days, looked at dozens of models. "We show the client something when we're sure we've got a good balance concerning bottle and cap dimensions—usually three or four alternatives."

At the same time, they looked at samples demonstrating the type of metal, the type of frosting, or whatever else would help the client to understand the final effect. Meanwhile, the graphic team, led by Sylvie Verdier, was working on the brand identity—the typeface, style, and colors—that could be used for the name, methods of applying it, and, most crucially, how to make the box. "For the identity we presented various solutions, but quickly settled on one in black and white which properly conveyed the universe of old movies as well as the elegant dinner jacket so often worn by James Bond. The packaging for this perfume had to be very new and surprising. Essentially we wanted a transparent round box, although we knew it could be really expensive," says Farhi. "Finally, everyone loved this idea and we managed to get prices that the client could accept."

Desgrippes Gobé's own production team did all the follow-up, working with the manufacturers to produce the technical drawings and correcting any defects on the trial models. The creative process, however, was not over. The team went on to work on a range of bath products. "It was the same process," says Farhi, "but this time, although they had many of the same characteristics, the bottles (which were now in a plastic very similar to glass in brilliance and transparency) had to stand up themselves."

She continues "this complicated project demanded involvement from all the partners and a professionalism which would have impressed James Bond himself."

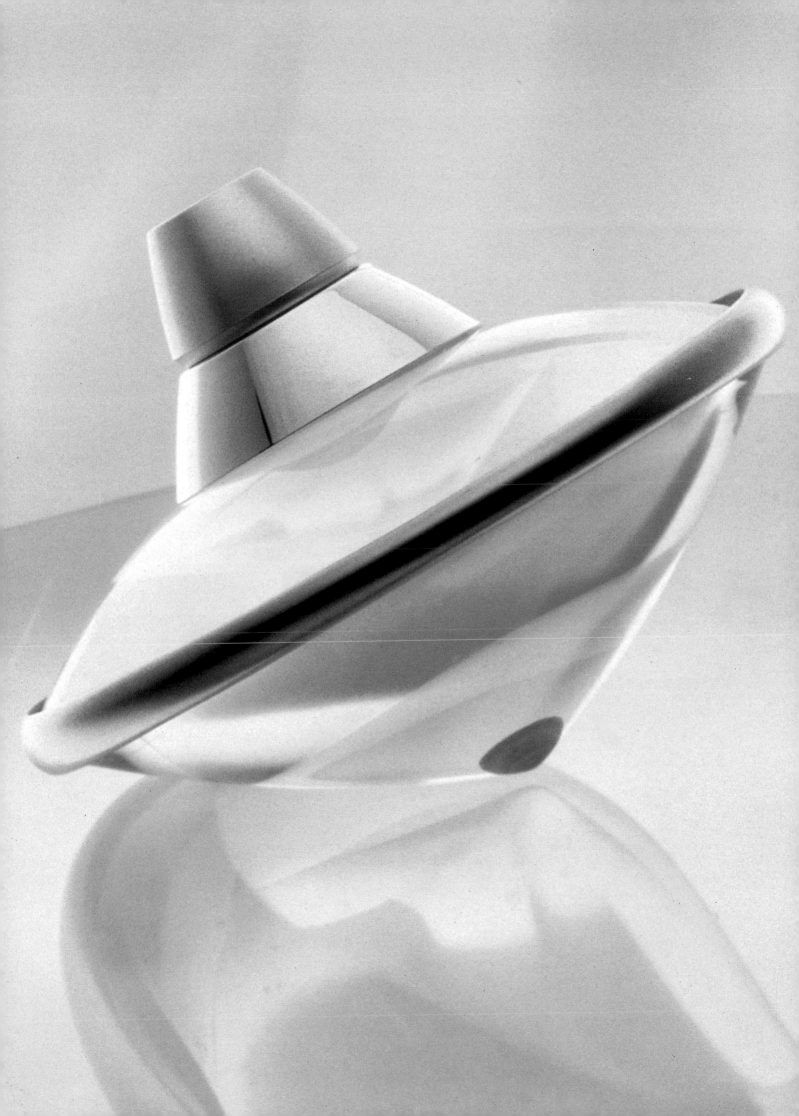

Fedrigoni

Sometimes there are no first roughs, no sketchbook of alternatives, no development of concepts. The idea just happens, and altogether it seems totally right. But whenever you talk to Lynn Trickett of the design group Trickett & Webb in London, she **always stresses the importance of thorough research.** "When you get all the information together, all the background material and references, the best solution invariably just falls into place"

EACH BUSINESS CARD IN THE NEW FEDRIGONI IDENTITY UTILIZES A DIFFERENT PHOTOGRAPH BY HERBERT LIST TO DEFINE THE ITALIAN CHARACTERISTICS, AND A TONGUE-IN-CHEEK PHONETIC PRONUNCIATION.

It sounds simple and, in the case of the company's work for Fedrigoni it probably was. The Italian paper manufacturer had been importing paper into Britain for the past 15 years—talking mainly to printers— but although the company had an agent, it had never done any serious promotion. In 1997 it decided to set up its own company in Britain with its own warehouse and sales force. In fact, the company had such a low profile in Britain that Trickett, who was used to specifying paper, had never heard of it until she was approached to design the new identity. Although Fedrigoni had produced a lot of material in Italy, the owners—it was an old family business—were extremely Anglophile and used names such as Tweed and Savile Row for the papers.

Trickett, whose impressions of Italy were synonymous with passion and romance, thought immediately that the company should position itself as Italian but seen through British eyes. At the same time, she was keen to avoid "the pizza and pasta route." She discovered the wonderful German photographer, Herbert List, whose work from Italy in the 1950s had exactly the qualities she wanted.

When it came to the launch of the company, its range, and its new identity at the Creative Show in Islington six months later, Trickett wanted something with a unique character that would say "paper and Italy without any words." The perfect choice, she thought, was to give the 500 guests an individual little panettone. Unmistakably Italian, the light, bread-based cakes are a common sight in Italy throughout the year, but they are also given as presents at Christmas, Easter, and

USED IN DIFFERENT SIZES ON THE VARIOUS FOLDERS, PRICE LISTS AND SAMPLE BOOKS, THE LARGE F WAS IN ADDITION TO THE ALREADY EXISTING CORPORATE TYPESTYLE AND SHIELD, AND WAS A CLEVER WAY OF FRESHENING OR UPDATING A TRADITIONAL IMAGE.

other festivals. In addition—and perhaps more importantly—
the paper packaging is also totally and uniquely Italian,
although its origins are lost in the mists of time.

The client helped to find a baker in London who already
made panettone and had the little molds. This governed the
size of the packs, whose scaled-down proportions were
designed to carry two of the striking photographs by List, as
well as the corporate pink and the company's new logo. Used
to putting together sample kits, the sales team was drafted in
to fold and pack all the miniature morsels. "It only took a day,
and they didn't complain," recalls Lynn Trickett.

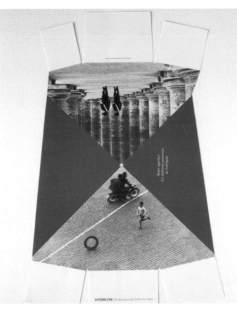

(*LEFT*) SEEN IN THE FLAT,
THE SIMPLE LAYOUT AND
CUT-OUT SHAPE BELIES ITS
UNIQUE CONSTRUCTION.
THE ARTWORK INCLUDED.
THE PAPER SPECIFICATION.

"SUMMING UP ITALY MORE
THAN ANYTHING ELSE
COULD," THE LITTLE PACKS
(*BELOW*) HAD A TACTILE AS
WELL AS A VISUAL
APPEAL. PRODUCED
ENTIRELY IN BRITAIN, THEY
ALL HAD TO BE
ASSEMBLED BY HAND—
INCLUDING THE LITTLE
SATIN RIBBON HANDLES.

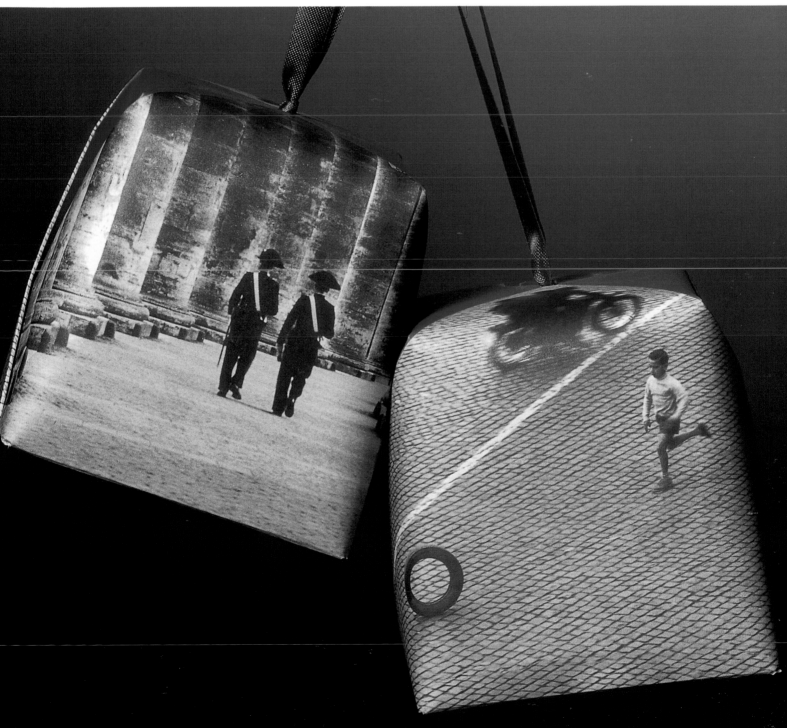

Kyusu was created by two very different designers, one concentrating on branding and identity and the other on form and texture. With the client as project manager, each creative contributor was dependent upon the other. All the more surprising, then, that they only met during the later stages of the project

David Ames directs a small team of product designers at David Ames Studio in London (formerly Lyons Ames Product Design); Mark Shaw is creative director of Jupiter Design Ltd in Nottingham. Both had worked for the client, Boots previously, and were brought together by the client, who must take the credit for successfully coordinating the project.

In the first instance, both were shown the same orientation boards and the same initial bottle shape. The client had already carried out a lot of initial research and development into a new toiletries collection featuring products with scientifically proven formulations, targeted at women between the ages of 25 and 35. The proposed new range was defined as: an exclusive care regime dedicated to your well being—the harmony of mind, body, and spirit.

"Every product in the range is formulated using nature's most effective ingredients, incorporating advanced science and beauty technology to deliver high-performance beauty solutions with proven benefits." From the outset, the client made it very clear that this innovative range of toiletries and skincare products, gifts, and bath and beauty accessories was to be as enticing as it was effective. The proven high performance of the products was not enough in itself—it was important the products also had to look better than anything else in the bathroom.

Shaw was impressed that Boots were taking the lead in venturing into this new market rather than following others. Boots, which has over 1,300 stores throughout the U.K. and abroad, is the leading retailer of beauty and bath products in the U.K., and its own No.7 range of cosmetics is the U.K. leader. Shaw had already worked with Boots on the Global Collection range of bath and hair care products. This time, however, his task, and that of his team of designers and writers, was to be much more difficult. Not only did he work closely with Boots in the brainstormings for the range, but also developed the sub-brand names for nine different sectors and a host of suitable item names for individual products. There was also the back of pack copy to consider, as well as supporting literature. For this range every single item (of which there were over 80) was to have its own specific message on the pack.

"We took our lead from one particular picture on the orientation boards, which seemed to have a Zen feeling and suggested a minimalist approach, but with quite a lot of resonance to it, as reflected in the basic Zen philosophy," Shaw explains. "We also tried to put a spiritual element in

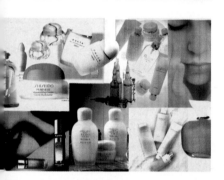

TWO ORIENTATION BOARDS CONTAINED A COLLAGE OF PRODUCTS CURRENTLY ON THE MARKET COMBINED WITH KEY WORDS. THEY WERE USED TO HELP BRIEF THE TWO DESIGN TEAMS AND TO FOCUS ON A PARTICULAR BRAND POSITIONING.

ONCE BOOTS HAD FOUND A NAME, JUPITER STARTED TO WORK WITH TYPEFACES AND ILLUSTRATIVE ELEMENTS. "THE LOOK OF THE WORD WAS AS IMPORTANT AS THE SOUND IT MADE." SAYS MARK SHAW. THE FINAL CHOICE WAS A TYPESTYLE DRAWN UP BY JUPITER, COMBINED WITH A DISC THAT ECHOED THE INDENTATION IN THE CAP.

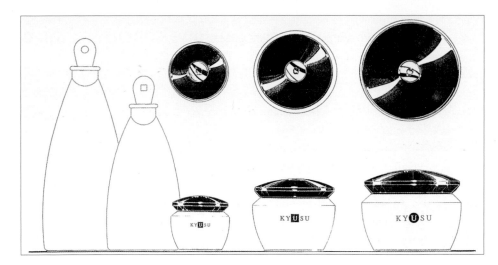

DAVID AMES'S FIRST JOB FOR THE NEW RANGE WAS A SERIES OF JARS THAT WOULD REFLECT THE FEELING OF THE INITIAL BOTTLE SHAPE AND INTRODUCE A SIMILAR "INGOT" OR "JEWEL" SHAPE IN THE LID WHICH IS ALSO MIRRORED IN THE LOGO. AT FIRST, THE TEAM SPENT A DAY PRODUCING ROUGH SKETCHES BEFORE PRESENTING MORE DETAILED PROPOSALS (*LEFT*).

KNOWN AS A TOTTLE, THESE STANDING CONTAINERS FOR SHAMPOO AND SHOWER GEL AND SCRUBS REFLECTED THE SHAPE OF THE BOTTLE.

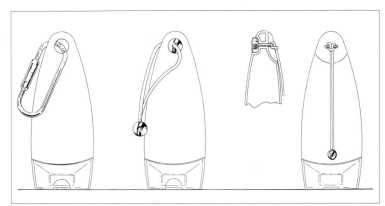

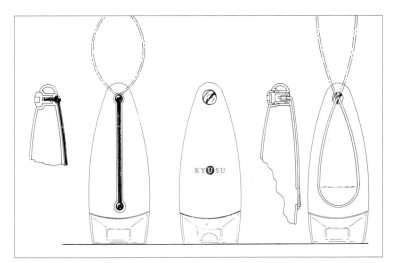

ONCE HE WAS ASKED TO DEVELOP THE BOTTLE ITSELF, DAVID AMES AND HIS TEAM EXPERIMENTED WITH THE HEIGHT AND PROPORTIONS OF THE VARIOUS SIZES AS WELL AS TURNING THE CAP INTO A RING. IN THE FINAL LINE-UP THERE WERE SIX BOTTLE SIZES, INCLUDING THE TOTTLE WITH A SPECIALLY DESIGNED FLIP TOP.

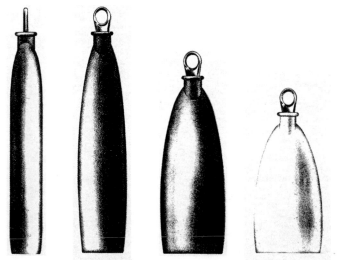

there", he says, recalling the "fairly bizarre brainstorming sessions" they held, which sometimes took all day. "We started by trawling the English language, armed with every dictionary and thesaurus we could find, books of Zen haiku poetry and even the *Karma Sutra*."

He worked with copywriters Rachel Shaw and Richard Adams to help Boots reach a shortlist of 25 names. "Boots contributed the larger proportion of the names and ours were also included for consideration," explains Shaw, "but getting the best ideas through to final approval was to prove challenging to say the least. Once the client was happy with a particular name it was then put through 'research' to find out if it was already registered. Some of the very best names bit the dust at this late stage, and many were rejected simply for having a vague similarity to a name registered decades ago yet virtually unknown in the marketplace. Finding a new name is soon going to be a major problem," Shaw says, referring to the global shortage he anticipates, "it requires a certain combination of imagination, steady nerve and blind faith to discover the true potential of a word that initially may seem to be unsuitable. The final shortlist comprised five very different options. Kyusu, which was thought up by Boots, has a strong Japanese feel and good phonetic values."

Once the Kyusu name h ad been decided upon, Shaw's designers, Steve Seamark and Sandy Wilson (who had also contributed range names during the previous months' brainstorming sessions) put forward graphic interpretations of the Kyusu brand. Five ideas were produced. One in particular was instantly picked up on within the Boots Beauty Business Center, and when market research backed this preference a unanimous choice was made.

While the designers began to concentrate on the typography on the products and packs, Shaw's copywriters faced a new challenge—creating the names for the nine sub-sections within Kyusu, each of which was to have a clearly defined personality. The client brief clearly described the characteristics and colors of each sub-section; all Shaw's team had to do was set the style and tone for sub-sector names in general and then encapsulate each Kyusu

personality with an outstanding name. "After the traumas of putting good words 'through legal' and witnessing the best of them hit the wall, this new brief was approached very carefully," he says.

Meanwhile, in London, David Ames had been shown the same bottle sketch that had been briefed to Jupiter and was asked to come up with ideas for a range of three coordinating jars and a "tottle" (part tube, part bottle) for the Kyusu shower gels and shampoos. Boots outlined the colors and ingredients of the new product and explained the brand positioning. One of Ames's starting points was the shaped caps on the bottles. Working with colleagues Toni Papaloizou, Kerrin Lyons, and Howard Chapman, he drew up eight or nine designs, five of which he modeled in an easy-to-sculpt, high-density polystyrene foam.

Although the squat designs of the jar could not match the bottle, Ames echoed the gently curved sides and experimented with textures and indentations in the lids. With the tottle, he was able to have more design flexibility and produced a variety of innovations.

A few weeks into the project, Ames was also asked to work on refining the bottle shape and, in conjunction with the manufacturer, AMS, and Boots Contract Manufacturing (BCM) division, to work on the structure and function of the cap. Ames recalls that each stage took about a day. "We'd all work on ideas and then pin them up, eliminating some and putting little groups of shapes together." Another day would be taken working them up in more detail in magic marker pen. From these, the client was able to do "internal" research within the Boots Beauty Business Centre before choosing two designs for Ames to develop. The brief was for three different sizes, with structurally defined designed specification drawings ready to show the manufacturer in France.

By now Jupiter's designers had been commissioned to do the entire graphic job for Kyusu, controlling the typesetting and bar-coding as well as the implementation of the brand identity. With so much copy to be written, approved and amended in typeset form, Jupiter's Apple Macintosh network produced many time saving benefits. "It was 12 months before all the words were finally approved," admits Shaw, who spent a great deal of time maintaining the brand personality across all 80 products and working with the many manufacturers to

FOCUSING ON WHAT WAS KNOWN AS THE "INGOT", THESE THREE SKETCHES SHOW HOW THE DESIGNERS EXPERIMENTED WITH VARIOUS METHODS OF CLOSURE, EVEN BEFORE THEY HAD GOT THE JOB OF DESIGNING THE FINAL BOTTLES.

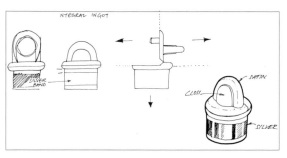

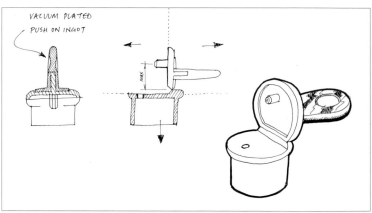

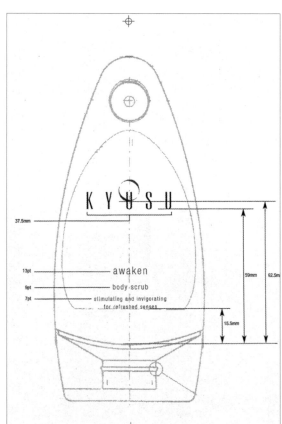

EACH PRODUCT HAD ITS OWN EMOTIVE RANGE TITLE—UNWIND AND SO ON—PRODUCT NAME AND UNIQUELY WORDED EXPLANATORY COPY. THE LOGOS WERE A COMBINATION OF SILVER-EMBOSSED NAME AND PRINTED DISC, A SOLUTION THAT TOOK HOURS OF CAREFUL COORDINATION WITH THE MANUFACTURERS AND THE PRODUCTION OF AN EXTENSIVE PAGE DESIGN MANUAL (LEFT).

ONE OF THE PRESENTATION BOARDS THAT JUPITER PRODUCED, USING THE THREE BASIC PACKS SHAPES, TO SHOW THEIR IDEAS FOR A LOGO. THIS ONE, USING BOTH COOL AND WARM COLOR COMBINATIONS, SHOWS A "PAINTERLY" LEAF DESIGN THAT WAS NOT PURSUED BEYOND THE CONSUMER RESEARCH STAGE.

make sure that the logo detail was acceptable when produced on a large production run. Designer Steve Seamark recalls, "the potential problems of printing two types of silver onto a hollow bottle were mind-boggling. We consulted the printers and adapted our designs where possible to assist with the production process, yet we steadfastly refused to compromise the brand at any time."

David Ames was spending his time liaising with BCM and their manufacturers. By now the development team had grown to two manufacturers for the jars, one for the tottle, one for the cap, one for the bottle stopper, and two for the bottles themselves. Each manufacturer had different capabilities and limitations—and a tendency to modify Ames's drawings to suit their particular needs.

At the center of this massive process was Boots Product Manager, Louise Thompson, "steering the agreed concept through to final production without compromising the brand values required enormous patience, determination and team work but, even though at times some of the challenges seemed insurmountable, we got there!" says Shaw.

At a later stage it was also decided to create a flip top for the tottle incorporating a special silicon valve, produced in the U.S.A. by Seaquist Closures. At the same time, Ames and his team had started to produce ideas for a range of bathroom accessory products, including brushes, soap dishes and a back massager, all to be produced in the Far East.

The launch, through larger Boots stores throughout the U.K. was a resounding success, and distribution is now extending to 500 stores.

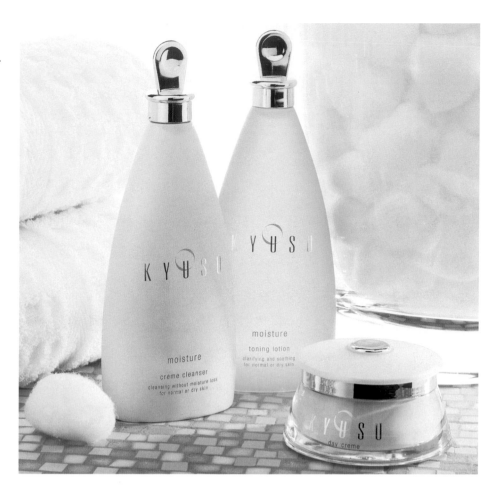

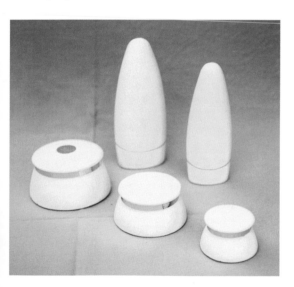

(ABOVE) PRODUCED BY DAVID AMES'S STUDIO THESE BLOCK MODELS SHOW TWO SIZES OF THE TOTTLE AND THREE SIZES OF JAR.

(ABOVE RIGHT AND RIGHT) THE RANGE THAT WAS LAUNCHED CONSISTED OF TWO POLYPROPELENE TOTTLES, FIVE BOTTLES IN BOTH CLEAR AND FROSTED FINISH, TWO JARS WITH A SILVER-COLORED TRIM AND ONE FLIP-TOP BOTTLE.

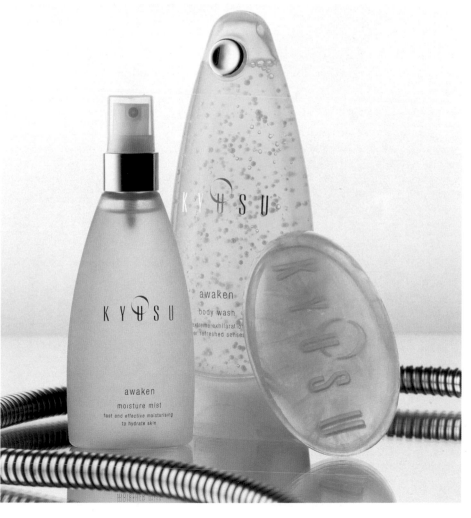

Sun Essentials
During their careers, designers must wear many hats, but a sombrero is not usually one of them. However, this wide Mexican headgear is the witty touch that gives this range of children's sun lotions its immediate appeal

When Hutton & Partners was given the brief by Leslie Cook of Tesco, they had already been working with the retailer for many years, (prior to 1994 as Hutton Staniford Ltd). Hutton was keen to develop his company into non-food items, particularly children's products and toys. Having two small children of his own, he began to see this as an exciting sector currently poorly served by design.

The brief came as a half-page typed note—20 lines listing the size of the containers and the properties of the lotions: hypoallergenic, light formulation, waterproof, and anti-stinging. With a launch set for five months away—in May 1996—the form of the pack was described as "dumpy tubes," unique, upside-down plastic containers that the client had sourced from a manufacturer in Sweden.

More information came at a briefing meeting a few days later. The sunblock products were targeted at mothers who wanted reliable protection and who needed to be convinced that it worked. The range would compete with some strong market leaders. Sun Essentials was already a Tesco sub-brand for adults' sun-care products, although this children's range would not need to look like part of that series.

Research consisted mainly of buying the competitors' products. The sample tubes they were given had a flip cap in the base and were in clear plastic, which Hutton decided

ALTERNATIVE
ILLUSTRATIONS OF
CHILDREN FROM THE FIRST
STAGE PRESENTATION.

STAGE ONE IDEAS WERE
SHOWN AS FLAT
PRESENTATION BOARDS.
ILLUSTRATIONS IN COLOR
WERE ADDED TO IDEAS
GENERATED ON THE
COMPUTER.

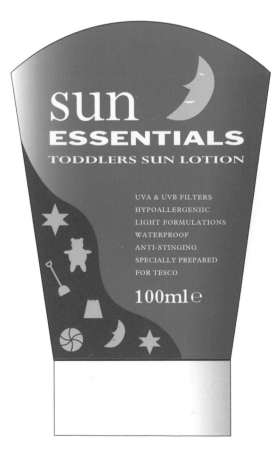

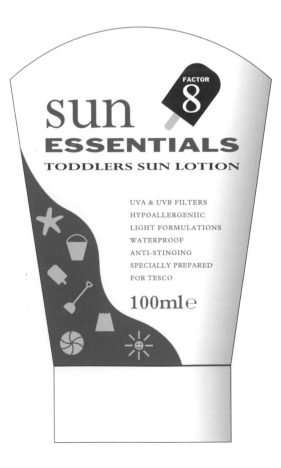

TRADE SECRETS OF GREAT DESIGN

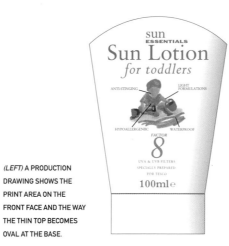
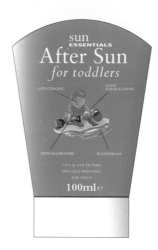

THE DUMPY TUBES,
ALTHOUGH NOT
ORIGINALLY THESE
PROPORTIONS, PROVED
AN IDEAL SHAPE. IN BOTH
PROVIDING A GENEROUS
FLAT SURFACE FOR
GRAPHICS AND GIVING
THE PRODUCTS
IMMEDIATE APPEAL.

(LEFT) A PRODUCTION
DRAWING SHOWS THE
PRINT AREA ON THE
FRONT FACE AND THE WAY
THE THIN TOP BECOMES
OVAL AT THE BASE.

SUNBLOCK WAS
INTERPRETED
GRAPHICALLY IN THIS
SOLUTION, WHICH ALSO
CARRIED THE TITLE IN A
CURVE THAT EMPHASIZED
THE CUT-OFF TOP.

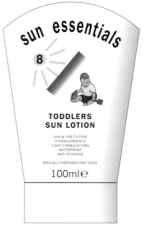
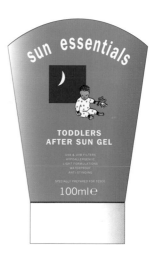

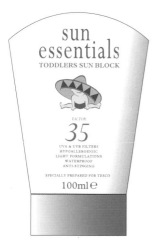
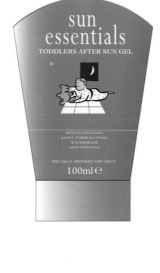

(ABOVE) THE BOLDLY
PATTERNED SOMBRERO
MADE ITS FIRST
APPEARANCE IN THIS
PREFERRED ROUTE,
ALTHOUGH THE TYPE WAS
FELT TO BE TOO FINE AND
THE AFTER-SUN
DRAWING DID NOT
REALLY FIT INTO THE
SAME LOOK.

(RIGHT) AN ALTERNATIVE
HAT AND POSE SHOW
CLEARLY HOW MUCH
IMPACT IS BEING
GENERATED BY THE USE OF
THE WITTY SOMBRERO. THE
CAPHBASEDECREASED IN
SIZE AND BECOME
COLORED.

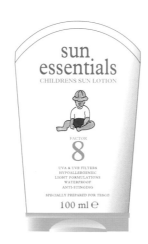

would be more suitable for the gel than for the lotion, and
while most suncream containers are brown, yellow or
orange—an allusion to suntan—in this case, the opposite was
needed. Because no sun could penetrate the application,
pale, cool colors would be more suitable and more
reassuring. The client agreed that "a more clinical look might
be appropriate—more reminiscent of cosmetics."

There were no other guidelines. The packs were printed
by flexography directly onto the plastic, and they could have
up to six colors, although the half tones had to be kept
fairly simple.

Two weeks later the designers showed four possible
routes. Hutton worked with designers Graham Pritchard and
Victoria Fenton, who developed several ideas featuring little
drawings, including one child wearing a big hat. The clever
touch was the way in which the size of the hat increased as
the sun protection factor increased. And that was it.

There was quite a lot of fine tuning still to do. They added
a night cap to the character in the after-sun gel to bring it in
line with the other products, and at one stage the client
asked them to try all the toddlers in beach hats, although,
looking back, Hutton cannot quite remember why.

A range of eight products went into production two
months later, including an additional lip balm, a sunstick and
junior T-shirt using UV reactive inks.

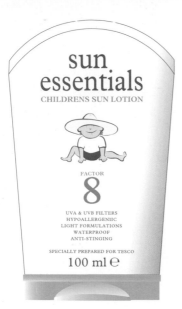

sun
essentials
CHILDRENS SUN LOTION

FACTOR
8

UVA & UVB FILTERS
HYPOALLERGENIIC
LIGHT FORMULATIONS
WATERPROOF
ANTI-STINGING

SPECIALLY PREPARED FOR TESCO
100 ml ℮

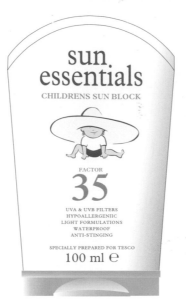

sun
essentials
CHILDRENS SUN BLOCK

FACTOR
35

UVA & UVB FILTERS
HYPOALLERGENIIC
LIGHT FORMULATIONS
WATERPROOF
ANTI-STINGING

SPECIALLY PREPARED FOR TESCO
100 ml ℮

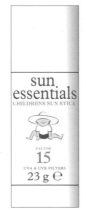

sun
essentials
CHILDRENS SUN STICK

FACTOR
15

UVA & UVB FILTERS
23 g ℮

(LEFT AND BELOW LEFT)
DEVELOPMENT STAGES
TWO AND THREE HAVE
LESS PATTERN ON THE
HAT. ALTHOUGH THE
BEDTIME TODDLER FITTED
IN BETTER AND THE TITLE
LETTERING HAD BEEN
MADE STRONGER.

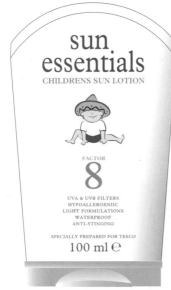

sun
essentials
CHILDRENS SUN LOTION

FACTOR
8

UVA & UVB FILTERS
HYPOALLERGENIIC
LIGHT FORMULATIONS
WATERPROOF
ANTI-STINGING

SPECIALLY PREPARED FOR TESCO
100 ml ℮

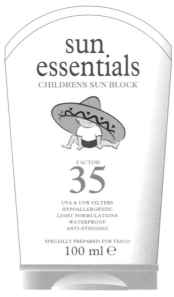

sun
essentials
CHILDRENS SUN BLOCK

FACTOR
35

UVA & UVB FILTERS
HYPOALLERGENIIC
LIGHT FORMULATIONS
WATERPROOF
ANTI-STINGING

SPECIALLY PREPARED FOR TESCO
100 ml ℮

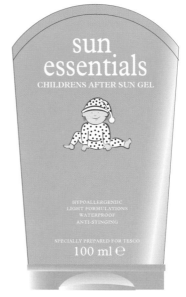

sun
essentials
CHILDRENS AFTER SUN GEL

HYPOALLERGENIIC
LIGHT FORMULATIONS
WATERPROOF
ANTI-STINGING

SPECIALLY PREPARED FOR TESCO
100 ml ℮

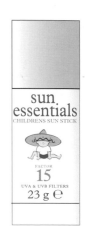

sun
essentials
CHILDRENS SUN STICK

FACTOR
15

UVA & UVB FILTERS
23 g ℮

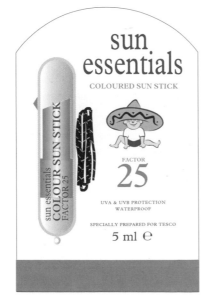

sun
essentials
COLOURED SUN STICK

sun essentials
COLOUR SUN STICK
FACTOR 25

FACTOR
25

UVA & UVB PROTECTION
WATERPROOF

SPECIALLY PREPARED FOR TESCO
5 ml ℮

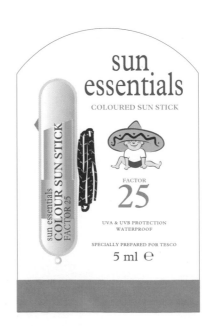

sun
essentials
COLOURED SUN STICK

sun essentials
COLOUR SUN STICK
FACTOR 25

FACTOR
25

UVA & UVB PROTECTION
WATERPROOF

SPECIALLY PREPARED FOR TESCO
5 ml ℮

AN ADDITION TO THE
RANGE WAS A LIP BALM
IN A CLEAR PLASTIC
TUBE, WHICH INCLUDED
A USEFUL STRIPED
ROPE. THESE
ALTERNATIVE
COMPUTER-GENERATED
VISUALS INVESTIGATE
THE USE OF A ROUNDED
TOP AND COORDINATING
COLORED BAND ALONG
THE BASE AS DEVICES TO
LINK THEM TO THE
OTHER PRODUCTS.

sun essentials
SUN LOTION
FOR BABIES & CHILDREN

FACTOR
12

UVA & UVB PROTECTION
WATERPROOF
LIGHT FORMULATION

SPECIALLY PREPARED FOR TESCO

150 ml ℮

sun essentials
SUN LOTION
FOR BABIES & CHILDREN

FACTOR
20

UVA & UVB PROTECTION
WATERPROOF
LIGHT FORMULATION

SPECIALLY PREPARED FOR TESCO

150 ml ℮

sun essentials
SUN BLOCK LOTION
FOR BABIES & CHILDREN

FACTOR
35

UVA & UVB PROTECTION
WATERPROOF
LIGHT FORMULATION

SPECIALLY PREPARED FOR TESCO

150 ml ℮

sun essentials
AFTER SUN
WITH INSECT REPELLENT
FOR BABIES & CHILDREN

PROTECTS AGAINST BITING INSECTS
COOLING AND SOOTHING

SPECIALLY SELECTED FOR TESCO

150 ml ℮

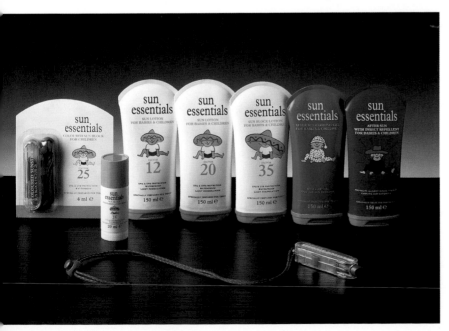

IN THE FINAL PRODUCT LINE-UP THE SOMBRERO ORANGE COORDINATES WITH THE PLASTIC CAPS. THE CHILD'S POSE STAYS THE SAME, EVEN WHEN THE HAT CHANGES TO INDICATE DIFFERENT CONTENTS. TO CONVEY THE COOL COLOR OF THE GEL THE TUBE WAS GREEN. THE PRODUCT RANGE WAS SOON INCREASED WITH THE ADDITION OF AFTER SUN WITH INSECT REPELLENT WHICH FITTED AMUSINGLY INTO THE CONCEPT BY CHANGING THE HEAD GEAR TO AN AUSTRALIAN'S CORK-FRIEZED HAT.

THE CHILDREN'S T-SHIRT HAD A SHADOW THAT WAS PRINTED IN UV REACTIVE INK SO THAT IT COULD ONLY BE SEEN IN SUNSHINE.

Monsoon

"We were so excited when we got this job that we went on and on producing more and more ideas, quite honestly, it was impossible to stop." We have all seen examples of actors we thought were not quite right for a role **suddenly blossom and excel.** Perhaps the same is true of packaging designers. Using someone on the basis of their **method and approach, breadth of experience and like-minded thinking,** rather than their portfolio, can reap rewards

DIA is one of Britain's top 10 design and image consultancies, with 50 people working across five divisions: brand development, corporate communications, events/exhibition design, DIA Interactive (a group dedicated to designs for electronic media, such as CD ROM, the Internet and so on), and DIA Displaywork (which specializes in the design and construction of point-of-sale display and merchandizing systems). In addition, DIA has an office in Singapore and will soon have a link in the U.S.A. But although it had experienced all sorts of packaging projects—from automotive to sport, to beverages to pharmaceuticals, it had not attempted cosmetics.

Nick Ovenden, creative director at DIA, the multidisciplinary design company from Wimbledon, London, recalls the events that led up to their working for Beauty International Ltd (now Coty Rimmel Ltd). With two or three consultancies all pitching for the same job, the brief was tantalizingly vague—a fragrance tailor-made around the identity of a high street retailer. The job was called Project Storm, and the qualities of the fragrance were outlined as "a force of nature expressed through a passionate relationship... created from the sea and sky, and warmed by the sun." The brief continued:

"This positioning brief is underscored with three distinct elements, which are required to be expressed through packaging (and subsequently advertising and point of sale). These elements are:

• Color—bright, tropical colors such as azure blues, jade greens and earthy terracotta; the colors of nature.

RENDERED IN WISPY GOUACHE AND PASTEL, THESE DELICATE DRAWINGS PRESENT VARIOUS INTERPRETATIONS OF THE THEME "UNINHIBITED AND UNTAMED PASSION," IN WHICH CONTRASTING ELEMENTS COMBINE TO CAPTURE THE ESSENCE OF A MONSOON.

LIKE A "DISCOVERED ARTIFACT FROM A TROPICAL ISLAND," THIS VESSEL COMBINED A STONEWARE BODY WITH A SOFT, HAND-CRAFTED CAP, AND IT MOST RESEMBLED THE DESIGN THAT WAS FINALLY LAUNCHED.

(RIGHT AND OPPOSITE TOP) AT THE SAME TIME BOTTLE SHAPES WERE BEING DISCUSSED, IDEAS WERE EMERGING FOR THE BOX—A TWO-SIDED POUCH, OR A FLIP-TOP.

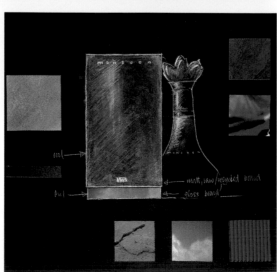

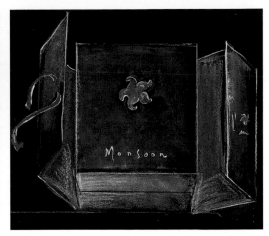

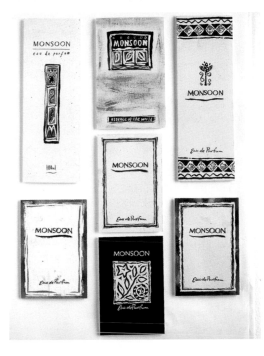

(RIGHT) A PAGE OF IDEAS FROM STAGE THREE SHOWS FLAT IDEAS FOR A TRADITIONAL BOX. ALL OF THE THEM UTILIZING PRIMITIVE-LOOKING HAND-BLOCKED TECHNIQUES AND SIMPLE TYPOGRAPHY.

- Ethnicity—reflecting a relaxed, bohemian approach to dressing; a sense of hand-crafting and traditional materials, perhaps discovered on an exotic journey.
- Nature—images of lush vegetation, exotic waterfalls, and torrential rains, and natural organic forms.

Within the concept lies an appreciation of the powerful sexuality of a woman full of confidence and self-expression. The positioning uses the analogy of the beauty, tension, excitement, and energy of a tropical rainstorm, reflecting the dichotomy of the diversity of nature:

- Frenetic energy/calmness
- Lightness and freshness/warmth and sultriness
- Cool and watery/hot and earthy"

So where did they start? The designers felt that they had only half the story—not knowing the identity of the retailer—so they were not able to do any research or customer analysis. But knowing the retail fashion scene pretty well, they soon guessed that the fragrance was for Monsoon. Nick Ovenden worked with colleagues Chris Travers and Suzy Davison for two weeks in November 1993 on the first ideas.

There were six concepts, with designs using bits of copper, frosted glass, seashells, inspirations drawn from Matisse and Gauguin, and even Aztec influences, along with moodboards with images of plants, ethnic interiors, tropical rainstorms, and natural modern materials.

The presentation went well, they thought, and then they waited for two or three weeks. Ovenden recalls that it was just before Christmas—in fact, they were all out, enjoying a Christmas lunch, when the call came. He had to rush over to the client for a debriefing meeting and then line up everyone to work through Christmas.

Contrary to expectation, although they had got the job, there was no feedback on the initial ideas: "Do something else—avoid tropical islands and concentrate more on jungles, less on beaches and coastlines." Ovenden confesses that he has never been to a tropical jungle.

Nevertheless, they now knew it was for Monsoon. It needed to be targeted to a broader customer profile—20- to 30-year-olds—if it was to succeed as an independent fragrance that could compete with other prestige brands.

(LEFT AND BELOW) "SYMBOL OF WOMAN"— LITTLE "M" LOGOS THAT COULD BE USED ON BOTH BOTTLE AND BOX WERE RETAINED FROM THE FIRST CONCEPTS, WHERE ELEMENTS SUCH AS A COPPER EARRING, A PIECE OF FROSTED, SEA-WASHED GLASS, OR A FRAGMENT OF SEASHELL WERE USED AS DECORATIONS.

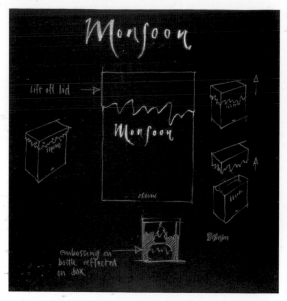

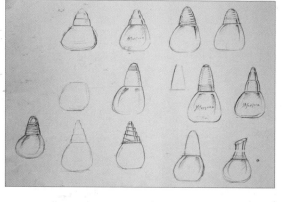

LIKE A PEBBLE WASHED UP ON THE BEACH." THE ASYMMETRICAL SHAPE EMERGING IN THESE EARLY DEVELOPMENT DRAWINGS PROVED TO BE ONE OF THE MOST DIFFICULT ASPECTS TO RETAIN. THE DESIGNERS HAD INTENDED TO HAVE A METAL CAP. BUT THIS, TOO, PROVED IMPRACTICABLE, AND THE FINAL VERSION WAS MOLDED IN PLASTIC.

(RIGHT AND BOTTOM RIGHT) THE FINAL RANGE INCLUDED TWO SIZES OF EAU DE TOILETTE BOTTLE AND A THIRD SIZE FOR THE EAU DE PARFUM. TO AID THE UNEVENNESS OF THE BOTTLES, THE THICKNESS OF THE GLASS AT THE BASE WAS THROWN OFF TO ONE SIDE. FOR ECONOMY, TWO BOTTLES, ALTHOUGH NOT THE SAME SIZE, HAD TO SHARE THE SAME SIZE CAP.

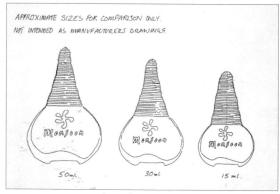

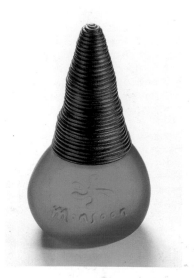

At this stage the creative floodgates opened. Because they had not been given any specific direction, they produced dozens of ideas, often playing with contrasts—hot and cold, an intensely colored flower in a green jungle, flame on water, sun during rain. Some bottles were tall, others squat and asymmetrical, and they worked with product designer Steven Aldridge, who took 18 embryo ideas and visualized them as jewel-like gouache artworks on matte black cards.

At the second presentation the client was "bowled over." Some ideas were quickly rejected for being too overtly ethnic or masculine, and over the next few weeks the designers started slowly to narrow down the field. Basically there were four elements—the bottle, the graphics and decorative elements, the pack, and the name style—but at this stage most of the effort had, naturally, been concentrated on the bottle and its graphics. One aspect that in the end proved the most problematic was the wobbly, asymmetrical shape of the bottle Ovenden was trying to create. Later in the program he engaged a glass-blower to hand-blow some samples—those produced after a lunch in the local pub proved to be the nearest to what he wanted. Another colleague, Andrew Cook, made the prototype cap by soldering together a spiral of wire.

But the problems did no not end there. There were further difficulties in producing specification drawings for this "wonky" shape, and these were compounded by the reluctance of the French glass factories to cooperate. "If I'd known more about glass before I started, I'd probably have accepted that it couldn't be done—naivety sometimes works to your advantage," reflects Ovenden.

And what about the contents—a citrusy, light, sweet, fresh scent? The smell was defined alongside the packaging. Both elements from the brief and developing simultaneously— "very different from the past, when great bottle designers like Lalique, were often inspired by the fragrance."

The results have been impressive, with a design award for effectiveness, and sales in the first year 34 percent above budget. But that isn't the end of the story.

Some 18 months later, the client was back with another brief, with the same emotive passages, for Project Sunset, with the intention of building a fragrance house out of the success of Monsoon. This one was to be a more mass-market, more sophisticated cousin to the first, but with the same Monsoon values—ethnic, individual, and sensual:

"Just as Monsoon was created from the sea and the sky warmed by the sun, so Monsoon II is a product of nature—like a precious gemstone—a product of the earth. Warm, spicy, oriental and derived from the power of the sun or deep in the earth—encapsulated with a drop of water to retain an element of coolness (anything too hot will be perceived as sweaty, acrid and dry—these are not "fragrance feelings"). She is a nymph-like creature—half-human, half-water baby. This is the

IN CONTRAST TO THE MONSOON SHAPES, THE 24 SHIMO BOTTLE IDEAS IN STAGE TWO WERE TALL, ELEGANT, AND GRACEFUL, EMPLOYING WARM COLORS AND SMOOTH TEXTURES, BUT WITH THE SAME IDEA OF TWO CONTRASTING ELEMENTS.

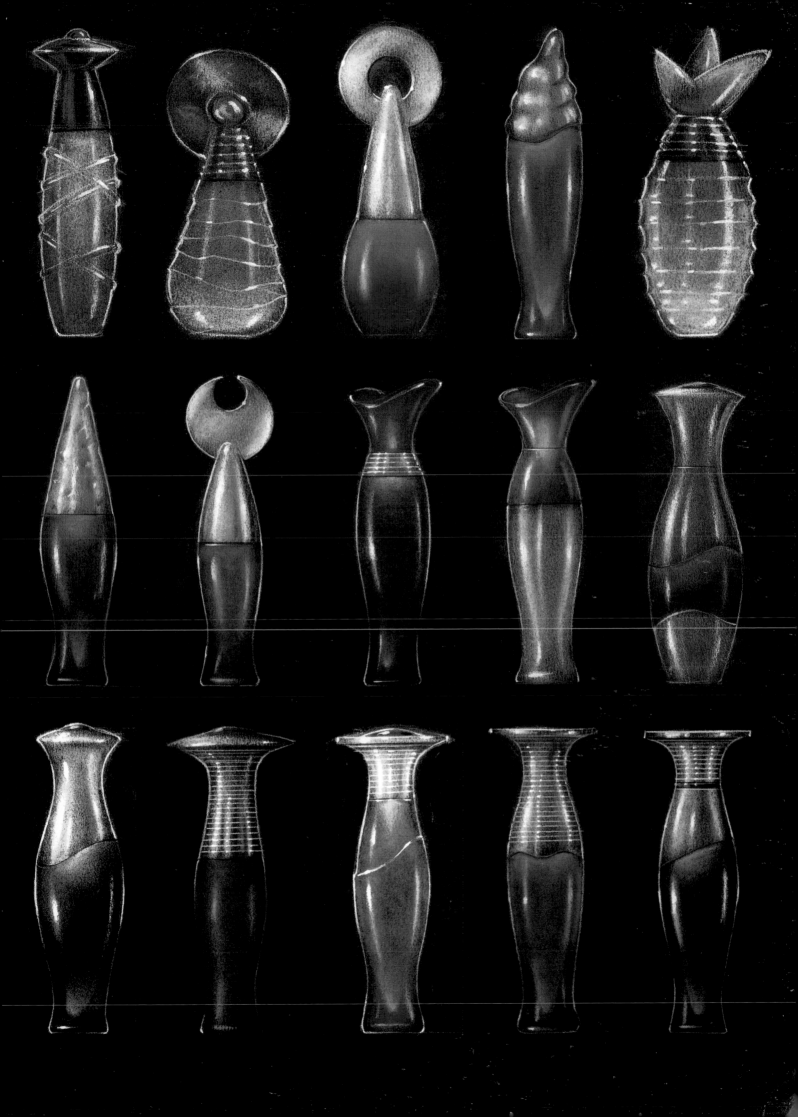

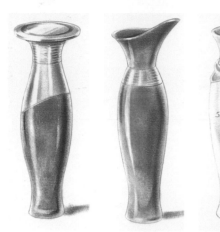

THREE OF THE FINAL CONTENDERS HAD THE FEMININE SHAPE AND EARTHY COLORS THAT WERE ECHOED IN AN EARLY IDEA FOR THE BOX.

AS AN EQUIVALENT TO THE ORGANIC ORCHID-INSPIRED MOTIF ON THE MONSOON RANGE, THESE SKETCHES INVESTIGATED SCULPTURAL SAND SHAPES AND LETTERFORMS THAT EVOKED ANCIENT SOUTH AMERICAN CIVILIZATIONS.

WHILE THE COLOR OF THE MONSOON BOTTLE DERIVES FROM THE COMBINATION OF THE GLASS AND LIQUID, COLOR WAS SPRAYED ON THE SHIMO BOTTLE IN A GRADUATED WAY THAT TOOK DOZENS OF TESTS TO PERFECT.

(BELOW AND RIGHT) IN THE FINAL LINE-UP THERE WERE TWO SIZES OF EAU DE TOILETTE AND ONE EAU DE PARFUM, WHICH FEATURED A LITTLE GLASS STOPPER (ALL BOXED), AS WELL AS THE LAST-MINUTE ADDITIONS OF A BODY SPRAY, BODY CREAM, AND SHOWER GEL, WHICH USED THE TEXTURED BACKGROUNDS OF EACH GROUP TO COORDINATE.

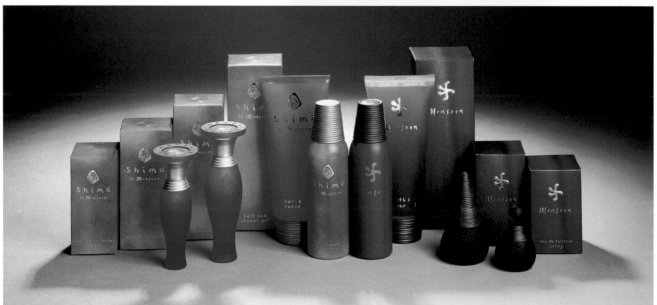

childlike quality in all women— untapped passion—an innocent child with an aura of heightened sensuality, sexuality, and power.

Simultaneously, the advertising agency Publicis was briefed to work on names and creative approaches, and Castaway, Naiad, Mary Mary, and Alias were each given suitable bottle concepts.

It was another false start. There was again no reaction to the bottle shapes, and the designers started to look toward Aztec, Mayan, and South American civilizations for inspiration. A total of 24 new bottle ideas were produced, again in immaculate pastel gouache renderings, and these were narrowed down to two. The two designers—Melanie Ryan and Caroline Messenger—also looked out lettering and graphic devices as well as an equivalent background texture to use on boxes and non-bottled products.

In the end, with the constant cooperation of Laura Hatch and Margaret Donnelly, marketing director of fragrances at Coty, the name Shimo and a tall, curvaceous bottle shape with graduated colors and a gold doubloon-style cap were researched and passed—as well as getting the all-important endorsement of major retailers. Internal morale has benefitted among sales staff at Coty, who "all enjoy being part of the company's success and increasingly high profile."

Remington

Writing the brief can be as important and crucial as creating the final design solution. But it is also important to establish that the client understands it. This clarification of a common visual language can be an important introduction to the design team and a mutual platform to build on. At Coley Porter Bell, they call this **the visual planning stage,** and it usually **precedes everything else**

When Remington came to Coley Porter Bell with their existing range of electric shaver packaging, there was no background research, the budget was tight, and there was no money for advertising support or launch campaigns. Fortunately the design team knew the market, and were able to start putting together the visual brand essence they called "The Remington Man," that would lead to the final solution.

The range consisted of three models: Micro, Dual, and Triple with several variations (battery, electric, etc) in each. A team of four designers led by creative director Allison Miguel and senior designer Ruth Waddingham, analysed the competition and looked at instore presentation. They decided that the products should be presented as one strong range, rather than three individual solutions (which meant unifying the size of all the packs) and that conveying some sort of lifestyle message was essential. In addition, the brief outlined the inherent weakness of the Remington brand, and this too, would need to be addressed.

Since no functional claims could be made for the product, (wet shaving is considered to be 'closer' than dry), and there were no technological benefits to lift them above the

TWO WEEKS AFTER THE GO-AHEAD THE DESIGN TEAM PRESENTED THEIR "CREATIVE STRATEGY FOR SHAVERS"—OF THE BRIEF IN VISUAL FORM THAT INCLUDED A COLLAGE OF THE 16-30 YEARS-OLD TARGET CUSTOMER — FACING ISSUES THAT INCLUDE IMPRESSING WOMEN, LEAVING HOME, ASSERTING STATUS, ESTABLISHING CAREERS AND ACQUIRING WEALTH.

THE THREE CREATIVE
SOLUTIONS CAME FROM
A SERIES OF
PRESENTATION BOARDS
MADE UP OF IMAGES CUT
FROM MAGAZINES IN
WHICH CLOSE-UP PARTS
OF THE FACE, AND
FIGURES RELAXING
STARTED TO EMERGE AS
A THEME.

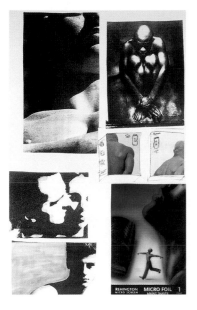

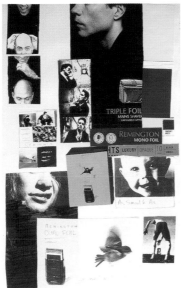

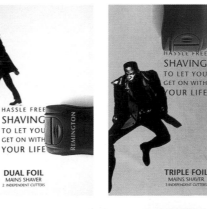

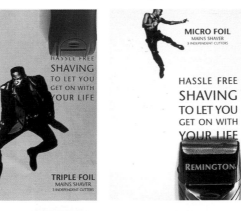

"FREE-FORM" WAS THE
FIRST SERIES OF IDEAS
TO BE ELIMINATED,
LARGELY ON THE BASIS
OF ITS RELIANCE ON
TYPOGRAPHY. THE
SUCCESSFUL SOLUTION
NEEDED TO BE PAN-
EUROPEAN, WITH COPY
IN FIVE LANGUAGES.

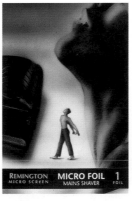

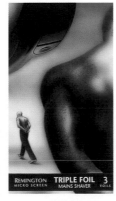

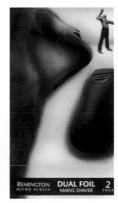

A DRAMATIC USE OF
CHANGE-OF-SCALE —
PARTS OF THE BODY
COMBINED WITH PARTS
OF THE PRODUCT —
PROVED "TOO
UNCONVENTIONAL AND
MOODY" TO GAIN THE
CLIENT'S APPROVAL.

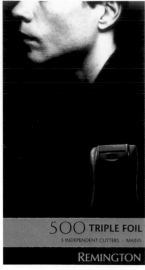 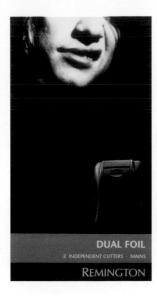 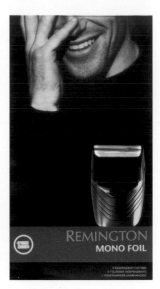

HASSLE-FREE EXPRESSIONS FROM "20 SOMETHING" GUYS WITH "A BIT OF ATTITUDE." VARIATIONS OF SHAVER MODELS IN THE THIRD OF THE FIRST CONCEPTS WERE HIGHLIGHTED BY A CHANGE OF COLOR ON THE SIDE OF EACH PACK, AND BY SYMBOLS DENOTING DIFFERENT FUNCTIONS. PHOTOGRAPHS OF THE NEW SHAVERS WERE FED IN VIA A DIGITAL CAMERA.

PHOTOGRAPHER IAN PHILPOTT SHOT THE THREE GUYS CHOSEN FROM OVER 50 DURING A THREE-DAY SESSION. RUTH WADDINGHAM RECALLS HOW DIFFICULT IT WAS FOR THE MODELS TO "ACT NATURALLY" WITH ONLY THEIR CHINS SHOWING.

competition—the creative team had to look elsewhere for competitive advantage.

The brief outlined the strategy—move the emphasis from the functional shaving values to emotional ones. Instead of emphasizing the product, the speed and convenience of dry shaving, the skincare values, or the safety—move the emphasis to the benefits—the inner reward: "You feel good, you look good, you have more time for yourself, and you can start to get on with your life." "Feel good inside—look good outside." Most important: "Feel comfortable with yourself."

By adopting these values, the product would leapfrog the competition, claim exclusive new marketing territory, and feed the values back into the corporate brand—where it might enhance other Remington products too. It was an exciting moment in the program, and became the point of departure for the creative team.

Looking at the target audience, they knew that, while anyone in the dry-shave market was a potential customer, they needed to focus on the 16-30-years-old age bracket, where new recruits had 'grooming' and 'looking good' as a priority, and who, once sold a lower-price model, might stay with dry-shaving for life, graduating up to the more sophisticated models later. In addition, these customers are more likely to buy shavers for themselves, rather than receive them as a gift from a parent or partner, as often happens later in life.

Among the initial ideas, three solutions emerged right away. Each of them embodied the idea: "hassle-free shaving lets you get on with your life." In a way, each route led on to the next, particularly once the designers were reminded that the packs were pan-European, with copy in five languages. So most of the work had to be done with pictures. Looking back, Ruth Waddingham is positive that they would never have come up with this solution without the springboard created by the Visual Planning Stage. But, if the rest seemed straightforward, it did not turn out that way.

Faces had to be found that would evoke the three age groups—16-30, 30-50, and 50 and over without being too young, too old, too handsome, or too English. Ruth and her colleagues joked that they could just go out and trawl the bars to pick up suitable guys, but in the event model agencies sent in over 50 candidates., The most difficult task was to find men who could shed their "model" characteristics, and relax. The three-day shoot was extremely stressful, recalls Waddingham. The faces had to be lit like packshots, which meant that the three guys could only move within a very narrow field of vision. To most models 'act naturally' means throwing yourself around the room during a fashion shoot.

The finished packs form a very strong 'family' when seen together on a shelf, even though manufacturing restraints dictated that the third version—the Triple model, could not be launched until six months after the first two. In all, customers will see the full impact from nine variations.

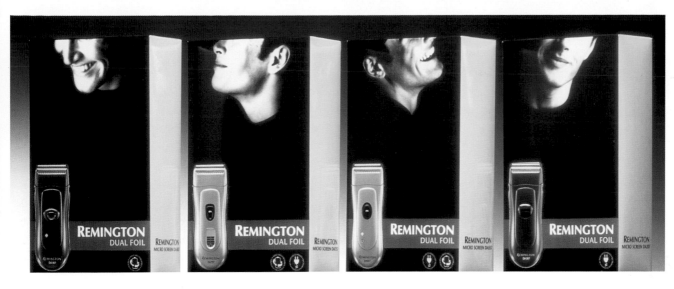

ON THE FINAL PRINTED PACKS, THE DRAMATIC BLACK AND WHITE PORTRAITS HAVE BEEN COLOR TINTED AND COMBINED WITH PRODUCT PHOTOGRAPHS BY ROBIN BROADBENT. THE PRODUCT PHOTOGRAPHS "WENT DOWN A STORM" WHEN THEY WERE LAUNCHED AT THE COLOGNE HOUSEHOLD TRADE FAIR.

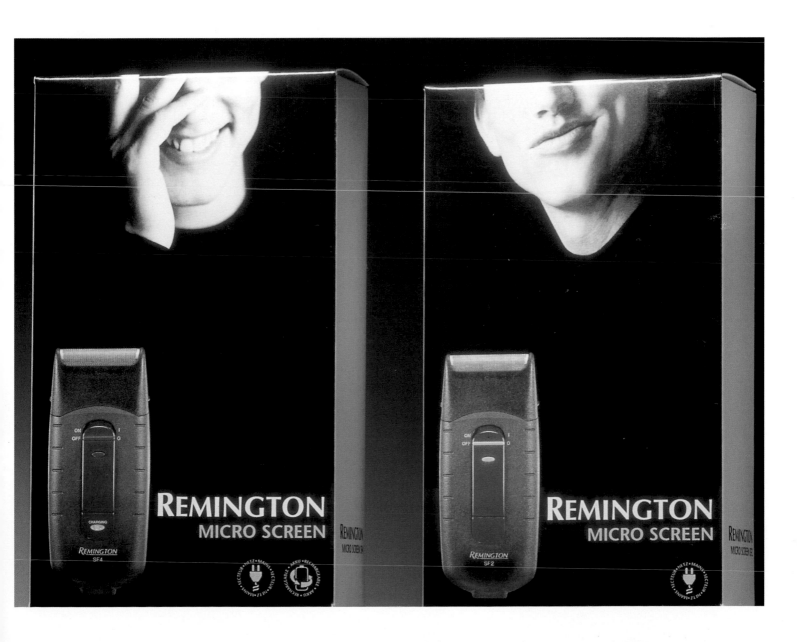

BP Visco

An antique tin horse stands in the reception area of a design studio, housed in the converted milking sheds of a farm in the Savernake Forest in Wiltshire, England. But this is no ordinary toy, for beneath the faded paint exterior is a mechanism that allows it to rise and fall in a rocking motion. John Lamb sees it as a perfect symbol of their design company, Tin Horse: its combination of function and style, with an **elusive ingredient that makes it unique**

Lamb and his colleague, Martin Bunce, met when they both worked at Addison Design. They set up on their own in 1990 and moved to Wiltshire in 1995 to build up their team of eight designers, specializing in packaging and graphics. Apprehensive at first, they agree that the impact of the countryside has been greater on their personal lives than on their design methods, although locals still comment on their strange working hours, noting the lights on late into the night. There has been no problem with clients making the journey to Wiltshire—in fact, one executive likes to stay a few days and explore the local canal system.

"Something happens when clients come here. If we are providing lunch, we don't stand on ceremony." Lamb can roll back the double wooden shelves that house examples of their packaging work and start preparing pasta in the adjoining kitchen. "Some clients help with chopping the onions, some are agog. It's great for breaking down barriers."

Generally, they work with brand managers, who like the direct link with the designers, even if sometimes they speak different languages. As often as not, "it's two small teams working together, even from a big company like BP." In fact, BP Visco is a good example of their working methods. When the brief arrived it was inviting five design companies to present their thoughts on a multiple pack upgrade. Ian Cook, senior business adviser in the lubricant and bitumen division at BP Oil International, had prepared a four-page document.

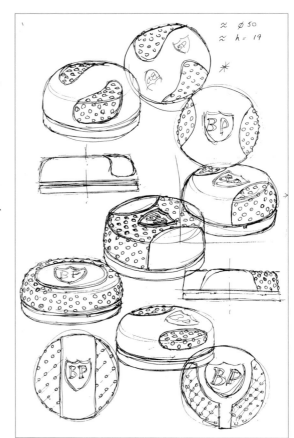

MIDWAY THROUGH THE PROJECT, TIN HORSE GOT PERMISSION TO DESIGN THE NEW CAP AS WELL AS THE CONTAINERS, BUT IT HAD TO BE NON-DIRECTIONAL AND COULD NOT, THEREFORE, HAVE A DESIGN THAT NEEDED TO BE LINED UP WITH ELEMENTS ON THE BOTTLE.

'STATIC ROUNDING' WAS A GROUP OF IDEAS THAT SIMPLY TOOK THE STANDARD SHAPE AND ROUNDED IT OFF, AT THE SAME TIME CREATING A HANDLE IN A EASY-TO-POUR POSITION.

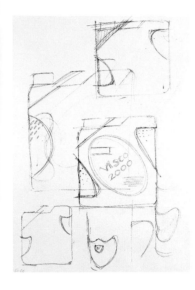

(LEFT) "SOFT CUBE" INCLUDED NEW WAYS TO INCORPORATE A HANDLE INTO THE CAP, WHICH COULD BE MOLDED SEPARATELY AND NOT AFFECT THE STACKABILITY OF UNITS.

(BELOW AND LEFT AND RIGHT) "SUPER SOFT" INTRODUCED FLOWING CURVES. WHILE "EDGE" AND "RETRO" WERE DEVELOPMENTS TO ANIMATE THE CAP AREA WHILE KEEPING IT UPRIGHT.

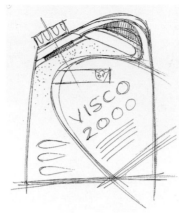

(LEFT) "DYNAMIC ROUNDING" THREW THE CAP OFF AT AN ANGLE BUT CLEVERLY ALLOWED AN EXTRA CORNER SURFACE SO THAT, FOR FILLING, EACH CAN COULD STAND WITH THE SPOUT UPWARD.

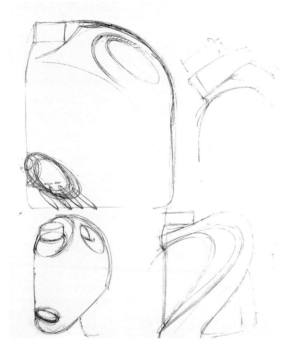

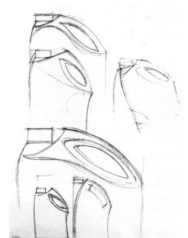

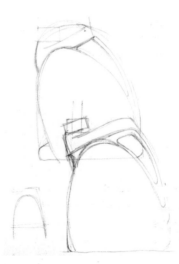

(LEFT & BELOW) "REBEL" INVESTIGATED QUITE RADICAL CHANGES TO BOTH THE FORM AND FUNCTION, MOVING THE HANDLE TO THE BASE AND COMPLETELY CHANGING THE DIRECTION OF THE CAP— IT COULD BE LAID EITHER ON ITS SIDE OR (FOR FILLING) ON ONE END.

Working with design companies in the past, BP had produced a range of four passenger-car motor oils in five sizes of container, three designed by Minale Tattersfield in 1989 and a 1-liter product by Michael Peters & Co.

BP experience has confirmed that the Minale pack presents a key element in communicating product quality for a number of BP's sub-brands. "Due to changing competitive positioning and the variable conditions of the global market, the sentiment expressed—mainly by our growth market associates—is that a modernization or 'rounding' of the pack design would revitalize our product range."

The project objective called for the selected consultants to modernize the existing three Minale packs with minimum changes to the "footprint" (the shape and size of the base) and the "pack engineering characteristics." At the same time, "a constraint on the design will be the need to keep our existing label standards in place," and "any changes [to the pack] should pick up some elements of the Peters pack."

A very tight brief with a very specific objective, you might

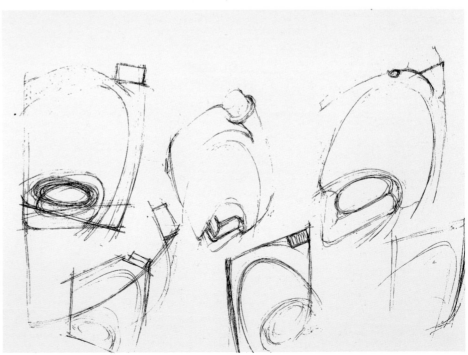

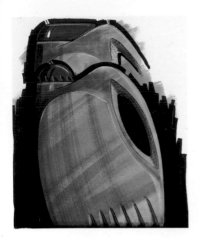
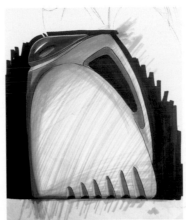

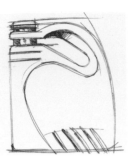

(LEFT) IN THE SECOND STAGE, TWO IDEAS FROM THE "DYNAMIC ROUNDING" GROUP WERE FURTHER DEVELOPED AS ACTUAL-SIZE SKETCHES USING BOLD BLACK MARKER PENS.

"PERSONALITY" DESCRIBES THIS BIRDLIKE CONCEPT FROM STAGE TWO, WHICH CALLED FOR A SPECIAL CAP SHAPE TO ECHO THE FINLIKE INDENTATIONS IN THE BASE. IN THE SECOND VERSION. (LEFT) A MORE PRACTICAL CAP WAS SUBSTITUTED. AND THE PIMPLE-DOT PATTERN WAS ADDED FOR GRIPABILITY.

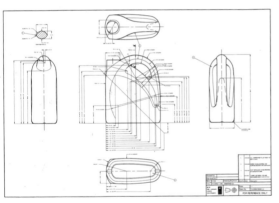

(LEFT AND BELOW) CONVERTING THE FINAL SOLUTION TO COMPUTER-AIDED DESIGN SO THAT MANUFACTURERS COULD ADAPT IT TO THEIR VARIED DIMENSIONS PROVED ALMOST IMPOSSIBLE. CAD WAS USED TO SPECIFY THE PROFILES AND DIMENSIONS.

think, but the secret of the success of this particular job lay in what happened next. The Tin Horse approach was to respond days later with a document that the client felt was "small enough to read." In the accompanying presentation, which Martin Bruce describes as being "very animated," they outlined three approaches. The first was a straightforward revisualization. The second, which they called a reincarnation, looked at wider issues of global concern, such as the recovery of materials, the use of the product in India and the choice of tin plate as an alternative to plastic, which cannot be recycled. The third, Project Phoenix, was the most radical approach. It included a suggestion to consider the long-term issues now emerging in relation to the marketing of lubricants and to create "an entirely new lubricant handling system." Needless to say, although the client asked them to go back to the original brief, he was impressed by their approach and clarity of thinking, and they got the go-ahead.

On a project like this, everyone at Tin Horse gets together, even the receptionist, for a brainstorming session lasting half a day. "Everyone has sketch pads and pencils, and we keep a structure. Everyone feels it's their job to contribute. We're nonjudgmental and keep it positive." This produced a huge pile of ideas, in very rough form, one a page. Three weeks later, they were ready with their first presentation, which they showed as hundreds of sketches, loosely grouped by working concept titles and supported by a dozen or so foam models.

Following this presentation, four routes survived. "Some good ideas got thrown out, but one did resurface later as another project,' recalls Martin Bunce. Now they moved ahead with great speed, producing more foam models with accurate voluming (checking that the correct contents would fit into each of the one- and four-liter containers currently being developed). "We sat down to analyze the palette size, 1200 x 1200 mm, and the footprint, and we discovered, talking now to the production people, that, contrary to what we had been told, the specifications of the existing Minale packs were far from ideal and actually uneconomical to handle." At the same time, John George started to look at graphic approaches to labeling and evolved a new layout for the multilanguage performance chart on the back of the pack.

The final designs, launched in a family of four sizes in Bangkok, Thailand, in June 1997, appeared in a range of colors, including a green that echoes the neon effect you see when you pass one of BP's service stations at night.

THE DESIGNERS DESCRIBE
THE FINISHED SHAPE AS
"LIKE AN ONION—WITH
LAYERS THAT HAVE
PEELED AWAY." ALTHOUGH
THE CAP FITS EACH SIZE,
ALL SIZES DIFFER

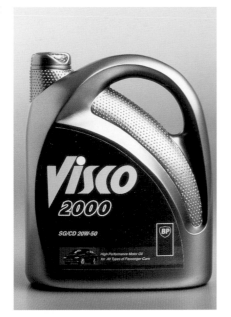

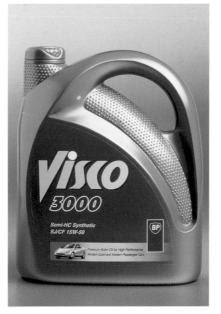

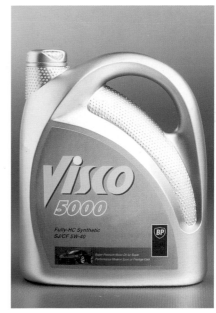

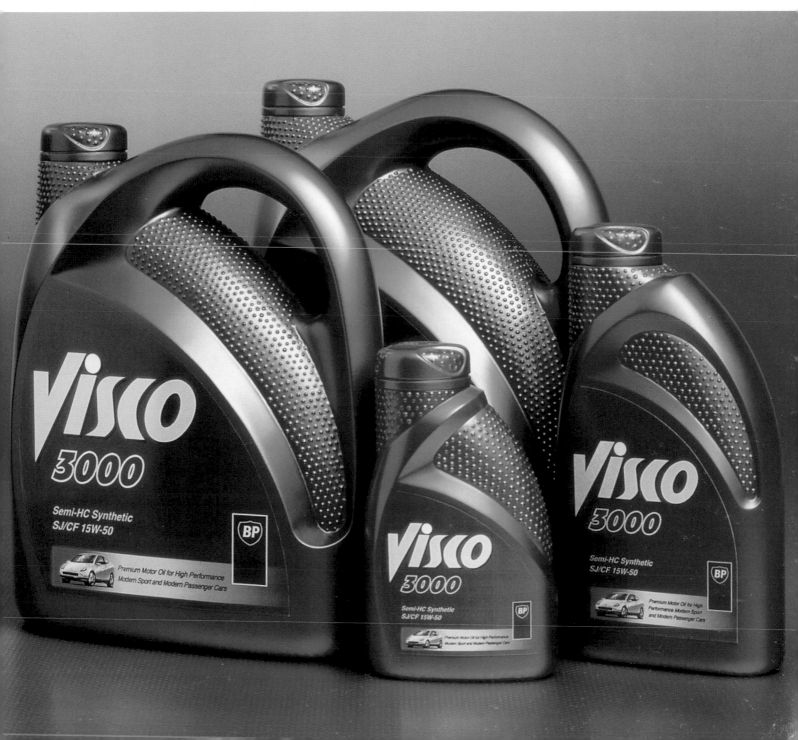

Seattle Coffee Co.

Before they could embark on a major expansion of their unique coffee shop formula in Britain this husband and wife retail team had to understand what their brand was all about as an analogy in terms of retail and packaging design. **If the brand was a person, what would the elements of that person be** – the "brand soul?" Explained by Carrie Bailey and Janet Brades at Wickens Tutt Southgate (WTS), the whole thing sounds simple, but to get to this stage, they had to go back to the beginning

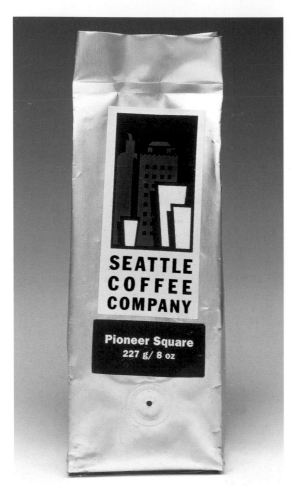

THE ORIGINAL COFFEE PACK FEATURED THE PENTAGRAM IDENTITY LABEL APPLIED TO SILVERED PLASTIC BAGS.

"The British are a nation of tea drinkers—the majority know very little about coffee," explains Brades, who is brand planner at WTS. Their clients lived in Seattle. Scott Svenson was a banker and his wife, Ally, worked in publishing. When they moved to London, Ally felt so homesick for the type of coffee experience she had been used to, as well as the relaxed atmosphere created by the Seattle coffee scene that she gave up her job. Ally and Scott even approached the American coffee companies to convince them to open in Britain. When nothing happened they hooked up with U.K. partners and founded the Seattle Coffee Company and in 1995 opened the first store in London's Covent Garden. Using a logo designed by Pentagram, the shop quickly grew to a chain of 26 stores, including outlets in Edinburgh, Glasgow and Cambridge.

Joining forces with Torz and Macitonia, an English duo who themselves had been converted by their experiences in the West Coast, and set up their own roasting business, they were now in catering, not retail.

Starbucks were on the horizon threatening to open their own shops in Britain and word got out of a "big blast on the market" and, of course, a big threat to the Seattle Coffee Company, which now suddenly needed to consolidate its hold on the timid British coffee drinker.

Along came WTS, which, with its unique partnership with Rodney Fitch & Co., retail design consultants, was able to offer both packaging and retail advice in one package. This

IN THE FIRST PRESENTATION, ONE BOARD SHOWED PEOPLE—ON THE STREET—ON THE PACK. THE COMPLETE SPECTRUM FROM ACTIVE TO INACTIVE. THE PORTRAITS WERE INCLUDED TO SHOW WHAT THE DESIGNERS DIDN'T WANT AS WELL AS WHAT THEY DID.

THE WEST COAST BOARD
PROVED THAT THERE WAS
NO GREAT ICON AND THE
TEAM "DIDN'T WANT TO
REMIND PEOPLE ABOUT
'CHEESY' PARTS OF
AMERICA." AT ANY RATE,
IT WAS NOT MEANT TO BE
AN AMERICAN COFFEE
BAR, DESPITE THE NAME.

brings us back to the "brand soul." Bailey and Janet Brades, along with chairman Mark Wickens, design director Clem Halpin, and creative director David Beard, spent a day with their clients investigating the essence of the Seattle brand, the company values, the passions of the people involved, and the brand vision.

Coffee, they realized, was "more about people—experiences—emotions," in the same way that Ally and Scott had missed their Seattle coffee shop as much for its atmosphere and community spirit as for the "coffee the way you want it" philosophy.

Ultimately they evolved a marketing plan that translated into four core elements:

- **Communication and promotion**
- **Publicity**
- **Store design**
- **Brand in the hand.**

Back in the studio, David Beard and his team started to look for a "creative language" for everything that would happen when you went into the shop. Before long, they all came to the same conclusion—not about coffee but about people—from the staff, to the suppliers, to the customers. This took it "out of the land of serious coffee language and into the land of how people talk to each other," explains Beard. More importantly, it was a proposition that was immediately "ownable" by Seattle, away from the "dry, patronizing tone of other coffee shops." Beard imagined a place where he could sit and relax for an hour, in the way he recalled he did at Vescuvio in San Francisco. This was a place that encouraged regulars to stay and where staff would remember what they drank, and it recalled the passion and love that drove Ally and Scott to set up their very first shop.

In their proposal, they called it "a third place—outside the home or the office, where you can relax and be yourself. At its most challenging, it is about providing people with stimulation that draws them into being creative beyond

(RIGHT AND BELOW RIGHT) WORD BITES," TAKEN FROM NEW YORK THEATER POSTERS AND ASSORTED MAGAZINES. THE IDEA OF USING SNIPPETS OF CONVERSATIONS RENDERED AS CUT-UP TYPE FITTED PERFECTLY WITH THE CASUAL PHOTOGRAPHY.

(BELOW) A WEEK LATER THE THREE STRANDS CAME TOGETHER, UNITED BY TEXTURAL PAINTINGS THAT FORMED "THE PLACE" WHERE PEOPLE, CONVERSATION, AND COFFEE MEET. THE USE OF DIVERSE CHARACTERS WAS IDEAL FOR DIFFERENTIATING THE PRODUCTS. THE LOGO WAS STILL THERE, AND THE "HARD" SILVER COLOR WAS TONED DOWN.

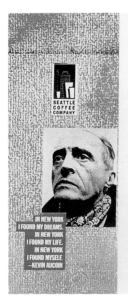

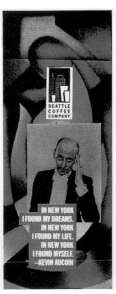
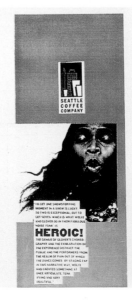
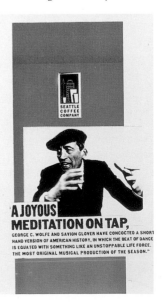

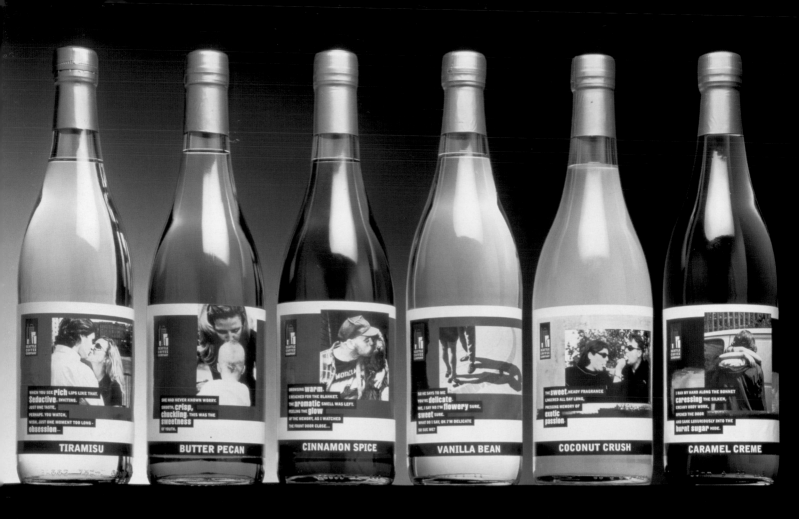

The bottles from left to right are labeled:
TIRAMISU · BUTTER PECAN · CINNAMON SPICE · VANILLA BEAN · COCONUT CRUSH · CARAMEL CREME

(ABOVE) THE CLIENT PROVIDED JANET BRADES WITH KEY DESCRIPTIVE WORDS FOR EACH BLEND, AND THESE FOLLOWED THROUGH ONTO SYRUP BOTTLE LABELS. HERE, THE IDEA WAS DRIVEN BY THE KISS, LIKE TWO PEOPLE IN A SWEET EMBRACE. THE ADDITION OF SUGARY SYRUP TO POTENT COFFEE WAS "THE ULTIMATE PARTNERSHIP."

(ABOVE) EIGHTEEN DIFFERENT PAINTINGS, WERE COMMISSIONED FROM ILLUSTRATOR COLIN SHEARING TO "SOFTEN" THE PACKS.

themselves." A demanding proposition and one that would, the team recognized, need to be achieved in stages, most notably by raising awareness through store location and PR, and by getting people across the threshold.

Needless to say, the Seattle Coffee team were delighted, but now there was an urgency to develop packaging for a fall launch of their fresh coffee bean product, and their new stores would be launching over the next two years.

Two weeks later the retail designers at Rodney Fitch & Co. and the packaging team at WTS presented their first creative proposals. "We started, more or less, with the answers," explains Beard. "But to get the client to the same place, we showed them what we didn't want to do." This included what other coffee packs looked like and what the West Coast of America looks like — no obvious pictures of Seattle and no references to Frasier. At the end of the two-hour presentation, three strands emerged, and these formed the nucleus of the new Seattle Coffee Company: snatches of conversation; pictures of "real" people; and colorful textural paintings in the style of Mark Rothko. On the two-dimensional pack visuals, the hard silver finish of which had been softened to a more friendly-looking bronze, the three elements came together graphically in an overlapping layout that evoked the coffee shop atmosphere, with snatches of conversation from an international mix of people in an artfully created space.

NEEDING 18 INDIVIDUAL PHOTOGRAPHS, THE TEAM HIT THE STREETS OF LONDON. WITH NO BUDGET FOR MODEL FEES OR STUDIO PHOTOGRAPHY, ANDY FLACK PHOTOGRAPHED INTERESTING PEOPLE. GETTING THEM TO KISS COULD HAVE BEEN DIFFICULT, BUT "THEY WERE DELIGHTED TO DO IT," RECALLS CARRIE BAILEY. EVEN THE CLIENTS OBLIGED.

For WTS it was unusual to have just one concept on the table, but everyone seemed convinced that it was right. A week later the team proved it by showing the solution applied to 18 different products. Janet Brades wrote copy for each pack in the style of 20th century American literature, and the Rodney Fitch interiors team showed how the quotation and the textural paintings would work within the interiors, both in new shops as well as refurbishments of existing sites.

The client approved everything and the project slipped into stage three. The illustrator Colin Shearing was commissioned to paint 18 different paintings and photographer Andy Flack went on a four-day walk across London, starting at Broadgate and ending up at Notting Hill. Accompanied by Carrie Bailey and David Beard—and joined by the client from time to time—Flack went up to "anyone he found interesting" and asked if he could take their picture. Of course, they had to explain what it was for, and everyone had to sign a release form, but even though there was no fee, only four or five people refused. In the end, they had shot 40 rolls of black and white film and many more images than they needed for the first launch.

Eventually, all the artwork was sent to the printers for a launch in October 1997. Everything from sandwich labels to cups, bags, and leaflets was included—even sugar sachets. In the modern reception area of WTS a huge painting, commissioned three years ago, depicts all the staff laughing, and talking, and drinking cups of coffee. Perhaps that's why the Seattle Coffee Company gave them the job in the first place.

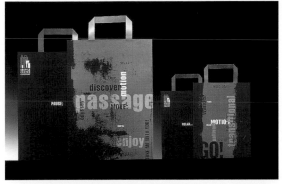

(LEFT) SUBSEQUENT SHOPPING BAGS TOOK THE TYPOGRAPHIC ELEMENT ONE STEP FURTHER.

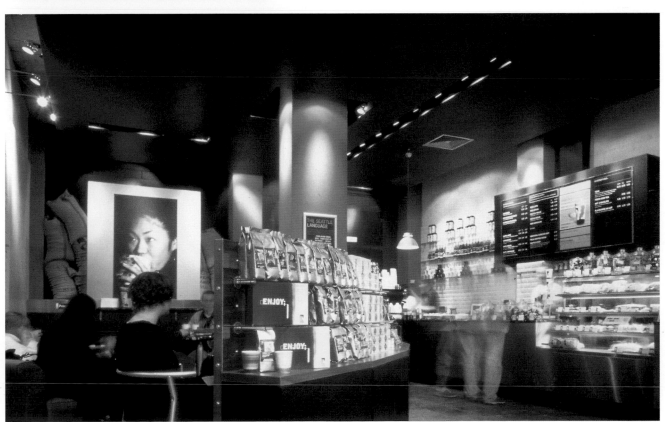

(OVERLEAF) WITH ALL ELEMENTS IN PLACE, THE DESIGN TEAM PIECED IT ALL TOGETHER—WHICH PHOTO WITH WHICH QUOTATION, WITH WHICH COLOR BACKGROUND. "SOME SEEMED TO FIT INCREDIBLY WELL," RECALLS BAILEY. IN THE FINAL DESIGN PRESENTATION WTS PRODUCED THREE-DIMENSIONAL PACK MOCKUPS, "TO DEMONSTRATE AS REALISTICALLY AS POSSIBLE WHAT THE FINAL RESULT WOULD LOOK LIKE."

(LEFT) THE NEW COFFEE SHOP INTERIOR BY RODNEY FITCH & CO. THE EXPERIENCE IS ABOUT SELF-EXPRESSION, INDIVIDUALITY, RELAXATION, AND COMFORT.

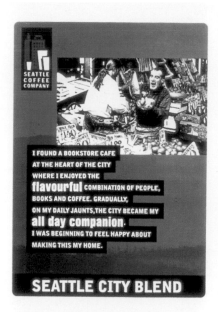

I FOUND A BOOKSTORE CAFE
AT THE HEART OF THE CITY
WHERE I ENJOYED THE
flavourful COMBINATION OF PEOPLE,
BOOKS AND COFFEE. GRADUALLY,
ON MY DAILY JAUNTS, THE CITY BECAME MY
all day companion.
I WAS BEGINNING TO FEEL HAPPY ABOUT
MAKING THIS MY HOME.

SEATTLE CITY BLEND

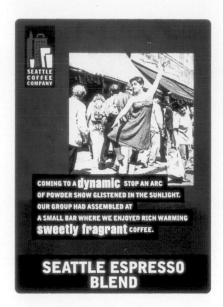

COMING TO A **dynamic** STOP AN ARC
OF POWDER SNOW GLISTENED IN THE SUNLIGHT.
OUR GROUP HAD ASSEMBLED AT
A SMALL BAR WHERE WE ENJOYED RICH WARMING
sweetly fragrant COFFEE.

SEATTLE ESPRESSO BLEND

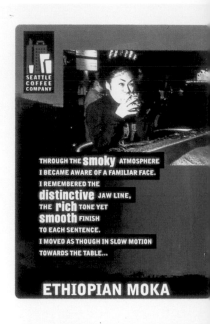

THROUGH THE **smoky** ATMOSPHERE
I BECAME AWARE OF A FAMILIAR FACE.
I REMEMBERED THE
distinctive JAW LINE,
THE **rich** TONE YET
smooth FINISH
TO EACH SENTENCE.
I MOVED AS THOUGH IN SLOW MOTION
TOWARDS THE TABLE...

ETHIOPIAN MOKA

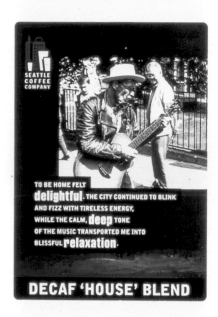

TO BE HOME FELT
delightful. THE CITY CONTINUED TO BLINK
AND FIZZ WITH TIRELESS ENERGY,
WHILE THE CALM, **deep** TONE
OF THE MUSIC TRANSPORTED ME INTO
BLISSFUL **relaxation**.

DECAF 'HOUSE' BLEND

THE EVENING
light FLOATED DOWN
THROUGH THE HIGH RISES RESTING LIKE A
smooth VEIL
ACROSS THE SQUARE.
FROM MY SEAT I WATCHED IN
joyous meditation.
AWAITING HIS ARRIVAL.

DECAF COLOMBIA

DRY FROM THE HEAT OF THE CITY NIGHT,
I DRANK DEEPLY AS IN A DREAM.
A **bright fruity** HIT,
uplifting LIKE A FALL BREEZE.
I WAS READY TO FACE
THE DAWNING DAY.

MOUNT RAINIER BLEND

OUR HANDS TOUCHED
AS WE LUNGED
FOR THE SAME SUPPORT RAIL.
A tantalising SHIVER
TRAVELLED STRAIGHT TO MY HEART.
WE HAD SO OFTEN CROSSED PATHS
ON THIS JOURNEY, BUT THIS TIME I WAS CLOSE
ENOUGH TO **whisper**
THE INVITATION.

JAVA

HE SPOKE WITH
AN **earthy** TONE,
A VOICE WHICH REFLECTED A STRONG,
full bodied CHARACTER
WHICH WAS IMMEDIATELY MAGNETIC.
AS HE UNFOLDED HIS STORY,
I WAS TRANSFIXED.

SUMATRA LINTONG

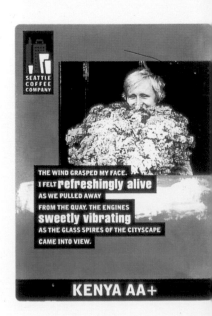

THE WIND GRASPED MY FACE.
I FELT **refreshingly alive**
AS WE PULLED AWAY
FROM THE QUAY. THE ENGINES
sweetly vibrating
AS THE GLASS SPIRES OF THE CITYSCAPE
CAME INTO VIEW.

KENYA AA+

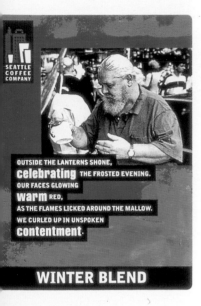

OUTSIDE THE LANTERNS SHONE, **celebrating** THE FROSTED EVENING. OUR FACES GLOWING **warm** RED, AS THE FLAMES LICKED AROUND THE MALLOW. WE CURLED UP IN UNSPOKEN **contentment**.

WINTER BLEND

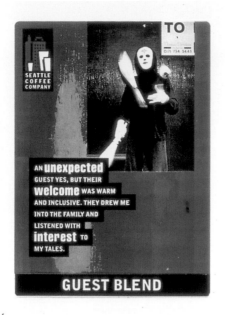

AN **unexpected** GUEST YES, BUT THEIR **welcome** WAS WARM AND INCLUSIVE. THEY DREW ME INTO THE FAMILY AND LISTENED WITH **interest** TO MY TALES.

GUEST BLEND

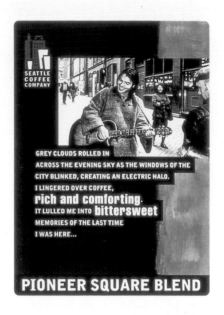

GREY CLOUDS ROLLED IN ACROSS THE EVENING SKY AS THE WINDOWS OF THE CITY BLINKED, CREATING AN ELECTRIC HALO. I LINGERED OVER COFFEE, **rich and comforting**. IT LULLED ME INTO **bittersweet** MEMORIES OF THE LAST TIME I WAS HERE...

PIONEER SQUARE BLEND

THE CONVERSATION WAS INTERESTING YET **complex**. IT STROKED MY EGO AS WE WALKED INTO THE ROOM. I COULD TELL THIS WAS GOING TO BECOME A **satisfyingly rich** RELATIONSHIP.

SEATTLE DECAF ESPRESSO BLEND

MY INTIMACY WITH THE CITY GREW EACH DAY I WOULD **discover** A NEW SIDE, A DIFFERENT **flavour**, EXPERIENCES WHICH WERE CONSTANTLY **surprising** TO MY SENSES.

GUEST BLEND

THE STREETS SHIMMERED IN THE NOON SUN, THE AROMAS FROM SURROUNDING CAFES AND RESTAURANTS MINGLED WITH THE HEAT CREATING **subtle depth**. I SAT BACK TO BATHE IN THE RAYS OF AN **easy going** PERFECT WEEKEND.

COLOMBIA ARMENIA

THE **exquisite** SMELLS OF MIDDLE **eastern** SPICES WAFTED UP AND THROUGH THE OPEN WINDOW, EXCITING MY TASTE BUDS AND LURING ME AWAY FROM MY WORK. JUST A FEW MORE SWOLLEN THOUGHTS, THEN THE **promise** OF SOME STOLEN HOURS OVER COFFEE.

ARABIAN MOCHA JAVA BLEND

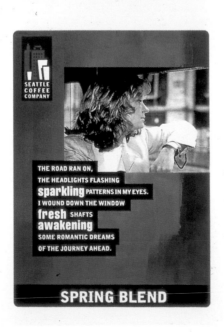

THE ROAD RAN ON, THE HEADLIGHTS FLASHING **sparkling** PATTERNS IN MY EYES. I WOUND DOWN THE WINDOW **fresh** SHAFTS **awakening** SOME ROMANTIC DREAMS OF THE JOURNEY AHEAD.

SPRING BLEND

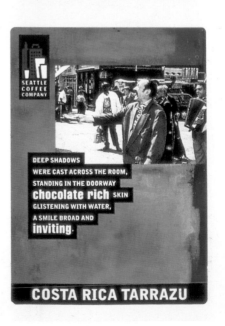

DEEP SHADOWS WERE CAST ACROSS THE ROOM, STANDING IN THE DOORWAY **chocolate rich** SKIN GLISTENING WITH WATER, A SMILE BROAD AND **inviting**.

COSTA RICA TARRAZU

Superdrug Multi-vitamins

Even with their newly formulated briefing forms, **this project was difficult to grasp**. The products were not new; the customer was universal; and the contents could not be shown. Bruce Duckworth saw a fuzzy, out-of-focus picture in a brochure and suddenly everything became clear

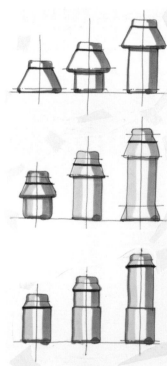

JUST ONE EXAMPLE OF THE UNCOORDINATED RANGE OF OWN-BRAND MULTI-VITAMIN PRODUCTS THAT TURNER DUCKWORTH WAS ASKED TO RE-DESIGN.

The FISI form (first important step to innovation), which the client Superdrug drew up for the 120-pack own-brand range of multi-vitamins, single vitamins, and supplements, had two pages. The first listed 22 aspects of product description, including:

• positioning—what is the specific central promise to the consumer?

• support—why should the consumer believe these claims?

• marketing objective—what are we hoping to achieve?

On the second page the design requirements were given in question-and-answer boxes, listed from one to 13, and these included:

• design objective—what, specifically, is the main problem our design must solve?

• personality—what emotional or character qualities are important to the range?

• graphic mandatories—what must be include or avoided?

Uniquely, it also asked, "What would the range be like as a person?" to which the answer is unrecorded. In fact, perhaps as a measure of the confusion that reigned at Turner Duckworth at the time, the copy of the brief seems to have gone missing from the job bag.

Nevertheless, Bruce Duckworth, senior partner at the London consultancy, knew how to proceed and promptly went shopping. "I tried to buy some multi-vitamins from

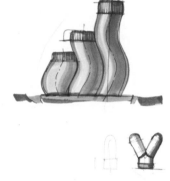

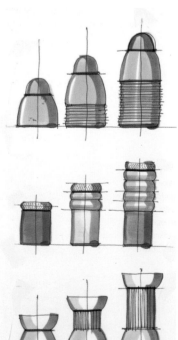

A SMALL SELECTION OF PACK SHAPES THAT BRUCE DUCKWORTH SELECTED FROM MORE THAN 30 DESIGNED BY PRODUCT FIRST. ALL THE SHAPES HAD TO UTILIZE THE SAME CAP SIZE ON EACH OF THEIR THREE SIZES. AND SEVERAL ROUTES ALSO INCLUDED THE SAME SHAPE THAT WAS EXPANDED BY THE ADDITION OF A SECOND FORM. COLORS WERE ADDED TO DIFFERENTIATE RANGES, AND ONE OR TWO MORE ADVENTUROUS IDEAS ROCKED FROM SIDE TO SIDE OR EMBRACED EACH OTHER (*ABOVE RIGHT*).

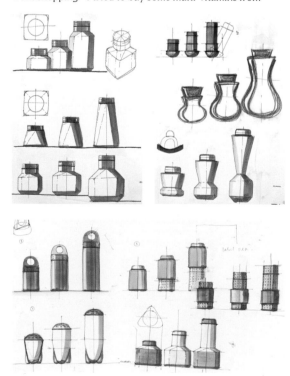

other stores and found it very difficult," he explains. "Nothing stood out as different, and when I studied pack information—the categories and strengths of doses —there seemed to be no real hierarchy. Everything was shouting for attention."

Versions of the products in question were already on sale in Superdrug stores in a variety of unrelated boxes and bottles, and Duckworth's job was to repack everything into a cohesive range, in line with the Superdrug corporate positioning of a more lively, fun and approachable image. The line-up consisted of the usual vitamin C and multi-vitamins, but was expanded to include evening primrose, cod liver oil, garlic, and *Ginko biloba* leaf extract. Nothing, it seemed, linked the products together, and in the feedback chart of the range, Duckworth divided them into three consumer entry levels: general health insurance; problems requiring solutions; made-to-measure. Looking at it another way, the range of products could be divided into two categories. The first of these, which Duckworth called the "superior range," included: Life stage; Beauty; Folic acid; Specialist innovations, and Chinese. The second category, which was called "fit for life," covered: Basic vitamins; Multi-vitamins; Children's; Garlic; GLA ; Fish oils.

"The packs had a lot of limitations," says Duckworth. "You can't make any medical claims, and you can't describe benefits. All you can say is what they are and how often you take them, and you have to list what's in each on the back of the pack." First, therefore, they tried to simplify the pack information. "Is it a tablet, a capsule, or a liquid? How many are there and what strength?"

"This stage of the work was almost more important to us than the design of the labels," says Duckworth. At the same time, because of the long lead times involved in producing new pack shapes and lids, he briefed Graham Thompson at Product First, a small product design company he had used before, to start working on new container ideas. "Fortunately, our budget included the possibility of new caps and bottles," explains Duckworth. "We realized that there was an opportunity to design something that added value to the product, as well as making it stand out on the shelf, both in the stores and at home, where, because it wasn't medicine that had to be hidden away, could be left on display in the kitchen or bathroom."

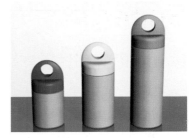

FIVE ROUTES WERE TO BECOME COMPUTER-GENERATED MODELS. OF THE TWO PRODUCTS, ONE (*TOP RIGHT*) ENABLED LESS AGILE CUSTOMERS—A LARGE SHARE OF THE MARKET—TO GAIN EASIER ACCESS. THE OTHER (*TOP LEFT*) HAD AN OVAL BOTTLE WITH A "FILLED-IN" CAP. "IF IT LOOKED GOOD ENOUGH, PEOPLE MIGHT DISPLAY THEM." SUGGESTS DUCKWORTH..

I (*LEFT*) IN THE FINAL DESIGN PRESENTATION, A COLOR BAND DIVIDED EACH PACK IN TWO AND EXTENDED THE CAP VISUALLY HALFWAY DOWN THE LENGTH, AS WELL AS LINKING THE BOTTLES TO THE BOXES IN THIS 20-PRODUCT RANGE. THE IDEA WAS TO ILLUSTRATE THE CONTENTS USING CIRCLES AND DISCS.

(*RIGHT*) THE ALTERNATIVE ROUTE ALSO USED CIRCLES BUT WITH MORE ILLUSTRATIVE FLEXIBILITY. " PRODUCTS WERE DENOTED BY COLORS—ORANGE FOR VITAMIN C, YELLOW FOR MULTI-VITAMIN, BLUE FOR EVENING PRIMROSE..

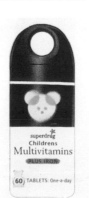

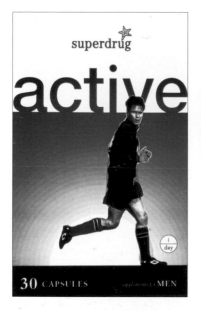

Duckworth's first client presentation was on two levels. First, in addition to clarifying the information, they showed plain white pack shapes that had only the copy details, presented in a newly rationalized layout. Second, from the design point of view, they chose six shapes that Product First had designed and visualized them with the three-dimensional package on the computer.

"The client was very excited," recalls Duckworth, "and we had a debate over two quite similar shapes—one looked slightly more feminine than the other, more like a cosmetic or a shampoo product, perhaps."

Graphically, there were also two routes. One idea used dots and circles as a way of illustrating different contents, and encompassed every product in the range. The other idea divided the range into three groups—basic vitamins, natural supplements, and lifestyle products—and treated each group differently, using visual devices and typefaces.

The two groups were sent off for research along with the typographical exercise the designers had produced. "The results were more or less as we had expected," confesses Duckworth. "Unanimous for the circles route and the caps with holes in them—the whole thing revolved around circles." Having taken nearly three months to find a direction, the designers found that things now started to move more quickly. Product First made a representative number of models of the new packs in three sizes, and Duckworth talked to the plastic bottle manufacturer who was going to make the caps. "Because of costs, we had to have one cap for all three bottle sizes, and this presented some difficulties when it came to the largest version," he says. The child-resistant closure was added at this stage, too, and had to be integrated into the new cap shape.

"We realized that the whole success of the concept hinged on the position of the circle on the cap lining up with the graphics when it was closed. We didn't know how, but we figured it must be possible," confesses Duckworth.

At this stage, they were seeing the client on a number of different jobs, so they would show them updates every few

IN THIS SERIES OF SUBSEQUENT LABEL SOLUTIONS, THE CIRCLES WERE ABANDONED IN FAVOR OF MORE CONVENTIONAL FIGURATIVE ELEMENTS AND STRONGER, MORE VARIABLE TYPOGRAPHY.

WITH SO MUCH EMPHASIS ON COLORS, THE DESIGNERS HAD A COMPLEX JOB WORKING OUT A HIERARCHY THAT FULFILLED ALL THEIR NEEDS, AS THESE TWO CHARTS SHOW (LEFT).

days. Although he had shown roughs of the graphic circles, Duckworth did not know how he was going to achieve them until he found computer illustrator Justin de Lavison, who started to develop a system by which everything was illustrated by the shapes of pills and capsules. "It took nearly four months to produce the 21 different images we needed," says Duckworth. "We chose the colors of the plastic caps first, and then the repro people were told to match them, using a new process called Hexachrome, a six-color litho process with more intense colors, especially the orange and green. It was the first commercial use of it, I believe." Duckworth produced artwork guidelines, and the client, in line with its procedures, did all the artwork and production liaison.

"It was the most complex job we've done," admits Duckworth. "When we got the job, I didn't know if it was a good thing or a bad thing. A friend said to me, 'If a range of packaging doesn't fit on your desk, don't do it!'"

"COMPUTER WHIZ" JUSTIN DE LA VISON WORKED OVER A PERIOD OF FOUR MONTHS ON THE ILLUSTRATIONS. ALTHOUGH HE HAD NEVER DONE ANYTHING LIKE THIS BEFORE. "WE WANTED SOMETHING THAT LOOKED MODERN AND BRIGHT AND HAD A CERTAIN AMBIGUITY." SAYS DUCKWORTH.

THE FINAL PRODUCTS SOLD WELL—AND THEY GAINED VARIOUS DESIGN AWARDS. THE LIDS WERE DESIGNED SO THAT ELDERLY CUSTOMERS COULD OPEN THEM WITH THE ASSISTANCE OF A PENCIL, AND CHILDREN COULD USE THEM AS TOYS WITHOUT BEING ABLE TO GAIN ACCESS TO THE CONTENTS, THANKS TO THE CONCEALED CHILD-RESISTANT CLOSURE.

superdrug
Ginkgo Biloba
Leaf Extract

30 TABLETS One-a-day

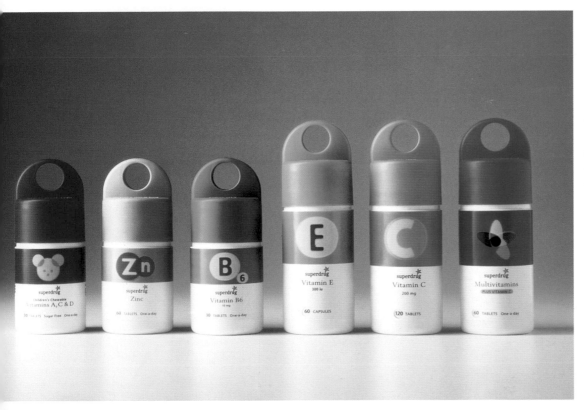

superdrug
Co-Enzyme Q10
30 mg

30 CAPSULES One-a-day

Joy

"My packaging is very simple," says chef and retailer Kevin Gould. "This person made this, and you should eat it this way. But there's also a little bit of romance there too. **People want that little vacation as they put the food into their mouth.** That, for me, is where food is at"

There was always a lot of passion about food in Gould's extended family. He remembers his Iranian grandmother preparing "feasts with four kinds of rice." In his two food shops, Realfood in London's Little Venice and a second called Joy in Finchley Road, he has established a link between the producers and the customers in an attempt to "bring food alive."

In Italy he tracked down "... a hard-up Tuscan aristocrat with lots of land who was making a very green, thick, spicy, peppery olive oil—the best I'd ever tasted.". Gould arrived on the last day of pressing—if the oil is to be any good, olives are picked, washed, and processed within 24 hours. "The farmer couldn't believe I wanted 260 gallons," remembers Gould. "He thought there must be a catch." Olive oil deteriorates very quickly if it is exposed to light or heat. Light causes oxidation and will turn it rancid. "Now I'd got the oil, I could package it how I wanted." He recalled the Tuscan Barone's storage vaults, where oil is stored in earthenware urns.

In Germany he found the perfect solution. Used for schnapps, it was a glazed earthenware bottle made by a company known only as M.K.M. Eventually, with the help of the German Packaging Federation, he found the manufacturer, but they made only 1 pint and 2 pint sizes in blue and brown. Persevering, Gould discovered that the company had the molds for the size he wanted, but was told, "you can only have them in white"—which he wanted anyway. The oil is shipped in 6.6 gallon containers and Gould bottles only what will be sold in two weeks. "We use the same system for a wide range of foods. We import in bulk and repack in our own packs," he explains. At *Realfood* they carry 6,000 lines, but not all the imported produce goes into his shops.

All the labels are generated on a PC in the shop, using a typeface called Trade Gothic. "I'd never have found it on my own, but designers, Michaels Nash, who are also customers, suggested it. I didn't like any that were on the computer, but this type is easy to read, even very small." The design, Gould continues, "was trial and error. It's not a particularly sophisticated layout. I haven't underlined anything, but I don't believe one should notice any of that. I love labeling— you can't get any more on than the boundary will allow you, so the size establishes a discipline." Gould remembered that he experimented for two days to get it just right—the size of the copy and the position on the bottle evolved slowly. Gould writes most of the copy, too, but curiously there is no pictorial element to the design. "What's the point? I love brands," explained Gould. "But for some perverse reason I don't want to do it. I can't tell you why—it seems like the modern thing to do."

A POSTCARD FROM THE SHOP PROCLAIMS: "EASY FRESH DELICIOUS FOOD TO GO." THE NAME, JOY, CAME WHEN GOULD RECALLED A COOKBOOK FROM THE 1950S CALLED *THE JOY OF FOOD.* "LONDON HAS BECOME THE RESTAURANT CAPITAL OF THE WORLD, BUT WHAT IS MISSING FROM MODERN BRITISH COOKING IS A DEGREE OF PASSION AND JOY."

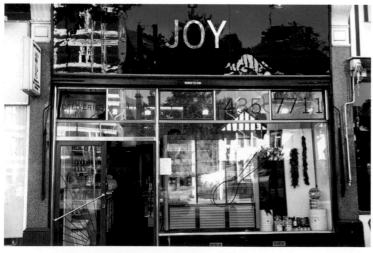

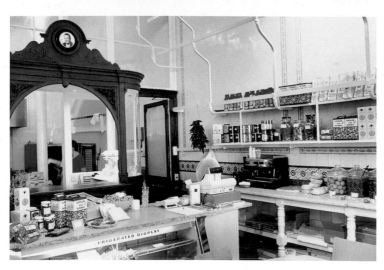

(*LEFT*) CUSTOMERS CAN SEE AND SMELL FOOD BEING PREPARED BEHIND THE COUNTER IN THE REAR OF THE SHOP. ALL THE ORIGINAL SHOP FITTINGS HAVE BEEN KEPT, AND THE PRODUCTS, PREDOMINANTLY ORGANIC, HAVE "AS LITTLE HUMAN INTERVENTION AS POSSIBLE." THE OLD BUTCHER'S SHOP WAS COMPLETELY INTACT–NO ONE HAD SPENT ANY MONEY ON IT FOR 50 YEARS, SO IT HAD ALL THE ORIGINAL 1890 TILES AND VICTORIAN FITTINGS.

(*RIGHT*) KEVIN GOULD CHOSE THIS 25 FLUID OUNCE GLAZED EARTHENWARE BOTTLE FOR ITS PROPORTIONS AS MUCH AS FOR ITS CAPACITY, AND HE WASN'T TOO CONCERNED ABOUT THE COST. ONCE THEY HAVE BOUGHT ONE, CUSTOMERS CAN HAVE THEIR BOTTLES REFILLED IN THE STORE. IN ADDITION, GOULD HAD CORKS WITH WOODEN TOPS IMPORTED FROM PORTUGAL.

Fabris Lane

If every style-conscious teenager has not stolen a pair of sunglasses in their life, **they have almost certainly been tempted.** Major retailers and opticians deal with **the problem in a variety of ways, usually by attaching unattractive 2-inch long security tags to each pair**

When Fabris Lane International Ltd wanted security packaging for a range of adults' and children's high quality sunglasses, it could have required a long and complicated brief. In fact, however, there was no brief at all—at least, not one that was written down. But designer Steve Hutton and his team were not too worried. It was the first time he had worked for Fabris Lane, and he thinks that "written briefs are not usually as useful as being briefed face to face."

Even so, it was a tricky problem—how to pack sunglasses so that they could be removed and tried on without being separated from the pack. In addition, the pack had to present the product as "cool" to style-conscious kids from the age of six upward, as well as have a version for adults and a provision for a case and cleaning cloth. The range was to sell not in upmarket opticians and department stores, but in supermarkets and pharmaceutical chains.

Hutton decided that it would be impossible to prevent pilfering completely, but he was convinced that if they were seen to be fixed to their pack it would help.

This is when he hit on the idea of using the cord that is often used to hold on sports glasses. At this point, he could have got the studio to spend hours visualizing and mocking up ideas. But he did not, and perhaps this is the secret of the packs' success. He dashed off a few quick construction and shape sketches, and sent them immediately to a colleague, Bob Grayson at Greenups Printers in Sheffield, which produces a lot of speciality packs. They had worked together before, so he was able to ask Grayson to look at the problem, and in two or three days see if any of the ideas had practical possibilities. Grayson was delighted to be involved at such an early stage and responded right away with a whole range of dummy packs made up in white card.

STEVE HUTTON AND VICTORIA FENTON SKETCHED OUT IDEAS, WHICH WERE SENT BY FAX TO THE PRINTERS, WHO COULD DEVELOP THEM AND SEND BACK COSTED SOLUTIONS *(BELOW LEFT AND RIGHT)*.

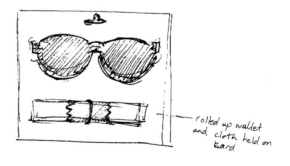

GREENUPS PRINTERS IN SHEFFIELD TOOK THE DESIGNER'S SKETCHES AND REALIZED THEM IN WHITE CARD.

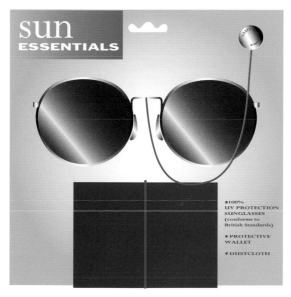

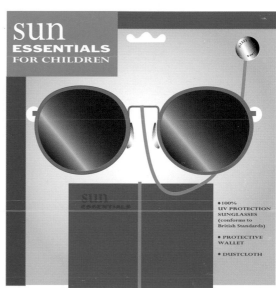

SUN ESSENTIALS, THE NAME THE SUNGLASSES MAY INITIALLY HAVE HAD IN TESCO STORES (SEE PAGE 178), WAS APPLIED TO A FLAT CARD HANGING PACK THAT FEATURED THE SOFT GLASSES CASE FOLDED IN HALF AND ROLLED UP LIKE A BACK-PACK. A SOLUTION THAT MET WITH A POSITIVE RESPONSE BUT PROVED TOO COMPLICATED TO PRODUCE.

EXPERIMENTING WITH ONE OF THE SUGGESTED NAMES, HUTTON SHOWED A RANGE OF IDEAS FOR LOGO-TYPES.

Mojave

MOJAVE HAD A SIMPLE USE OF COLOR BUT A STRONGER LOGO AND BRANDING THAN THE CLIENT FELT WAS NECESSARY.

**100%
UV PROTECTION
SUNGLASSES**
(Conforms to
British Standards)

**PROTECTIVE
WALLET**

DUSTCLOTH

ONE OF STEVE HUTTON'S FAVORITE SOLUTIONS WAS THE "PILLOW PACK" FORMAT, MADE OUT OF CORRUGATED CARD. IT HAD AN EMBOSSED LOGO AND A HOLE CUT OUT TO REVEAL THE CASE, WHICH WAS HELD IN PLACE BY THE FOLDED-IN SIDES OF THE POCKET. "TOO SOPHISTICATED — PERHAPS TOO UPMARKET," WAS THE CLIENT'S VERDICT.

MOJAVE

MOJAVE

MOJAVE

JUNIOR

THE FINAL SOLUTION HAD MAXIMUM IMPACT WITH EFFECTIVE USE OF VIBRANT COLORS, MAKING IT IDEAL FOR DEVELOPING RANGE VARIATIONS. THE NAME JUNIOR WAS CONSIDERED INAPPROPRIATE FOR STYLE-CONSCIOUS SIX-YEAR-OLDS.

dummy packs made up in white card.

At this stage the range had no name, so Hutton could look at the graphics and the name as a joint approach and focus them on a pack shape that he knew could be produced. He liked the idea of giving added value with the cord, though in the end it proved impossible for it to function as anything more than an anti-theft device.

Visualized on the computer, the first presentation consisted of six ideas, each under a different name, shown as flat-colored renderings, some with a flat card base and some featuring a pillow pack, an idea suggested by Grayson that already existed but was not used for sunglasses. This had two advantages: it contained the case and the cleaning cloth, and it threw the bottom edge of the glasses forward, so that they

were held in a more front-on, realistic angle.

In addition, rivets and cords were simulated, and some variations featured an embossed logo, for which there was a list of 10 names, including Apollo, Celsius, Glint, Mojave, Monteray, Rayburst, Rayscreen, Reef, SunSee, and Sunshield. Martine Leaman at Fabris Lane reacted well to the simple, strong colors approach and asked for two versions, one for adults in more sophisticated hues. But she "took a lot of persuading to accept the cord, due to its possible increased cost implications."

There was still work to be done — sourcing and feasibility studies and finding a suitable way of fastening the cord at both ends. As for the name, Apollo (the god of the sun) was the final choice.

FORMING AN IMPORTANT PART OF THE LOOK OF THE PACK. THE SECURITY CORD DEVICE WAS LONG ENOUGH TO ALLOW THE PACK TO HANG BELOW THE CHIN WHEN THE GLASSES WERE TRIED ON IN THE STORE.

Chocca Mocca

The key to the success of these packs was teamwork by the client and the designer, a collaboration that included lively discussion and lots of give and take. Ideas, after all, can come from anywhere, **even an aphrodisiac cookbook**

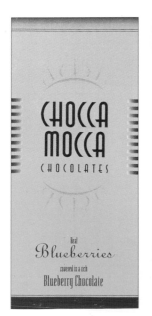

THE 1995 RANGE, WHICH REPLACED THE ORIGINAL SELF-ADHESIVE LABELS, WAS DEVELOPED BY CHOCCA MOCCA'S CATHERINE MELVIN, HELPED BY TWO EX-ART SCHOOL STUDENTS, DONALD BREENAN AND NIALL TYRELL. ON THE INDIVIDUAL-SIZED PACKS A GOLD CARD SLEEVE WAS PRINTED WITH THE COLOR-CODED BEAN LOGO, BUT CUSTOMERS DID NOT RECOGNIZE THE DIFFERENCE AND COULD NOT SEE THE PRODUCT.

Geoff Caird and Catherine Melvin, who are based in Dublin, created Chocca Mocca chocolates in November 1993, with the idea of producing gourmet chocolate products of the highest standard, but with a contemporary twist. They started with chocolate-covered coffee beans, and the logo, designed by an English designer called Robert Carter, was an O divided down the center. "Our original packaging was a brown paper bag with a self-adhesive label," recalls Caird. In 1995 this was changed to a sleeve that wrapped around the bags and was tied with black ribbon. Over the years new products were added and the choice increased, until in 1997 the duo decided it was time to introduce a new range of chocolate products, matched by a pack that was in line with the company's marketing philosophy: Irish, modern, innovative, and international.

"We also wanted to make the range very accessible to our target audience," says Caird. This is when they heard about Acrobat, a local design company, set up and run by Bernie Sexton, who had been working on packs for a similar food producer called Lime and Lemongrass Gourmet Foods. "We were keen to build up our portfolio of packaging work— we got on with Geoff and Catherine immediately," she recalls.

The brief was to redesign the range of packaging around a natural handmade, feel—brown craft paper was to be used, to keep a hand-produced look to the packs. Sexton continues:"The chocolate market has expanded greatly in the last few years, with a huge number of new players producing very sophisticated fresh cream and hand-made chocolates. The target audience now has a greater choice. Chocca Mocca packaging needed to make its presence a lot stronger and also needed greater distinction and clarity between each

(BELOW) SHOWN AS FLAT VISUALS, THIS SERIES OF DESIGNS, WHICH WAS THE BASIS OF THE STAGE ONE PRESENTATION, INVESTIGATED THE USE OF THREE COLORS, INCLUDING GOLD, AND A PRODUCT VARIATION COLOR (BLUE IN THIS INSTANCE) PLUS THE NAME AND THE BEAN LOGO. MOST ATTENTION FOCUSED ON THE PHOTOGRAPH OF A BOWL OF STRAWBERRIES (RIGHT). COULD THIS BE A WAY OF INDICATING THE CONTENTS OF THE PACKS?

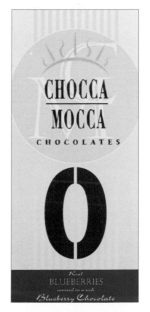

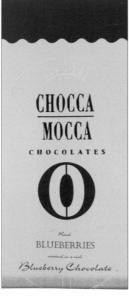

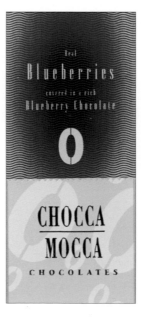

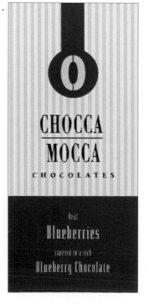

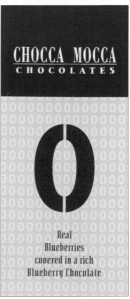

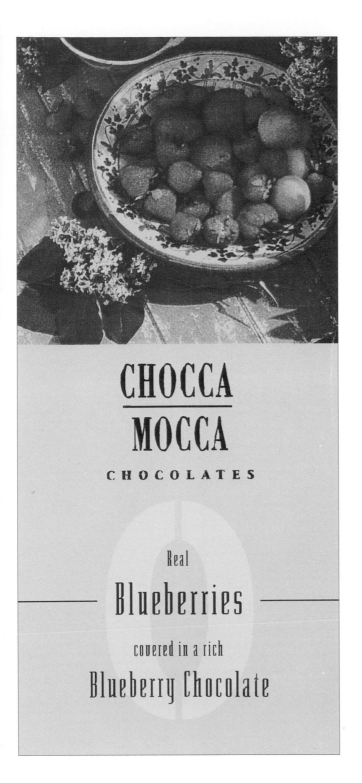

CHOCCA
MOCCA
CHOCOLATES

Real
Blueberries

covered in a rich
Blueberry Chocolate

DURING THE SUBSEQUENT PHOTO SHOOTS TREVOR HARTE CUT OUT A LITTLE BLACK PAPER MASK SO THAT HE COULD PLACE IT OVER THE CAMERA'S VIEWFINDER AND ARRANGE THE FRUIT AND CHOCOLATE IN A MORE PRECISE WAY.

hamlyn

INTER

COURSES
an aphrodisiac cookbook

martha hopkins randall lockridge

THE COVER OF THE BOOK THAT WAS THE INSPIRATION BEHIND THE IDEA OF USING PLAIN AND CHOCOLATE-COVERED FRUIT AND NUTS ON THE PACKS.

product. Also, because it was such a unique product, we needed to build awareness of this chocolate experience—it was not just another chocolate!"

The solution evolved over three months. Jenny French at Acrobat worked on the initial ideas with Sexton. She produced around 20 black and white pencil sketches, and these were worked up into color visuals on computer.

"We endeavored to address the problems and branding issues," says Sexton, "while keeping what the client liked about the old packs but coming up with ideas we felt would improve their shelf presence and strengthen the brand. They liked the gold, so the initial visuals were based on using a gold background color."

The original logo was another element that the client had wanted to keep, but Sexton and her team were not so sure. "It didn't define the product, and we thought we should broaden our investigation of other ideas first—start with a clean page." The client, however, was keen to retain the original logo in some form so it became a question of the level at which it was to be used and how.

"The first presentation was a really interesting discussion," recalls Sexton. "Showing so many alternatives helped us to focus on the possibilities." From the presentation came the realization that they needed to show the customer "what was inside each variation."

Of all the designs the one that showed a monochromatic picture of the product, was the most favored route. "It was a very lively meeting," says Sexton. "Geoff and Catherine were very enthusiastic and had a lot to say." In the end, they went away with plenty to discuss.

Catherine then remembered an idea I had had for a different product range some months earlier—of using a dominant color-coded logo on a white background. She also remembered the cover of a book we had recently bought, *Intercourses*, an aphrodisiac cookbook by Martha Hopkins and Randall Lockeridge published by Hamlyn, which had a really vivid photo of a girl covered in strawberries on the

cover. Her idea was to place photos of the strawberries or blueberries or any one of the range in the logo. Catherine did a sketch of the concept, and over dinner that evening we knew we were on to a winner."

Caird and Melvin went back to Acrobat and presented their idea exactly as they wanted it to look and they helped translate this into reality. "At this point the project really jumped ahead," says Sexton, who did a mock-up of the new idea of combining in one picture ingredients as well as the finished, chocolate-coated product, and then setting it inside the bean. It was a dramatic move and meant much higher origination costs, but Caird felt it was "worth going for." Dublin-based photographer Trevor Harte took all the pictures, including strawberries, raspberries, blueberries and various nuts, in and out of chocolate.

The next stage of the project was to look at the structure of the pack. Earlier it had been suggested that instead of having a bag they should make a sturdier pack, and, in collaboration with Lime Street Print Works in Dublin, Acrobat experimented with various forms and heavier board weights. "This is one part I really enjoy," admits Sexton. At the same time, she adds, "Catherine from Chocca Mocca had done extensive research for ribbons, so we unanimously agreed on the black gauze type ribbon rather than a satin one, because it was lighter and more stylish. We looked at other materials for closing the pack because we were concerned that a ribbon tied with a bow might look too pretty. We wanted the pack to look hand finished and stylish but not feminine and pretty, a product that any man or woman would purchase."

WE WANT OUR BEAN-SHAPED LOGO AND WE WANT IT BIG"—PART OF THE FEEDBACK FROM THE CLIENT AFTER THE FIRST PRESENTATION. THE DESIGNERS RESPONDED WITH A RANGE THAT CLEARLY AND ELEGANTLY DESCRIBED THEIR CONTENTS. "WE REDREW THE CHOCCA MOCCA CHOCOLATES LOGO AND STACKED THE WORDS INSTEAD OF IT BEING ON TWO LINES. IT MADE IT MORE COMPACT. TO ACHIEVE THE CREAM BACKGROUND COLOR WE WANTED, WE PRINTED A TINT OF YELLOW, RATHER THAN CHOOSING A CREAM BOARD." SAYS BERNIE SEXTON.

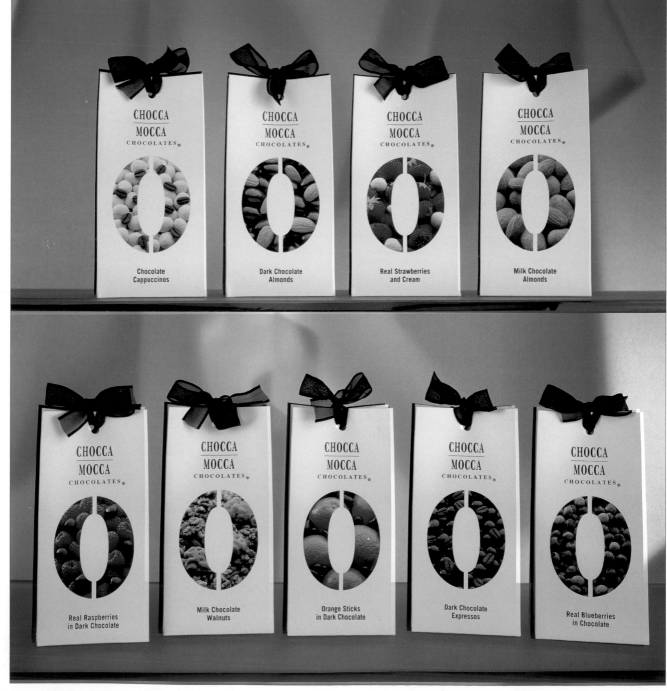

CHOCCA

MOCCA

CHOCOLATES®

Real Strawberri
and Cream

Giro
One man, working late each night in his garage, created **a revolutionary new helmet for cyclists,** which was at once better looking, better fitting, and lighter than anything else on the market. But although the helmet was an immediate winner when it was eventually produced, the packaging owed its success to a process of evolution

It was 1985 when Jim Gentes of Santa Cruz, an industrial designer and avid cyclist, set out to design a cycle-related product that he could make himself. At the time, cycling helmets were uncomfortable, heavy, and lacked the aerodynamic styling with which we are familiar today. With friends at NASA to help with the shape and vent placement, Gentes used his parents' retirement savings as well as his own money to pay for the tool to mold the new helmets, which he assembled in his garage at home. The Prolight™ was an immediate success, and the business soon expanded into Gentes's neighbor's garage. Four years later his second model, the Aerohead™, was worn by Greg LeMond, the winner of the Tour de France in 1989, and this led to a series of other high-profile victories, including the Cycling World Championships and IronMan Thiathlon

By all accounts, Gentes could not make the helmets fast enough. "He had created a new market, selling his product throughout North America," says Maia Ming Fong, art director at Giro Sport's Studio in Santa Cruz. The company is now a multi-million dollar producer, selling helmets in 40 countries and through over 2,000 US retail stores. "Because he is a designer, product design is the focus of the company—he is a fanatic about details, and whenever other companies have tried to knock them off, he would up the ante, pushing back the technology as well as the esthetics," she explains.

The name Giro was chosen because Gentes liked the sound of the Italian word for 'rotate' or 'spin'. If you look closely at the logo you will see the shape of a two-wheeler as well as, in the 'i', a cyclist with arms in the air. When the helmets were first launched they came in a plain cardboard box. A lot of other helmet products had boxes with windows, cellophane

(*ABOVE*) BEFORE 1994, THE NON-CUT-OUT BOX, USED THE LOGO BASED ON A SKETCH BY JIM GENTES. ONCE COMPETITION STARTED TO INCREASE, INSTORE PRESENTATION BEGAN TO MATTER A LOT MORE.

THE FIRST SOLUTION (BELOW) FOR THE NEW BOX, HAD A DIFFERENT DESIGN FOR EACH MODEL. THE CUT-OUT IN THE CORNER WAS LARGE ENOUGH FOR THE PRODUCT TO BE VISIBLE BUT NOT SO LARGE THAT IT FELL OUT—AND IT WAS SMALL ENOUGH TO KEEP THE BOXES STACKABLE.

(*ABOVE*) INTRODUCED IN 1995, THE NEXT SERIES WAS DIVIDED BY COLOR INTO ROAD, MOUNTAIN, SPORT, AND KIDS' MODELS. THE BOXES WERE PRINTED AS LITHO SHEETS, LAMINATED ONTO CARDBOARD.

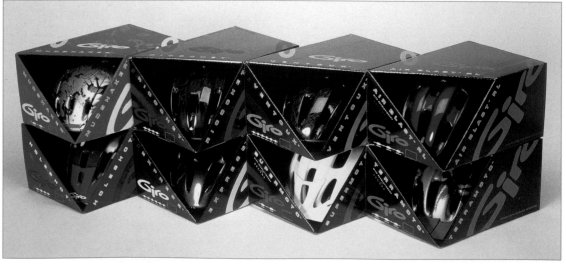

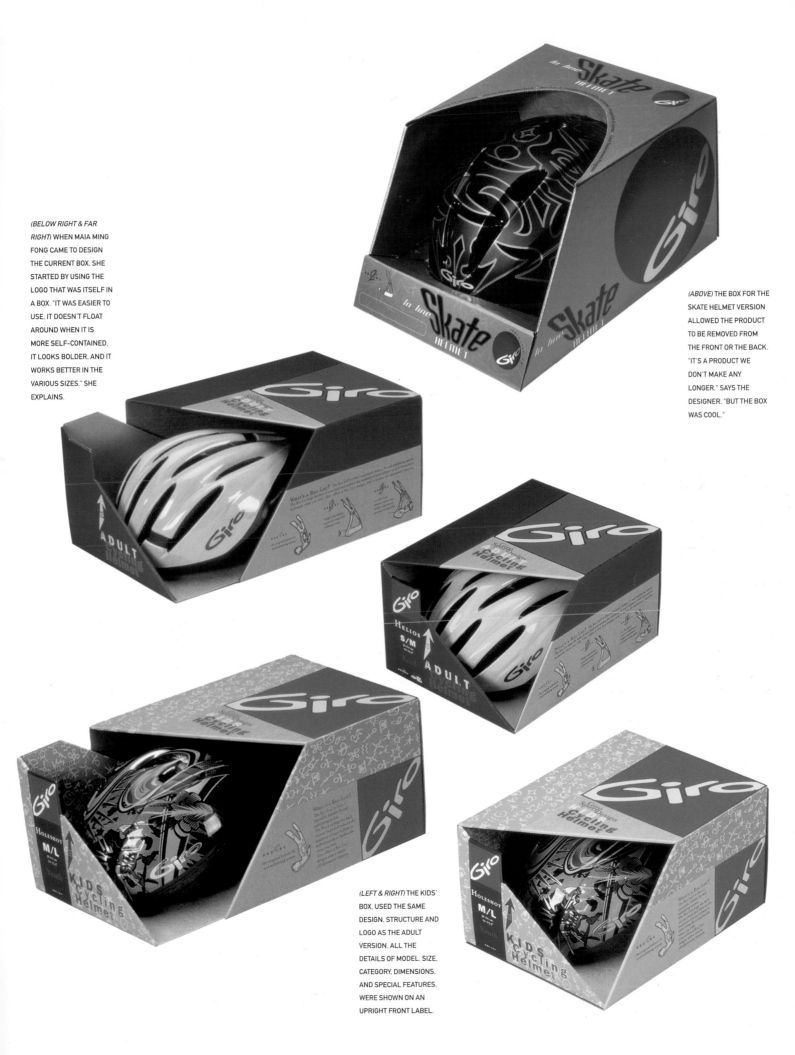

(BELOW RIGHT & FAR RIGHT) WHEN MAIA MING FONG CAME TO DESIGN THE CURRENT BOX, SHE STARTED BY USING THE LOGO THAT WAS ITSELF IN A BOX. "IT WAS EASIER TO USE, IT DOESN'T FLOAT AROUND WHEN IT IS MORE SELF-CONTAINED. IT LOOKS BOLDER, AND IT WORKS BETTER IN THE VARIOUS SIZES," SHE EXPLAINS.

(ABOVE) THE BOX FOR THE SKATE HELMET VERSION ALLOWED THE PRODUCT TO BE REMOVED FROM THE FRONT OR THE BACK. "IT'S A PRODUCT WE DON'T MAKE ANY LONGER," SAYS THE DESIGNER. "BUT THE BOX WAS COOL."

(LEFT & RIGHT) THE KIDS' BOX, USED THE SAME DESIGN, STRUCTURE AND LOGO AS THE ADULT VERSION. ALL THE DETAILS OF MODEL, SIZE, CATEGORY, DIMENSIONS, AND SPECIAL FEATURES, WERE SHOWN ON AN UPRIGHT FRONT LABEL.

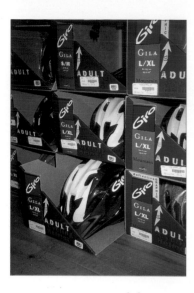

(LEFT AND OPPOSITE)
SEEN IN STORE, THE
ADVANTAGE OF THE
SLIDE-OUT TRAY IS
IMMEDIATELY EVIDENT.
WILBUR WONG AT
FLEETWOOD CONTAINERS
IN VERNON, CALIFORNIA
WENT THROUGH DOZENS
OF ALTERATIONS ON THE
BOXES TO FINE TUNE THE
STRUCTURE. NOTCHED
AREAS INSIDE THE TRAY
WERE ADDED TO HOLD
THE HELMETS IN PLACE.
"WE WENT THROUGH
AGONY TO GET ALL THAT
INTEGRATED AND STILL
NOT USE TOO MUCH
BOARD," HE CONFESSES.

CREATED BY FLEETWOOD
CONTAINERS, THIS
CUTTER GUIDE SHOWS
THE COMPLEXITY OF THE
INSIDE TRAY, WHICH,
WITH THE BOX, HAD TO BE
ASSEMBLED ON THE
SAME PRODUCTION LINE
AS THE HELMETS.

THE BOX FOR THE ADULT
CYCLING HELMET LOOKS
SIMPLE WHEN IT IS SEEN
IN THE FLAT, BUT FONG
HAD CONCEIVED THE
DESIGN SO THAT THE
ELEMENTS LINE UP
WHEN THE BOX IS
ASSEMBLED. THE AREAS
SHOWN WHITE ARE
CRAFT COLORED IN THE
FINAL APPLICATION, AND
THE HISTORY OF THE
INVENTOR APPEARS ON
THE BACK.

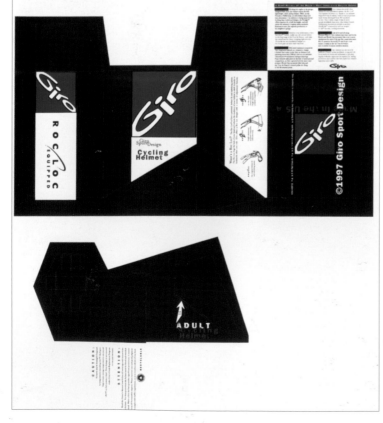

wrap or blister packs. "I looked at all the alternative ways to pack the helmet," says Fong. "They had to be stacked in the warehouse and in the stores, but at the same time I wanted people to be able to see them without taking them out. I also realized that the helmet design looked better when seen from a three-quarter front view, and this eventually led me to cut off the corner of the box. I certainly didn't want a standard window. In this way, customers could see two views of the helmet in one," she explains.

She started by working with little cardboard mock-ups, on which she developed the graphics. "I think of them as jewels inside their boxes, the bright ones really pop." The first of the new pack designs were launched in 1995. "They had good and bad reactions," she recalls. "But we learned some very valuable lessons." Although stores liked the fact that it was possible to see the product, they complained that the helmets got dusty and when customers tried to pull the helmets out through the corner, it tore the pack. A customer or a retailer would take a box out from the bottom of the pile and not put it back neatly or in the right place.

The following year, although the design of the packs was the same, they were re-branded by category—road, mountain, sport, and kids—since as the number of designs grew, it had become impossible to have one style of graphics for every box. This time, instead of all black, each category had its own colorway. But customers still wanted to take out the helmets and try them on. "I saw that another company was making boxes with a slide-out tray, and they worked really well," explains Fong. "It uses up a lot more cardboard, so I started to look at craft board as an alternative. This means that we had to switch from litho printing to flexography. I saw several printers—they all showed me their own variation on the design—and I chose the best solution at the best price," says the art director, who lets her supplier in Vernon, near Los Angeles, work out the construction details and creates her design to fit their cutter guide. Adding to the complexity of the new two-piece pack design was the fact that Giro's own production line had to assemble not only the helmets, now grown to a range of 16 different models, but also the packs. "It took a bit of getting used to," says Fong. "The time it took to assemble them increased the production cost and with only three corners, the shipping department could not stack them so high."

She got several dummy samples made up and tried a shipping test, during which she discovered that the helmets "rattled around" and got scuffed. "The helmets weren't protected enough," she says. "They used to be in a bag in the box, but now there was no point." The secret was the addition of a little foam pad in the top. "A kind of `fix it'."

After this, the design almost fell into place, according to Fong. "I look at the whole thing, not at one side at a time. There is a mathematical logic to the elements and the position of everything."